DIANA
VREELAND

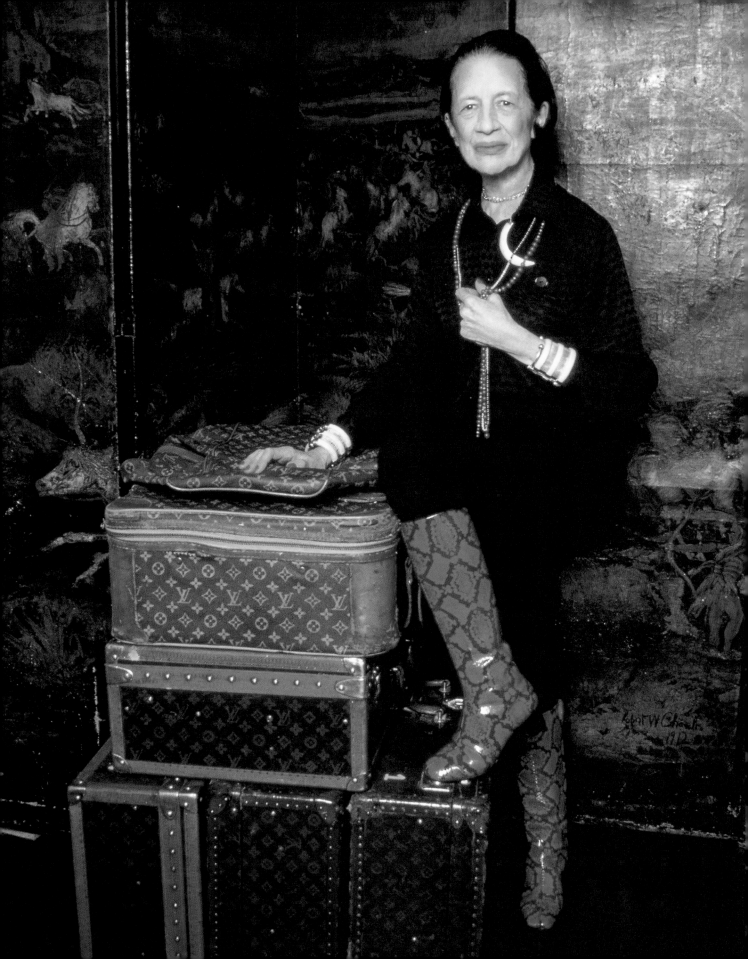

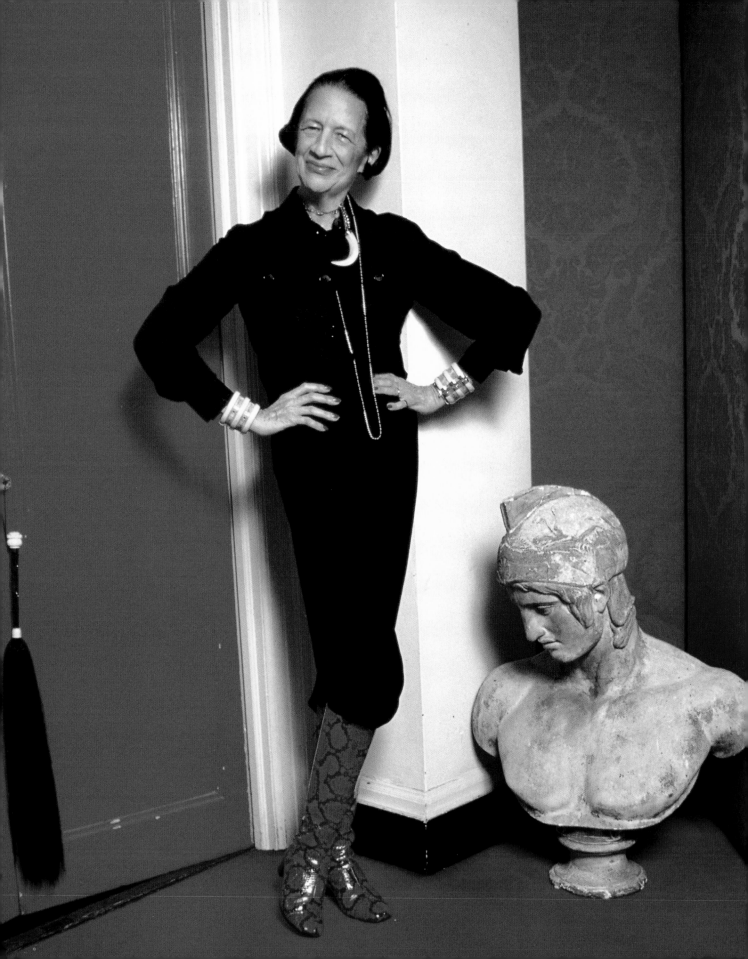

DIANA VREELAND

ELEANOR DWIGHT

WILLIAM MORROW

An Imprint of HarperCollinsPublishers

THREE OPENING PHOTOGRAPHS BY JONATHAN BECKER

Photograph and illustration credits appear on pages 300–301,
which serve as a continuation of this copyright page.

FIRST EDITION

Printed on acid-free paper

Library of Congress Cataloging-in-Publication Data
Dwight, Eleanor.
Diana Vreeland/Eleanor Dwight.—1st ed.
p. cm.
Includes bibliographical references and index.
ISBN 0-688-16738-1
1. Vreeland, Diana. 2. Fashion editors—United States—Biography.
3. Women periodical editors—United States—Biography. I. Title.
TT505.V74 D93 2002
746.9'2'092—dc21
[B] 2002024382

02 03 04 05 06 ❖/TOP 10 9 8 7 6 5 4 3 2 1

DESIGNED BY ELIZABETH PAUL AVEDON
WITH LAURA WHITE

For Candida Mabon Dixon, who as a beautiful little girl played on the floor

of Mrs. Vreeland's office at *Harper's Bazaar* while her mother did business with the grown-ups,

including the fearsome figure behind the desk wearing a black snood

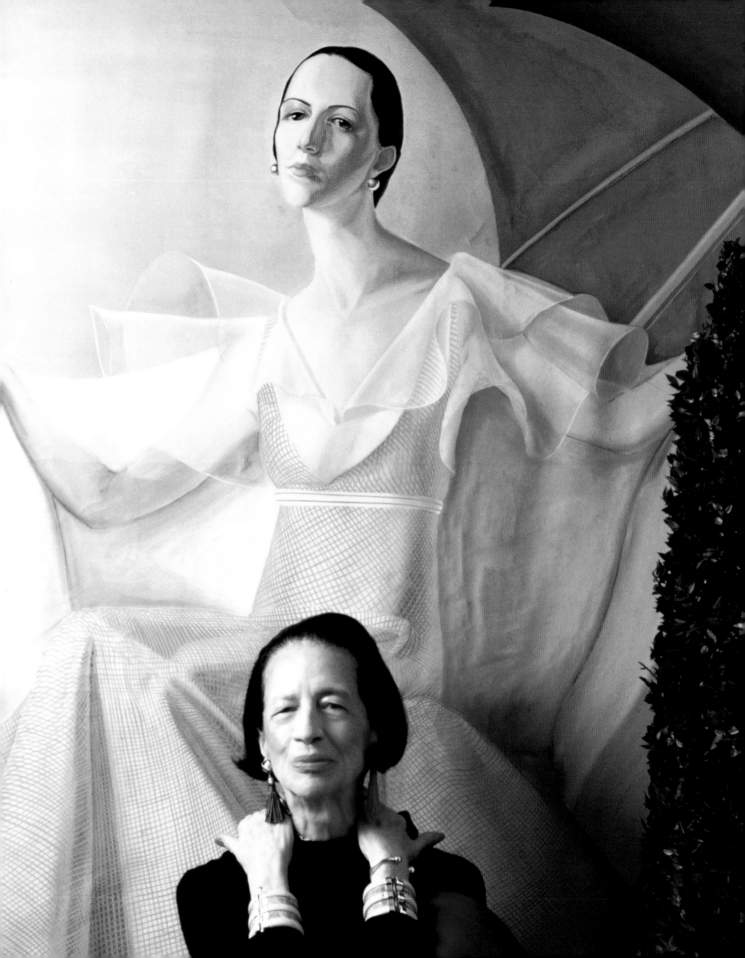

CONTENTS

FOREWORD

I met Diana Vreeland once, years ago. It was a winter evening and she was waiting, dressed in a beautiful fur coat, for the elevator in the lobby of a Park Avenue apartment house. As she was a celebrity and was striking-looking—with her coal-black hair and unusual face—and because she radiated energy and enthusiasm, she caught everyone's attention. We were introduced and she fixed her eyes upon me. I felt that in a good-natured way she was assessing me—sizing me up as polite small talk was exchanged. Our brief encounter ended when the elevator doors opened, and I wondered if I had failed her test.

Of course I did know about her, having followed her career at *Vogue* and the Metropolitan Museum of Art's Costume Institute. I attended her glorious shows with my children. In the 1970s, I stood in awe among the assembled groups of dazzling figures she produced year after year in the wonderland of the Met's basement. In the 1960s, I devoured her issues of *Vogue*, where she introduced a new standard for beauty, which included sex appeal, youth and originality—exemplified by Twiggy, with her huge eyes staring out from the page, and Lauren Hutton leaping through space.

I thought of Diana Vreeland while I was writing a biography of Edith Wharton. A brilliant observer of upper-crust society at the turn of the twentieth century, Wharton told stories of women who were trying to make their way in a world in which money and looks were greatly important. I realized the leap from Wharton's novels to Diana Vreeland's story was not so enormous. At the center of Diana Vreeland's life's work were questions Wharton had also posed in her novels: "Can women break free from society's conventions to experience a full life?" and "How does a woman's beauty determine her fate?" Diana's beautiful mother resembled a tragic Edith Wharton heroine, and her resourceful and resilient daughter made a full life for herself starting out in a world that mirrored Edith Wharton's fiction.

Diana grew up in the first decades of the twentieth century, and throughout her life she made herself the central character of her own tale, embellishing her autobiography with amusing stories, giving herself an intriguing and rich history. It was so elaborate and inconsistent that those she met in her work and in society were often curious about her background and wondered who Diana really was. Her memoir, *DV*,

published in 1984, added to the mystery. Its fabulous tales featured a Parisian childhood, frequent trips to the Louvre with nurse Pink, and a glamorous mother with connections to the demimonde.

It sparkled with so many entertaining fantasies that when members of the family read it, they felt compelled to confront her. As her son Frederick ("Frecky") Vreeland recounted, one cousin asked her, "This isn't all fact, Diana. Isn't it part fiction?" "Yes," she replied, "it's faction."

Diana's history, some of which she preserved herself in carefully packed boxes and family scrapbooks, has remained unexplored since her death in 1989. As I read her memoir and correspondence with friends and family, and interviewed the colorful personalities who knew and admired her, I began to see what was fact, what was fiction and what was the faction in between. I realized that even if a story in *DV* is not the truth, it is her story and so part of her life and legacy. It expresses her fantasies and must be seen as part of her approach to living.

I came to see that her gift for fantasy enhanced her life and the lives of everyone who came in contact with her. She was in love with a life that was dazzling and pictorial, and she generously shared her visions.

The New York into which she was born did have its social rituals and its spectacles—the weddings, debutante parties and other entertainments of the rich and privileged. But she sought a more exciting milieu than what her parents knew—the international jet set, the world of fashion and photography, a group of talented and creative friends and associates. The social and artistic spectacles in Paris became the passion upon which her imagination fed for decades. The Ballets Russes, with Nijinsky's dancing and Diaghilev's productions, became an image she appropriated as a part of her aesthetic and cultural memory. She became entranced with fashion, epitomized by the luxury and excellent workmanship of haute couture.

How did this homely little American girl, born into a New York family without any particularly creative members—except for her flamboyant mother—become one of the most interesting, cosmopolitan working women of the century? The search for the answer led me into the labyrinth of Diana's life, so filled with energy, excitement, and her unparalleled devotion to style and beauty.

I have always had a wonderful imagination, I have
thought of things that never could be . . .
 —Diana Dalziel diary, 1918

New York Childhood

When a guest arrived at the Park Avenue apartment of Diana Vreeland, he was greeted in the alcove before the front door by a full-length painting of the glamorous but fey young Diana in a pink cotton gingham and white organdy dress under a green parasol. Once inside, he was surprised by the bright shades of red and objects suggesting a life rich in the present and exciting in the past.

In the spring of 1962, a young reporter with the *New York Times* came to 550 Park Avenue to interview Diana about her new job as *Vogue* magazine's top editor. She found that the apartment was like its owner—"outrageous, individual and warm," shocking but appealing with its brilliant hues and fascinating objects.

Carrie Donovan had observed Diana at work and she drew a vivid picture of her older colleague, who at that time was not much known outside the fashion business. As Donovan wrote, inside the industry Vreeland was considered "probably its most colorful personality," viewed with "a combination of awe and astonishment." Designers craved her appearance at their fashion shows: "When she jots down the number or name of a model during a showing, other editors are quick to do the same."

Donovan also described how she looked— her way of walking and her unusual face "with flat planes, brown eyes, a generous mouth and strong, aquiline nose." And, Donovan added, "Mrs. Vreeland's colorful manner of speaking is part of the legend. Fixing the listener with a steady gaze, she rolls out declarative sentences in a booming voice that has an electrifying effect on the people around her. At least one word in every sentence is emphasized."

As readers learned, Diana Vreeland was not only expert at creating beauty and excitement, but also at recognizing the exquisite when she saw it. She transformed herself, her apartment, her magazine pages and later her Costume Institute exhibitions. But how she did this remained mysterious. The casual observer would not know of the hard work and many carefully chosen ingredients that made up Diana Vreeland creations.

As one approaches the story of her life, can one get beyond the carefully choreographed performance, the marvelous details, to learn the whole story—the facts that she would have preferred to leave shrouded in mystery?

Where Diana was born and raised was always a mystery. Once she claimed to have been born in Vladivostok, as she told her grandson Nicky. He was studying filmmaking in the 1970s, and decided his grandmother, "Nonina," was the perfect subject for a profile. He went to the red living room and she emerged from her bedroom all set to perform. She faced the camera and began: "I was born in Vladivostok." Her story unfolded from there. When she had finished, Nicky realized the camera hadn't been working. With apologies he adjusted it and they started again. She began the same way: "I was born in Vladivostok," and she continued her tale to the end, word for word, exactly as before.

Another time she said she was born in the Atlas Mountains—"in a nomad community, accompanied by Berber ululations."

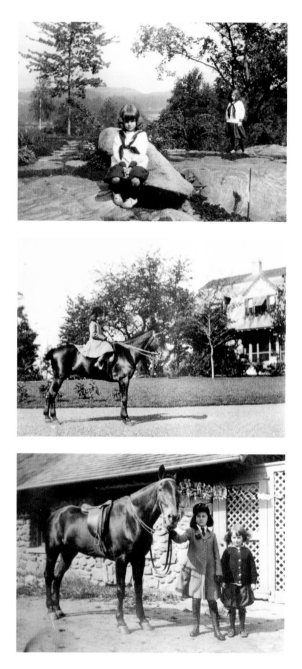

Top: *Alexandra and Diana.* Center: *Diana would sit for hours on her grandmother's horse, happy to be with the "steam and the smell of that divine horse. Horses smell much better than people—I can tell you that."*
Bottom: *Diana holding the horse and Alexandra.*

Her appearance gave little away about her true origins. A curious stranger encountering this strange-looking woman in the 1960s might have guessed that she was a White Russian émigré of noble birth, or the daughter of a Cherokee chieftain or Bengali rajah, or as those in New York's garment district suspected—a Sephardic Jew.

The true story of her beginnings is to be found in an album carefully kept by her father. She was born in Paris, at 5 Avenue Bois de Boulogne (Avenue Foch since World War I) in the summer of 1903. Her American mother, Emily Key Hoffman, and her English father, Frederick Young Dalziel (pronounced the Scottish way: dee-YELL), had been married two years earlier, at St. Peter's Church, Eaton Square, the fashionable Anglican church in London's Belgravia. The couple were living in Paris because Fred was working as the French representative for a South African gold mining company.

She didn't stay long in Paris, for on April 2, 1904, the Dalziel family sailed for America on the SS *Ryndam*. Little Diana, beginning at the age of eight months, spent her childhood in New York City living at several addresses in the East Seventies until she was married twenty years later.

The setting of her early life was determined by her mother's friends, family and social position. On their return from Europe, the Dalziels took their place in the world in which Emily had grown up, a society of the well-to-do and the well connected. Emily knew the Vanderbilts and the Astors, and the staid New York upper-crust society in which money and position mattered above all else. But her New York friends also had flair—they were bohemian and cosmopolitan, at ease in London, Paris and the south of France. As a result, her daughter Diana later saw herself as a member of the leisured class. "She always emphasized that that's where she came from and that's where she stayed," Frecky Vreeland recalled, "that was the link she never broke."

Emily brought home a husband who was neither rich nor socially prominent, qualities valued in her world. Fred was sophisticated and charming, however. As Diana's sister described their father, he "wasn't distinguished in his family but was very good-looking, which is why [my mother] married him." His grandson remembered that "he had a wonderful sense of form, of class and elitism."

Later Diana saw her father's forebears as a great source of pride—brave Scots, whose motto was "I dare." The Dalziels, however, had not lived in Scotland for generations. Frederick Dalziel, Diana's father, grew up in London and spent two years at Brasenose College, Oxford, leaving in 1893 without a degree. In New York he became a stockbroker. Though he lived in New York until his death in 1960, Frederick remained a British subject. "My father was a penniless Englishman," Diana said. "He was terribly square, terribly nice and terribly conventional." He was also a steady, dependable father his children could look to as a foil to their flamboyant and temperamental mother.

Emily Dalziel had the sort of charismatic personality that Diana would later encounter in her own fashion work. When the young Dalziels returned to New York, society columnists commented on the striking couple. Emily was "a lovely and graceful woman" who at the opera "flitted from box to box, smiling and shaking hands." Readers learned that "the arrival of a baby girl has not made the mother less piquant and charming."

She was a lively and original personality, whose family was prosperous and distinguished, and quite conventional. Her father, George Hoffman, was a lawyer who grew up in Baltimore and was educated in Europe, at Yale and at Columbia Law School. He practiced law and managed trusts. Little Emily, born in 1876, was nine when her father died.

Emily's mother was Mary Martin Ellis, whose father, the well-to-do John Washington Ellis, lived in New York and summered in Newport. Ellis had made his fortune in Cincinnati as a partner in a general store and later as a New York banker. When she was widowed, Mary married Charles Gouverneur Weir. Diana called him "Daddy Weir."

Little Diana spent her childhood on New York's Upper East Side, with its brownstone houses and rising apartment buildings. Fashionable men still wore top hats, and women long dresses. Hers was the New York of the prosperous families who sent their children to private schools, and to Central Park with their governesses to play in the afternoons.

In her memoir she remembered her childhood fondly: "I adore the way I was brought up. I adore the amount I knew before what I know today and I adore the way I got to know it. My experiences were so innocent and so easy and so charming." They were not, however, always so

Diana, her mother, Emily Dalziel, and her beautiful sister, Alexandra.

THIS BAND OF
ARE
THEY'LL
PLAY IN
"TRELAWNY"

$$$$$$$$$$$$$$$$$$$$$$$
$$ MEMBE
$$ OF THE
$$ "400.
$$$$$$$$$$$$$$$$$$$$$$$

Miss Emily Hoffman, Actress, in Gauss

She will appear in the leading role of Rose Trelawney in an amateur production
members of New York's most exclusive social set will give for the benefit of charity
and a talented one.

Herald: "'Pandora's Box' reveals bewildering beauties
women of society pose and dance for charity."

Times: "Superb spectacle is 'Pandora's Box.'"

FOR THE BENEFIT OF

Our Own American Unemployed

AT THE

FORTY-FOURTH STREET THEATRE

(West of Broadway)

on Friday Afternoon, December 11th, at 3 o'cloc

The only public performance of the brilliant spectacle
and ballet

"Pandora's Box"

Produced at the Seventh Regiment Armory with overwhelming success

Pandora Mrs. Frederick Dalz
Hephaestus Mr. Nigel Cholmeley Jon
Hermes Miss Marie Dor

innocent and easy and charming as she remembered, but one thing is clear. Diana, the star performer of her own drama, began writing the script for her life as soon as she could.

Diana's sister, Alexandra, was born in June 1907. Her arrival changed the family dynamics forever. From the start it was obvious that the sisters were different—in appearance as well as disposition. Little Diana had dark curly hair, dark eyes and a big nose. She looked smart and perky, but she didn't have the classic, angelic features of her little sister. Alexandra had a symmetrical face, blond curly hair and a lovely demeanor.

The sisters not only looked different, they were different. Alexandra, or Teenie as she was called, was a star at the Brearley School, playing on teams and earning high marks. Diana was funny and imaginative; she loved to ride and to dance, but she didn't like the routine of schoolwork. When she was thirteen, Diana was asked to leave Brearley because she could not keep up with the work. As Alexandra remembered later, "Diana was always being expelled, not because she was stupid but because she wouldn't work: She didn't like school. It wasn't one of her things."

The society press often featured Emily Key Hoffman Dalziel, "a striking brunette who belonged to an old New York family," who took "an active part in social activities during the brilliant seasons just preceding the War." At "fashionable philanthropic events" she often appeared as "a Spanish dancer" or as an actress in a play. Her "famous Spanish dance" featured "bewildering and fascinating poses and steps." At opposite top left Emily is seen in period dress dancing with her brother at the Bradley-Martin Costume Ball. At top right Emily is pictured in the New York Times in 1910. At center she dances in the role of Iris in 1916. At bottom left readers learned that Emily's "Band of Actor Folk" are members of the "400" with their plays performed "in cause of charity." Bottom right: Emily played Pandora in the ballet Pandora's Box.

Teenie was the favorite of their nanny, Katherine Carrol, or Kay, who joined the family around 1910 and stayed on with Frederick Dalziel until the next generation—Diana's sons and niece—had grown.

But Kay was not the only adult to favor Alexandra over Diana. Diana later recalled how Alexandra often attracted attention for her good looks. When the children went to Central Park, people would stop and look at her as she sat in her pram, "terribly dressed up." She was, as Diana later recalled, "the most beautiful child in Central Park." As soon as Diana would see people looking, she'd run over to the pram, because she was so proud of her sister. This prompted some bitter remarks from her mother. One day she said to her, "It's too bad that you have such a beautiful sister and that you are so extremely ugly and so terribly jealous of her. This, of course, is why you are so impossible to deal with." Diana remembered that "it didn't offend me that much. I simply walked out of the room. I never bothered to explain that I loved my sister and was more proud of her than anything in the world, that I absolutely adored her. . . . Parents, you know, can be *terrible*."

This poignant reminiscence some seventy-five years later illustrates how Diana came to deal with the pain of growing up in her family, just as she would later transcend the painful moments of her own family life and her career. She learned to live with and even cherish beauty, personified by her talented and adored younger sister. She also learned to live with a flamboyant and beautiful mother who favored Alexandra. And even though her mother would stoop to hurt her "impossible to deal with" daughter just to win an argument, Diana emulated her mother's style and effervescence. Although Diana felt that she was homely, she herself took pride in being the sister of the most beautiful child. She always sought out and enjoyed intimacies with beautiful people, from her school friends to the fashion models she would come to know.

Diana adored her beautiful younger sister, Alexandra.
Top: *Alexandra at Windwood;* above: *Alexandra and
Diana in Central Park; and* opposite left: *in Venice.
Diana was proud of the Dalziel ancestors of her father*
(opposite right)*, brave Scots whose motto was "I dare."
As she told it: The son of a clan chief was kidnapped by
a rival clan. When the chief asked for a volunteer to sneak
into the enemy's camp to bring him back, a Dalziel stood
up and said, " I dare." These Scots of Diana's imagination
were Highlanders, dressed in tartans and speaking Gaelic.*

Diana's mother, who was also a beautiful woman, was a complicated role model for Diana, and the two had a difficult relationship. As a debutante Emily Hoffman had attracted attention for her looks, and also for her personality. Before she married Frederick Dalziel, she had gained something of a reputation for her dancing. In the late 1890s, her congenial group—young, socially prominent and bohemian—spent evenings entertaining one another in the Greenwich Village studio of James L. Breese, a successful photographer. They called themselves "the Carbonites," after the carbon process for developing photographs, and newspapers reported their "high-jinks," including "weird midnight suppers and dances and gay little dinners" and costume masques. Stanford White, the architect and a notorious philanderer, more than twenty years older than Emily, was a leading spirit of the group. Emily Hoffman, tiny, with dark hair and a lovely face, was a star performer who smiled out from newspaper photos looking vivacious and sexy. She was dubbed "the Society Carmencita" after John Singer Sargent's popular painting of the Spanish dancer.

As a child, Diana knew her mother's fun-loving and eccentric friends, like her godfathers Henry Clews Jr. and Robert W. Chanler, who were both artists and worked in adjoining studios on East Nineteenth Street.

Clews, the only son of a banker, could afford to buy a château in the south of France, and Chanler was one of the ten eccentric "Astor orphans," heirs to part of William B. Astor's fortune. Two of Bob Chanler's brothers had their brother Archie ruled incurably insane and committed for life to the Bloomingdale Insane Asylum. When Bob Chanler's wife, an exotic actress who married him for his money, left him days after their unfortunate marriage, Archie cabled from the asylum, "Who's looney now?" This became one of Diana's favorite expressions.

In fact, one of Diana's cherished possessions was a screen painted by Bob Chanler, who created a sensation in the famous Armory Show of 1913. The little Dalziel girls loved to go to Chanler's house on Nineteenth Street, which was filled with exotic caged birds, fish in a tabletop tank, monkeys, even a boa constrictor that once got loose.

Since Emily and Fred enjoyed the social rituals of the time—elaborate weddings, benefit theater performances, balls, dinners and evenings at the opera—Diana and her little sister were soon included in this lively and privileged world. In the winter of 1911, seven-year-old Diana played a starring role as a flower girl in a grown-up pageant: the wedding of Vivien Gould, the older sister of a school chum, Gloria Gould, to Lord Decies. The society wedding was the great public ritual in the first years of the century, and this one was another transatlantic union of a land-poor English blueblood and a well-endowed American heiress, a tradition dating back more than a generation, when Jennie Jerome from Brooklyn charmed Lord Randolph Churchill.

Having taken part in this society spectacle at age seven, Diana was used to such gatherings by her twelfth year, when "The Children's Revolu-

tion," a fund-raising evening which included guest Teddy Roosevelt, was staged at the enormous Century Theatre on Columbus Circle by members of New York society, in support of the Allied cause. Again, Diana played a starring role.

A special feature was the presentation of children of families with Colonial ancestors. Diana Dalziel took a bow as a descendant of George Washington's family; along with Alexandra, as a descendant of Francis Scott Key, thereby staking the Dalziel family to a double claim of elite and historic lineage on Emily Hoffman's side.

In 1911, 1912 and 1913, Diana took part in another typical pastime of the New York social world—summer trips to Europe. These excursions opened up the world for Diana—dazzling her with the sight of marvelous palaces, beautiful gardens, glorious spectacles, sparking her imagination with the awareness of kings and queens and their intriguing stories, which included beheadings, wars and living luxuriously. The Dalziels crossed the ocean on the great liners, and on their first trip visited France, England and Scotland.

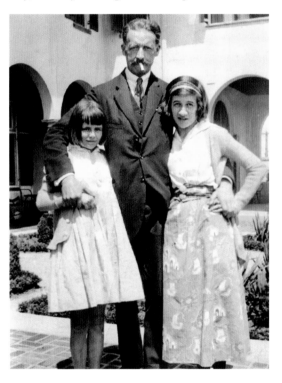

Diana (right) *with her sister, Alexandra, and her father, Frederick Dalziel, at Villa Diana.*

In her album Diana carefully described the events that exhilarated her most, such as the changing of the guard at Buckingham Palace, seeing King George and Queen Mary, and going to Westminster Abbey to view the tombs of Mary, Queen of Scots, Queen Elizabeth, Longfellow, Tennyson and "lots of others." The greatest treat was seeing the crown jewels and hearing stories of intrigue and death in the royal court.

When they returned to New York, Diana and her godmother, Anna Key Thompson, went up to "Windwood," the place in Katonah, New York, that her grandmother Mary Weir had bought in March 1911. There Diana rode her pony every day and helped Anna in the garden. In her album she pressed two red autumn leaves "from the trees planted in my grandmother's place called 'Windwood,' in Katonah 1912." She included her own family's plants next to those she had seen in Europe—heather and thistle from Scotland, sand thistles and sand peas from Deauville, a red poppy from Vichy, and a "Blue Hidleathroat planted by Queen Mary at Hampton Court."

In the summer of 1913, the Dalziels again visited London, Paris, Switzerland and Venice. Later, Diana would claim that her mother knew Diaghilev, the great master of the Ballets Russes, and that Nijinsky came to her parents' house. Maybe while the Dalziels were abroad they met these famous Russians who had ushered in an exciting artistic epoch when they changed the nature of dance in 1911. In any case, the idea of the iconoclastic Ballets Russes—with its energy, color and movement—would become central to how Diana saw the past. These creative people—Stravinsky, who composed the music;

Diaghilev, who organized the productions; Nijinsky and Ida Rubinstein, who danced in them—burst into Diana's pictorial imagination and continually inspired her.

When European trips became impossible during the war years, Emily Dalziel took her children to spend the summer of 1916 in Idaho with her cousin Caroline Postlethwaite Cobb (who had established a residence at Hayden Lake, near Coeur d'Alene, Idaho, to obtain a divorce). Here Diana's fantasies were actualized in organizing her sister and two younger Cobb cousins to don flowing garments and put on plays.

During this summer Emily discovered her own passionate pastime—big-game hunting. She had not felt well, and had been in wretched health for several years, the cause of which was "just a nervous miserable condition." But once hunting had "taken possession" of her, she said, she felt cured and happy. In the Rockies she shot everything that moved: deer, elk, bear, mountain sheep, mountain lions, lynx, coyotes and a variety of small game. She was asked later by a reporter how such a "delicate, highbred woman" had taken up hunting. "It would be so much easier imagining her in a setting of a Louis XV drawing room and a roseblown boudoir," the article said. The writer had sensed the fascinating sides of Emily Dalziel—she was adventur-

In her teenage years, Diana made strict resolutions for improving her looks and her charm. Among other things, she vowed each day to "spend a heavenly night sleeping out of doors," "go for mad walks" and "dance for two hours in my costume."

ous, beautiful and sophisticated but also temperamental.

Diana didn't share her mother's affection for hunting. In fact, she never spoke with admiration or affection about anything her mother had done. She characterized Emily as flirtatious and claimed that she always "traveled with a very good-looking Turk." Diana saw her as irresponsible and self-absorbed, a beautiful woman pleasing herself by living a splashy life without regard for her children, her own well-being or her reputation.

While many praised Emily for her flair and love of life, Diana found her flamboyance embarrassing. She later claimed that Emily Dalziel came to Mother's Day at the Brearley School in "a *bright* green tweed suit and a little gold-yellow Tyrolean fedora with a little black feather, gilt at the end, that was short but sharp—I'm talking *sharp*—and she was very made up."

In her teenage diary, Diana confided that "Mother and I agree on practically nothing." She scolded herself for contradicting her mother: "It's awful but I can't help it. I don't like this that Mother does & I don't like that. I don't like Mother's manner. Other girls could not even think of writing or thinking things that I do but I can't help it. . . . If I went to her and told her that I was unhappy she'd never understand & say that I was an ungrateful little wretch."

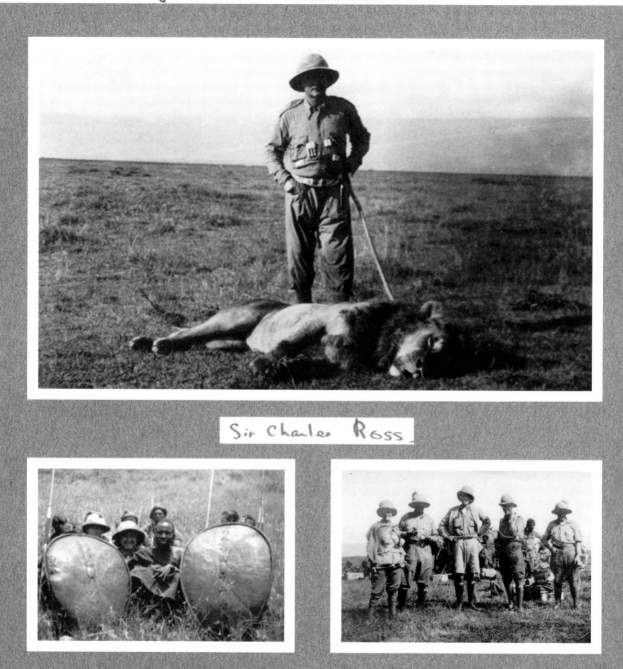

Sir Charles Ross

Emily Dalziel spent seven months big-game hunting in East Africa during 1920–21 without her husband. Her companion was Sir Charles Ross of Chalnowan, Scotland, who had hunted and fished with her before. He was a baronet whose title dated back to 1672. He had made the Ross rifle, manufactured by the Canadian government for its army during the First World War.

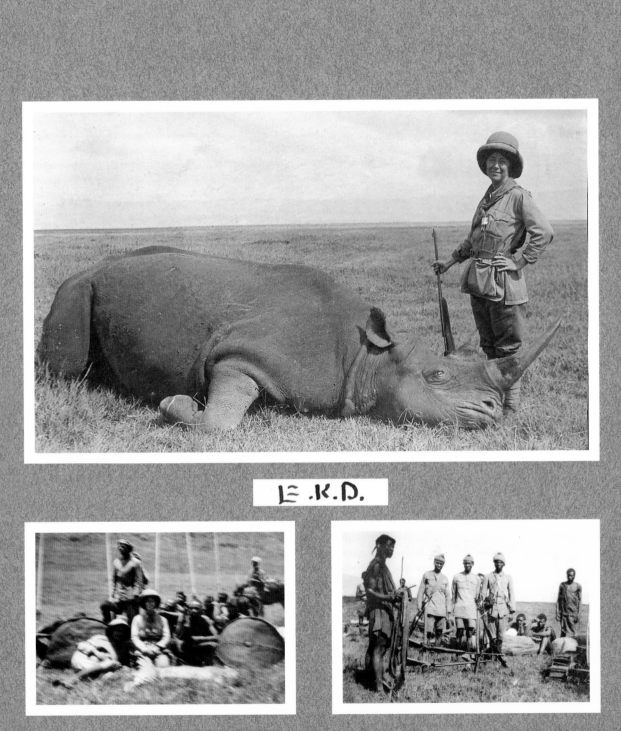

E.K.D.

The *Times* reported that Emily's rhinoceros was "a souvenir of her marvelous escape from death." She had wounded the monster with her first shot but, unable to fire again before the animal charged, was hurled into a thornbush. Sir Ross brought it down with a bullet in the brain. "Apart from scratches, the plucky huntress was uninjured."

"Miss Diana Dalziel on the tennis courts at Hot Springs, the great all-year-round Virginia resort." Opposite: *"The autumn life at Hot Springs, Va." Miss Diana Dalziel and Miss Rosalie Bloodgood with Devereux Emmet Jr. and John C. Newtington.*

Although her mother had told the teenager they were good friends, Diana insisted, "We are not. It seems to me we never were & if we ever will be I don't know."

As a young woman, Diana admired her mother's "pizzazz," but not much else. One suspects that there simply wasn't room in the family for two strong females, and that the child struggled to find her own identity in the shadow of her powerful mother. Years later she remembered her mother more kindly as "quite young and beautiful and amusing and mondaine and splashy, all of which I'm glad I had in my background—now. But I've had to live a long time to come to that conclusion." She also came to see that "I was much stronger—with a stronger will and a stronger character—but I didn't realize it then. All I knew was that my mother wasn't proud of me. I was always her ugly little monster."

Although Diana was outgoing and charming like her mother, Alexandra took after her father. She was quiet and very fond of sports. While Diana wasn't necessarily beautiful, Alexandra remembered that boys liked her—"despite her big nose!"—and others appreciated her vivacious personality.

When she was fourteen, Diana began a diary that reveals her adolescent angst and her urgent need to transform herself. She wanted to separate herself from the ugly girl she imagined being, and to cultivate a charismatic personality and a distinctive appearance. Her vibrant, extroverted personality and her ability to capture people's attention with her smart outfits were a carefully calculated way of becoming someone more in tune with her true self. If "elegance is innate," as she later claimed, her outer appearance had to reflect her inner character.

The unhappiness that Diana reported in her teenage diary was central in forming her personality. Her first step was to find role models for beauty and behavior. She vowed "to work terribly

hard at everything no matter how small it is." She emulated her classmates in how to dress and how to study well so as to be popular. She worked on becoming neat and tidy, enlarging her vocabulary, improving her ice-skating and her manners. She also wanted to look wonderful. For the rest of her life, Diana would refine this ability to reinvent herself.

At Mrs. MacIver's School, Diana was still having trouble with history and Latin, and she was behind in algebra. On January 8, 1918, she reported that "Miss Lente, Sister's music teacher told me that one of the little girls in school said I was wonderful. I'm going to try to make that impression on everyone. My skirt has been lengthened & my hair is held back with a comb & I feel new and fine."

Her beautifying did not stop with herself—it extended to everything around her. In her room she painted the electric light fixtures black, and the lamps looked nice against the bright blue wall. Her father said her room looked "nifty," which encouraged her to want to become an interior decorator. She fantasized about being rich and painting her bedroom "in French grey & turquoise blue & then a boudoir opening off it in a dull grey and dull grey blue."

It was only a matter of time before Diana would become her own most inspiring ideal. "For years I am and always have been looking out for girls to idealize because they are things to look up to because they are perfect." But since she had never discovered "that girl or that woman," she announced, *I shall be that girl. . . .* As it is Sunday I shall begin anew." She vowed "never to be rude to Mother, Sister or anybody. To improve my writing, I shall make myself the most popular girl among boys & girls. I shall always try terribly hard in everything I do." On January 23, she "decided I don't look pleasant & if I want to look as well as I do want to I must look pleasant and be sweet & look charming and be 'the girl.'" After

all, she was Diana Dalziel, descended from the brave members of a Scottish clan. She sat in front of the mirror and told herself, "I am Diana, a goddess, therefore ought to be wonderful, pure, marvelous, as only I alone can make myself . . . no one can ever rob me of that name, never shall I change it. Diana was a goddess and I must live up to that name, Dalziel = I dare, therefore I dare, I dare change today, & make myself exactly how I want to be."

After shirking her diary for four months, she resumed writing in June and reported progress: "I have become much more popular with everyone . . . all the girls at school the latter part of April and May were awfully nice to me. I'm going to make myself the most popular girl in the world."

At this time she began what would become a lifelong love affair with dance. She felt her true self when she was dancing, wearing "my yellow chiffon Greek dancing costume and gold ballet slippers." Music had the power to transform her and connect her to an exotic fantasy world: "It just makes me forget everything." When she danced the polonaise, she felt "the anger, the style, and pride mingled with the jealousy of a

race of people that live in a cold barren country." Spanish music brought her straight to "sunny warm Spain full of people in brilliant costumes crowding to café and cabarets." In "The Temple Bells," she was transported to "an incense filled dark temple," and "the dark lighting, the sandalwood and the jewels upon the dancer" evoked the richness of India.

As her first year in the new school ended, she looked forward to going to the dancing classes attended by all New York society, which were held at the Plaza Hotel and run by Adelaide Robinson, a dainty little woman, well coifed, with high-heeled black satin slippers and long white gloves. The great treat was that Irene Castle came to the school to dance with each girl.

Having given up emulating her schoolmates, Diana continued her search for a more exotic role model, "some great person" she could imitate. She found one in the novelist George Sand. "She was wonderful and exceedingly like me in this way: I have always had a wonderful imagination, I have thought of things that never could be and so did she."

George Sand was a practicing Catholic, but Diana's commitment to religion was, at best, vague. "I have moods where I want to just pray and I look up and see the lord and then perhaps the next moment I don't feel a bit religious."

October 13, 1922: "Interested Gallery Follows Hot Springs Golf Contest: Miss Marianne McKeever and Miss Diana Dalziel of New York at Hot Springs."

Despite her religion, George Sand "went around with the Bohemian set, the set I am going to go around with, not the foolish 'chic set.'" She also admired George Sand because she was a good sport, loved horseback riding, was very popular at school, loved art and had lived for a long time in Venice. "She went to a convent and then learnt English therefore I must learn French I simply must as my ideal did."

By June 15, Diana concluded that George Sand "becomes more and more ideal as I read on. She wore men's clothes, smoked black cigars and every time she met a man she would exclaim 'I never was so in love before.' I'm going to be a dancer or an actress. I'm going to wear men's clothes but I refuse to smoke cigars but I will most certainly smoke cigarettes."

And she was certainly determined to marry a different sort of man than the one her mother had chosen. While her mother had married a stockbroker who adored her, Diana dreamed of being the muse for a creative man. "When I'm grown up I never could be like Mother. I want to marry an artist, a painter and I want to be his model and he is to fall in love with me."

Although Diana the teenager was quite sure how she wanted to look, she was uncertain about the type of boy she would like to marry. Sometimes she wanted to marry an artist, "wild and

fantastic that will fall in love with my small white feet etc.—Oh but very, very wild and horribly good-looking." The next day she wanted "a man with money, moustache, good looks and kind and gentle." She knew it would be more practical to marry a rich man, but it would be more exciting to find "an Italian painter who will want to model me in marble and paint me as the bohemian girl with a tambourine and dagger."

In Diana's teenage thoughts, we can find the crystallizing of her aesthetic. She realized that a woman does not exist in a vacuum, but the way she looks makes a profound impression on others. Hard work and confidence in being able to change made the transformation possible. And changing herself covered up a deep wound—the pain of being rejected by her mother and her classmates. Even though she was critical of her mother, she felt the agony of her mother's disapproval. It is the child who feels unloved who needs to make herself into somebody very special.

From an early age, she fashioned herself as an original. Like the fairy godmother transforming drab reality into something beautiful and exciting, she made sure when she went to the dance that she was dressed as a princess. In later life, Diana's models, her magazine pages and her Costume Institute shows would all benefit from her deep need to wave her

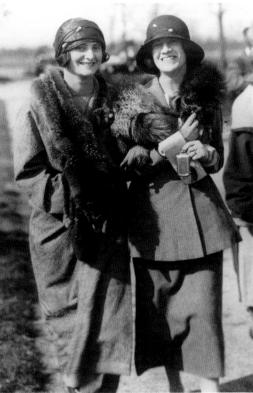

"Social Luminaries" Miss Barbara Brokaw and Miss Diana Dalziel. "popular leaders of society's younger set," attend the races at Belmont Park.

wand and transform the ordinary and the flawed into the mesmerizingly beautiful. And one day, rather than being the object of criticism by her classmates and her mother, Diana, the powerful fashion editor, would be the judge and decide who was and who wasn't beautiful. She would be the priestess at the shrine of beauty.

Making the right choices about clothes was terribly important to her. Years later, when Diana was almost eighty, she was standing amid the crowds in the great hall of the Metropolitan Museum of Art with a young intern. She placed her hand on his arm to steady herself and said, "I want you to look around and remember that every one of these people went into a store at which other things were available and chose the clothing that they are wearing. There is no such thing as unconscious dressing."

Besides feeling insecure about her looks, Diana felt distress about her family's financial situation. Although the Dalziels mixed socially with the well-to-do and the fashionable, they themselves were not rich, but depended greatly on the resources of Mary Weir, Emily's mother, and her father's cousin Anna Thompson. Alexandra remembered that her parents "weren't rich in comparison to their friends, but they weren't poor." They enjoyed the amenities of a good life, but could not take them for

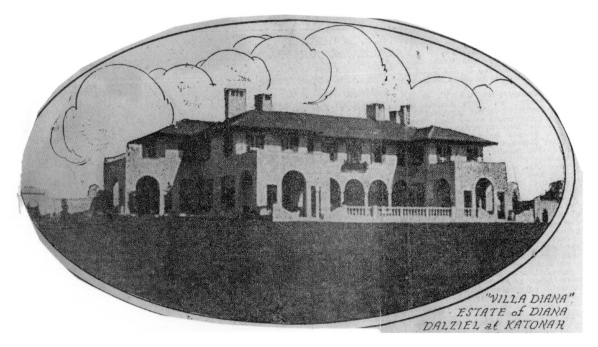

Diana, the favored grandchild, at seventeen inherited this Italianate villa from her grandmother. Opposite: *The vivacious debutante.*

granted. "When I was little, we had a cook, a kitchen maid, a laundry maid, and a couple of housemaids." Their little brownstone house was crowded with family members and Emily's hunting trophies—antlers, the head of a rhinoceros hanging over one side of the dining room table, and lion skins on the floor, which the butler often tripped on.

While working on her memoir in the mid-1980s, Diana confessed that at about fourteen or fifteen she had discovered that her family had no money. Then she understood: "I got it, I got it," she wrote. "That's why they're so unhappy." Their financial situation was alleviated a bit after World War I, when Emily's mother died in Katonah on September 8, 1920.

Mary Ellis Hoffman Weir was wealthy, and she left an estate of about $700,000 (worth more than $5 million today). Her will assured her daughter Emily of an income of about $14,000 a year (in current value, close to $139,000). She also left Diana her country place in Katonah, known as "Villa Diana," together with all household furniture, furnishings and appurtenances. In addition, Diana received $20,000, to be held by her father until she reached twenty-one, with the income to be used for the upkeep of Villa Diana.

As it turned out, Villa Diana was sold two years later, and the proceeds of about $88,000 were held in trust for Diana, so that when she reached twenty-one, she received about $110,000. Emily tried to make things even by leaving her elder daughter almost nothing. In her own will, she divided her "purely personal effects" between the two daughters, but also left Alexandra a "city motor car," the Nantucket house and the rest of her assets. She set up a trust for her husband Frederick's lifetime.

According to Alexandra, Diana spent a lot of time with their grandmother, Mary Weir, dur-

ing the summers, while she and her mother enjoyed hunting and fishing in the outdoors. Their grandmother showed her favoritism to her elder granddaughter by virtually passing over Alexandra and another grandchild. Diana, therefore, had a nice amount of money by the time she was twenty-one, and when their own mother died in 1927, she and Alexandra each received about $160,000. As a young woman, Diana's net worth increased with the inheritances from her mother's side of the family; the $110,000 that she inherited at twenty-one would be worth almost $900,000 today, and the $160,000 about $1.2 million.

On May 28, 1921, Anna Key Thompson, Emily's cousin on her father's side and Diana's godmother, died. A member of an old Louisiana family impoverished by the Civil War, Anna had come to New York and made her fortune by opening a fashionable girls' finishing school, which she operated successfully during the 1880s and '90s and then sold. Her will left Emily and her daughters the bulk of her estate of about $200,000 (a sum comparable to $1.9 million today)—to the chagrin of a sister and a niece.

In 1921, while her daughter was struggling to make herself into a more beautiful girl, Emily was pursuing her love of the outdoors, her adventurous pastime that would now lead her to unwanted fame and eventual scandal. On July 24, 1921, the *Times* reported on its front page from Paris that a remarkable feat in big-game hunting and exploration had been accomplished by "an American society woman, Mrs. Frederick Dalziel of New York," who had just reached Paris on her way home after a seven-month trip in the wilderness of German East Africa. "Other members of the party were Sir Charles Ross, inventor and manufacturer of the Ross rifle, and Mr. and Mrs. Barnes, the latter a well-known African explorer and photographer." Emily Dalziel was the first white woman to visit the world's greatest extinct volcano, with a crater ten miles in diameter, in the Ngorongoro, and was bringing home with her a splendid rhinoceros to present to the American Museum of Natural History.

In a follow-up article three days later, Emily, who had a way with words, described her adventures, raving about the flora and fauna: "the birds—small parrots of an infinite variety of colors, snow white egrets, marabou . . . as brilliant and numerous as the flowers," the insects, "gorgeous butterflies and moths like live jewels" and "metallic beetles, whose whole being seemed made of beaten gold or silver or bronze." She pictured scenes beautifully—"the forest of great trees covered with white orchids," and trees "festooned with gray moss hanging, like giant beards." She also showed her bravery and strength as she described using the same kind of heavy rifle, a Rigby 416, as the men of the hunting party.

In the next holiday season of 1922, Christmas decorations and a profusion of greens—southern smilax and ferns and palms—festooned the most beautiful ballroom in New York at the Ritz-Carlton. On December 21, it was Diana's turn to be the star. She and her friend Ann-Elizabeth Kaufman were presented in "one of the largest coming out parties of the winter," with more than eight hundred guests.

The press clippings of her debutante year chronicle Diana's party-going and traveling. Her self-improvement campaign was an evident success. Her presence was strong, her personality excellent. Diana was first presented at the Colony Club—the chic and exclusive New York club for ladies to which her mother belonged, where her grandmother had been an early member and where she herself would later be "blackballed"—at a luncheon for forty-three debutante friends. By now she was wearing her dark curly hair very short. A society column, with her photo labeled "an editor of the 'debutante calendar,'" stated that she was "keenly interested in amateur journalism."

Although as a young teenager she had felt homely and rejected, by the time she came out, Diana was seen as attractive and charming. She stood out as being especially outgoing and amusing at a party. She was particularly pleased to be invited to a party by Condé Nast, whose daughter Natica was a great friend of hers, at his beautiful apartment at 1040 Park Avenue. "Condé Nast asked me because he thought I was the cutest or the brightest." She was thrilled to be the only girl her age to be asked. "Young people then weren't the fashion."

Diana had lots of boyfriends, and was part of a congenial group of young people who saw one another at parties, at the theater, and at various watering places on weekends and vacations. But in 1923 she was introduced to a particularly handsome new face, Reed Vreeland, a recent Yale graduate. He was tall, thin, graceful and serenely poised. His debonair charm and his lovely singing voice turned heads at parties, as did his exceptional good looks—black hair combed straight back and precisely parted, and kind, dark eyes. He dressed exquisitely, and when he smiled (which was often), others around him wanted to smile, too.

Reed (whose full name was Thomas Reed Vreeland but was always called "T. Reed" or "Reed") was born in 1899 in Brewster, New York, and had grown up in New York City. Unlike his father (who didn't go to college and was working at thirteen), Reed had been educated at the Hill School and then Yale. At Yale he was successful as a cheerleader, a leader of the glee club and the head of the Whiffenpoofs. He was invited to join Scroll and Key, which, next to Skull and Bones, was the most prestigious of Yale's secret societies. In New York his Yale buddies helped him break into the social world.

According to Diana, she was completely snowed from the start. When he asked her to play golf, she jumped at the chance, although she barely knew how to play. She showed up at the first tee with a bandaged arm and announced that because of her injury she could only walk around the course with him.

A little more than a year after her debut, the society columnists reported the engagement. Diana was a familiar subject to them, but her fiancé was an unknown. His name did not appear in the Social Register, the bible for the rich and well connected.

The marriage of Diana Dalziel and Reed Vreeland brought together two families with almost nothing in common except that they lived in Manhattan, not so many blocks from each other. But the distance between Central Park West, where the Vreelands lived, and the Upper East Side, where the Dalziels lived, signaled more than just a geographical distance—it pointed to the vast social gulf between the families. Reed's father, Herbert Harold Vreeland (H.H. to his business colleagues), was the archetype for success, a self-made railroad man from upstate New York who started work at thirteen filling ice carts, and was rich but still hard at work in 1924. His wife, from Newark, New Jersey, bore him five children and did not attract newspaper attention.

By eighteen, Herbert Harold was working on the Long Island Railroad, first as a gravel shoveler on a night construction train, then as a track walker, switchman, freight brakeman and passenger conductor. Switching to the New York and Northern Railroad, now Conrail's Putnam Division, he rose to trainmaster, superintendent and, eventually, general manager. His ambition to be president of the railroad was realized in 1893, at the age of thirty-seven. He would eventually be managing more than eight hundred miles of consolidated street railway trackage in Manhattan and the Bronx. Herbert Harold's second business career began in 1912 after the street railway venture inevitably went bankrupt. Thomas Fortune

Ryan had watched Vreeland in action managing Ryan's street railway monopoly and hired him to manage the many other companies he owned or controlled. H.H.'s son Reed would later succeed his father as a director of Royal Typewriter and other Ryan enterprises.

Reed's family was one illustration of the "American Dream." Diana's family was another. The Hoffmans and the Ellises had made money several generations back and were prominent in New York and Baltimore society. Emily was an effervescent figure, admired in the society columns. Although some New York families may not have approved of her, Emily clearly did not care. And even though her diffident, Oxford-educated English husband did not contribute vastly to the family's financial security, his charm helped the Dalziels garner dinner invitations. Their daughter Diana, the extrovert debutante, was secure in the New York social world, but she had dreams of making a much more exciting life for herself. And for Diana, who struggled with insecurity about her looks, it was very important that her husband be extraordinarily handsome. More important, that he appreciate Diana as a woman. As she said later, "I never felt comfortable about my looks until I married Reed Vreeland. He was the most beautiful man I had ever seen."

Diana and Reed Vreeland were married in the chantry of St. Thomas's Church on Fifth Avenue on March 1, 1924. Unlike most brides of the time who, she said, wore "the most vulgar bouffant couture," Diana chose a white satin gown in the medieval style with a graceful silhouette and carried Easter lilies. A medley of soft greens and shades of lavender and purple lit up the old Gothic chapel. Alexandra, maid of honor, was dressed in green tulle and the bridesmaids wore orchid satin gowns with large taffeta hats.

ENGAGEMENT ANNOUNCED.

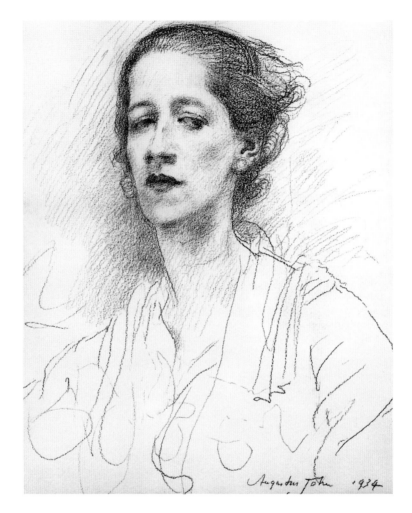

My God . . . the only chance in life
I ever had to learn anything was those twelve years
in England! —DV

MRS. REED VREELAND OF HANOVER TERRACE

I n the midst of all of the happy wedding preparations, a bomb exploded three days before Diana's marriage. The following headline appeared on an inside page of the *New York Times:* NAMES MRS. DALZIEL AS CORRESPONDENT "Lady Ross, Suing Sir Charles in England, Brings in New York Society Woman." The story reported the initiation of a divorce lawsuit by Lady Ross, naming Emily Key Hoffman Dalziel as correspondent, brought in Edinburgh sessions, a Scottish court, based on the incidents "alleged to have taken place during a hunting expedition in East Africa." The lawsuit was postponed until May "to give time to get evidence from natives and others who accompanied the expedition who are not in Africa."

The gossip columns took up the lurid story, dwelling on Emily's impropriety and the unhappy timing for the bride-to-be. "Mrs. Frederick Dalziel, shuddering at the idea of being the cynosure of a thousand eyes during the marriage of her daughter Diana to Reed Vreeland, has arranged for the ceremony to take place March 1, 1924, in the chantry of St. Thomas's. That means that only an eighth portion of New York's dehydrated society will be asked to witness the sacred ceremony and afterward partake of home brew at the Dalziel residence."

In her memoir Diana described how, about ten days before the wedding, she was called by a reporter who claimed she had watched her at parties and admired her great style. Not wanting her to be taken by surprise, the reporter told Diana that an announcement naming her mother as "the other woman" would soon make "an enormous

blaze in the newspapers." Discovering that her mother had taken the dogs to Central Park, Diana took a cab to The Ramble, where she knew Emily usually went, and found her sitting in the sun with her little Scotties, laughing and talking to them. Diana sat down beside her and told her what she'd been told. "I felt *nothing*. And that's how she answered me—with *nothing*. She was smaller than me. Very Quiet. Then she said, 'I think we'll go home. Don't you?' I don't think I saw her for two or three days. I was very sorry for her." Later her father told her that the stories were untrue and that she must simply rise above them. The scandal didn't affect her father nearly as much as it did her mother. "Daddy was British in a very healthy way: he could get over things. 'Worse things happen at sea.' That was his great expression. That's the kind of family we were—very English. Very little visible emotion."

The morning after Diana and Reed were married, the *Sunday News* blazed a front-page banner headline, THORNS IN HIS EDEN. Below it was a photograph of Emily Dalziel, looking beautiful, and a caption reading ONE-THIRD OF A TRIANGLE? The story was bannered ONE WOMAN TOO MANY SPOILED MODERN ADAM'S EDEN. It also included a photograph of Diana with the smarmy comment "And Diana Dalziel by the way is to be married to T. Reed Vreeland, son of Mr. and Mrs. Herbert H. Vreeland of 135 Central Park West, just as the storm of gossip burst around her mother."

It is not hard to imagine the cloud of embarrassment that engulfed the Dalziel family during what became a four-year barrage of publicity. Although extramarital affairs were common in

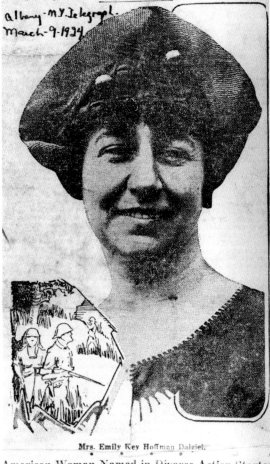

Although Sir Charles and Emily went hunting "attended only by natives," the judge concluded: "A hunting expedition engaged in by persons of opposite sexes was in itself an innocent recreation." Opposite: Cecil Beaton.

fashionable society, the details were to be kept discreetly out of view and certainly not written about in the newspapers. As Alexandra Dalziel

remembered, "My mother was clearly unfaithful to my father, but my father would never acknowledge it." And, as Diana says in *DV*, the accusations were probably true.

In June 1927, Lady Ross was refused a divorce, and the presiding judge held the allegations of misconduct "not proved." Even so, the damage to Emily's reputation had been done. She had been living alone in a house she had bought on Nantucket Island. She died there three months later, at the age of fifty, on September 12, 1927, "suddenly," as the family's death notice read. Eventually Diana would say her mother died because she was simply bored with life.

When her mother died, Diana was living happily with her husband in Albany, New York. Her sister Alexandra, who was studying at Bryn Mawr, returned to New York to live with her father. Although Frederick Dalziel had worshiped his wife, and Alexandra had fond memories of her, Diana almost never mentioned her to friends and family again.

But however deep the antipathy between the mother and the daughter may have been, Emily's personality and fate left a permanent if not conscious impression on Diana. It is no wonder that Diana continued to be fascinated by complicated and charismatic women for the rest of her own life and career. She admired women like Maria Callas, Queen Mary and Coco Chanel, who were noticeable, daring, but also vulnerable and occasionally defeated, like her mother. And while Diana did her best to be strong and successful, she was always aware that her vulnerability was a reality, and downfall always a possibility.

After their marriage the young Vreelands moved to Albany, not far from where Reed's Vreeland ancestors had originally settled. He had a coveted job as "secretary" to Robert Pruyn, president of the National Commercial Bank. Pruyn was already noted

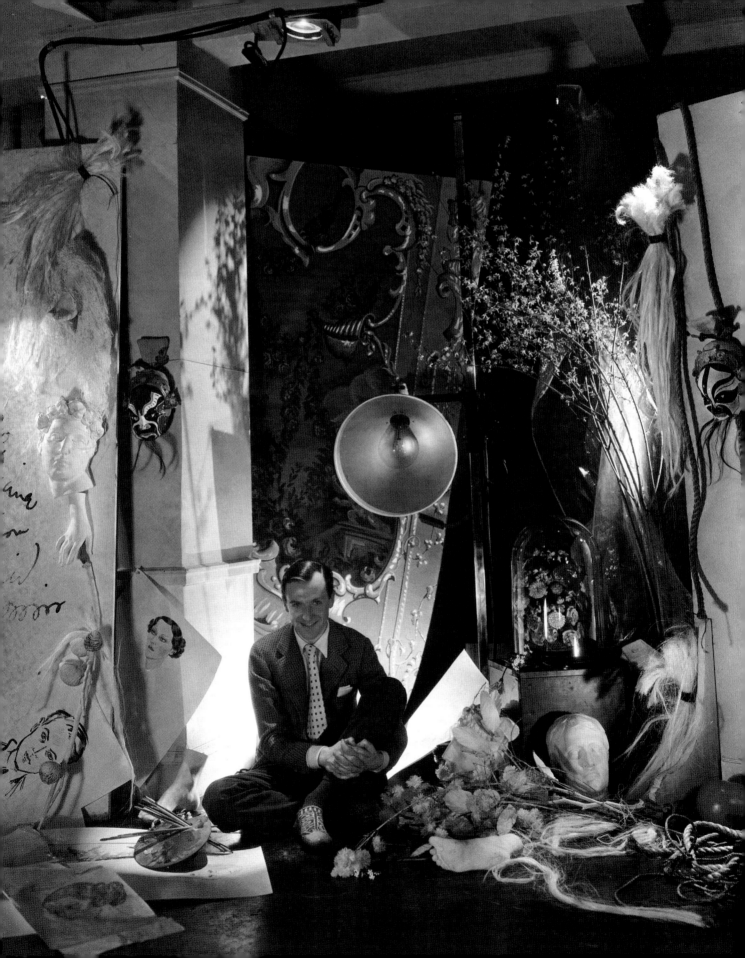

Brewster

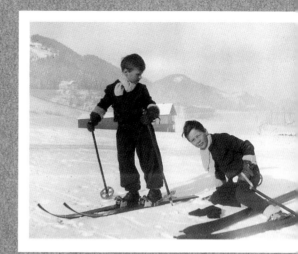

Frecky and Timmy skiing in Kitzbühel, Austria

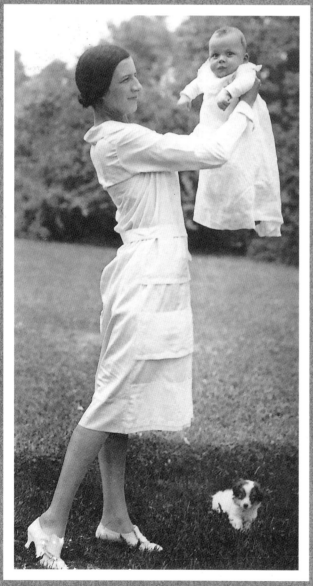

Diana with Timmy, 1925

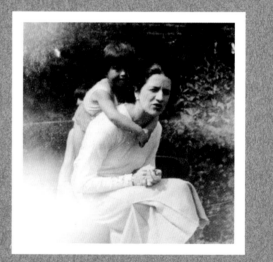

Diana with Frecky, 1929

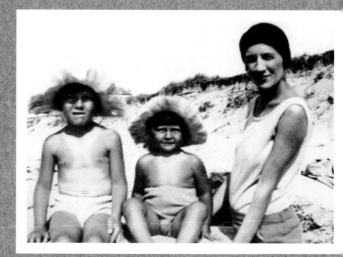

Brittany coast, 1929

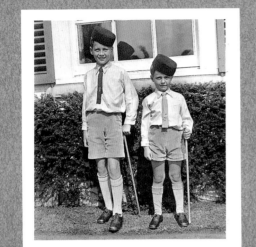

The boys wearing Montenegran hats

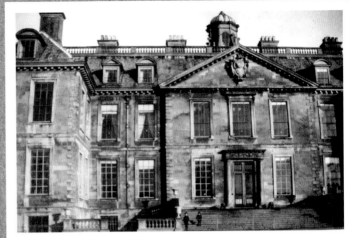

Belton House

Tim and Frecky in England

Diana was determined to have her sons well educated and well traveled. In London they spent the nanny's days off together, and holidays took them all over England and to the continent. And always, "they had such beautiful clothes!"

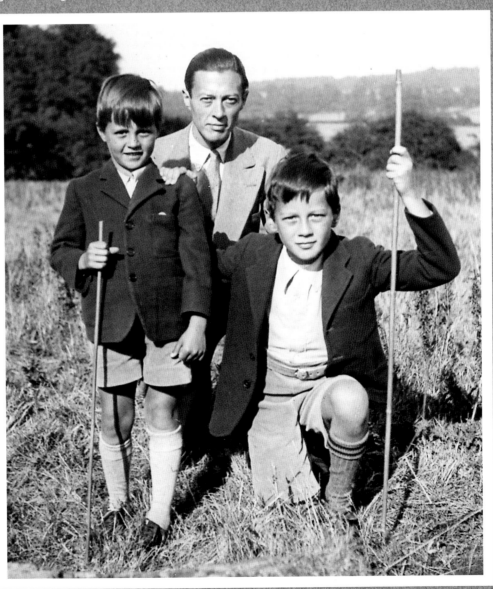

Frecky, Reed and Tim

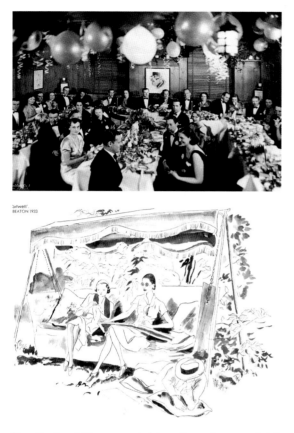

Sitwell.
BEATON 1933

Top: *Reed and Diana attended Joan Payson's twenty-eighth birthday, February 5, 1937.* Above: Diana Vreeland and Georgia Sitwell *by Cecil Beaton (in the foreground).*

nationally for selecting promising young men who went on to become leaders in banking, finance and other fields—as Reed did not, despite his promising start.

Tim (Thomas Reed Jr.) was born in 1925 and Frecky (Frederick Dalziel) in 1927. After several years in Albany and two more in Manhattan, the family of four moved to London. Reed joined the Foreign Department of the Guaranty Trust Company, was assigned to the job of assistant manager of the London office, and Diana put her mind to creating a beautiful life for her sons and husband.

When they arrived in London in 1929, Diana was twenty-six and a mother. She was madly in

love with her handsome husband and was beginning the six years abroad that would transform her from a postdebutante into a soignée woman of the world. The $160,000 that Diana inherited from her mother helped considerably to launch the Vreelands in their new glamorous life. By 1930, Reed was moved to be in charge of new business, a difficult assignment, one would suppose, as the Great Depression deepened. Diana moved in aristocratic British circles and visited French couture houses, acquiring a sense for the highest standards of fashion. Her greatest asset was her handsome husband.

Reed Vreeland was by all accounts the "kind and gentle" man Diana had hoped to marry. Being surrounded by beauty, which Reed emanated, made Diana feel invigorated. Her son Frecky remembers how his mother took the lead: "My father, who had a great sense of humor and loved jokes, was prepared to accept the overemphasis on aesthetics which she insisted on, uncritically as far as I could see."

Friends recall Reed Vreeland as gentle and sweet, caring toward his wife and helpful to others. Mary Warburg, an old friend, remembers that when she was living in New York between marriages, Reed helped her move from an apartment he considered unsuitable: "You can't live there," he said. Later, when Diana's job at *Harper's Bazaar* and then at *Vogue* became all-consuming, Reed, who had excellent taste, would plan the menus and intimate dinners. When they traveled, he would mastermind the arrangements. Some found him the best-looking man they had ever seen—and beautifully dressed, with help from his wife. To Diana he was the most attractive and romantic man imaginable. "He had fantastic glamour for me. And he always retained it. Isn't it curious that even after more than forty years of marriage, I was always *slightly* shy of him? I can remember his coming home in the evening—the way the door would

close and the sound of his step. . . . If I was in the bath or in my bedroom making up, I can remember always pulling myself up, thinking, 'I must be at my very best.' There was never a time when I didn't have that reaction—*ever*." He had a strong and sympathetic presence, and his gift for listening made a pleasant contrast to his wife's quick-witted proclamations.

Diana lived in London only from 1929 to 1933—not twelve years as she later claimed. But during those years, England, or her image of England, came to represent important standards—a level of sophistication, a sensibility, an attitude toward life that included monarchy with all its rituals, its exemplary royal figures—and the empire as a place that was exotic and fascinating—a whole worldview with which she wanted to be identified. She adored the monarchy, she liked "the robust pink English faces, well-weathered and smiling," and she admired the English skill for housekeeping. "The households of England in my day were a big part of life. . . . That's why I could go to work for *Harper's Bazaar* when I left England—I knew how to work because I knew how to run a house. My God . . . the only chance in life I ever had to learn anything was those twelve years in England!" Her housekeeping philosophy was basic to her outlook on life. "I believe in tidy housekeeping, I believe in neatness, I believe in a fresh bed, a clean dressing table. But these are *first* things." In England she also learned about conversation: "In England there are proper talkers; they're riveting, *riveting*."

And of course she continued to perfect herself. As her son Freck would later say, Diana learned how to live in London. "In England life is partially a pageant. It begins with royalty and it includes the aristocracy, which has a role to play and they played it. We lived a very British life. I remember going to see the changing of the guard and being taken to look through a fence and seeing the little princesses playing, the present

Queen and Princess Margaret who were vaguely the same age. Then Mom was presented at court, which was an important part of being a society matron. All their friends were British. British society, a hierarchical society, was very sympathetic to someone who had an elitist view as my mother had. It's a very European thing to make the most of oneself, and she considered herself very European. You play a role, and she knew playing."

So little Diana Dalziel who, as her son described it, "was never very attractive" but who was determined to "be that girl" whom everyone liked and admired, found in London a new stage for her performance.

Reed and Diana not only moved to a fascinating city, but they moved in great style, taking up residence in a dream house of noble proportions in an exclusive and historic neighborhood. The house they bought was at 17 Hanover Terrace, next to Hanover Gate on the edge of Regent's Park, the creation of famous architect John Nash in the early nineteenth century. The house—which had giant columns, both Corinthian and Ionic—looked out over the park with its acres of fields, gardens, buildings and the zoo. Sir Edmund Gosse (1849–1928), literary figure, biographer and eminent zoologist, friend of the Pre-Raphaelites, Victorian poets and novelists, had lived at 17 Hanover Terrace for many years just before the Vreelands.

This spacious house with its paneled rooms was in a shambles and needed to be entirely refurbished, calling forth Diana's considerable talents. "There wasn't one spigot of water. . . . I put radiators and running water in each servant's room." Her decorating schemes made it into the newspapers. An article titled "Primary Colours in the Nursery—American Mother's Scheme" announced that "boredom is a word that has been eliminated from the nursery vocabulary of Frederick and Timothy Vreeland, whose aunt is daughter-in-law to Sir David Kinloch," as their

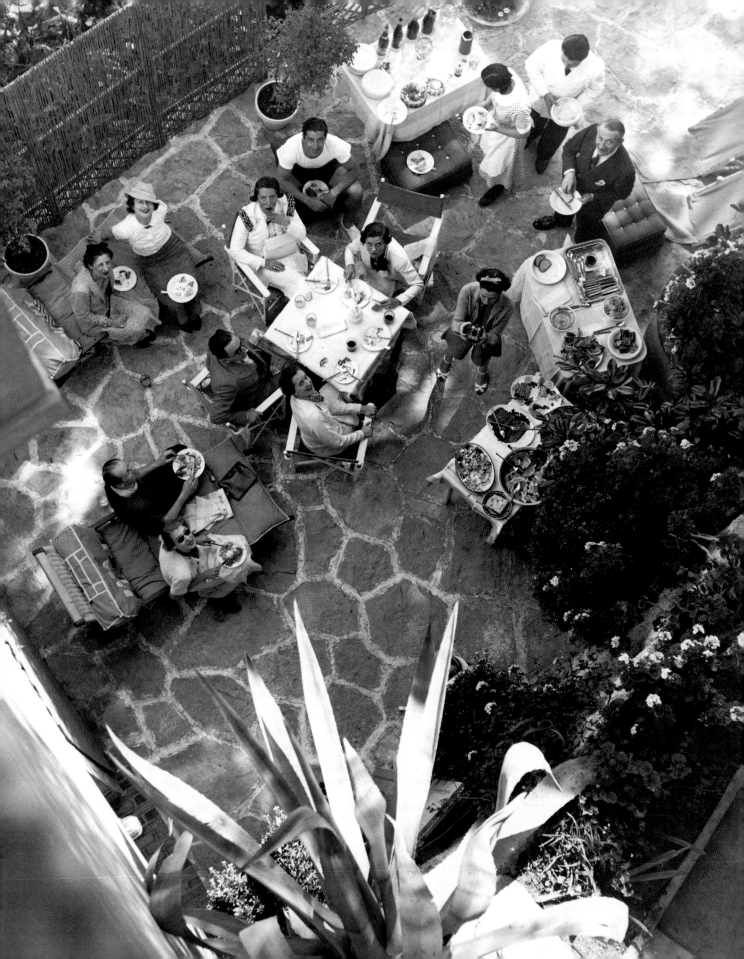

rooms were so colorful and the furniture and rugs in these unusual nurseries were "petunia red."

Living in the colorful third-floor rooms, Tim and Freck were quite separated from their parents. Freck Vreeland, who was two when they moved, remembers that in London the main people in his life were his brother and their nanny. He watched his mother from afar, catching an occasional glimpse of her taking dancing lessons.

Reed would go off to work at the Guaranty Trust every day at a quarter past eight. "He was just like an American," Freck said. "He dressed beautifully and took the same sort of interest in his clothes as a woman would." He liked to buy his shirts and ties in multiples—"everything was enormous quantity and marvelous quality. [His hats] were all measured and fitted. The felt was like satin, all made on St. James's Street."

Frecky and Timmy were beautifully dressed, too. It was "just paradise" for her to dress her two little boys. "My God, they had such beautiful clothes! Such beautiful dressing gowns with monograms and slippers with pom poms and all this to come down and kiss you good night." Her enthusiasm was not always so well received by her sons, who, as they got older, dreaded their mother's selection of their clothes—which always matched.

Diana's positive and even distorted way of seeing the world kept the children in a happy, if deceptive, atmosphere. The young family developed ways of keeping many things quiet, of "tiptoeing all the time" around problems and imperfections. The boys' upbringing was, as Freck Vreeland remembers, "a formal bringing-up in an atmosphere of unreality. A spade was never called a spade. Therefore, you have a distance from somebody you don't have with other people." For if everything wasn't always wonderful, it wasn't mentioned. It was an unreal world with no criticism of anything. Freck Vreeland was shocked, when he went away to boarding school, to find that life had a negative side, too.

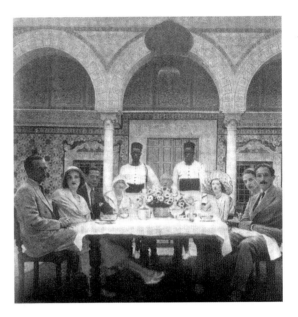

Diana's new cosmopolitan set gathered in exotic settings for house parties. Above, *the d'Erlanger guests lunch at the white villa high above the sea at Sidi Bou Said in Tunis and,* opposite, *Baba and Johnny Lucinge entertain at Cannes with "buffet tables, geraniums, cushions, pyjamas, poets, painters and all the internationals."*

Diana's sister, Alexandra Dalziel, was also living in London, as she had married Alexander Kinloch, whose father was a baronet. Although Diana had cherished her beautiful sister when they were small, their different natures now became more pronounced. As her niece, Emi-Lu, describes it, "In Europe Aunt Diana and Uncle Reed knew the right people, a little bit of the Duke of Windsor set—people who went to smart restaurants." Alexandra Dalziel Kinloch "never knew those people—she was not in that sort of life. They were totally incompatible. Mummy belonged to everything that Aunt Diana had thrown off like a yoke." While Diana was entertaining and living glamorously, Alexandra became very much part of her husband's family, who, although titled, lived rather simply in London and in an old family house in Scotland. She

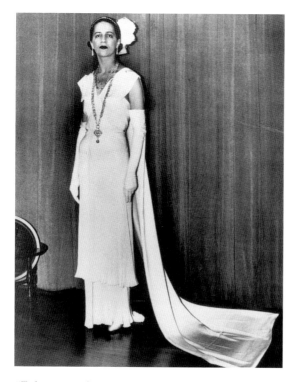

"To be presented at court—that was something . . . the Scots in all their regalia . . . and the two royals, King George V and Queen Mary . . . the most royal people in memory." Opposite: *Diana's inspiration, Elsie de Wolfe.*

was soon mother to two girls and she continued her interests in sports—including golf and gliding—for which she won prizes.

During the London years Diana made many friends among English aristocrats and aesthetes, such as Georgia and Sacheverell Sitwell, who had a taste for smart society and were also interesting and literary. According to Mary Warburg, Diana did not want to spend time with Reed's banking colleagues; she wanted to be with "the jolly people."

Few of these society people whom the Vreelands befriended worked for a living. In this period before the Second World War, gentlemen and their sons felt no guilt about not working. As young men they might go into one of the

Guards regiments for a short time, but later would settle into the life of a country gentleman, becoming magistrates, high sheriffs and masters of hounds; owning racehorses and attending public banquets; opening agricultural shows and bazaars, with the occasional foray to London to visit their clubs, their tailors and their shirtmakers.

One important association that started while the Vreelands were in England was Diana's friendship with Cecil Beaton. The imaginative artist/ photographer/set designer, who was about Diana's age, had just started to make a splash—photographing Edith Sitwell in 1926, beginning work for *Vogue* in 1927, and writing pieces on London and New York society. Diana shared with Cecil a fascination for society, its beautiful women and elegant clothes, as well as the visual arts, theater and ballet. The two quickly became soul mates.

The Vreelands were spending a lot of money in London, presumably from Diana's inheritance and Reed's Guaranty Trust salary (which went a lot further in London than it did in New York). But there are signs that by the early thirties the money was running out. Perhaps Reed's business affairs were suffering; it was, after all, the Great Depression.

Her children recalled financial problems in the family. "Money was a very dramatic thing in my mother's life," said Tim Vreeland. "Part of the role she was acting was the role of a rich person when she didn't have any money. I remember Dad telling me that the headline in the newspaper when they got married was 'Banker Marries Heiress.' He said, 'Well, I am a banker.'" While she had inherited money, she was good at spending it with great flair and with great speed.

Diana took her first step into the working world and started a lingerie business. It would be the first of many times that she had to find work when she needed the money. Her fascination for beautiful clothes made this a natural move.

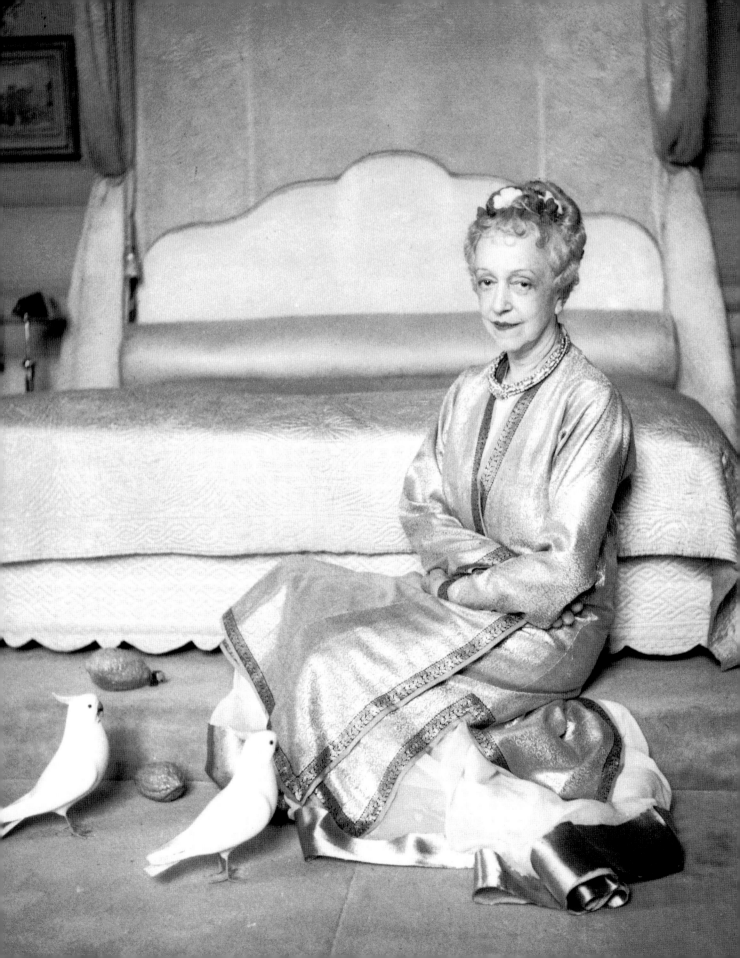

Although it was unusual for a society woman to go into business in the late twenties and early thirties, Diana followed the example of Syrie Maugham and Elsie Mendl. Syrie's shop, as Beverley Nichols described it, was an "elegant establishment at the corner of Grosvenor Square . . . filled with exquisite but faintly dubious objects of furniture that were liable, if examined too closely, to fall to pieces." Her clients, mostly American millionairesses, would lunch with Syrie beforehand and afterward would buy "old bits and pieces of French provençal armoires, Biedermeyer sofas, nineteenth-century Italian chests, etc., etc.—all most delicately 'pickled' and tarted up." They were then taken back to America, where they slowly decomposed in the mansions of Long Island.

Elsie de Wolfe, one of Diana's idols, had first been an actress. More appreciated for her costumes than her acting, she then had started a highly successful and innovative decorating business in the early 1900s, when she created the interior of the new Colony Club in New York. As Diana wrote about Elsie in the early 1980s, "She was a part of international society, but she never stopped being an American—a working woman—and she was the most fantastic business woman there ever was." When Vreeland saw Elsie in the early 1930s, she had recently married Lord Mendl, and was a fixture in the social scene in London and Paris. For Diana, Elsie became a flamboyant inspiration.

Diana's lingerie shop was near Berkeley Square. In a room above a space where a friend kept his cars, women sewed and Diana supervised. She went to Paris to find fabrics and designs, and she employed women from a Spanish convent in London. She would command the mother superior: "I want it rolled. . . . I don't want it hemmed, I want it r-r-r-rolled!" Her taste for perfection and her sensitivity to the beauty of fabrics become clear in her description of her first

endeavor in the commercial fashion world: "You don't know the luxe, you don't know the beauty." Her records show that her customers were her friends: a scarf for Mrs. Leslie Benson, three scarves for Mrs. Gilbert Miller, a dressing gown and sheets for Mrs. Harrison (Mona) Williams, a bed jacket for Mrs. John Barry Ryan, a pink satin robe for Mrs. Leo d'Erlanger and a dress-mending for Mrs. Richard Currier. Edwina d'Erlanger's sister, Mary Currier (later Mary Warburg), went to the lingerie shop in search of an evening gown. "I was very thin," she recalled. "I was about twenty-three and I saw the most beautiful nightgown which I bought and wore backwards because it was low in the front and in back. It was pink, so I wore it and I had great fun at the ball."

Diana's favorite story about her lingerie shop featured Wallis Simpson buying nightgowns for her first weekend with the Prince of Wales. Although it is likely that Diana had met the Prince of Wales on Long Island in the 1920s when he was playing polo there, she probably made Wallis's acquaintance in the expatriate American group in London in the early 1930s. The Prince of Wales may even have come to Hanover Terrace, as Tim Vreeland remembers being told as a boy that the man who would be king was coming to dinner.

About seven years older than Diana, Wallis was thirty-two and newly married to Ernest Simpson when she moved to London in the spring of 1928. Like Diana she had a lovely figure for clothes, and impeccable taste, which she used to counterbalance her lack of facial beauty. As she had been brought up by her young, widowed mother, who had little money, was ostracized by Baltimore society and was on the fringe of respectability, Wallis had learned early to make the most of herself.

When Wallis began seeing the Prince of Wales, he was much in the public eye, an attractive, charming personality. Popular with the workingman and ex-servicemen, he enjoyed sports and

a good time. The images of him in the photographs, diaries and letters of the time show the prince, with his boyish face, dancing with Lady Emerald Cunard, or playing in a golf tournament against Lady Astor at Walton Heath in July 1933, dressed in his usual gay clothes: a blue check shirt, gray plus fours, checked stockings and black-and-white shoes. The prince had always been most comfortable with married women. Now he became obsessed with Wallis Simpson.

Diana claimed that Wallis came into the shop to order nightgowns after the prince had discovered her. "She knew exactly what she wanted." She ordered three nightgowns, one in white satin copied from Vionnet, all cut on the bias. "The whole neck of this nightgown was made of petals, which was too extraordinary, because they were put in on the bias, and when you moved they rippled. Then the third nightgown was a wonderful crêpe de chine." Wallis had left her husband, Ernest Simpson, and was on her own then with no one to support her. "This was a big splurge for her. The nightgowns were for a very special weekend." The story must be apocryphal, for Diana had left England in 1933, and Wallis and Edward did not begin to see each other constantly until 1934. In January 1936, when George V died, their relationship took on even more political importance. By the time Edward abdicated in 1937, the Vreelands were back in America.

In the early 1950s, the Vreelands met the Windsors again in France when staying with Ben Kittredge at Senlis. Diana later recalled how she was "excited to death" to be asked to dine with them because she was curious, not because "I was so stuck on them. So we went to dinner and we became friends." Later the Vreelands would see them at their house in Paris or in New York and on Long Island when they stayed with C. Z. and Winston Guest. Diana and Wallis often met at couture showings in Paris.

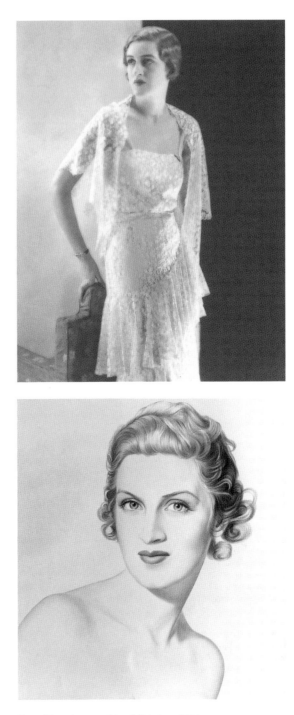

Top: *Diana's great friend Edwina d'Erlanger.*
Bottom: *Edwina drawn by William Acton.*

In these post–World War I years, the Vreelands took part in smart society excursions that became good copy for the fashion magazines. They went to North Africa to stay at the d'Erlangers' villa at Sidi Bou Said, near Tunis; to Mallorca to visit the Gilbert Millers; to the south of France; to Italy, Switzerland and Bavaria. The magazines documented some of these glitzy excursions with fashionable cohorts, and Diana's memoir, often greatly embellished, tells of others. However, Diana's photograph album contains snapshots of the less glamorous forays from London with Reed and the two boys. Their first European summer was spent in Brittany, the summer of 1930 saw them in Essex, and the next spring they made trips to the English seaside. In the summer of 1931, they were at Le Touquet in the north of France, and at Easter, 1932, they stayed at the inn of Diana's cousin Caroline Postlethwaite Cobb at Chagford. They also made visits to Knole Castle and to Belton House, owned by the Brownlows, who were the brother- and sister-in-law of Diana's sister, Alexandra Kinloch.

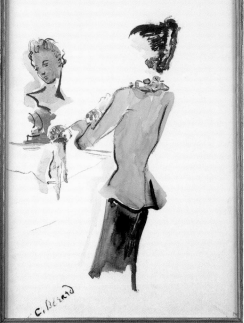

Diana by Bébé Bérard, the painter she called "my very best friend in Paris."

The most memorable adventure was the house party at Tunis with Baron and Baroness d'Erlanger in 1931 that included the Brownlows and Diana's idol, Lady Mendl. The house, which had white domes and minarets, sat five hundred feet above the Mediterranean Sea, in the village of Sidi Bou Said, guarding the entrance to the harbor of Tunis. The old baron was a French banker who had set up his business in London, and he and his wife were the parents of Diana and Reed's great friends Leo and Edwina d'Erlanger, also members of the party.

The guests arrived on a marble terrace that stretched to the door of the palace. Below was the blue, blue Mediterranean and the white, white Arab village, visible in the distance through tall cypress trees. There were six servants to help with the countless pieces of luggage "piled high like the equipment of an explorer's expedition." It was a dreamlike setting. The Arab menservants wore baggy white trousers, "short blue jackets, fezzes, and the pale blue and white sashes of the house livery." Diana remembered that only menservants waited on them, and "it was like the Arabian Nights—these great pantaloons with gold and silver brocade and lamé boleros worn over very clean white shirts." In the marble hall "an alabaster bowl, full of floating flowers, dripped water into a square pool that flowed away in a little canal to the outer courtyard, and smoking incense-burners gave off the odour of amber."

At dinner everyone sat on dark velvet-covered banquettes at a long table set with gilded goblets. The old Baron d'Erlanger and the Arab servants wore magnificent robes, but the women

guests outshone them. Lady Brownlow appeared in a golden-embroidered green velvet tunic with long sleeves and green satin Persian trousers. Lady Mendl and Mrs. Leo d'Erlanger wore Vionnet dresses with trousers, and Mrs. Vreeland, a pink satin outfit that looked like many scarves tied about her. Fragrant bouquets of jasmine flowers graced every place, and the men as well as the women wore them behind their ears, in true Arab fashion. Far away at the end of the hall, the moonlight crept into the open courtyard, "turning the little stream of water flowing through the open doorway into a silver rivulet."

Edwina d'Erlanger and Diana visited Edwina's sister Mary when she was living in Florence. On the trip south to Italy they insisted on bringing their personal maids to change the linen on the wagons-lits. Mary Warburg recalls that Diana was quieter then and determined to educate herself: "When Diana had two enormous packages of books tied together, I said, 'Diana, what is that?' And she said, 'That's about il dusay [she meant Mussolini] and de Medisay.' And I said, 'De Medisay? You mean de Medici?' She never pronounced them wrongly again." While in Florence, she had her portrait painted by William Acton, brother of Harold Acton and a great friend of Mary's, who did many portraits of young society beauties. The whimsical picture of Diana in a pink and white frock under a green

Mrs. Reed
Vreeland
went to
Mainbocher

Diana saw the black wool coat at Mainbocher and said, "That coat was made for me."

parasol hung at the entrance to her New York City apartment until the end of her life.

The most important of Diana's European jaunts were her visits to her spiritual home, the glorious city of Paris. There she stayed at the inexpensive little Hotel Napoleon. Passionately fond of beautifully designed clothes, she naturally sought out the best that Paris could offer, and during these years she learned fashion. She met the exciting designers as well as many of their glamorous customers, and she acquired her own look, which would remain very much the same and dazzle those who saw her for the rest of her life.

In the early 1930s when Diana frequented the couture houses, the fashionable women wore glamorous and understated evening gowns by Patou, Schiaparelli, Vionnet and Mainbocher. These gowns were sketched in the magazines. It was during the Depression (a fact that Vreeland omits from her lively memoir) that designers responded to the tightening of belts by producing ready-to-wear garments and more practical clothes. In 1931, Coco Chanel showed a collection of cotton evening dresses, and the following year she cut her prices in half.

American *Vogue* acknowledged that the changing economy had an impact on fashion by proclaiming that "the best look is an understated look." Johnny McMullin wrote in 1932 that "real chic today" is personified "not by the

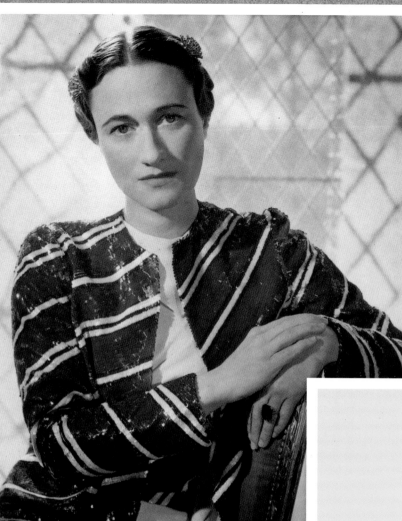

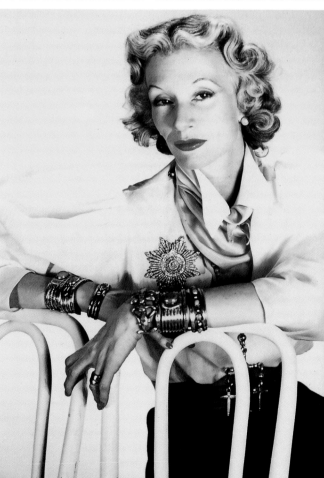

Wallis Simpson (*above*) and Millicent Rogers (*right*) were friends of Diana's who inspired her with their chic. Bébé Bérard (seen at far right and with Marie-Louise Bousquet) did drawings of such beautiful women and gave them to his friends, like Diana.

Finn Louise Dahl-Wolfe

To dear Diana —
in memory of
that Darling Bébé
——— 1949 ———
Finn Louise Dahl-Wolfe

woman who sweeps in wearing a magnificent coat with a fur collar standing above her head, and looking like 'a million dollars,' but by the woman who does not appear to be expensively dressed, yet whose perfection of taste and detail gently permeates your senses."

During these years couturiers designed for powerful women of fashion. As Bettina Ballard, editor in Paris for American *Vogue* in the 1930s, wrote: "Women of fashion were . . . dictators, in the sense of a luxurious and capricious way of life." The social standing of these women depended "on their power to make others emulate the way they dressed or entertained or talked and on their ability to make fashionable the people and the places they preferred."

Diana, now in her late twenties, aspired to join the group of women the designers dressed: the Honorable Mrs. Reginald Fellowes, or Daisy, a Singer sewing machine heiress who dressed at Schiaparelli; Princess Jean-Louis de Faucigny-Lucinge; the Vicomtesse Marie-Laure de Noailles, a patron of the arts; Nathalie Paley, famous for her beauty. The other very visible Americans in the Paris fashion world that the public emulated included Millicent Rogers (then Mrs. Ronald Balcom and an old friend of Diana's), Bettina Bergery, Mrs. Harrison Williams, and of course Lady Mendl, who wore Mainbocher and presided over the parade grounds of fashion that took place Wednesday afternoons in her Paris apartment. Diana cut out articles from *Vogue* and *Harper's Bazaar* and pasted them into a scrapbook. And beside drawings of Marlene Dietrich, Garbo and Princess Bibesco, she pasted in a photo of herself that had been recently taken by William Acton as a study for her portrait, thus placing herself in a celebrated cluster of stars.

Occasionally she herself was cited in articles about couture. In the November 1, 1933, issue of *Vogue*, Mrs. Reed Vreeland was sketched wearing a Mainbocher coat and an evening dress. Diana's strong clothes sense comes through clearly in the article. She is described as "one of the most chic of the international set living in Europe," and praised for having "the tall and thin figure and the profile of a wife of the Pharaohs," with her jet-black hair, "which she arranges like a cap on her head, curling at the nape of the neck. She knows what she wants at a glance."

Diana was keeping very expensive company by being included in fashion articles with countesses, marquises, princesses, British aristocrats and American heiresses. Tim Vreeland remembered: "They always managed to live as if they had money. When they went on vacation they carefully arranged to go to the south of France to stay with some people and then move on to Biarritz to stay with other people and then go on to Scotland. Whenever they went off on vacation, Mom would leave a beautifully typed itinerary of exactly where they would be. Mom got all her clothes for next to nothing which was a great help."

Her London and Paris friendships would stand her in good stead in her later career. She met Coco Chanel in the early thirties and, although they were never close friends, their paths would cross from time to time. Diana recognized Chanel as the great designer of the century; she especially admired Chanel's innovative use of an everyday but versatile material like jersey and the fact that her clothes fitted the body. "While she threw ropes of costume jewelry onto everything in this wonderful way, she kept her clothes very nice and vivid and controlled." Chanel designed clothes to show off a woman's natural beauty and made the most of her healthy and fit self, a credo Vreeland shared.

Another friend Diana made during this period was Elsa Schiaparelli. Her clothes were for "living women who look piquant, flirtatious, delicious in their playful clothes, cut in the most professional and extraordinary manner." The

Italian designer came into her own in the 1930s. As Diana said, "She started by making sweaters with trompe l'oeil designs—collars, neckties, cuffs—woven into the knit," and her business grew until she was a "full-fledged couturiere." Her clothes were in the tradition of being cleanly and simply cut—a favorite silhouette was the mermaid shape of evening suits and pajamas. On these classic creations she included motifs that showed her "wonderful Italian sense of amusement"—"hats trimmed with a mutton chop, a slipper sitting on top of the head, jackets with pockets that looked like bureau drawers." Jean Cocteau's profiles were embroidered on evening jackets; Salvador Dalí's paintings became her fabrics. Elsa Schiaparelli's clothes reflect the crossover of ideas between modern art and couture that became popular at this time; her vivid colors appealed to Diana.

Diana also met Bébé (or Christian) Bérard. About her age, Bérard was a talented and jovial French artist who was an easel painter, a designer for stage and films and an illustrator for fashion magazines like *Vogue* and *Harper's Bazaar*. In 1933, he achieved his first theatrical success with sets and costumes for George Balanchine's ballet *Mozartiana*. When he died at the age of forty-six, in February 1949, he was the leading stage designer of his period and had helped Louis Jouvet revive the Comédie-Française as a major force in French cultural life.

Prince Jean-Louis de Faucigny-Lucinge also became Diana's new friend. Known as Johnny Lucinge, he could trace his family back to the eleventh century, when they ruled the barony of Faucigny in Savoie. He and his wife, the former Baba d'Erlanger, were at the center of the social world of Paris. In 1928, they gave a costume party in the ballroom of their Paris house entitled "Remembrance of Things Past," inviting all the haut monde, including friends and acquaintances of Marcel Proust dressed as incarnations of such Proust characters as Madame Verdurin, Baron de Charlus, and Prince de Guermantes. The evening ended with dancing at the Eiffel Tower at six in the morning.

The easy access that the Vreelands had to Paris did not last. By 1933 their financial situation had changed drastically. It may have been the fallout from the 1929 crash that affected all banking and eventually Reed himself. Diana and her family left England and lived at the Hotel Beau Rivage at Ouchy, near Lausanne, for a year. Tim was eight and was sent to boarding school in Coppet. Reed had a mysterious illness and left work in order to recuperate. As Tim remembers, "Most of the time Mom and Dad were undergoing cures. They were caught up in the twenties' mad search for eternal youth—like Auntie Mame. In Lausanne Frecky and I were undergoing some sort of cure where we got inoculated once a week (lucky we survived). My mother used to say, 'I'll do anything I can for your body; there's very little I can do for your mind.'"

Diana embraced her stay at Ouchy as a time for introspection. "I was so happy in Ouchy, on the water. My bed faced Mont Blanc. Every night, I'd leave a small space open between the curtains so that I could see Mont Blanc in the morning when I woke up. And some mornings—this was in winter, when the snow lay very, very thick on it—it would have a pink glaze. Other mornings it would have a blue glaze to it. I would sit and watch the pinks and blues change during the day as the light changed and the clouds constantly moved across the sky. Every day was totally and completely different. I can remember thinking how much like my own temperament it was—how much like everyone's temperament. The light on Mont Blanc was a revelation of what we all consist of. I mean, the shadows and the colors and the ups and the downs and the wonderment . . . it was like our growing up in the world."

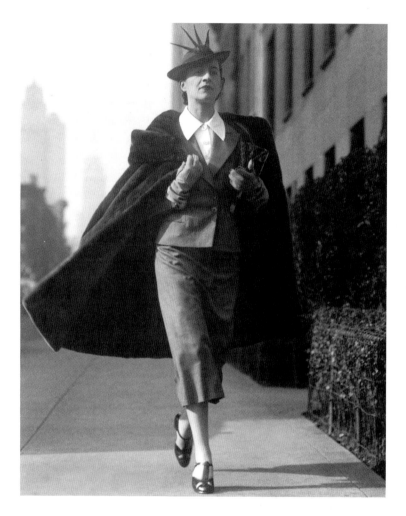

Why don't you rinse your blond child's hair
in dead champagne to keep its gold as they do in
France? Or pat her face gently with cream
before she goes to bed as they do in England?
—Harper's Bazaar

"W H Y D O N ' T Y O U ?"

In late 1935, the Diana who strode down the gangplank with Reed, her impeccably dressed escort, and with two handsome little boys in tow, carried no traces of the ingenue newlywed who had ventured to London six years before. She had used her European experience to settle and refine an innate style that would become distinctively her own. Withdrawn from New York society and soaking up every detail of Paris fashion and London social life, she was becoming more and more comfortable with the persona she had begun to shape long ago. She carried out the teenage diary resolutions of the ugly duckling who had felt slighted by a flamboyant mother and eclipsed by a blond and beautiful younger sister, and she had majestically transformed herself into a striking and memorable presence.

When she returned to New York with a new, self-created image, Diana had even given herself a new name. She was no longer Diana, pronounced Die-ANNA, a name she now felt needed a new touch. To her close friends and eventually to her business associates, she became Diane, pronounced Dee-AHN or Dee-AHN-a, in the French way.

She made a startling first impression, wearing bold yet simple clothes from Paris, which, though very high-styled for New York, were always beautifully cut with a classical and conservative line; later on they were most often by Mainbocher, whose clothes she liked for their simple shapes and their beautiful workmanship. She had a great color sense, loving red and black, white and "greige," plus originality and whimsy in using objects as accessories. Her hairstyle evolved over the years, but her hair was always coifed in a sim-

ple and dramatic way. When she returned from Europe, it was long and was coiled in a French twist. Later, she would dye it jet black, and sometimes it appeared navy blue at a time when hair dye was not widely accepted. Still later, the ultramodern, extreme shape almost resembled a helmet. Her high cheekbones were heavily rouged. The look was that of an impersonal mannequin— an abstract form that showed off the clothes. At the same time she projected a vibrant and elegant presence: "Pay attention, I am somebody worthwhile." Her way of walking was choreographed with a ballerina's rhythm, her entire body shifting from the hips, with each unfolding thrust of the leg, the foot leading, outturned. Her way of speaking in emphatic, short, elliptical phrases, but getting right to the point with surprising ideas, amused and attracted her listeners. As Frecky said later, "She understood early the 'sound bite'"; for example, "The bikini is the most important thing since the atom bomb!" (the bomb had been tested on the Bikini atoll in the Pacific). She looked you right in the eye, attention focused on what you were about to say. And, wrote *Vogue* editor Bettina Ballard, "Nothing, no matter how extravagant, that Diana Vreeland ever says is nonsense. It is painting with words and gestures, and her gestures are often more imaginative than her words. She makes you see and feel and smell what she is talking about."

Musing on Diana's metamorphosis, Lady Airlie, born Virginia Ryan, daughter of Diana's friend Nin Ryan, said: "It is difficult to know whether she made herself into this creature with the exaggerated voice, the hair, the look that she became famous for. I think she probably found a

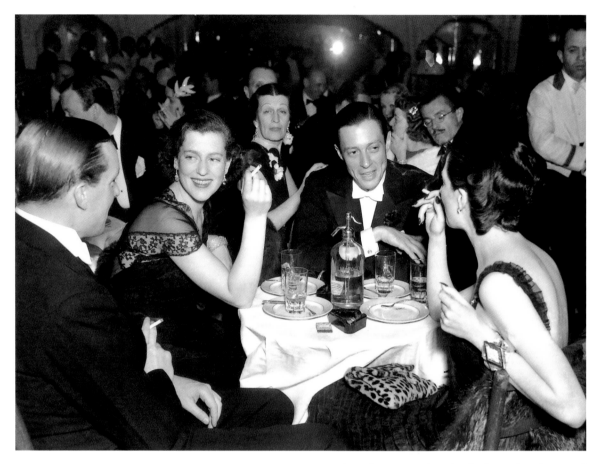

Before going out, Reed would climb the stairs in his dinner clothes to talk with his sons. A table drawer filled up with Cholly Knickerbocker clippings, so the boys knew their parents were enjoying themselves at night clubs. Opposite: Diana. Photograph by George Hoyningen-Heune. Page 42: Diana in felt hat by Suzy and famous T-strap shoes. Photograph by Martin Munkacsi.

sort of performance persona and she kept with it and it became part of her and she became part of it. And the whole thing jelled perfectly—which doesn't very often happen because it doesn't ring true. But it did with her."

The new Diana soon attracted attention and started to appear continually in fashion magazines. The March 1936 issue of *Vogue* reported on Americans coming back from London, and noted that Mrs. T. Reed Vreeland "swings a loose brown suede coat over a cardigan jacket and skirt of red-plaided brown tweed, and adds a red scarf, chamois gloves, [and] rubber Wellington boots." The February 1937 *Town and Country* described Diana's arrival in Palm Beach, bringing "plenty of color with her to wear against the white sands. Her heavy linen shorts were bright emerald green, with red zippers; her jerseys (cut like a concierge's jacket) were lemon yellow or scarlet . . . with practically every outfit, she carries—around her neck or her waist or in her hand—the most enormous contrasting handkerchief of sheerest linen."

Diana's favorite color, red, made it into print

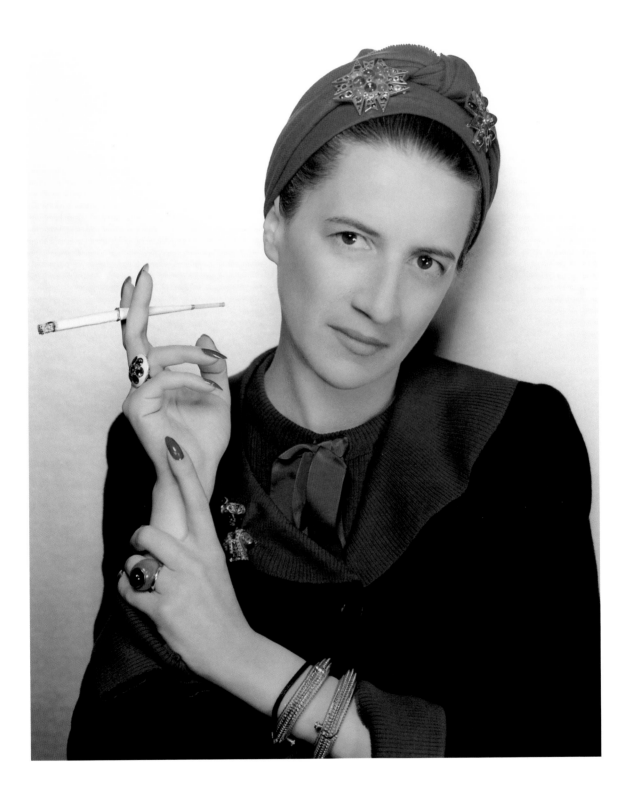

when the November 1938 *Harper's Bazaar* announced that "Mrs. T. Reed Vreeland dines at home or in country houses over the week-end in red brocade pants patterned in blue. She wears them with a red wool sweater, lots of gold jewelry, and lovely little flat gold slippers."

And it wasn't just Diana alone who was noticed; she had an accessory in her husband, Reed, and together they made a dazzling couple. As Cecil Beaton wrote, the Vreelands "are always an asset at any party. Mrs. Vreeland, possessor of a most strict sense of chic and a poetical quality quite unexpected in the world of tough elegance in which she works, gives colour and life to the most commonplace event: 'What a bad film,' one might remark. 'Yes, but I always adore the noise of rain falling on the screen.' To me, beautiful Mrs. Paley in sequins is beautiful Mrs. Paley in sequins, but to Mrs. Vreeland: 'My dear, she is a star in the sky.' A swarthy brunette may seem ordinary to me, but to Mrs. Vreeland she is, 'exceptional, my dear, she's wonderful! A wonderful sulky slut.'"

By then, as Beaton noted, Vreeland was at work "in the world of tough elegance." She started working for *Harper's Bazaar* in early 1936, hired by Carmel Snow, its extraordinary editor-in-chief, who was always on the lookout for new talent. Vreeland later described how Snow spotted her on the dance floor at the St. Regis in a white lace Chanel dress with a bolero, and roses in her hair. She was also looking for a job, as the Vreelands had been living off their capital and needed two incomes to check the financial erosion. "I'd only been here for six months and I was going through money like one goes through . . . a bottle of scotch, I suppose, if you're an alcoholic," she said. And the new

Diana wearing her Chanel necklaces and a smart turban, photographed by Cecil Beaton. Page 48: Diana on a shoot with George Hoyningen-Huene.

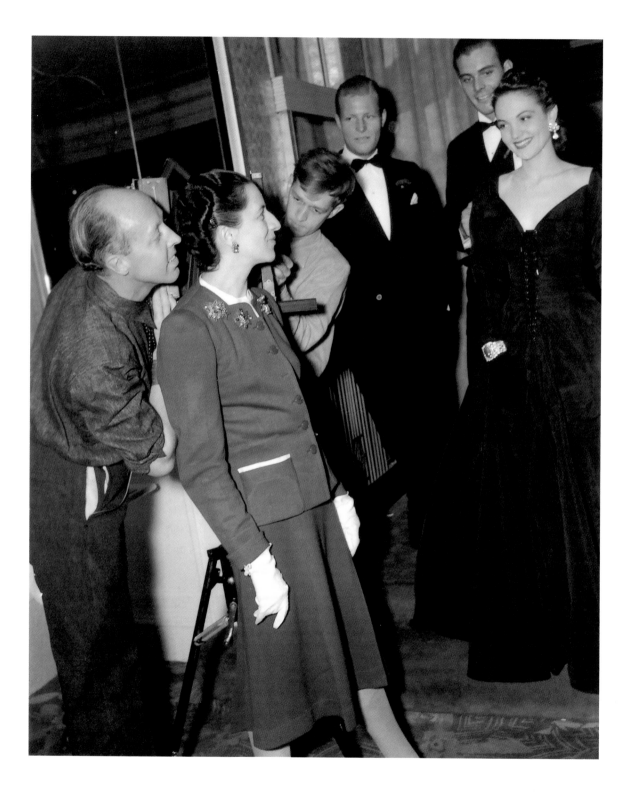

Diana, who used her extensive social network in her job hunting, must have been an attractive lure for any magazine executive. In addition to *Harper's Bazaar*, she also had an offer from Harry Bull, editor-in-chief of *Town and Country*.

In her first job at *Harper's Bazaar*, she wrote an amusing column that she did from home. By late 1939, she worked as the full-time fashion editor. She would become an instant success for the magazine, and the magazine would become the natural place for the new Diana, who said later: "I was always fascinated by the absurdities and the luxuries and the snobbism that the world of the fashion magazines showed.... Very few people had ever breathed the pantry air of a house of a woman who wore the kind of dress *Vogue* used to show when I was young. But I lived in that world, not only during my years in the magazine business but for years before, because I was always of that world—at least in my imagination."

The mid-1930s was an exciting time to work at a fashion magazine. Artists and creative people were flocking to New York from Europe. The look of *Harper's Bazaar* and *Vogue* was in flux. After having presented the clothes in an unimaginative way, showing stiff figures in drawings wearing dresses like the offerings in a Sears Roebuck catalogue, they were beginning to feature the work of avant-garde photographers. *Harper's Bazaar* under Snow was acknowledged to be the leading American fashion magazine, with *Vogue* trying to keep pace.

Into this creative world burst Diana Vreeland, a superenergetic and imaginative force who had been fascinated by fashion since childhood and had a profound understanding of how to make the most of one's looks. She quickly became an important voice at the magazine, setting high, even excessive, standards for the kind of clothes that were shown and in the way they were represented. She favored designs that were at once natural and elegant, and knew how to

brilliantly stage a sitting with photographers like Louise Dahl-Wolfe, another strong personality, with whom she worked well.

Readers first became aware of Diana Vreeland with the inauguration of her "Why Don't You?" column. In the August 1936 issue she asked readers: "Why don't you . . . Turn your child into an Infanta for a fancy-dress party? Remember that little girls of eleven to thirteen look divine in black taffeta with crimson sashes, white silk socks and Kate Greenaway slippers of crimson satin? Keep your nurse out of uniform or veil in the park? The best English nannies wear gray flannel suits, white shirtwaists, black boots and white cotton gloves. Remember that very little boys look best of all in hot weather in shantung, tiny white sleeveless blouses buttoned onto colored shantung shorts or natural shantung tailored overcoats with little stitched hats made of the same? Hide your little girl's lanky limbs in Chinese cotton pants and little Chinese printed cotton coats? They're sweet for supper at home. Remember little girls and boys look divine in tiny green felt Tyrolean hats?—the smaller the child, the longer the feather."

Her new column, outrageous and hyperbolic, was funny and fresh, combining whimsy, exaggeration and practical advice. It was alive with color and fashion examples taken from European or other exotic milieus. Diana suggested new takes on fashion styles and silhouettes, imagining the whole effect—a skill she was always strong on—and she urged new uses of old things. Impressive names of fashion notables were dropped everywhere; readers were told to dress "like Lady Abdy does," or "wear, like the Duchess of Kent, three enormous diamond stars arranged in your hair in front." Fanciful jewelry was proclaimed a must.

The theme repeated over and over in Diana's column was the personal credo of its creator: Don't just be your ordinary dull self. Why Don't You be ingenious and make yourself into something else? Vreeland's limitless imagination was

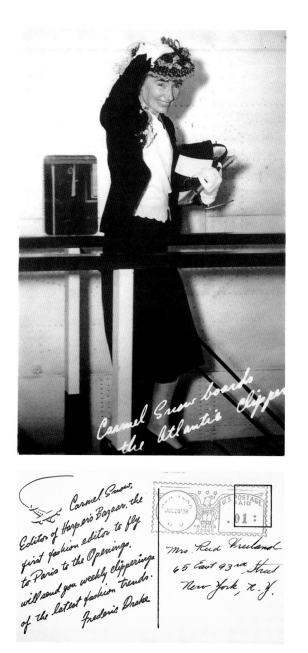

Carmel Snow looked to Paris for her fashion inspiration. Here she is catching the Clipper to cross the Atlantic for the Paris collections.

at work here, suggesting to readers that they stretch themselves beyond the banal and ordinary. Understood, of course, was that most of the suggestions were preposterous and out of reach—for both practical and financial reasons.

In the January 1937 issue she wrote, "Why don't you own, as does one extremely smart woman, twelve diamond roses of all sizes? Wear one as a buttonhole on a tailor-made. Wear five for a necklace around the top of your dress. Wear them all at once one night, in the hair, on your bag, up and down your dress." On the shape of a dress she wrote, "Why don't you realize that you are infinitely smarter this year if you dine out with tiny sleeves in your exciting dress, no matter how naked your back or under arms, than in a sleeveless dress?" Again on shape: "Remember that the smaller your head the more extreme shoulders you can wear on your coats and the more extraordinary your accessories, furs and all your effects may be?"

Her vivid sense of color, and her ability to imagine the whole composition produced other tips: "Why don't you have a black silk knitted sweater with little gold paillettes to wear with a circular wool jersey skirt under your black fur coat?" On making new out of old, and creating what was important—surprise: "Why don't you get some very flat inexpensive fur and have it made into a little sleeveless waistcoat to wear under your ski jacket? The back of suede, the front of leopard, ocelot or black pony. This will look extremely smart when you get warm and take your jacket off." And, as always, Vreeland was practical: "Why don't you remember that if you never scrub across the ends of your nails with a nailbrush, your varnish will remain twice as long?"

The success of her column can be measured by the appearance of imitators as Vreeland's more extreme examples were immediately lampooned. In June 1937, *Harper's Bazaar* itself reprinted a spoof of "Why Don't You?" originally written for

the *Boston Herald* by the cartoonist Dahl. "Why don't you—as does Schiaparelli—wear violent velvet mittens with everything? Pin an enormous beige topaz on your beige suit? . . . Why don't you use a gigantic shell instead of a bucket to ice your champagne? Well, perhaps it's because we have a bucket." In this cartoon, working-class men are shown shivering in the presence of a man who strolls by wearing the recommended "violent velvet mittens. . . . They know there is a hand of steel in the violent velvet mitten."

In 1938, *New Yorker* humorist S. J. Perelman, famous for his scathingly funny satire and criticism, joined the fun by observing that if a perfectly strange lady came up to someone on the street and asked, "Why don't you travel with a little raspberry colored cashmere blanket to throw over yourself in hotels and trains?" the chances are that he would turn on his heel and hit her with a bottle. "Yet that is exactly what has been happening for the past twenty months in the pages of a little raspberry colored magazine called *Harper's Bazaar*." Perelman confessed that "the first time I noticed this 'Why Don't You?' department was a year ago last August while hungrily devouring news of the midsummer Paris openings. . . . 'Why don't you rinse your blond child's hair in dead champagne, as they do in France? Or pat her face gently with cream before she goes to bed, as they do in England?' After a quick look in the nursery, I decided to let my blond child go to hell her own way, as they do in America, and read on. 'Why don't you,' continued the author, spitting on her hands, 'twist her pigtails around her ears like macaroons?' I reread this several times to make sure I wasn't dreaming and then turned to the statement of ownership in the back of the magazine. Just because the Marquis de Sade wasn't mentioned didn't fool me; you know as well as I do who must have controlled fifty per cent of the stock. I slept across the foot of the

The patriarch H. H. Vreeland with his granddaughter and ten grandsons. At Brewster the children made movies—westerns with cowboys and pioneers as characters—played ball, swam in the swimming hole with their cousins and shot billiards in the playhouse.

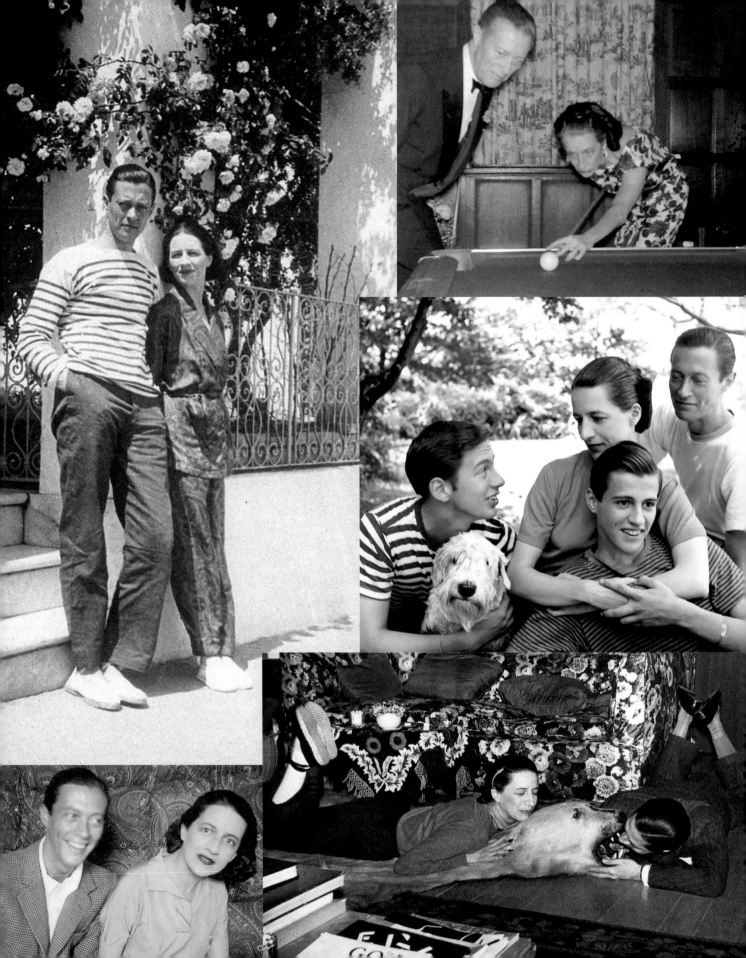

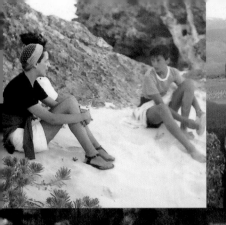

The Vreelands at play. The fashionable young couple at the d'Erlangers' house party at Sidi Bou Said (*far left*) and caught in various moments of happiness in Europe, Bermuda, Southampton and the Vreeland family place in Brewster, New York. *Left center and below:* The family was photographed at Brewster and in New York City by Louise Dahl-Wolfe, who often caught the boys and Diana and Reed in spontaneous moments. *Bottom, second from left:* Reed checks the breath of their famous bear rug; *bottom, third from left:* Diana in a holiday mood lets her hair fly free with her niece, Emi-Lu Kinloch, who spent weekends with the family and loved swimming in the swimming hole.

crib with a loaded horse pistol until the next issue appeared."

In her memoir Vreeland remembers that "Carmel Snow wrote Perelman a letter saying he shouldn't do such things, that it was very upsetting to a young girl to be criticized!" This was not Diana's reaction. She was delighted. "Good heavens! I was in my thirties at the time and was very flattered."

In addition to the "Why Don't You?" column, Vreeland wrote other small pieces as she began what would be her twenty-six-year stint at *Bazaar*. Before long, she chose the American clothes to be featured in the magazine, oversaw the photographing, worked with the models and was eventually in charge of all the fashion that appeared in *Bazaar*, reporting to editor-in-chief Carmel Snow.

Diana was making trips around the country to do shoots, going to the office every day in New York and spending time on Seventh Avenue—the capital of American fashion—attending shows and collections, meeting with manufacturers, making choices for articles, but she kept this routine separate from her life with her children and her husband. As Frecky explained, "Mom never talked about her work at home." The boys still did not see a lot of their mother, but were cared for by "Mlle," their German governess. They occasionally visited their mother at the office.

The two boys were happy at St. Bernard's, a conservative private school in the British tradition just a few blocks away from where they lived on East Ninety-third Street. A classmate remembers that Diana often asked her sons' friends for tea. Tim, the elder, was tall and good-looking like his father and an excellent student. As his father described him, he had "a gentle nature which made him unselfish but also slightly intolerant." He was shy on meeting people, "but once a situation interests him all shyness is lost." He was very sensitive, intensely curious, and gifted in drawing and in English and history. Frecky looked more like his mother—with strong brown eyes and a charming manner. He was the little brother trying to keep up with his very smart elder brother and more of a character, funny and lively.

When Diana and Reed were not visiting friends for the weekend or taking a holiday in Europe, the whole family went to Brewster, the Vreeland family compound. Reed's father, Herbert Harold, had bought a large tract of land on Turk Hill, near Brewster, New York, a pleasant, hilly town about fifty-five miles north of Manhattan and just west of the Connecticut border. There he built a complex of buildings: a mansion, named "Rest Awhile," with stone lions at the gate, a stable and other farm outbuildings. The stable would eventually become Diana and Reed's country place. In *DV*, she remembers Lindbergh flying overhead on his way to Paris, a memory that gave dash to her own country house, that put it on the map in her exciting fantasies.

During the summer Reed's three brothers and his sister would assemble with their children. The dominating presence for the fourteen grandchildren (thirteen boys and one girl) was the patriarch, Herbert Harold (H.H.), a tall man with a big paunch, a moustache and a great sense of humor. The boys were allowed to run the lawnmower, and their grandfather would sit above the porte cochere and wave down at them.

Although Diana and Reed were somewhat remote and cosmopolitan, they took part in some of the larger family gatherings, and their children loved Brewster. It was there that Timmy and Frecky were left when their parents were working in the city; they played with their cousins, who lived in houses nearby. Watched over by aunts and uncles, they were very much part of Vreeland summer family fun.

The boys, too, seemed cosmopolitan and eccentric to their American cousins. Their gov-

Diana, during her Bazaar *years, at her 400 Park Avenue apartment framed by red curtains and her Bébé Bérard drawings. Photograph by George Platt Lynes.*

erness, "a real disciplinarian," used to call out to the boys over the large lawn, "Teemie, Frecky, venez maintenant." Diana seemed strange, too, to the older boys who were becoming teenagers and aware of the opposite sex. They used to giggle at her, imitating her loping walk and the way she held her cigarette in its holder. Reed also seemed quaint in this setting, with his perfect clothes and reserved demeanor.

While the other Vreelands had help in the kitchen, only the Reed Vreelands had a butler. His name was Edwards. (All the Vreeland butlers were named Edwards, which Frecky thought strange. He remarked on it to one of them, who said, "Well, actually, my name is Frank.") Cousin Everett Vreeland remembers watching Frank play ball as catcher for the town team in Brewster, "full of beer." Later in the day he would transform himself back into Edwards, formally attired, to serve drinks to Reed Vreeland's smart friends, thus perpetuating the cosmopolitan and chic style Diana had become known for.

Reed was living in Montreal through
the whole war, working for British interests.
He was away for seven years. . . . It was a very
vivid period in my life. For seven years,
I was by myself . . . —DV

THE WAR

War erupted in Europe in September 1939, but the first months of that year were an idyllic time, the most brilliant season Paris had enjoyed since the carefree twenties. Visitors flocked to Paris by the thousands during the spring holidays. *Vogue* reported, "All the usual visitors are back; . . . Paris is still here, so why not enjoy it?"

That summer Diana and Reed had been enjoying a holiday in Capri, staying with Mona Williams, a colorful and generous hostess who entertained many fashion and society figures at her beautiful houses in Paris, Capri, Palm Beach, New York and Long Island.

Diana sent Frecky and Timmy to Bermuda with their governess, where they stayed in a house by the sea. They reported on their boat trip in illustrated letters. Frecky wrote, "Our cabin was a very good subject for a nightmare. That's about all it was good for. It had a bed about two feet wide and four feet long with a wooden mattress and a cobblestone pillow. . . . There was no air, a fan that does not work and a porthole with an iron covering on it. We were ten feet under water and the temperature was 100 degrees. [When you come] take the clipper. It's quicker."

Reed and Diana stopped in Paris on the way back from Capri. Bettina Ballard remembered lying around the pool at André Durst's place in the country, where Diana was staying. She was "packing and unpacking an enormous suitcase in her indecision about leaving." The decision would be made by Reed: "'My husband was a man with such a marvelous sense of . . . how women are. He got on a ship with a lot of American friends leaving France, and he left me behind.'

"'You mean you'd leave your wife,' they said—you know, that bourgeois spirit—'in a country that's at war?'

"'Look,' he said, 'there's no point taking Diana away from Chanel and her shoes. If she hasn't got her shoes and her clothes, there's no point in bringing her home. That's how it's always been and that's how it has to be.'"

She stayed on in Paris at the Bristol for about two weeks. Then Leo d'Erlanger came down from London and insisted she leave the next afternoon. He had promised Reed that when the time came, he'd get her out. "You've got to get out of France, you've got to get out of Europe—this is your last chance," she remembered him saying. He had booked her on the last passenger ship sailing before war began.

"I'll never forget that afternoon, coming down the rue Cambon—my last afternoon in Paris for five years. I'd just had my last fitting at Chanel. I don't think I could have made it to the end of the block, I was so depressed—leaving Chanel, leaving Europe, leaving the world of . . . of my world. There was an unearthly silence of hundreds of people strolling out of doors under the stars."

The war affected everyone, but in different ways. As Vreeland said later, "The United States was not yet in the war but I was in the war because I'd spent so much time in Europe. I had so many friends and family there." For her it would mean walking home during the blackouts—"black as the inside of your hat"—from the garment district

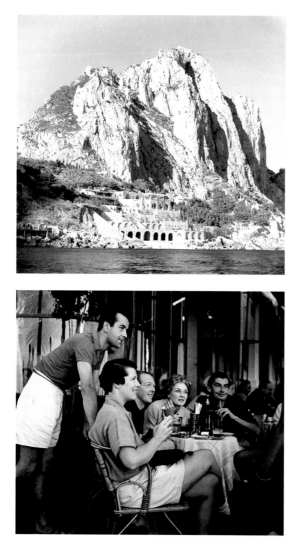

Top: *Il Fortuno, formerly an abandoned fortress on Capri, was the island paradise of Mona Williams, who had been born Mona Strader in Louisville, Kentucky, in 1897, the daughter of a horse farm manager. By 1926, as Mrs. Harrison Williams, she was the wife of the "richest man in America," worth $700 million. She entertained beautifully at her lavishly decorated mansion on Fifth Avenue and by the late thirties was on every best-dressed list and was mentioned in a Cole Porter song. Diana often visited Mona in Paris and on Capri (above); here she is surrounded by guests. Page 56: Photograph by George Platt Lynes.*

around Thirty-third Street to her apartment at 400 Park Avenue, at Fifty-second Street.

For her children it would mean watching the war's progress from where they were—off at the Groton School. Tim had gone to Groton as a second former (eighth grade) in September 1938, and Frecky followed in the first form, or seventh grade, one year later. Reed, who had been hired by his friend Leo d'Erlanger to manage Moorgate Holdings, the d'Erlanger Bank branch in Canada, was living in Montreal. Diana stayed in New York in order to keep her own job at *Harper's Bazaar*. Reed wrote John Crocker, Groton's headmaster in 1941, explaining why he needed scholarship help for his sons: His wife's niece (Emi-Lu Kinloch) from Scotland was living with Diana's father in New York City. "I am employed in business in Canada where my entire income from that source is now blocked by foreign exchange control restrictions. Consequently we now must rely entirely upon my other income in the States, supplemented by my wife's salary from her work in New York, to support our family of five and educate three children."

Diana's work in New York would be dramatically affected, as Paris was the cornerstone of fashion coverage. Carmel Snow always made sure her readers were aware of French fashion in the years before the war. She went to Paris with assistants in January and July; she found the models, and she chose the clothes to showcase in the magazine. During the collections, as she described it, Paris was "jammed with buyers— frantic, amusing, exhausting and glorious." The editors at *Bazaar* felt a spiritual bond with the fashion capital. When the war started, the magazine was featuring the dresses and suits of Chanel, Molyneux, Lelong, Patou and Balenciaga, who was Spanish but had his business in Paris. Readers of *Harper's Bazaar* were now kept abreast of what was happening during the unfolding conflict.

In the October 1939 issue, Carmel Snow's letter from Paris, written in August while she was at the collections, tells how she was now seeing a completely different Paris: "The city had become, almost overnight, an empty city. The taxis disappeared. All the telephones were cut off. You can walk for miles without seeing a child. Even the dogs—and you know how the Parisians love their dogs—have been sent away."

Vogue's October 1939 issue illustrated the changes with a Bébé Bérard drawing: "Gas masks are worn nonchalantly." "Snoods are almost uniform." "Rendezvous in an air raid shelter." Since most Parisians were without heat, Molyneux's "fur-lined coats are marvelous. . . . If you have a three-piece suit and a fur-lined topcoat you are set for any abri or evacuation that might come your way." The fashion capital now faced an enormous challenge. Some of the couture houses closed. Mainbocher left for America, and Chanel closed when the Germans occupied Paris, not to open again until 1954. The September 1940 issue became "the first issue of *Harper's Bazaar* that has ever appeared without fashions from Paris."

During the first eight months—from September 1939 to May 1940—there had been almost no fighting on the western front. Boredom was the enemy. This "phoney war" ended with a thunderclap when the German "blitzkrieg" began on May 10, 1940. Within a few days German tanks and aircraft overwhelmed the French defenses in coordinated attacks at their most vulnerable point in the Ardennes and swept virtually unopposed across northern France to the Channel. On June 10, the government abandoned Paris. Four days later German infantry marched in unopposed. A defeated France was divided into two parts, with Paris in the occupied part under direct German rule. Hundreds of thousands of Frenchmen were shipped off to Germany as slave labor.

Lucien Lelong, himself a couturier, was the

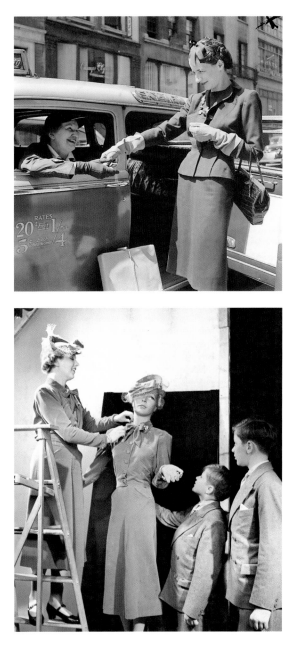

Top: *In July 1943, a* Bazaar *article showed women who had "stepped into men's shoes." The article also asked, "If women like Lube Phillips weren't manning taxis, how would Fashion Editor Diana Vreeland rush her merchandise to and from Seventh Avenue's wholesale houses?"* Above: *Frecky and Tim visit their mother's workplace.*

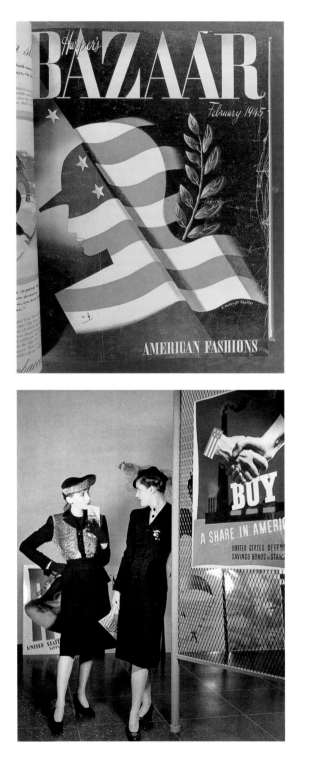

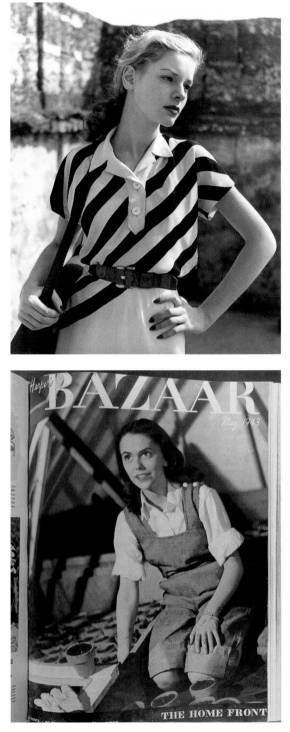

president of the Chambre Syndicat de la Couture Parisienne during the four years of the German occupation. After the Liberation he presented a brief report, the gist of which was that his skill as a negotiator kept at bay the blundering German officials determined to destroy *la Haute Couture*, the fashion industry centered in Paris. As Lelong reported, in the summer of 1940, just after the Nazis occupied the northern half of France, the Germans made clear they intended that French couture disappear. It was to be integrated into a German organization based in Berlin and Vienna. "The great fashion houses would continue to exist, but they would no longer be able to exercise a virtual 'unjust' monopoly on fashion which did not correspond to the necessities of the New Europe of which Berlin was to be the cultural center."

Lelong and M. Gorin, secretary general of the Chambre Syndicat de la Couture Parisienne, argued that "Paris couture cannot be transplanted either as a whole or in its elements." They saw couture as not only "a spontaneous outburst but also the consequence of a long cultural tradition."

Diana, who felt so strongly connected to London and Paris, experienced the European war vicariously through her friends' tribulations. Cecil Beaton wrote to her in the summer of 1940 that he was very fortunate in seeing the war from varying aspects. "I have three books of war photographs coming out here—one 'History Under Fire' on all the lovely things that have been lost in the city—a more general one on England Under Fire—and an R.A.F. book."

Harper's Bazaar issues during the war years showcased models with uniformed servicemen and reflected on the war work done at home. The covers featured hopes for peace and victory gardening; opposite bottom left: *models are photographed with war bond posters;* top right: *Lauren Bacall appears in the magazine in her pre-Hollywood modeling days.*

In the early 1940s, Johnny Lucinge wrote from France describing how he and his wife, Baba, and their children were living in the south near Antibes, and he was traveling up and down to Paris to take care of his hotel business. People in the south of France lived as if they were "in little villages," not venturing very far, as fuel, too, was scarce. He had seen Elsie Mendl, who looked "very old and tired. On my way through Paris I had been to Versailles in the afternoon, and there she was, after the usual lunch of 50, playing backgammon with Laura, little old Johnny [McMullin] arranging the flowers. The whole thing, with the guests, had something very anachronistic and yet consoling."

Johnny wrote to Mona Bismarck suggesting that Diana advise Suzy Michaud, the hatmaker, who wanted to open a shop in New York. His wife, Baba, was a shareholder in Suzy's business in Paris. Suzy thought she now needed $10,000, and Johnny and Baba were coming to her aid. "There are tremendous difficulties about getting money out of France and England, and I don't know if we'll get leave to do it, but before doing anything I would like to know if you and Diana think it a good idea."

Johnny Lucinge described how Suzy had "prepared 150 hats quite unusable for ladies who cycle or live in tube stations, but that she wants to take to America!" Johnny had advised her, if she was asked anything by the press, to get in touch with Diana at *Harper's Bazaar*. Johnny also reported that Mona's beautiful house on the Right Bank near the Seine had been saved from German occupation. Another friend had made such a fuss that the Germans left it alone.

Many refugees—some, friends of Diana's—made their way to America. Those who were in the fashion world made news in the magazine. "Mainbocher Opens in New York," declared the November 1940 issue of *Harper's Bazaar*. Readers learned that Schiaparelli, just before her

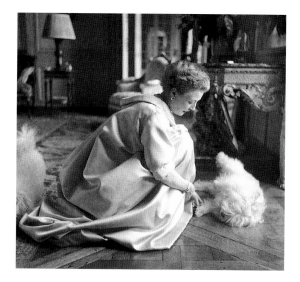

*Mona Williams, later Bismarck (above and opposite),
photographed by Cecil Beaton.* Below: *Elsie de Wolfe,
"A great friend—she was witty, put up with no nonsense
and had me down many times to her delicious little
house at Versailles."*

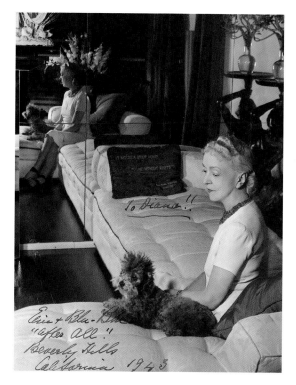

countrywide lecture tour, went into a New York
workroom and designed a collection of clothes
for America. And by April 1941, Suzy Michaud
had made it to New York and was selling her
hats at Bergdorf Goodman. *Bazaar* announced,
"Suzy is here!"

Like many English children who were sent
to America during the war, Emi-Lu Kinloch,
Alexandra's daughter, came to New York to be
with her grandfather, Frederick Dalziel, at his
home on East Sixty-ninth Street. Diana, who
strongly felt the hardships of those overseas,
helped in any way she could. She included Emi-
Lu in all their family events. The grateful Kin-
loch family wrote to Diana, reporting on the
realities of life during the war and thanking her
for the packages she continually sent her family
in England and Scotland.

Diana arranged for Emi-Lu to speak to her
parents on the radio, and Alexandra Kinloch wrote
from Aberdeen in November 1940 saying how the
whole family enjoyed Emi-Lu's "broadcast." They
hired "the biggest and most powerful wireless in
Aberdeen" and invited friends and family to listen
so that the "wee sitting room was fairly bursting.
Much laughter, and much whiskey, and heaven to
hear the wee mutt's voice."

By the winter of 1941, Alexandra was work-
ing full-time in an organization to aid English
prisoners-of-war. She wrote in February that the
Luftwaffe had continued to avoid them, and they
had only heard two or three sirens in recent
months. "The knitting here is a great art and
would appeal to your fashion mind." As an
American who had made England her home, she
was proud that "all eyes look to the U.S.A. for
help, and are deeply grateful. Roosevelt is a god
here, Willkie very popular, in fact no American
can do wrong." She also felt that it was a privi-
lege to live in Britain at that time: "Everyone is
unselfish, friendly, industrious, with a crusading
look in their eye." And she concluded that "war

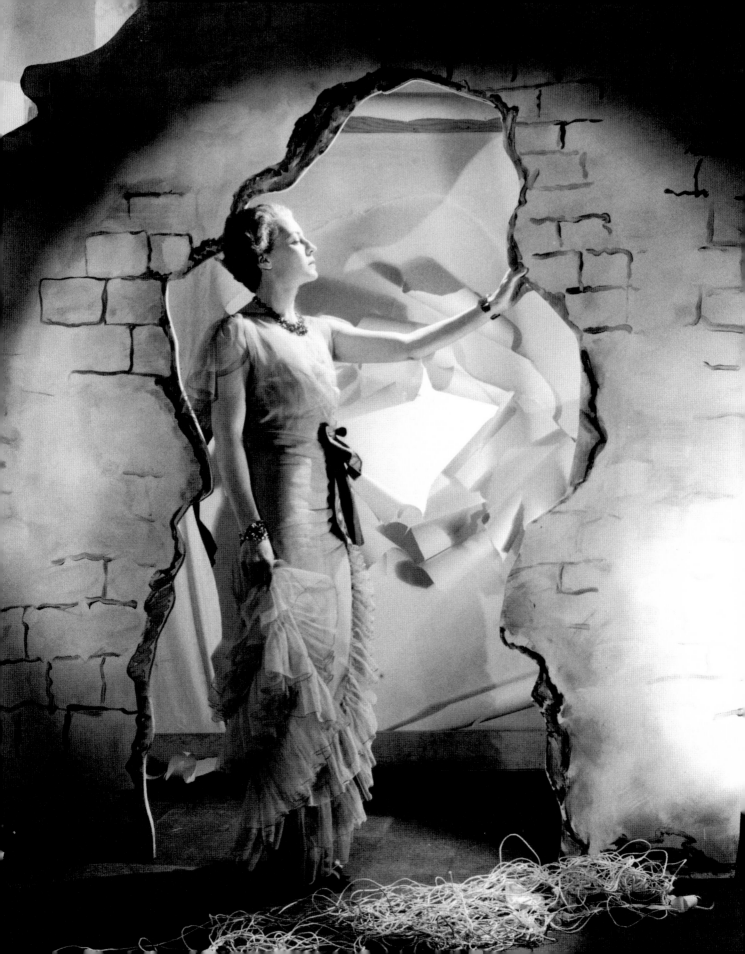

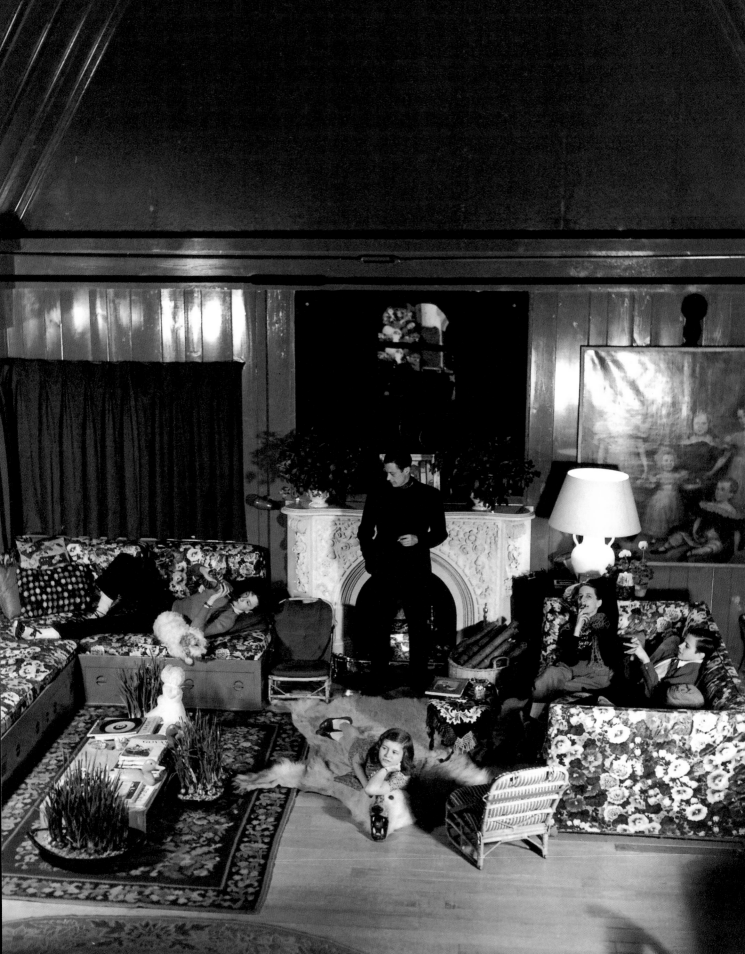

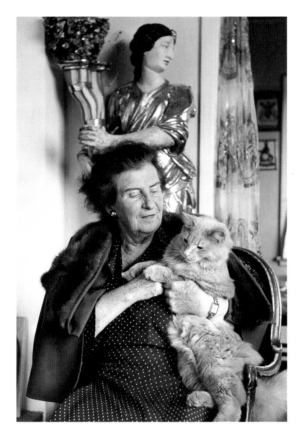

Opposite: *Louise Dahl-Wolfe shot the two-story, shocking-pink living room at Brewster. Tim stretched out on the banquettes, playing the recorder, and Diana, Frecky, Emi-Lu and Reed listened. Catherine d'Erlanger (above) decorated the bedroom fireplace with shells. Reed and his wife each had a bathroom, with a window in the wall between them, which intrigued the boys' cousins.*

is in a strange way, a great tonic, for everyone can get a useful job—and therefore feels happy."

On the fashion front, the war was causing an important shift—one that would benefit American designers. Out of necessity, *Harper's Bazaar* looked homeward, publishing the record of the New York autumn openings with pride in the achievements of American designers. *Bazaar* noted with chauvinistic pride that Lord & Taylor had reaffirmed "its faith in the integrity and tal-

ent of American designers with the opening of its new Designers' Shop, where labels are proudly American." And in February it was noted that "as Paquin and Worth stood for a certain civilization, these [American] names stand for American style, and the American way of life. Our zippers have revolutionized dressmaking. Our bathing suits excel from the Riviera to Vina del Mar." On the cover of this issue was an eagle on a branch of a tree and a nest of more than eighty American labels.

By the late 1930s, Diana's feelings about the "Why Don't You?" column had changed. She "hated the bloody things" because "if I sign my name to something, it's all mine—but I suddenly realized that Carmel Snow was putting in all sorts of things that might bring in the eye of our advertiser, and I said I didn't like it. Also, we went to war—Europe went to war—and once we went to war I was a different person," and the column seemed "a bit frivolous."

But in May 1941, she returned to it briefly to give ideas for a country home. A sketch of her by Bébé Bérard and a description provide a good picture of Diana at the time: "A fair-skinned brunette with blue-black eyes and blue-black hair, dresses like a blonde and is never long out of her favorite color combination—oyster beige and white. . . . All that interests her in a dress is silhouette and fabric—these must be perfection. She would rather have a new jewel, or an old one re-designed, than a new dress any day. Next to jewels, shoes are her greatest passion. She loves her job, declares that for her fashion is of the essence—she thinks, lives, and breathes it. And she is full of fireworks. Her pronouncements—dramatic, discerning, and decisive—are like rocket bursts, spellbinding the entire staff of the *Bazaar;* behind the pyrotechnics, a wise, loving, and generous woman."

The column again expressed her fresh and original ideas—some of which she and Reed had

0

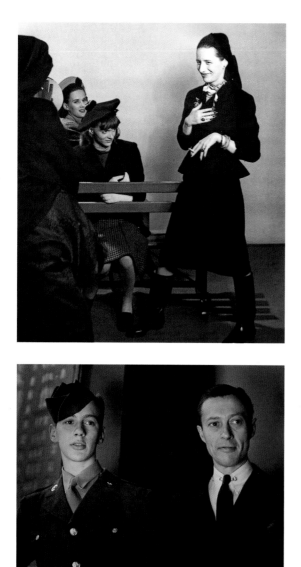

Louise Dahl-Wolfe photographed all the family members during the war years. Top: Diana *at* Harper's Bazaar. Above: Tim *in his army uniform with Reed. In December 1944 Tim joined the paratroopers, and the family followed his career through letters that described how the jumping was going. He felt confident and calm. He was not sent to Europe until after the end of the fighting there.*

used in their Turk Hill house in Brewster. Timmy described it: "The house itself was extraordinary." You looked down the hall and saw that every door was painted a different color. The pink living room was two stories high. Elderly Baroness d'Erlanger, Leo d'Erlanger's aunt—a big woman, like Gertrude Stein—"came up to Brewster and decorated the fireplace in the living room and in the bedroom created a fantastic fireplace with shells. Later she painted the carved marble fireplace in the living room which had carved flowers with different colors."

In "Why Don't You?" Diana suggested these country living tips: "Use indoors on a brilliant tablecloth square mats made of round black beads, solid and shiny? . . . Paint every door in a completely white house the color of a different flower—and thereby give each room its name. . . . Wear yourself: olive-green corduroy breeches, a loose chemise shirt, knitted white cotton stockings, strong shoes of black leather with silver buckles—like a boy of the eighteenth century?"

Vreeland's imaginative work can also be seen in *Bazaar*'s January 1942 issue, in which a long opening spread of Louise Dahl-Wolfe photographs shows models posing in buildings in an old western town in Arizona. There were shots taken at the Jokoke Inn, near Phoenix, and at the old mission church of San Xavier, six miles outside of Tucson. Another striking site was Taliesin—Frank Lloyd Wright's beautiful house near Tucson, "clinging like an eagle's nest to a mountainside." It was very hot when they were taking the pictures, and one of the models became ill. Diana suggested that she herself put on the clothes, and she modeled an outfit.

It was a stunning moment in fashion reporting. The models suggested youth and health and freedom from anything formal or staged. They appeared completely at home, at one with their surroundings—the sky, the dramatic landscape.

Louise Dahl-Wolfe used color and black-and-white, and shot out in the natural light. It was the forerunner of many such fashion shoots Vreeland would orchestrate in her long career. The sports clothes of Claire McCardle were young and American, and the piece gave credibility to what would be America's great contribution to fashion: sportswear, made of simple fabrics—denim, cotton and jersey—cut in ways that were becoming and comfortable.

Vreeland also appeared incognito in another article in the May 1942 issue, called "There's No Place Like Home." The piece—also photographed by Louise Dahl-Wolfe—pictured her family at Brewster, but it appeared to present any American family content during these hard times and enjoying simple resources and pastimes. The import of the article was that "the main figure of the Home Front is the woman. It is she who must make the stand, rally her family round her like a general, and plant her own feet firmly on the home ground."

In July 1943, a *Bazaar* article entitled "You'd Have No *Harper's Bazaar* if Women Hadn't Taken the Place of Men in These Civilian Jobs" showed women who had "stepped into men's shoes in the press room of the Cuneo printing plant in Philadelphia," and Carmel Snow receiving information from a female information clerk at the Long Island Railroad. The article also asks, "If women like Lube Phillips weren't manning taxis, how would Fashion Editor Diana Vreeland rush her merchandise to and from Seventh Avenue's wholesale houses?"

Even though Diana was not with her children all the time, as she probably would not have been even if she weren't working, she was a warm, loving, enthusiastic if somewhat distant mother. At that time it was unusual for upper-class mothers to spend a lot of time with their children. Diana sent her sons affectionate letters full of amusing stories when they were away at school; she plied them with

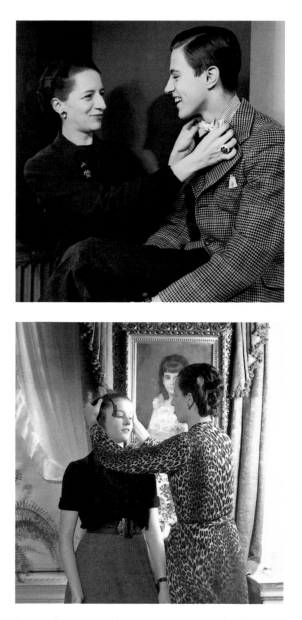

Diana always wanted to improve everyone's looks. Here she straightens Frecky's tie and adjusts the hair of Emi-Lu Kinloch, who was living with her grandfather Frederick Dalziel and spending weekends with the Vreelands.

books, many for readers beyond their years, which they devoured. During school vacations Diana took the boys to the theater. And the greatest gift she gave her children was her enthusiasm for life.

Frecky conferred with his mother on literature and the arts, and wrote her asking about the life and writings of renowned contemporary playwrights he was reading. He reported how he participated in school plays and won awards for his performances, and wrote for the weekly school paper, knowing she would be pleased.

She constantly saw to her sons' wardrobes, in ways that were sometimes unappreciated. In fact, they thought she masterminded some things in their lives too much. She had very strong ideas about how they should look, what they should wear and later what sort of girl they should marry. Frecky remembered that "she had a way of wanting you to be the way she wanted you to be. Tim resented this terribly. I was more relaxed about it." There was "a big emphasis on intelligent conversation. In the course of a meal Dad would have one or two volumes of the *Encyclopaedia Britannica* out. It was a challenge—the sort of thing you read about of the Kennedy family. You had to be on your toes." Frecky tried hard to keep up with "my smarter older brother."

While the boys were at school, Diana mothered Emi-Lu, who both adored and feared her. She counseled her on clothes and manners, and demanded that she live up to her high standards for neatness—standards that were often hard for her niece. Emi-Lu nonetheless admired her aunt greatly. "For all her faults, she could love," Emi-Lu said later. "She was devastatingly critical, but she could love." When Emi-Lu first arrived, Reed's sister, "Aunt Marjorie," was a cozy surrogate parent for the teenager. But when Emi-Lu turned fourteen, Reed realized she could learn about being attractive from her soignée aunt.

What Emi-Lu really loved were the family weekends at Brewster. She wrote Diana in June 1947, while she was studying at St. George's School in Switzerland: "How I envy you being in Brewster. You know I *did* love it so much there—*everything* about it. The flowers, your wonderful bedroom and the divine living room—with Timmy and Frecky playing their records. The gorgeous food I never appreciated. Aunt Marge, Uncle Reed— But most of all, the woods and you. . . . Brewster always was divine! In fact, I teen-aged through it—which always is Hell but Heaven!"

Not surprisingly, the boys were also clothes conscious and clothes were a constant topic in letters home from school. Timmy wrote in the fall of 1940:

> I am getting rather fed up with the sock situation. I have no socks, and don't let Mlle tell you differently. All my colored socks (only two pairs being left) are shrunk so that they are impossible to wear. My grey socks are very old and full of holes, worn at toes and heels. The shoe situation is also terrible but there is nothing I can do about that until Christmas. Therefore, couldn't you order me some more socks, and please lets have some colored ones. I have reached the age where, I believe, I am capable of wearing something other than blue (plain) and grey (plain) socks. It may seem terribly bourgeois to you but I would like some MULTI-COLORED SOCKS. I thank you—
>
> Timmy
>
> P.S. I also will need a new pair of garters.

Although Reed was away in Canada, he did come back for vacations and the family enjoyed their weekend house at Brewster in 1941, and in the first months of 1942. Their guest book shows that

they entertained lively and creative friends. Some of the guests they knew from Diana's work: George Davis, the literary editor of *Harper's Bazaar*, and Louise Macy, as well as fashion editor Niki de Gunzburg; Frances McFadden, the managing editor; George Hoyningen-Huene, the photographer; and Bill and Lorelle Hearst, son and daughter-in-law of William Randolph Hearst, the publisher. She also entertained other good friends, like Pauline Potter, who was designing for Hattie Carnegie, and others they had seen a lot in Europe: Edwina d'Erlanger, jewelry designer Johnny Schlumberger, and Kitty and Gilbert Miller, along with Kitty's eighty-year-old father, Jules Bache, head of Bache & Company, the big Wall Street firm, and Elsie Mendl and Ethel and Philippe de Croisset from the social and fashion worlds of Paris. On Sunday, June 15, 1941, Elsa Schiaparelli came, and in November the actor Jean-Pierre Aumont. In the fall of 1941, Elsie Mendl was back with Johnny McMullin, Vreeland's good friend who wrote for *Vogue*, and with Syrie Maugham. In November the reporter Virginia Cowles, whose book on the war in Europe, *Looking for Trouble*, had recently been published, wrote that "she had decided to move in for good." On December 7, 1941, the guest book noted that "Japan attacked USA on Sunday," when *New Yorker* writer Janet Flanner had been in Brewster. That evening Frecky hunkered down with his classmates and listened to the radio broadcast of Roosevelt's declaration of war while simultaneously penning a letter to his parents. "It is all gruesome," fourteen-year-old Frecky wrote in the letter to Diana and Reed on the news of the war and his boarding-school life.

For the holidays of 1941–1942, Diana recorded that "3 children and all of us [here] after December 23–Jan 3 . . . Hattie Carnegie came and called on Sunday." They opened the house next for the Easter holidays on March 21. On March 23, Louise Dahl-Wolfe visited. In the sum-mer of 1942, Harry Hopkins, the U.S. secretary of commerce, was there.

Timmy wrote his father from Groton in the fall of 1941 that he was excited about going skiing with his dad in Canada. The two boys went to Montreal by train and were taken to the apartment of a woman who was a friend of their father. They met her two children, who were about the same ages. The whole group went on to the Laurentians, where Reed had rented a chalet at Mont Tremblant. The boys had met the woman Diana later discovered was her husband's mistress.

There were always rumors about Reed's liaisons. There had been a rumor when they returned from England that Reed had had an affair with Edwina Mountbatten. Now people said that Reed had left his wife and was living in Canada with another woman. When Diana was asked out for dinner, she said, "I would love to come, but Reed is away," even though he was no longer living at home. Later people would talk about Reed's wanderings. It was rumored that Diana went to Montreal and confronted his girlfriend. She sat her down in front of a mirror and said, "Look at you, you are young and beautiful, and you have everything ahead of you. I am getting older and I have only my wonderful husband." Another story was that Reed sent his girlfriends gardenias floating in a bowl. If Diana went into a room and saw the gardenias, she knew.

Diana never spoke to her friends of Reed's infidelities. She kept her feelings to herself. Occupied with her work at *Harper's Bazaar*, she looked the other way and carried on. While Reed was away, she kept in constant touch with Tim's and Frecky's teachers. Unlike her mother, who apparently was oblivious to her daughters' successes or failures, Diana was watchful of her sons' progress, and vigilant about their health. After a bicycle accident in which Tim broke his collarbone, she cautioned Groton headmaster Jack

Crocker: "He can't jump straight into sports." And writing about Frecky's schoolwork, she said: "We all at home know that from time to time Frecky needs a bit of bullying."

The boys' years at Groton were the years of the war, beginning in the late thirties. A Groton teacher wrote that when the parents were preparing for the boys to go to school—"your last name tapes sewn on and trunks sent off, Poland was being crushed." Before Frecky's second-form year, "France had been defeated by Germany and Italy in June." By the spring of third-form year, "most of the world had plunged into the war against Germany and the Axis," and many faculty members had left to join the armed forces. By the spring of Frecky's last year, 1945, with victory imminent, the class had shrunk by several boys who had been taken off to military service at age eighteen.

In 1943, just after graduating from Groton, Timmy joined the army. When he was on his way to Fort Dix, his mother saw him off at the station in Brewster. She began to cry. "I was amazed. I had never seen her cry before. I couldn't imagine why she was so upset." They were in "very different frames of mind. I was looking forward to it and she was seeing her oldest boy going off to war. It was one of the few times I felt the real love she had for me because we, like a lot of families, weren't demonstratively affectionate. My mother had very exacting standards. She tended more to tell you what you should be doing and how it should be done and how you should be dressed and so forth than to tell you how fond she was of you."

By November 1944, things were looking up in France. *Harper's Bazaar* was able to "welcome back Paris and the couture.... We welcome back, too, our beloved arch-collaborators on Paris fashions, Pierre Mourgue and Jean Moral, whose sketches and snapshots flew to us—the first word we'd had of them in four long years, and our first good view of Paris clothes." *Bazaar* informed the American woman that "Paris likes bulk at sleeve and hip."

French designers created the Théâtre de la Mode, a collection of wire-frame dolls dressed to perfection, with hats, shoes and matching accessories—even fur capes—all in the latest styles created by Parisian couturiers. Everyone worked together night and day, without heat and with little to eat during the winter of 1945–1946, the most miserable first winter after the Liberation. With the collaborative efforts of the best Parisian artists available, led by Diana's good friend Bébé Bérard, these dolls—"They have a magical aura about them, these little dolls of the Théâtre de la Mode"—were displayed within their decors, miniature stage settings of Paris, each created with as much painstaking effort and imagination as the dolls themselves.

The exhibition opened on March 27, 1945, as the Allied armies moved toward final victory in the heart of Germany. All of Paris was there, led by such fashion personalities as Marie-Blanche de Polignac, Louise de Vilmorin and Marie-Laure de Noailles, as if no war had intervened. From Paris the exhibition went to London and then to other European cities. In the spring of 1946, with their clothes updated to the latest 1946 fashions and miniature jewelry added by twelve of the leading Parisian jewelers of the day, the dolls of the Théâtre de la Mode arrived in New York City, where they were a smash for Carmel Snow and Diana Vreeland and thousands of others in the U.S. retail and fashion worlds. In a 1947 issue of *Bazaar*, there would be an article about this creation traveling to New York and from there to a triumphal exhibition at the De Young Museum in San Francisco. Couture had regained its prewar eminence: "Make no mistake about it," wrote a U.S. fashion consultant, "Paris is still the magic five-letter word."

As Diana told the story years later, three weeks after the Liberation of Paris she got a message at *Harper's Bazaar* from Paris: "'We must give work to *les petites mains de la France*. Will you show embroidered gloves?'

"'Never!' I said. 'Send me one perfect black organdie rose.' You see, that was France's first thought after the war, for her artisans, her *petites mains*." She examined the workmanship and found it as well made as anything before the war. Couture had survived!

Paris soon recovered its power as fashion capital of the world, and the coverage of its yearly collections would continue to be the centerpiece of fashion reporting at *Harper's Bazaar* for several more decades.

After the war Diana visited her favorite city as quickly as she could. There were dramatic differences in Paris, but Diana was thrilled to be there on Bastille Day of 1946. At about four in the morning, after driving all over the city, and seeing the fountains on the Place de la Concorde playing for the first time since the Liberation, she and Reed were desperate to find a place to eat. On a little street above Montmartre they saw a restaurant with closed shutters. They banged and banged on the shutters.

"'We've nothing to eat,' I said. 'We've just arrived from America and we've been spending this wonderful night in Paris, but we're so *hungry*.'

"'Mais entrez, Madame et Monsieur!' the man said. 'Entrez. C'est une auberge!'

"I've never forgotten that, because for me, France has always been an auberge for feelings, for emotion, and for so many other things. Reed and I spoke of that experience for years after. The man opened up the door so wide that he could not have made a greater gesture if it had been the Hall of Mirrors!"

After his graduation from Groton in 1945, Frecky joined the merchant marine.

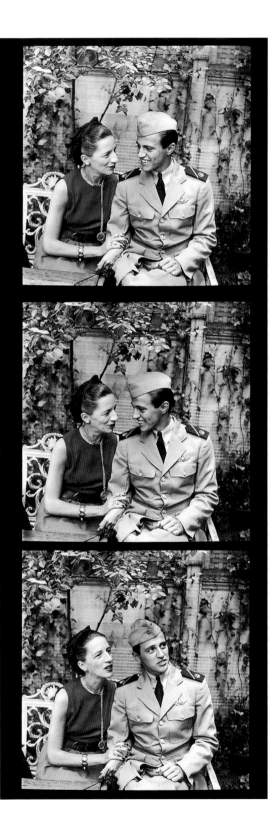

Diana was the mastermind behind this famous Louise Dahl-Wolfe shoot, and she herself appeared unidentified as a model in a number of shots. Although location shoots had been done since the 1930s, this one showed off fashion in the outdoors at its best. Readers of the January 1942 issue of Harper's Bazaar learned that the valley of Arizona was "where Scottish, Chinese, and American pilots are training for the war, where little boys and girls can learn their lessons out of doors . . . where a Frank Lloyd Wright house looks as if it had been there forever." It's a land where "every cock of the hat, every phrase, every gesture, has color. It's a land not only to bring things to, but to bring things back from . . . this is the way all fashion is born." Dahl-Wolfe made a scrapbook for Diana of shots that appeared in the magazine and others that recorded the good time they shared.

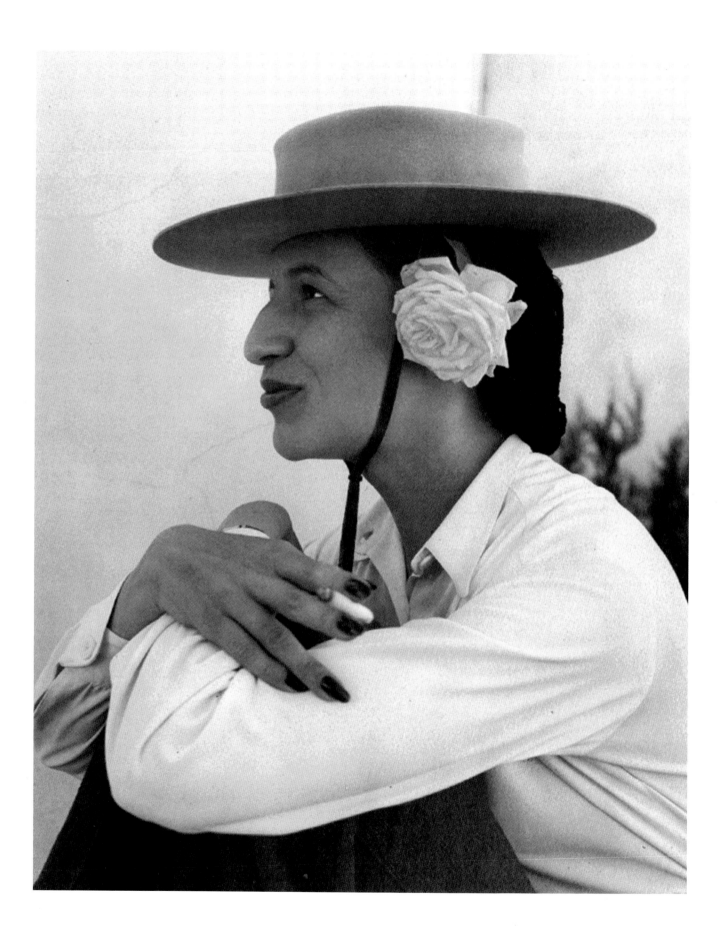

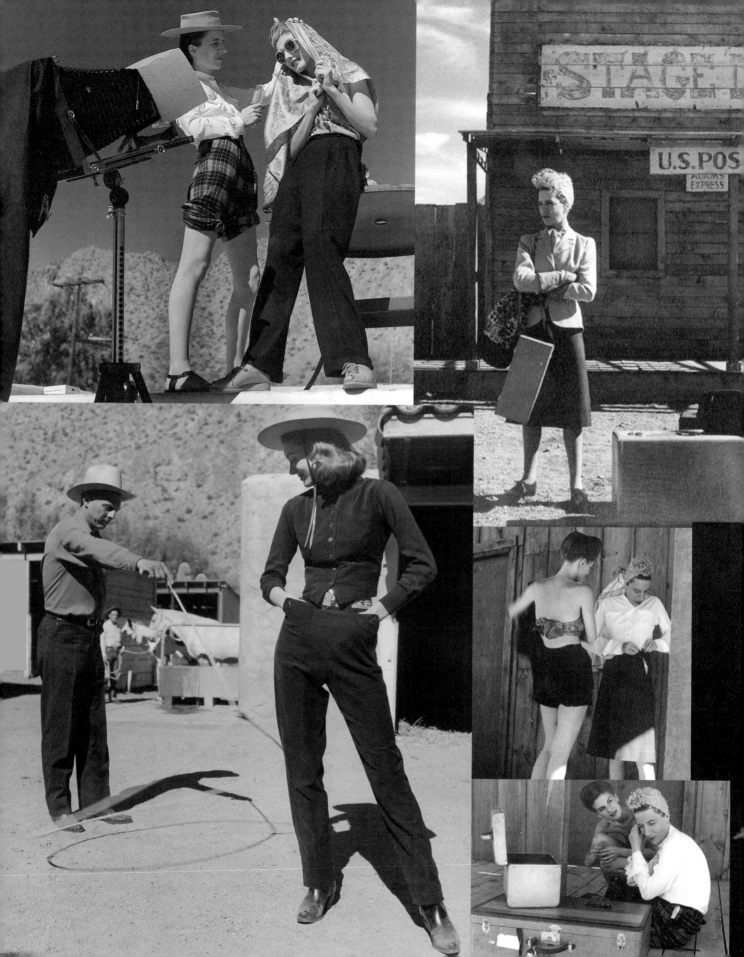

Diane Dear—

XMAS- 1941 —
New York

With fondest love
and just a few of
our memories of that
wonderful trip — so
you won't forget Mrs Hearst
in years to come —
Affectionately + Devotedly
Louise Dahl Wolfe

Fashion is a passing thing—
a thing of fancy, fantasy and feeling.
Elegance is innate. —Allure, 1980

HARPER'S BAZAAR

After the war, *Harper's Bazaar* continued to reign as the most artistic and innovative fashion magazine, illustrating art director Alexey Brodovitch's dictum "Astonish me!" Like an international bazaar exhibiting its seductive treasures—silks, velvets, cashmeres, spices, perfumes and glittering jewels—*Bazaar*, above all, was a visual delight. During the 1950s its pages offered portraits of the rising Elvis Presley; the "bejeaned members of the beat generation"; Queen Elizabeth II, whose coronation wowed the world on TV in June 1953; and superstars Gina Lollobrigida, Sophia Loren, Audrey Hepburn, Marilyn Monroe and America's own princess, Grace Kelly.

The magazine also covered newsbreaking events, such as the astonishing developments in America's space program at the end of the decade. Carmel Snow made sure she published the work of the best contemporary authors of fiction and poetry—T. S. Eliot, Langston Hughes, Richard Wright, W. H. Auden, Colette, Eudora Welty and Flannery O'Connor, as well as Jack Kerouac (*On the Road*) and Allen Ginsberg (*Howl*). And under Diana Vreeland, the fashion reportage made a big contribution to these visual and literary delights.

Parisian couture had survived the war, and *Bazaar* chronicled its postwar recovery. The April 1947 issue announced the "sensational success" of Christian Dior, "a rival to Balenciaga, at last." Dior's clothes would again encase women in garments of definite structure—long skirts of yards of material—and they would appear glamorous in a way that hearkened back to an earlier era. But Dior reaffirmed the high standards of tailoring, workmanship and luxurious detail that had always been the hallmark of French couture. Because of an offhand remark by Carmel Snow that Dior had created a new look, the French magazines began to speak of "le new look" that the designer's postwar couture inspired.

Diana would call it the "guinea hen look," despite the dressmaking skills it reaffirmed. For her, Chanel's simple line freed a woman to move easily and suited the figure better than an exaggerated structural effect that relied on a corset to cinch in the waist. But she was curious: "We cannot wait to see the Dior sketches and the photographs after Carmel's wire that he is the Saviour of Paree. . . . I am longing to know how individual people look." Her curiosity, however, could only be satisfied at second hand. Carmel always led the *Bazaar* team to the Paris collections.

At *Bazaar* Diana's brilliant fashion reportage was done under Carmel's leadership. She may have chafed at being number two, but she performed her duties faithfully. To cover the American designers, she went herself or sent other editors to the manufacturers' showrooms on Seventh Avenue; she orchestrated sittings, chose the final photographs and approved the copy. And she managed to make this continuous process produce results that were unpredictable, fresh and fascinating. Adoring young editors, many of whom came from socially prominent families, assisted her.

The relationship between Carmel Snow and Diana was complicated. Adrian Condon (now Adrian Allen), who worked as Alexey Brodovitch's

assistant and eventually took over his design responsibilities, saw Vreeland's work at first hand. She remembered that Carmel kept the willful and powerful Diana in check. "I think she resented it, but there was nothing she could do about it," Allen said. "I think [Diana] really thought she had a far better grip on fashion and taste, but Carmel was her boss."

Carmel Snow was a woman who knew precisely what she wanted to see on the pages of her magazine. Her constantly evolving vision of the "top quality" that the *Bazaar* audience expected was relentlessly grueling on the staffers whose job it was to deliver that vision to the public as succinctly as possible. Never one tacitly to accept the conventions of executive protocol, Carmel successfully molded the magazine around her personal understanding of what *Bazaar* should provide to "the type of woman" to whom it pandered. "It was the first appearance of a concept that came to be widely imitated but was never surpassed: the magazine editor as auteur," said Calvin Tomkins, writer and cultural historian. Richard Avedon said that Carmel Snow was "a real star . . . before fashion people were stars."

Carmel was an elusive monarch. She kept out of sight, but when she appeared, everyone responded with awe. She chose the order of the pages by pointing to them one by one with her cane while her employees watched in silence. She instructed Brodovitch to reduce this one or blow this one up, and he knew it was pointless to object. Then she would leave. Diana's presence in meetings was, in contrast, "pure theatre." She would waltz in and make a pronouncement, and "as if she were on stage, she would say, with a flourish and a wave of the hand, 'the whole June issue should be magenta. This year everything is in magenta.' But Carmel would reply, 'Well maybe two pages in magenta or four pages in magenta.'"

Dorian Leigh made the cover of Bazaar *because the girl who had been scheduled was terribly sunburned and "since Louise Dahl-Wolfe used strong floodlights, her skin turned bright red." As Dorian put it: "I was launched. That was it. That's all I needed." Opposite: C. Z. Guest was surprised that Diana wanted Louise Dahl-Wolfe to photograph her, since "I was ready to have a baby. You can't imagine what I looked like. 'From the waist up,' Diana said, and that's the way it was." Page 78: Diana with model, photographed in 1946 by colleague Richard Avedon.*

Carmel Snow was greatly admired in the fashion world, as Richard Deems remembered, "for her combination of creativity, business sense and the ability to get along with people." The contribution of Diana Vreeland, on the other hand, was her "understanding that fashion is theatre." Top: *Carmel with Louise Dahl-Wolfe and,* above, *Carmel at Schiaparelli in Paris.* Opposite: *Suzy Parker in Balenciaga's fisherman's overblouse.*

The two worked well together because of their mutual respect and their determination to produce a beautiful magazine.

Although these two editors told their readers how to look and how to change, they never changed their own looks. Carmel was dressed by Balenciaga, and Diana by Mainbocher and Chanel. Diana was flamboyant and rather loud—a performer; Carmel Snow spoke quietly and had a tight little voice. She always wore a little hat, while Diana wore lots of Chanel chains, clanking along, unlike the serene and silent Carmel.

Alexey Brodovitch, the art director and the third member of the triumvirate, was, after Carmel, the most decisive voice in how the magazine looked. He loved the white spaces on the page and would even sacrifice a beautiful photograph to preserve them. He sat quietly in an alcove surrounded by stacks of clear white layout paper and photostats of different sizes of chosen photographs. Vreeland remembered that "it was very hard indeed for him to put in even the most beautiful blow-up of a Cartier-Bresson photo to spoil the immaculate clarity and whiteness—and then have to add beautifully selected typography." The look of the magazine became more fluid, with a spatial continuity between text and illustration that Snow and Alexey Brodovitch initiated together and that continues to dominate today's layouts.

Richard Avedon credits Diana with starting "a totally new profession." Before her, the fashion editor was a society lady putting hats on other society ladies. The young photographer who started at *Bazaar* in the mid-forties saw how Vreeland's method began with "the amazing gallery of her imagination," an imagination with no geographical or historical limits. Her references were always to the past, to the sphinxes, the early nineteenth century, or to the attenuation of an Utamaro throat. "She wasn't interested in photographers' imaginations," Avedon said,

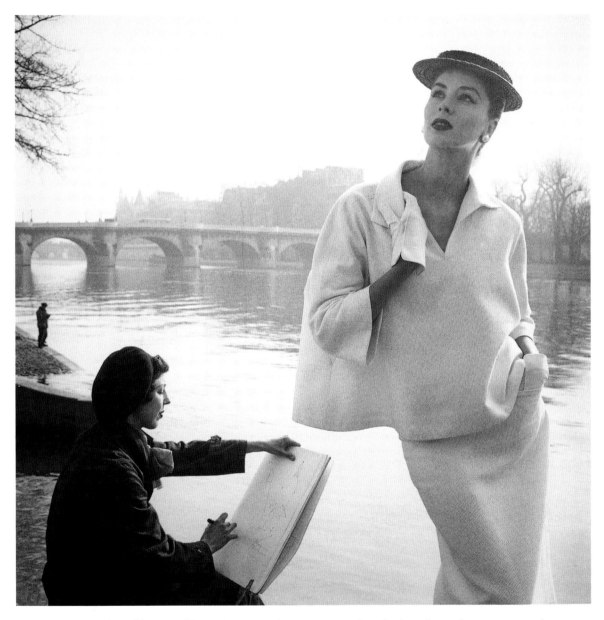

"not Louise Dahl-Wolfe's, not Huene's, certainly not mine." It wasn't she who followed fashion, fashion followed her. "I know what they're going to wear before they wear it, what they're going to eat before they eat it," said Diana. "I know where they're going before it's even there!" And her decisions, whether to feature accessories, an emerging designer's work, or a new take on an old look, were eagerly adopted by the readers.

One of the basic aspects of human nature that Vreeland understood was the individual's desire to stay one step ahead of current fashion and constantly to be exposed to the new and beautiful. She felt it was her job to create a standard of

Dior launched his full-skirted collection just after the war. Coco Chanel waited until 1954 to reopen her business. Bazaar had always championed her work and by 1915 stated that "the woman who hasn't at least one Chanel is hopelessly out of fashion." During the First World War years, Chanel had designed loose-fitting styles with sashes draped around the hips, perfect for doing war work. She closed her business during the Second World War and was rumored to have taken a Nazi lover. She made her successful comeback at the age of seventy-one. Diana, who had known her since the 1930s, said Coco was "the most interesting person I've ever met."

beauty beyond the wildest dreams of her public. Twenty-five years later, when she was the transforming spirit of the Metropolitan Museum's Costume Institute, Diana's attitude was the same. The lights were turned up and the music turned down at her Russian costume show because of complaints. She retorted: "You don't go change something because somebody asks you to. That's the trouble with this country, they want to give the public what it wants. Well, the public wants what it can't get and it's up to the museum to teach them what to want."

When Avedon first met Diana, he was standing at the doorway of her long, narrow office, at the far end of which was a model in a stiff wedding dress. "Mrs. Vreeland never looked at me. She cried, 'Baron!' Beside her stood Baron de Gunzburg, the only male fashion editor in the world, a pincushion hanging like a Croix de Guerre from a ribbon at his throat, and she cried, 'Baron! Baron, the pins!' She took one pin and walked swinging her hips down the narrow office to the end. She stuck the pin not only into the dress, but into the girl, who let out a little scream. Diana returned to her desk, looked up at me for the first time and said, 'Aberdeen, Aberdeen, doesn't it make you want to cry?' Well, it did. I went back to Carmel Snow and said, 'I can't work with that woman. She calls me Aberdeen.' And Carmel Snow said, 'You're *going* to work with her.' And I did, to my enormous benefit, for almost forty years."

Diana Vreeland's method began with her forming a picture in her mind of an ideal page, showing how the clothes should look and how the model should stand. Then she would articulate what she wanted. Adrian Allen remembered how "her bizarre analogies just knocked your socks off." The editors would be in her office, "and she would come out with a quip like 'Pink is the navy blue of India,' and you knew who the photographer should be, what the layout should look like,

everything. She would talk, in the most marvelous way, why that hat—not that she had to explain. Before we would assign the photographer or the artist, she wanted us to understand the *essence* of it. . . ." She could combine things that you might not even combine yourself, but in a way that was just right. In fact, her outrageousness sometimes made it work. . . ." The more baroque subjects (like lamé or an outfit that used a turban) would be given to Louise Dahl-Wolfe to photograph; or "if it was something that moved well and had a kind of joie de vivre and would look well on Suzy Parker dancing down the Champs-Elysées, you'd give it to Avedon."

Diana would also project the mood for the sitting and inspire the photographers to see fashion the way she saw it. When the photographer Lillian Bassman came to Vreeland's office to learn about the clothing, Vreeland would move in front of the full-length mirror, posing and making gestures and throwing the clothes around on her shoulders. When they shot kimono dresses, she "did gestures to show me that in Japan the knees went forward and the body went forward. She would drape things around her and give you a sense of how the outfit was to be worn, and how you should feel about it"—and how Bassman should photograph it.

Implementing her visions sometimes produced conflict. Vreeland occasionally forgot that *Harper's Bazaar* was first and foremost a business, and that the editors had to deal with the advertisers and the dilemmas that that relationship produced. The merchandising department worked closely with the editors. According to Adrian Allen, Mary Phillips, then executive editor of *Bazaar*, was the liaison between the two departments. She knew how many ads Ben Zuckerman was taking, and it was understood that if he took ten ads he would get a color spread. The best manufacturers advertised the most, so it wasn't usually a problem. But there was one

advertiser, Lilli Ann, whose clothes Vreeland could not stand, but who always took the inside front cover, which was the most expensive placement. The agreement was that because they took this ad they would have to be on the cover once a year. "So Mrs. Vreeland would go down and design a suit to go on our cover and it would be a Mainbocher knock-off because that's all she wore, Mainbocher. So once a year, you'd see this Mainbocher suit credited to the dreadful manufacturer. We always hated having to do that, but that was the agreement."

As Ann Cogswell Murphy (now Ann Vose), sportswear editor in the 1950s, remembers: "Every month the editors would be given something called 'The Must List,' the names of advertisers whose clothes had to go into the magazine." Vose would go to Seventh Avenue to find clothes to be photographed from these advertisers. "We were told not to pick out something that we might wear but something that made a splash, that made a statement on the page, an exaggeration. Mrs. Vreeland never liked anything. 'That's perfectly ghastly,' she would say. She'd tell you to take it back and put a purple bow on it instead of a red bow. She'd tell me to ask a sweater designer to make a sweater with orange, and yellow and green and blue. I'd tell him and he would roll his eyes up to the heavens." Designers created special garments to be photographed, on her instructions, but they never saw the light of day. "They were never sold," Vose said.

The Must List functioned discreetly, however, with minimum effect on editorial content and without overt intervention from the advertising side. As Richard Deems, *Bazaar*'s business manager, explained, "If an advertising manager for the pages of *Vogue* or *Harper's Bazaar* or *Elle* or *W* walked into an editor's office and said you have got to put a page, an editorial page, in your next issue for this advertiser, the editor would

throw him out." He also affirmed the traditional position that there is a separation between the two, as that between church and state. "The Must List story was overblown. You would never get any self-respecting editor to put up with that."

The editorial work took place in the very sympathetic atmosphere of the Hearst offices at 572 Madison Avenue at Fifty-sixth Street. Before Diana came in at about 10:30 or 11:00, her loyal staff could relax somewhat (although some, like Allen, were called daily to discuss business at 7:30 in the morning). If anyone was talking or gossiping, they would be warned when the elevator man signaled her arrival by banging on the cables. That meant "She's coming," and everybody would "zoom to her typewriter."

As Dorothy Benjamin (now Dottie Schott-Henry) remembered, "Mrs. Vreeland might announce her mood to everyone on her entrance by screaming when she got off the elevator, 'I have a mee-graine!' And I would correct her, 'It's a my-graine!' But what it really meant was, Don't even think of coming near me. Then she would issue commands all the way down the hall, and go into her office and close the door."

Diana inspired a number of responses, including respect, love and terror. Sometimes her assistants went home in tears, but they were back in the morning. She addressed her helpers as "Girl," and made all kinds of demands on them, including asking some to model the clothes for her. Lillian Bassman was able to establish a rapport beyond that of the typical editor and photographer. One day Bassman walked into the office. Diana looked at her and said, " 'Do you stand on your head?' And I said, 'No. Why?' and she replied, 'Well, my *dear*, if you don't stand on your head for a half an hour every day, you will never have an orgasm.' " However bizarre her advice, Bassman enjoyed going by at the end of the day to sit and listen: "It was like going to the theater."

As she was able to inspire her editors and photographers to produce artistic sittings, she also made the most of her models. She worked them hard, but she also mothered them and helped them to see themselves as more beautiful. She often called the Ford Model Agency and, as Eileen Ford remembered, would issue an order like, "What I'm looking for is *hair*, long, *lustrous* hair."

Dottie remembers the appearance of "a young sweet girl with lots of hair" in Mrs. Vreeland's office. Mrs. Vreeland said to her, "'How would you feel about being on the cover?' This girl replied, 'Oh, Mrs. Vreeland, I'd love to be.' Vreeland responded, 'Well, we'll have to cut your hair off.' And the girl went pale, but Vreeland insisted. 'No, you'll definitely have to cut it off.' And the girl said, 'I'll have to call Mrs. Ford. I don't know if I want to cut my hair.' She called Mrs. Ford, who said, 'Well, okay, if Mrs. Vreeland promises you the cover.' So she came back and reported, 'Miss Eileen says it's all right and so, fine.' Vreeland then opened the desk drawer and pulled out a pair of long scissors. Then she picked up this mane of hair and went clomp, clomp, clomp. And then she said, 'There, that's the Italian cut. You'll do very well now.'"

One of her favorite models, the tall, willowy Carmen dell'Orefice, is still modeling today. When she began her career at fourteen, she had the innocence of a teenager and the look of a sophisticated woman. Carmen lived with her mother in a cold-water walk-up flat without a telephone, and, like many teenagers, never heard from her mother what she wanted to hear. Vreeland helped her to feel grown-up, giving her the responsibilities of going to a location and living up to the challenges of her job. "She'd sit me in front of the mirror and say to me, 'I'd like to see you get two inches more of your neck. Stretch your neck for me and come back next week and we'll see how your neck has grown.'"

Mrs. Vreeland told Carmen she had "chocolate curls" and must never wear anything but chiffon. Wanting to please her mentor, the girl tried to make dresses of chiffon for herself but found it almost impossible; the material was so fragile that she had to put tissues on the dress parts to hold them together. Louise Dahl-Wolfe said she couldn't photograph Carmen because she didn't believe in child labor.

Soon after being hired, Carmen went to the collections in Paris, first with Gleb Derujinsky and then the next year with Avedon. "It was a big production in the late forties to photograph clothes on location with no strobe lighting, but with huge two-thousand watt lights, generators on trucks, and lots of umbrellas in case it rained." They brought along sewing machines to redo seams in the clothes, as the American bone structure is often larger than the French, as Carmen's was. Mrs. Vreeland called her large shoulders "so Egyptian," a reaction that stopped Richard Avedon "from seeing me as a football player." Diana would point to Carmen's photograph on her bulletin board and say, "I want you to look at this perfect woman in this perfect picture." Carmen was buoyed up by her attention and felt happy to be working with someone who was so original.

Another famous model of the time, Dorian Leigh, began her career at twenty-four. Lovely, with blue eyes and high cheekbones, she went to the Harry Conover Agency at the urging of a co-worker at her wartime engineering job. Conover sent her right over to Diana at *Harper's Bazaar*. After their first meeting, Diana insisted that Dorian return the next day for a scheduled picture, and abruptly added, "Okay, but don't do anything to your eyebrows." Dorian recalls, "I thought she was crazy. Who does anything to their eyebrows?"

Like most people after their first encounter with Diana, Dorian was not quite sure what to expect next. But her uncertainty quickly turned

to trust and respect. It was her good fortune to look young enough at twenty-four to replace a sixteen-year-old on the cover of the September 1944 issue. In two days she had made herself into a cover girl—a feat that took most models two or three years.

Dorian soon learned that Diana laid down rules as the law or else, while she herself followed the rules only if they suited her whim. One day Dorian returned from a shoe sale at Bergdorf Goodman where she saw the most marvelous red shoes. When she told Vreeland about them, the editor admonished her, "No lady wears red shoes." True to her complicated nature, Vreeland showed up one day wearing red T-straps.

Although Vreeland admitted to spending hours on dressing, putting on jewelry, making sure the rouge on her cheeks, elbows and earlobes was perfect, her fingernails long and red, and every hair in the snood, when asked what was the secret to looking great, she answered earnestly, "Simplicity."

Another model whom Vreeland got an early cover for was Suzy Parker, Dorian's younger sister, who began modeling at the age of fourteen. When her sister took her to see Eileen Ford, Suzy was told she was too tall: Five feet nine was considered gigantic for models in those days. Nevertheless, by the early fifties her photograph was everywhere. She became "the" model of the decade, with her angular and graceful form, her full hair framing the great bone structure of her face.

Even at Southampton, the very chic summer place, Diana and Reed stood out—Reed suntanned and wearing shorts and T-shirts, Diana in her stunning summer outfits. At far left, center, they are at a dance at the Meadow Club, and at far left, bottom, enter the Southampton Bathing Corporation, known to members as the Beach Club. Page 90: Diana talking to Frecky at his and Betty Breslauer's wedding in 1950.

Vreeland's reputation for flamboyance grew. The movie *Funny Face* (1956) spoofed her style. In it, a tall, skinny fashion editor (played by Kay Thompson) known for saying "Think pink" and "A magazine must have blood, brains, and puhzazz," takes an intellectual ingenue (Audrey Hepburn) to Paris and, with the help of photographer Dick Avery (Fred Astaire), makes her a star model. While the Hepburn character spends time in a café hobnobbing with intellectuals, the fashion people are seen frequenting the chic Parisian hotels. The worlds of intellect and fashion are contrasted, and the fashion world—usually seen as superficial—wins. Light and ephemeral as it was, the movie illustrated Vreeland's own conviction that fashion is an authentic art form, and is important because it makes life more beautiful. And the Vreeland-inspired character, the fashion editor, became an American icon.

In the 1950s, fashion magazines portrayed women as objects worthy of worship, who could present themselves through artifice as otherworldly and perfect. The ideal woman of the 1950s was aloof, glamorous and "elegant," a word that Vreeland understood completely but didn't like to see overused. The liberated working woman of the late sixties had yet to emerge in full bloom. Diana, however, always felt that women were "free" as long as they maintained power over their lives, even if they gained it through their men. Her use of society queens showed her respect for social credentials as well as for beauty.

The April 1956 issue of *Bazaar* featured a stunning Avedon portrait of the Vicomtesse Jacqueline de Ribes, then in her early twenties. She was having lunch with a friend in a fashionable restaurant, wearing her hair pulled back in a long plait, when "Mrs. Vreeland stared at me across the restaurant and asked who I was." The next morning she got a call from Vreeland: " 'Are

you the Vicomtesse de Ribes? I thought your looks were wonderful. Would you pose for Richard Avedon tomorrow?'" Jacqueline felt a little shy about it. "The meeting was at three o'clock, and I spent all morning at the hair-dresser and doing a special makeup. I didn't trust the way I looked, so I came with my hair all curly and all made-up and I even had false eyelashes on the side. I thought I was perfect. I walked into the studio. She looked at me and said, 'Jacqueline, *what* have you *done* to yourself?' 'I got ready for the picture.' 'But you *destroyed* yourself. I was struck by the way you looked two days ago.' Diana put a brush into water, and she brushed out all my curls, and we had to take off part of the makeup and everything had to be started again and we redid the plait." The result was Avedon's famous profile of a beautiful young woman with her large plait.

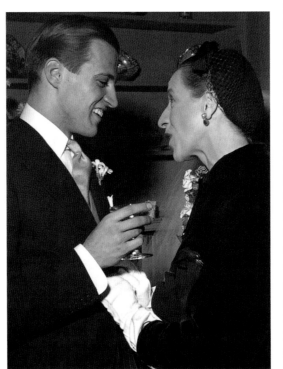

In the 1950s *Bazaar* established a new standard for beauty, with fresh faces of the new decades. In April 1954, Gloria Vander-bilt and Marella Agnelli appeared in portraits by Avedon. These portraits abstracted their features— Vanderbilt appears bathed in light, a stark study in black-and-white that emphasizes her almond-shaped eyes, her short dark hair and the curves of her lips, brows and shoulders. Agnelli's long neck and pointed chin and nose are also accen-tuated. Hers would become one of Diana's favorite photographs. The reader was told that beauty "is an ideal—difficult, distant, unfathomable."

Although the socialite C. Z. Guest initially resisted being photographed, she ultimately was pictured again and again in *Bazaar*. When first asked to model, the beautiful blonde replied that she couldn't because her husband and his family absolutely hated publicity of any sort. Diana looked her straight in the eye and said, "'But they'll never know, my dear.' Diana absolutely and completely seduced me right then and there. And I believed her, that's the amazing part." She needed more convincing in 1952, when she was pregnant with her son Alexander. Diana called her in Saratoga, saying she had to come down to be photographed. "And I said, 'Diana, I can't be photographed by any-body. I'm going to have the baby.'" Diana wouldn't be deterred by this small inconvenience. She replied, "'What's that got to do with it? From the waist up, dear.' So I made some excuse to Winston and came down to Louise's studio. I weighed 165 pounds. And it was the most beautiful pic-ture." C. Z. Guest's por-trait was typical of the many beautiful and glamorous photographs that resulted from the collaboration of Diana and Louise Dahl-Wolfe during their *Bazaar* years.

In 1952, *Harper's Bazaar* praised the col-lection of Hubert de Givenchy as he joined the ranks of first-rate Parisian designers. Along with Chanel, Dior and Balenciaga, he became a favorite of Carmel's and Diana's throughout the decade. Women's fashion again became mini-

malist, and in 1954, Coco Chanel reopened her business with the unveiling of her now famous suit. *Bazaar* covered the event with a piece by Jean Cocteau. The French press stated that her designs were a disaster: These nubbly fabrics and boxy jackets were *vieux jeu,* incompatible with Dior's New Look. By 1957, however, Chanel's two-pocketed, jewel-buttoned suits had been copied around the world and now were declared revolutionary by the same French press.

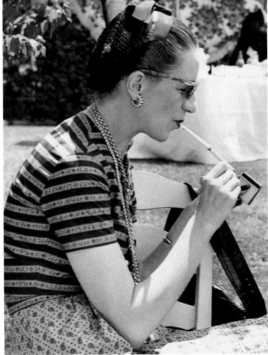

While Diana was lighting up the offices of *Harper's Bazaar* with her enthusiasm, her family life was becoming happier as well. After the war Reed came back to live in New York. The Moorgate Holdings job was over and now Reed worked with American friends in the investment business. As Diana's friend Pauline Potter told Ethel de Croisset, "He's come home to roost." Frecky and Timmy finished their military service—Tim in the U.S. Army paratroops and Frecky in the merchant marine—and by 1946 they were both at Yale.

Diana and Reed again enjoyed their colorful converted stable in Brewster. In the late forties Diana wrote to Cecil Beaton: "We are here in our house having a heavenly ten days. Boys have left Yale until September and will spend six weeks working in the West on a cattle farm and in the meantime painting gutters and barn and generally

throwing their weight." She found the house, which had been closed for a long time, "a dream—many things here grown and we are surrounded by mad chirping of brilliant birds and croaking of frogs and we sun ourselves and fuss here and there all day. It's all exquisite joy and we are completely happy." In 1947, Reed made the first entries in his garden notebook since 1942, and the two of them worked in the garden again.

Later in the summer they went to Southampton. Diana loved their weekends there. As she told Cecil Beaton, "You know how much we crave the sun, salt, exercise—builds us for the entire winter." Although Diana saw Southampton as the perfect place for maintaining her health and exercise regimen, there were both positive and negative aspects to the fashionable resort—constant parties, dances at the Meadow Club, flirtations and romances. Even though Reed had returned from Canada, he was still rumored to have affairs. One such disturbing situation was an infatuation with Cordelia Robertson, which was deeply troubling to Diana. While she never liked to express sadness, jealousy or anger, she let out her annoyance with Reed one day in Southampton after he had returned from playing mixed doubles with Cordelia: She picked up an object from her bedside table and hurled it at her husband.

At a time when women dressed in bathing suits with skirts, Diana startled everyone at the Beach Club by wearing a beige wool jersey one-

piece bathing suit and a charcoal gray "play-suit," her hair pulled back in the black snood. She paraded onto the sand from the entrance, swinging her legs at the hip, Reed slightly behind her. Teenage girls would giggle and gawk and go home to practice imitations of her. Cathy Di Montezemolo remembers once seeing Diana and Reed and suggesting that they walk, not a long distance, from the Meadow Club to the Beach Club. Diana replied, "Oh, yes, I never take the car, because I'm wearing linen, and to sit in the car all the linen would get creased."

Although Diana moved in the crowd of old society friends who knew her well, she could always be counted on for a surprise performance. C. Z. Guest remembered Diana and Reed coming to a party for the World Wildlife Association in New York, her husband's favorite cause. Charles Lindbergh, a recluse since the kidnapping of his baby years before, was there as well. While C. Z. was talking to Lindbergh—"the most handsome, attractive and charming man you could imagine, and very tall, straight as an arrow"—Diana sauntered up and greeted her. "I said, 'Diana, do you know General Charles Lindbergh?' I thought she was going to faint. And then you know what she said to him? She said, 'You know, when you flew in the *Spirit of St. Louis* to France, you flew over my property in Brewster.' I thought I was going to *die*. Of course, I'm sure he didn't, but that's what she said to him. I thought, 'Diana, you never miss a beat.'"

One party that brought together Diana and Reed's New York friends and stars and socialites was the New Year's Eve party given by the beautifully dressed Kitty Miller and her theatrical producer husband, Gilbert Miller. The celebration began in their big, art-filled apartment at 550 Park Avenue at eight o'clock with dinner for fifty people. By a quarter of twelve, the dining room was again transformed for another hundred guests. Little tables lined the sides of the room,

and on a large table was a buffet prepared by Le Pavillon restaurant. The same people showed up year after year—Salvador Dalí, Audrey Hepburn, Bill and Ann Woodward, Nin and John Barry Ryan, plus people from the theater, music, art and publishing worlds and, of course, Diana and Reed Vreeland.

By 1955, the Vreelands' friends were dining with Reed and Diana at their new apartment in the same building. As Johnny Schlumberger told Diana, "I describe your vivid blood red apartment to whoever will listen and I do so with enthusiasm." Billy Baldwin helped transform a walled-off part of a larger flat into an enchanting hideaway. Diana herself announced: "I want this place to look like a garden, but a garden in hell. I want everything that can be to be covered in a lovely cotton material. Cotton! Cotton! Cotton!" The perfect material, a scarlet chintz covered with brilliant Persian flowers, was found in John Fowler's shop in London. In order to create an illusion of spaciousness, a red carpet was spread over the floors of the living room and hallway, and the ceiling was covered with an off-white material.

Taking a run-of-the-mill object and making it glamorous and exotic had always been her specialty. She told Baldwin to make the spaces fit the way she lived—where she wanted to sit, where the light had to hit her, where she must

Diana and Reed with Slim Hayward, then wife of theatrical producer Leland Hayward, at Kitty Miller's New Year's Eve Party. Overleaf: In addition to the Vreelands (seated at right), the guests included Elsa Maxwell (seated at left) and Fleur Cowles (standing in black dress). Gilbert and Kitty Miller entertained their society and celebrity friends yearly on New Year's Eve and it was the lavish party that everyone of that set wanted to attend. Guests could behold her marvelous paintings, including Goya's Red Boy. Although left to the Metropolitan Museum by her father, Jules Bache, it hung in Kitty's apartment when she was in New York, in between stays at her houses in London and Mallorca.

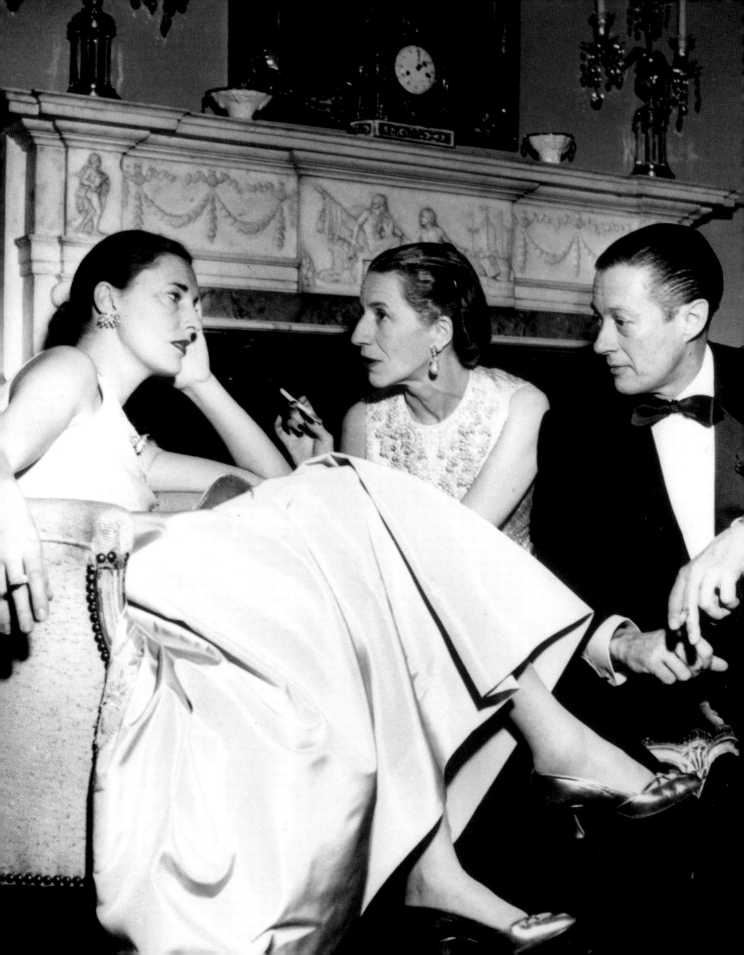

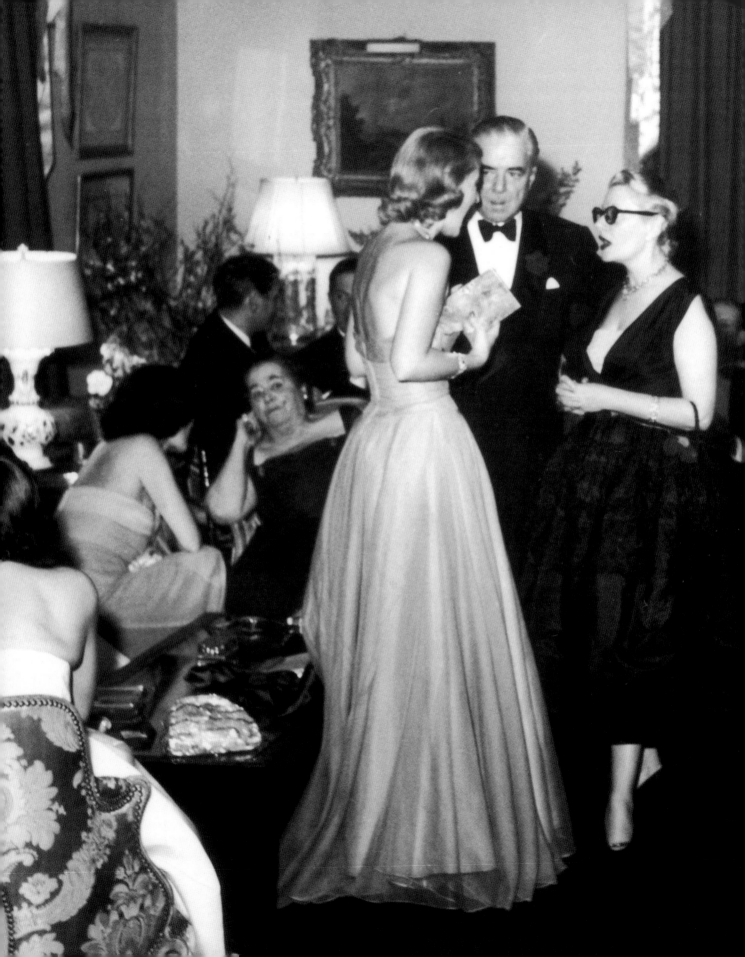

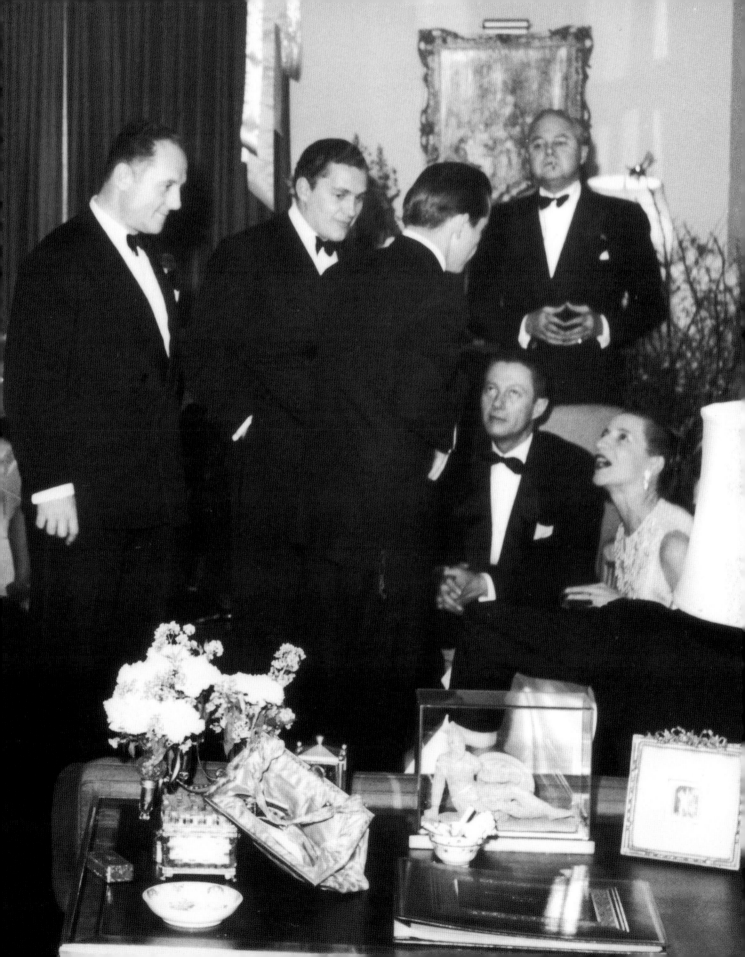

be quiet. She wasn't interested in valuable things—"high price, high style, great French furniture." It was color that shaped her decorating aesthetic in the eccentric and the personal. As she said later, "Red is the great clarifier—bright and revealing. It makes all other colors beautiful. I can't imagine becoming bored with red—it would be like becoming bored with the person you love."

Diana and Reed lunched with Billy Baldwin on Saturdays to discuss the designs. At four they would still be in the empty restaurant exchanging ideas. Reed thought to eliminate the hall and make the living room and dining room into an L-shaped space. This change created a spacious feeling that made gatherings easy and pleasant, as guests moved from cocktails to dinner to after-dinner conversation within the bright interior.

At one end of the room were banquettes, and at the other end was Diana's sofa—where she sat enthroned. "Don't you forget, Billy B, that I once heard Pauline say to you and me that there are only two things of any real importance in a woman's life, and those are her bed and her sofa." Some people might feel cramped in a place so filled with objects, but not Diana. "I know you can barely get around the chairs, but when I am in a room, I want to sit close to somebody. I never do really feel crowded." As Tim Vreeland describes it, "Every surface was covered with objects, so that you always had to put your drink on the floor." Many of her collections came from 400 Park Avenue, as 550 was an extension of its predecessor—"the same Venetian blackamoors, nacre shells, powder horn collection, silver sacred Indian fish, brightly enameled doors, lacquer screens and banquettes." In the living room was a mirror as wide as the sofa, reflecting the full depth of the room. On the walls hung framed watercolors by Eugene Berman, Cecil Beaton and Leonor Fini.

For the Vreelands' famous dinner parties, their terrific Spanish cook, Sen, could make anything for her guests, usually six or eight people, which was a good number for conversation. The food was marvelous "plain food," says Diana's friend and *Bazaar* editor D. D. Ryan. Favorite dishes were shepherd's pie or chicken hash, preceded by oyster stew or consommé madrilène with Melba toast. And for dessert, Greek oranges, madeleines and chocolate pots-de-crème. Years later Sir Hardy Amies recalled Diana's "wonderful light lunch dish"—a cheese soufflé.

Sen worked for the Vreelands from the mid-forties until Reed's death in 1966. Diana and Reed planned the menus, and according to Sen, Reed was very particular and would consult his library for a particular recipe. When she disagreed with his suggestion, a pleasant argument would ensue, and Diana would come in and ask them who would give in first. One time Reed came to the kitchen with a painting, saying that he wanted a dish like the picture, and Sen said, "Well, I am the cook, not Picasso," but she agreed to try. It was a fish pudding that came out beautifully. Reed liked to see things well done. One time when a waiter cleaned the ashtrays in front of guests, Reed fired him. He sent another waiter home to change into a spotless uniform when the one he was wearing wasn't immaculate. Once, a waiter came in to work drunk and was sent home by Sen, who told him to write a letter of apology. When Diana saw the letter, she raised her eyebrow and took him back.

On June 13, 1956, Cole Porter came for dinner and wrote to thank Diana the next morning on his way back to Hollywood. "As usual, it was perfection, and I shall never forget that menu." Gilbert Miller loved the food at the Vreelands' and tried to hire Sen away after Reed died. Sen enjoyed cooking for the Windsors and Twiggy and Grace Kelly (to whom Diana gave unwelcome advice on how to dress). Greta Garbo and

Lauren Bacall came often, as did Henry Fonda and Humphrey Bogart, although according to Sen the latter didn't say much.

Friends remembered how the atmosphere of the apartment both soothed and excited guests. In later years Diana might ask you for eight o'clock, but then keep you waiting for a long time. A young Englishman, Hugo Vickers, described how the maid would bring the message that you should help yourself to a drink. "There would be incense burning and you'd have time to see a Christian Bérard across the room. 'Can I get up there and have a look at it?' Yes, you always had time. By the time she arrived you were always completely *in* the atmosphere. The street had gone."

To friends, the apartment's ambience was delightful, but to the twenty-one-year-old ingenue and *Vogue* assistant Ali MacGraw, it represented a world filled with enticing possibilities. In 1960, Ali, a recent Wellesley graduate, was Diana's assistant. She was asked by her boss to pick up her portfolio every morning at nine and to take it to the Hearst offices at Fifty-sixth Street and Madison Avenue. The scent of Rigaud candles, good oatmeal and bath soap greeted her as she waited in the foyer: "I would drink in the sight of things, the Persian miniatures, the photographs of everyone I had ever heard of, the Scottish snuff horns." Ali, whose parents were academics and lived modestly, realized she "had everything to learn." Her daily glimpse into the apartment suggested a life filled with glamour, famous personalities and adventures beyond her wildest dreams.

There were no rooms at 550 for Timmy and Frecky, as the makeup of the Vreeland family had changed when each of Diana's children, including her niece Emi-Lu, had gone on to his and her grown-up lives. In 1950, Frecky had married Betty Breslauer and moved into the Brewster house. By February 1951, he began working for the CIA and had moved to Washington, and in 1952, Frecky and Betty said farewell to the United States and moved to Europe for his new appointment as vice consul with the U.S. Foreign Service. His absence became another reason that Diana's heart was on the other side of the Atlantic. Timmy was also in Europe, as he spent his junior year studying abroad in Paris, from 1948 to 1949, and later, while at the Yale School of Architecture, he spent a year in Rome.

While abroad, Timmy met his mother's artist friends, including luminaries like Bébé Bérard in Paris, and friends and acquaintances from the Vreelands' London days—all of whom fondly remembered Diana and Reed. In 1948, he visited several English country houses that he found "all very stately and beautiful," among them Lady Astor's Cliveden—"all wood paneling, large stone fireplaces and suits of armor." Timmy took in the charged energy of Paris and was thrilled with the experience. There he did a lot of soul-searching and came of age, learning to be *"content dans ma peau."*

Emi-Lu returned to England after the war and spent a year in school in Switzerland. Later, she came to New York and took a job at Lord & Taylor. Shortly after she returned home to England in 1949, she met and fell in love with Hugh Astor, ten years older than she, a foreign correspondent for the *Times*, which was published by his father, the Honorable J. J. Astor. *Bazaar* featured a full-page photograph of a young and radiant Emi-Lu announcing her November 1950 wedding. In several long letters to Diana in 1949, Emi-Lu excitedly described her courtship with Hugh. Emi-Lu was nineteen when they met at a cocktail party in London. She admired him from afar and confessed to Diana how she, a naïve ingenue, felt lucky to have fallen in love with this dashing man from an important family. "It just so happens to be my good fortune that the man I fell desperately in love with on his yacht a couple of

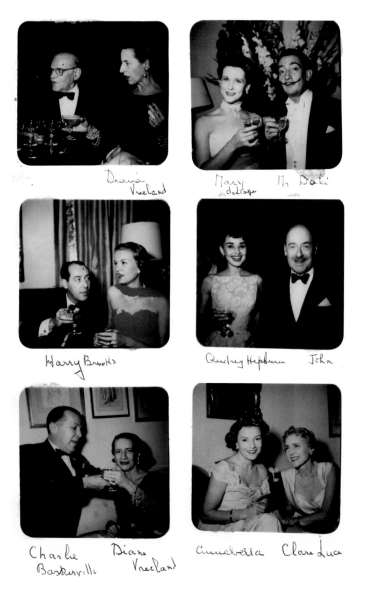

Diana
Vreeland

Mary
de Droze

Mr Dalí

Harry Brooks

Audrey Hepburn John

Charlie
Baskerville

Diana
Vreeland

Annabella Clare Luce

The Millers entertained the talented and the famous, including Diana, Salvador Dalí (top right), Harry Brooks (left center), Audrey Hepburn (right center) and Clare Boothe Luce (bottom right).

months ago just happens to have all this, too." Looking back in 1995, she said, "It was the dress Diana had given me that got him to fall in love with me . . . I'm not joking."

In her role as wise woman of the world, Diana was an anchor and source of good advice for Emi-Lu on how to transform herself from an "ordinary girl at 19 having quite a 'good time,' but thoroughly discontented, lacking any real interests, and having nothing much in mind," into a successful Astor wife. A few months before the wedding, Emi-Lu wrote that she had "so much to do and I must make a success of it. We must be by far the most attractive Astor couple—and you do realize, don't you, that by four years I am the youngest Astor wife! . . . I need so much advice. Be so stern and put me on the right track, etc. You are so wise and I need you now more than I ever have."

Now that Frecky was happily married and had children, Diana took a great interest in his expatriate family. Betty was a very talented and beautiful young woman. She was one of the few Jewish girls that Frecky and his friends palled around with, a fact that Diana mentioned to Frecky when he told her they wanted to get married. "She mentioned it to me once and I said, 'I know,'" and she never brought it up again. Betty was creative and imaginative, and later wrote articles and poetry, and designed costumes for a movie. She was one of many young women drawn to Diana, responding to her mother-in-law's warmth and vitality. They had two little boys: Nicholas, first called Piccolo or Pikki, was born in May 1954; then Alexander, in July 1955. She reported to her mother-in-law on fashion news, told her of shopping trips to Parisian couture houses, and sought advice on her own wardrobe. Betty's upbeat letters give the impression of a close and affectionate family group—the attractive and unconventional father, the young mother who was not only interested in the latest trends

and events, but wanted her mother-in-law to know of her children's charming exploits.

Diana and Reed visited the family in France and Switzerland in 1955. She wrote to Cecil Beaton: "I flew on May 20 for one week & was met by Reed who I hadn't seen for 3 weeks as he'd been in Amsterdam & Paris, Germany. Frecky who I had not seen in three years and my darling angel pie of 1 yr. who I had never seen— We had a heavenly week all together." She highly approved of their "lovely life . . . and our baby is just too sweet for any possible words as he is frightfully absorbed and speaks a Chinese patois all to himself. Very golden and unlike any known Vreeland who are black on my side— We spent all our time up in Haute Savoie—eating like Kings—Among the lovely Valleys (& all in the month of May). Glorious old Mont Blanc gleaming and grand like an old Mother Superior—the culture of the Land of France the espalier the fruit trees and the meadows of wildflowers—the peace and green is unbelievably touching."

As Diana was full of childhood enthusiasm and innocence herself, being a grandmother came naturally and the children always loved her. Alexander and Nicky watched with fascination as she sat in front of the mirror making up her face wearing a camisole like a little shift reaching to the knees. After hours of painting herself, she would finally "step into a dress, step into a pair of shoes, pick up a handbag and was out the door in thirty seconds." It was amazing to Alexander that it took four hours to get to that moment. The boys were fascinated with the care of her clothes and the daily reorganization of her pocketbook by the maid. They marveled at her eleven pieces of luggage.

Although Diana did not spend as much time in Europe as she would have liked, and couldn't see her friends there, the younger Vreelands often did. In November Betty and Frecky saw Givenchy and Marie-Louise Bousquet in Paris,

and Betty said about the two of them: "She is such a life giver, and he is so charming, so *bien élevé*—We both adored him." Bousquet, the French editor in Paris for *Harper's Bazaar*, maintained a famous salon in her small apartment on the Place de Palais Bourbon. As the composer Ned Rorem noted: "No American who knew Paris did not know Marie-Louise: the very soil and fluid of two cultures, in her sandwiches and daiquiris, merged every Thursday at the sun-filled flat." Americans would stop by from time to time to mix with talented French artists, writers and fashion personalities.

In March 1958, Betty was in Paris again, shopping. She wrote that she finally saw a Balenciaga collection, a lovely one, simple and classic, and these couture creations felt "like no other clothes I have ever had on my back. Like a cloud. They have no weight." They were different from clothes by Dior, which "are constructed as if of iron—marvelous" in a different way. She also got two suits from Givenchy, who "has one so smart idea for making a skirt. The narrow waistband is closed by large hooks, the hooks which close men's trousers. A large wide hook on one side (the width of the waistband), and the eye is on the other side. This makes the two sides close smooth with no cross over." She now had "a closet full of such beauty and elegance."

Later that same month, Tim Vreeland became engaged to Jean Partridge, a young woman from a southern family whom he met in Philadelphia. Frecky sent his parents a telegram saying, "Just heard Tim's happy news as you know we're very enthusiastic. Please be our proxies in warmly welcoming Jean into family. Love BetFreck." When Tim told his mother of their engagement, she burst into tears. Although Tim said she would have cried about any choice, perhaps it was the fact that Jean, a highly intelligent, nice woman, did not have the exalted social or financial credentials Diana would have preferred. After their wedding

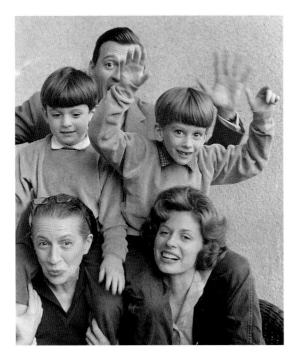

Above: Frecky, Alexander (left), *Nicky, Diana and Betty. Diana adored her grandsons, whom Timmy described thusly: Nicky was "very good looking, very bright and lively, often mischievous, but anxious to please and loves company." Alexander had "a great mop of brown hair and the biggest smile, the image of Frecky at that age." The boys learned that actions like jumping on Diana's banquettes only amused her. They loved their kind grandfather and played with the objects on his key chain: the whistle for a taxi and a swizzle stick to stir the bubbles out of champagne.*

they settled in Philadelphia, where Tim had been working with architect Louis Kahn and teaching at the University of Pennsylvania. One year later, on July 15, 1961, their daughter Daisy was born, and almost exactly a year thereafter, Phoebe was born on July 24, 1962.

At *Harper's Bazaar*, 1958 was the last year of Alexey Brodovitch and Carmel Snow. Since 1957, Brodovitch, whose drinking problem was well known to his assistant and others at the magazine, had come into New York from East Hampton less frequently. Adrian Allen regularly drove the layouts out to him for approval (although he sometimes only glanced at them). As Carmel Snow's reign was coming to an end, Vreeland was keen to get her job, but the Hearst executives had other ideas. Allen said later that Carmel warned *Bazaar*'s higher-ups that Vreeland "was a brilliant fashion editor who should never, ever, be editor-in-chief of a magazine." In late 1957, they chose to bring in Nancy White, Carmel Snow's niece. Richard Deems explained later: "It was a difficult choice. We felt that Nancy, who was the fashion editor of *Good Housekeeping* at the time and who had been with [Hearst] for between twenty and twenty-five years, was better equipped to take a whole magazine." Choosing Nancy White over Vreeland was "a tough decision. We didn't feel that Diana could do it or that she'd be happy doing it."

When Diana learned of Nancy's appointment, she said, "We needed an artist and they sent us a housepainter." As expected, she was not happy about the changes at *Bazaar*. She wrote to Cecil Beaton on June 27, 1958: "N. White leaving for Italy and France 15th of July and she is *mentally* off in a few days. . . . Do not please as an old friend hold against me the impotence that appears in my face when we discuss *H.B.*—I am

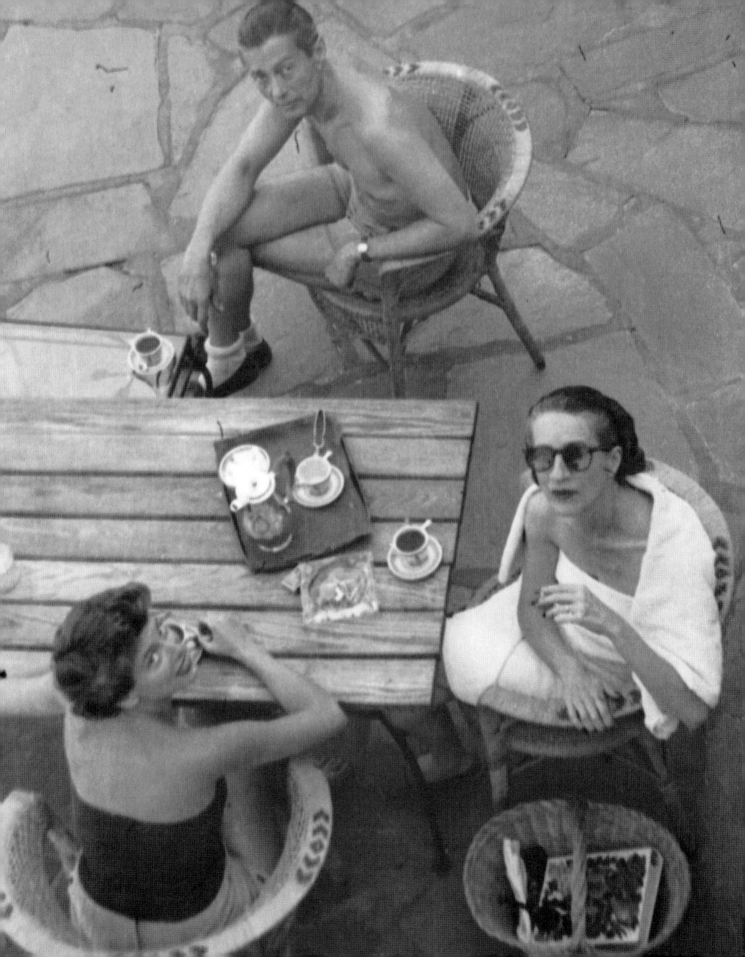

not good at being dishonest so I appear more helpless than I actually am."

But by September she was feeling better about the magazine: "I am slowly, I believe, coming out of my shock period and as no one has so far interfered with the clothes which is my business. I should be satisfied and I've made up my mind that the devil you know is better than the devil you do not and that there is bound to be something wrong with every job."

Things looked up with the appointment of Henry Wolf, a talented Austrian art director. He attracted photographers such as Melvin Sokolsky, whose original photographs Vreeland championed. As Sokolsky remembers, "Diana saved me on almost every shoot." Nancy White would find his pictures too arty, and Diana would say, "You know, Nancy, this shot has too much mustard but it's a fantastic picture and it would be a crime not to run it."

In the meantime, the world of fashion was about to be exposed to another major change. In January 1958, *Bazaar* readers were invited to "Enter the Jet Age." The current flying time across

Brassaï photographed the Vreelands traveling to Brazil by air. The plane broke through a hanging mist to encounter "convoluted mountains, sheathed in the intensest green." The newspaper O Globo ran a headline proclaiming that Diana had a "glamour and electricity that none could compare with." In Rio she and Reed met with local personalities as well as acquaintances from home.

the Atlantic was about eighteen hours with a stop in Iceland or Newfoundland for refueling, but now we were on "the threshold of a new era—the jet age—in which we will cross the United States from sea to shining sea in four hours, the Pacific in twelve." Models were featured in dresses comfortable for traveling "to Ceylon by air or by taxi to Main Street, U.S.A." Future flying times might shrink to "5 hrs. and 30 mins., from Boston to Shannon."

For the April 1960 issue, Diana and Reed journeyed to Brazil, where, as Diana put it, "the exotic is the everyday." From Rio de Janeiro to São Paulo to Salvador to Ouro Prêto, and finally to the new capital city, Brasília, she unearthed magical sights. Where on earth "but Brazil would one find a hummingbird farm" where "the birds remain uncaged, because of the jars of sugar and water set out for them?"

During this trip Diana began a lifelong romance with Brazil, soaking in and meditating on the beauty around her. Her concentration was interrupted only by a trip to Sasha's, a chic nightclub where she ran into Marlene Dietrich having supper, or by dinners at the finest French restaurants, or by the spectacle of a Afro-Brazilian ceremony called *macumba*, performed in an opening in the jungle under a full moon. She envisioned the Brazilian woman as spontaneous, full of spirit and humor, natural and above all meticulous about her appearance.

The jet plane was going to have a big influence on fashion reporting. It made such trips easy, and the fashion business truly international as photographs of clothes shown in Europe or other continents could quickly appear in the American press. But more important, it made it easier for shoots to be done in any country and for the clothes of these countries to make their way into mainstream fashion. And even more important for Diana, by 1962 there would be a change in her life that would enable her to soar as high as she wanted.

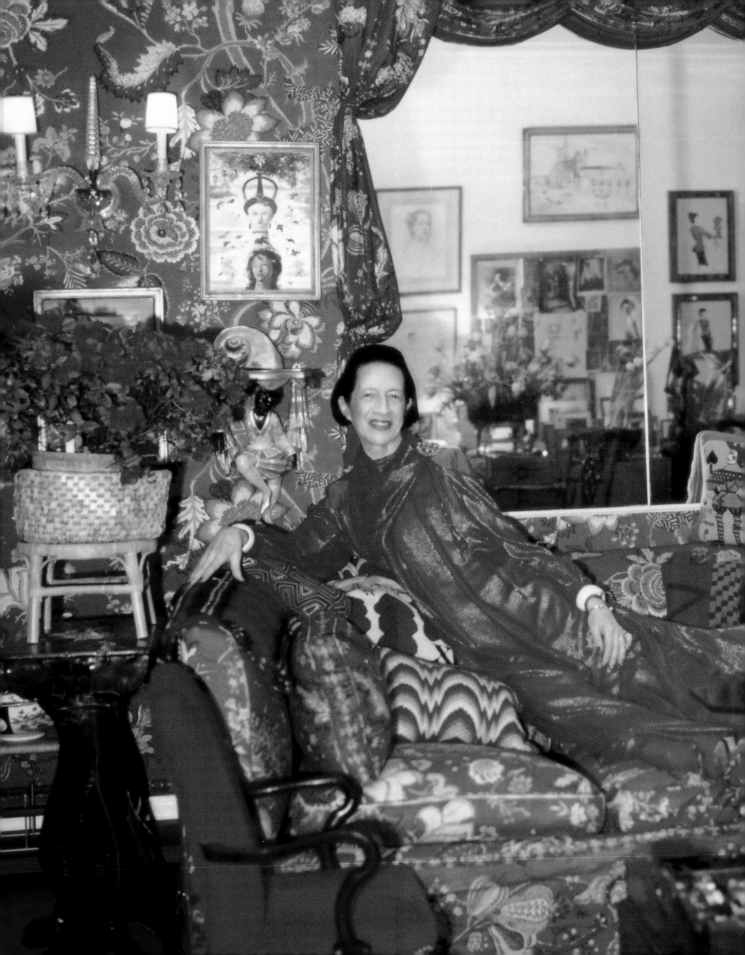

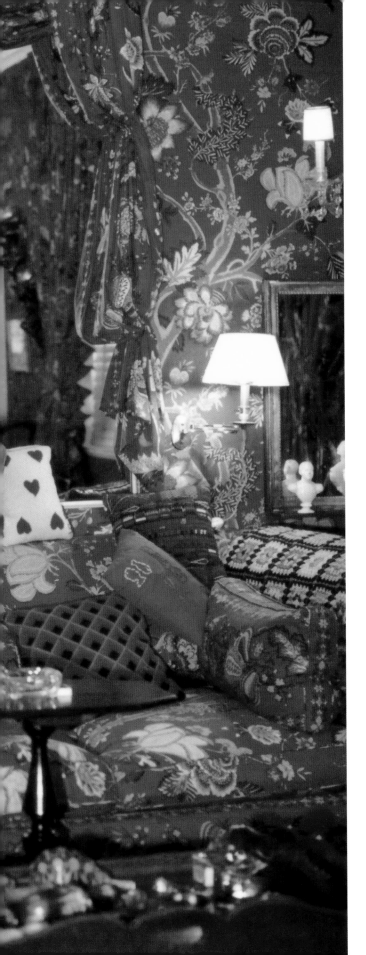

Diana's friend Horst P. Horst photographed her in her "Garden in Hell." As she said in DV, "All my life I've pursued the perfect red. I can never get painters to mix it for me. It's exactly as if I'd said, 'I want Rococo with a spot of Gothic in it and a bit of Buddhist Temple'—they have no idea what I'm talking about. About the best red is to copy the color of a child's cap in any Renaissance portrait."

Red was everywhere—on her walls, sofa, pillows, chairs; in the stripes on her banquettes. A large mirror reflected her desk, which exhibited her organizational principles. In addition to her big vases of flowers, photographs, drawings and watercolors, there was her "blotting paper, leather cups of sharpened yellow pencils, and legal-sized ruled pads." Note pads stamped DON'T FORGET in red ink, on which she distributed orders to the household, her family and her office, sat on the desk. As Tim described it, "Above this was a cork bulletin board full with brightly colored thumbtacks (she always requested these as Christmas presents when my brother and I were children), pinning an extraordinary assemblage of photographs, drawings and illustrated thank-you notes." The Drianz charcoal drawing of a woman leaping from Europe across the Atlantic Ocean always made Tim think of his mother.

Utility as well as atmosphere was important, as Diana told her decorator, Billy Baldwin. She had big crates for holding her treasures, photographs, scrapbooks and precious letters, crates that could be pushed around and made to fit the spaces. She also wanted places for flowers everywhere, growing plants as well as cut flowers, and room for ashtrays. In front of the sofa was a table that displayed silver powder horns; shells sat in a large shell-shaped container near her red door and over her banquettes on Venetian brackets (see overleaf).

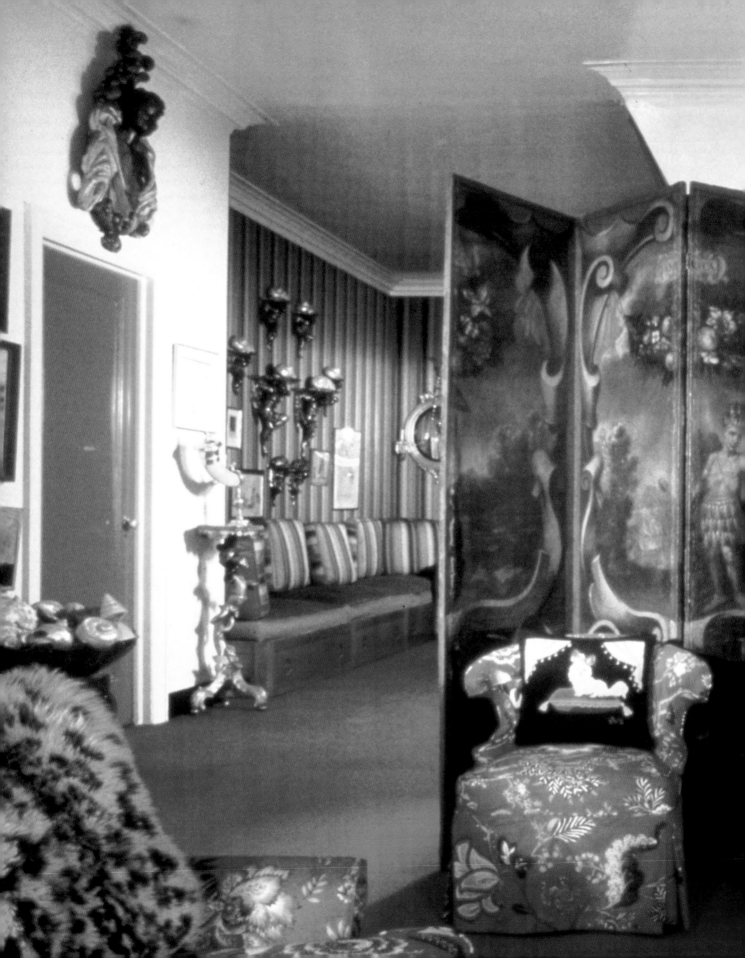

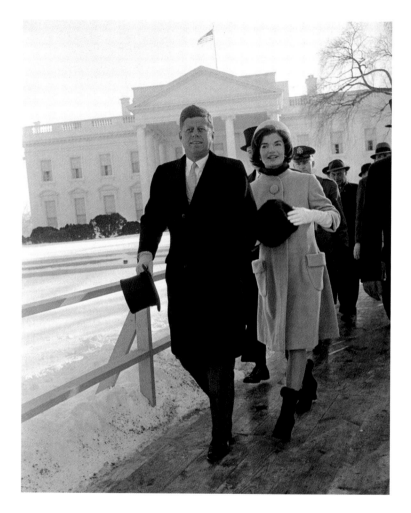

That day [of the inauguration], for the
first time in my life, I felt like an American. —DV

JACKIE AND DIANA

I n the summer of 1960 Diana Vreeland got a letter from a bedridden woman in Hyannis Port, Massachusetts, awaiting the birth of her baby:

Dear Mrs. Vreeland—
I write to you in hopes that in your busy life you could find a couple of minutes to help me solve an enormous problem, which is CLOTHES!

In the previous twenty-four years, Vreeland, in her editorial capacity, had helped millions of women with their fashion problems, but few problems would be as intriguing or challenging as this. The bedridden woman was Jacqueline Kennedy. And, as the letter explains, her clothing difficulties had just reached the level of national security. "The problem is this—I must start to buy American clothes and have it known where I buy them." She recounted how newspaper articles had been reporting that she wore Parisian designs, while Mrs. Nixon was running up her finery on the sewing machine, "and David Dubinsky, the head of the International Ladies Garment Workers Union, called Jack up to say would he please do something about it!"

Jackie had great trust in Diana Vreeland and great affection for her. The two women had known each other since the 1940s, when Jackie was one of the prettiest girls on the dance floor at New York debutante parties. Although Jackie was young enough to be Diana's daughter—she was three years younger than Frecky—they belonged to the same group who saw one another in New York and Southampton. Frecky knew Jackie through a mutual friend at Groton, Yusha Auchincloss, Jackie's stepbrother. Frecky's wife, Betty, had been a year ahead of Jackie at Vassar, and the two were friends. When Frecky and Betty moved to Alexandria in February 1951, Jackie was "the one D.C. friend" that they had. "Jackie was our first dinner guest," Frecky recalled. "We saw her constantly, as she had the only swimming pool for miles around and she didn't get away much in the summer, either, since she had this job as a photographer-interviewer on a D.C. paper. And one day, next to the pool, she introduced a thin young fellow on crutches to us as her fiancé."

From the beginning Diana sensed Jackie's uniqueness and made sure she was photographed for *Harper's Bazaar* the year she came out. When Avedon asked Diana how to photograph Jackie, Diana said, "Just get that voice." Their relationship, cemented by their mutual fashion conspiracy while Jackie was First Lady, was to last until Vreeland's death in 1989. In 1960, however, Jackie approached Diana as a mentor. She also predicted what would be Diana's response to the suggestion that the pleasures of French couture be forgone in favor of whipping up one's own frocks on a Singer sewing machine. "Terrible! Ter-rrr-rible!" Vreeland would cry, as she would in response to anything mundane. Jackie knew that Vreeland would be receptive to a scheme of hers: "I rather favor firms who make French copies—if they aren't too much known to be French—but surely I can be allowed that! Do you think I could ever get these designer's models—the ones that are well made?"

According to Jackie, the worst thing about being in politics was that you were always in the spotlight—having your picture taken and having to look nice. "So you can't wear your old spring coat for a month while you shop for a fall one!" Jackie wrote to Diana Vreeland detailing her needs. She wanted to find great-looking coats and suits, wool day dresses, afternoon and cocktail dresses, short evening clothes and long evening dresses.

By the summer of 1960, Jackie had been in the political arena for seven years, since 1953 when she married Jack Kennedy. She learned how to create her own life within the larger context of the Kennedy family with its strong set of personalities and the demands of Jack's political career, and how to survive in the atmosphere of politics—an atmosphere foreign to her. She had an artistic temperament and loved art, ballet and literature. Now she would learn to put her vital creativity to work in dressing herself in both a politically correct and elegant way.

During the fifties she perfected a striking image. As Hamish Bowles,

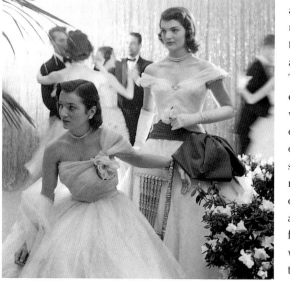

Jacqueline Bouvier behind her sister, Lee, photographed by Cecil Beaton. Opposite: Jackie by her husband's side during his 1960 campaign.

curator of the exhibition "Jacqueline Kennedy: The White House Years," says: "Jackie definitely had Francophile tastes" and "her elegant Continental tastes were revealed in her fashion, decorating and cultural interests." As the wife of the Massachusetts senator, she wore clothes by Givenchy, Cardin and Bob Bugnand, a couturier who had salons for fitting clothes in New York and

made in Paris. By the late fifties she was going to Kenneth, the hairdresser who created a bouffant coiffure for her. While she was pregnant and campaigning, she wore great spreading coats by Givenchy, close at the chest and billowing out below.

Mrs. Vreeland was the perfect person to help her continue with her French look. A Francophile herself, she also knew American fashion as *Bazaar*'s fashion editor for twenty-five years. Jackie wrote tongue-in-cheek that she needed "my own little Mollie Parnis" (Mamie Eisenhower's designer). She also asked Diana if in addition to Ben Zuckerman (who made copies of the French couture) she approved of Jacques Tiffeau or Originala for coats and suits. She wanted afternoon and cocktail dresses like the ones Chanel made, and she hoped Traina-Norell might be the answer. She confessed to already creating in her mind a gown for the inaugural ball and wrote, "I am anxious—that if it happens—it should be perfect—and in perfect taste—so simple and beautiful—not lots of Nettie Rosenstein paillettes," a reference to Mamie Eisenhower's inaugural gown, a long dress in a rather dull color covered in paillettes.

Jackie wrote again on September 7, having heard from Diana. "It sounds as if you know exactly the right things." She began that letter by outlining her fashion necessities both for an upcoming press release and for Pat Nixon Week (about which Jackie comments, "There really is

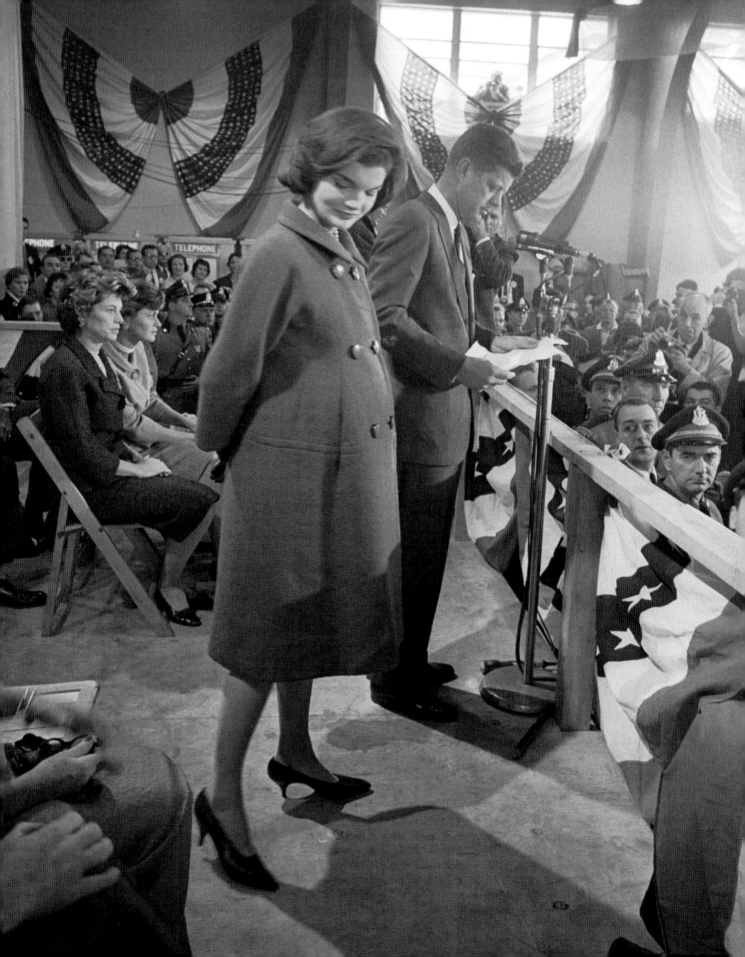

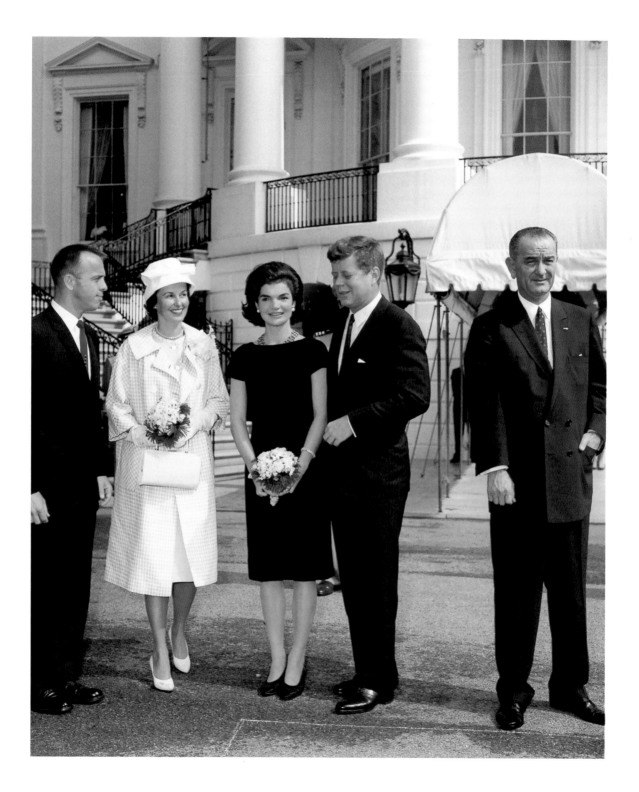

going to be one!"). She imagined that she would "no doubt be portrayed as a let them eat cake fiend who buys Paris clothes!"

Most of the letter centers on her ideas for the inaugural ball gown. Even though her husband was in a tough race, she let herself think ahead to this grand, Cinderella-like event. She admitted to Diana, "About the Big Eve! I feel it is presumptuous and bad luck to even be thinking about it now— But it is such fun to think about—I would be imagining it if my husband were a garbage man— But don't tell anyone as Jack would be furious if he knew what I was up to!" She then went on to speculate about designs and colors, explaining that she would like a simple, covered dress in "fantastic" material. She favored white ("It is the most ceremonial color"), but would also be open to other color options. Jackie addressed the issue of accessories and ruled out the possibility of a tiara for its undemocratic insinuations, although she still believed she needed something on her head.

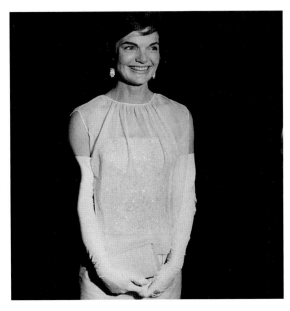

Jackie in her inaugural ball gown. Opposite: *Alan Shepherd and his wife, the Kennedys and Lyndon Johnson.*

Jackie realized her dress design was premature, but she ended her letter with "I will just have to get it anyway and wear it to watch TV if things don't work out!"

In another letter she explained her contacts with other fashion consultants. She felt guilty for her "infidelity" and explained, "I want you to know that you are and always will be my fashion mentor." She was upset, however, that *Women's*

Wear Daily accused her of spending $30,000 a year on clothes from Paris. Most important, she promises: "'The Big Eve' if it ever happens—will be all for you and me. . . . Please know that no one has ever been as helpful to me as you and I will never forget that."

Jackie continued to design in her mind a gown specifically for the inaugural ball. She sent Diana pictures from an English magazine as well as pictures of Dior designs, and she asked her to work with the designers at Bergdorf Goodman (where Jackie had been a customer for years) to create "something you like." She also expressed her interest in seeing Diana's sketches for a headdress, but warned, "The smaller the better—as I really do have an enormous head—and anything too extreme always looks ridiculous on me." At this time she didn't know her baby boy, John Kennedy Jr., would be born early, in late November, and she needed to be well prepared for the inauguration in late January. She also asked Diana, "If in your travels up and down 7th Avenue," could she talk to some of the designers to send her some spring sketches? She told Diana she needed advice for the day of the inauguration—"what kind of hat—dark fur? And gloves, shoes and bag?"

On January 20, 1961, John F. Kennedy was inaugurated as president and gave his famous speech: "And so, my fellow Americans: ask not what your country can do for you—ask what you

can do for your country." Despite the raging snowstorm that paralyzed Washington on the day of the inauguration, the city was, according to Diana, "so clean. The dome of the capitol stood out against this blue sky—blue like a China blue. I'll never forget that blue—or that day."

Jackie wrote to thank Diana for making the exhausting trip down from New York to Washington for the inauguration. ". . . Though you angelically write that it was alright, I just know you were frozen in a snowdrift and all the confusion." When the enormous snowstorm crippled the city during the festivities, Diana claimed that she and Reed simply hitched a ride on a snowplow. For the night before the inauguration, Jackie wore a simple white gown for her short appearance at the inaugural gala. For the inaugural ball the next

evening, she wore a white silk peau d'ange sheath veiled in white chiffon. The long bodice was embroidered in silver and brilliants, covered by a sheer overblouse; it was the dress she had imagined for herself in her letters, that Diana had helped to design. Her wrap was a floor-length cape of the same peau d'ange covered in triple silk chiffon, credited to Bergdorf Goodman.

Jackie ended her thank-you letter to Diana: "To paraphrase El Presidente you really came through for me all the way and you always have and I always will for you."

Years later in *DV*, Diana credited Jackie for putting "a little style into the White House and into being First Lady of the land." The Kennedys "released a positive attitude toward culture, toward style . . . and, since then, we've never

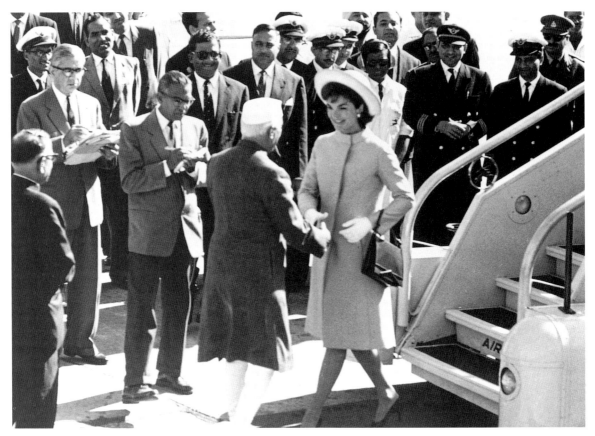

gone back." And then she admits, "I had a small part in this. I occasionally gave Jackie advice about clothes. I did suggest that she carry a sable muff on Inauguration Day. It was only for practical reasons—I thought she was going to freeze to death. But I also think muffs are romantic because they have to do with history."

Diana helped Jackie create one of the most important images of the century. In the spring of 1961, on her official trip to Paris, Jackie wowed the world. While her exquisite taste was expressed in everything she did—for example, when she transformed the White House from looking like a hotel lobby into a showplace for a great collection of historic American antiques—it was her personal style that became legendary. Her first public image was that of the young, pretty, aristocratic, pregnant woman. The second image was Jackie as First Lady. In the White House, she wore dignified and smart dresses, suits and coats that would stand out for state occasions, usually of one color. For relaxation she wore jeans to go riding and sport clothes and separates. The public loved to see her image in the newspapers and on television and couldn't get enough of her. After she left the White House, the paparazzi often photographed her dressed in sport clothes—T-shirts and slacks. Later she would be the glamorous woman of her mature years. Although she asked advice from others, she had her own strong sense of style and knew just how she wanted to look. Diana helped her then, and they continued to be friends through the decades, sharing their common awareness of beauty expressed in fashion, in art and in ballet.

In 1961, Jackie told Diana she wanted her magazine to be the first to have a picture of the First Family in the White House. It was taken for *Bazaar* by Richard Avedon. "We really bested Pierre Salinger and all the wire services, didn't we?" Jackie wrote later. "I was so furious today when I read *Newsweek* on how everyone was won-

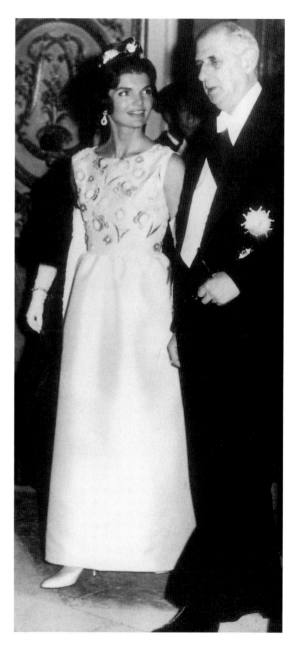

Jackie, dressed by Givenchy, with President Charles de Gaulle at a dinner in honor of President Kennedy at Versailles, June 1, 1961. Opposite: *Jackie meeting the prime minister of India Jawaharlal Nehru.*

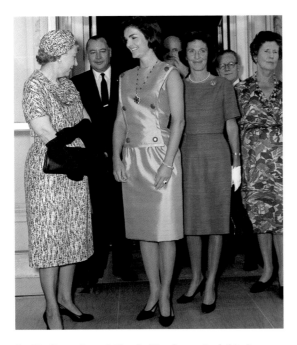

Jackie Kennedy and Mamie Eisenhower (at left), *June 1962. Opposite: President Kennedy, Jackie, Lyndon and Lady Bird Johnson and Chief Justice Earl Warren.*

dering why we chose *Harper's Bazaar* and they invent a million reasons and no one says the real one which is you."

Once Jack Kennedy had been elected, it became clear that Jackie would require a full-time couturier to dress her. Oleg Cassini, an American designer with a Continental manner, seemed a good choice. It was simply un-American to buy foreign clothing, and by choosing an American designer Jackie hoped to throw off allegations of her overspending on clothes. She confessed to buying Balenciaga and Hubert de Givenchy designs but, when accused of being extravagant, she bluntly stated, "I couldn't spend that much unless I wore sable underwear." Cassini had contributed generously to JFK's West Virginia campaign and knew the Kennedy family intimately. So close was Cassini's relationship with Joe Kennedy Sr. that the latter offered to pay

all of Jackie's clothing expenses should she choose Cassini. She did and he did. By this arrangement the U.S. taxpayer did not pay for Jackie's wardrobe as First Lady.

Cassini saw in his new assignment the chance to create an image for Jackie rather than just making her "a model for someone's pretty dresses." Unlike other designers, who were called to submit their existing work, Cassini sent only newly fashioned designs made especially for Jackie. He explained his strategy by saying that "he was proposing a new look, a new concept, my interpretation of how Jacqueline Bouvier Kennedy should appear in her role as First Lady." He became entranced by her "very geometric, even hieroglyphic, sphinx-like eyes, her long neck, slim torso, broad shoulders, narrow hips, and regal carriage"—all of it reminding him of an Egyptian princess. As a former designer for motion pictures, he approached his task as if she were a movie star.

Even though Jackie had faith in Oleg, she still needed assurance and guidance from her mentor, Diana. Diana Vreeland was the unspoken liaison between Oleg and Jackie. Not only did Mrs. Kennedy write to Oleg alerting him to this fact—"Diana Vreeland will call you about a dress she wants for *Bazaar*"—she often deferred her decisions on fashion items to Diana. In a post-inauguration letter Jackie thanked her for helping her with shopping and for "staying" with Oleg. "If you can spare the time I would appreciate you helping him as anything you say he takes as Scripture. He would make me a dress of barbed wire if you said it would be pretty."

From the beginning, the press recognized that Jackie wanted to maintain her European look and that even though Cassini would be chief couturier, he would be designing Givenchy-like clothes. Jackie did have Hubert make a number of items for her—the white dress with the bell-shaped skirt in heavy silk she would wear for the

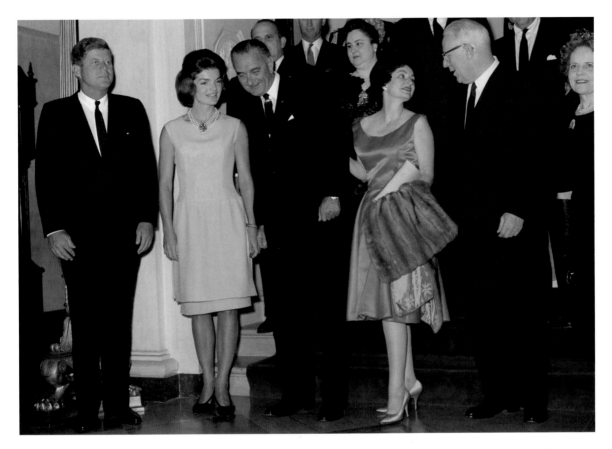

evening at Versailles and the pink gabardine coat for her celebrated spring trip to Paris. (According to Givenchy, he designed many other things for her during the White House years.)

When Hubert created the clothes for the Paris trip, it was kept a secret for months, due to the never-ending controversy surrounding who really designed her clothes. No matter how many gowns by Cassini Jackie would wear, the rumors persisted that Givenchy was in fact behind her wardrobe. In a postscript to the coverage in *Women's Wear Daily* of the Paris triumph, it was suggested that Givenchy had stumbled upon "a real coup" because he "all along has been controlling the Kennedy look. . . . The photographs of the entire collection have streamed into the White House direct

from Avenue George V [where the Givenchy boutique is located]."

Givenchy remembers how at the last minute Tish Baldrige called and said the First Lady would be wearing five or six outfits and the press could now be told. Again, Jackie, who always had her own ideas, had sent him "the most lovely sketches." Givenchy was invited to the American embassy to see the president and Mrs. Kennedy, and she told him, "Oh, M. de Givenchy. I have had so many compliments. The president loves my wardrobe." Givenchy remembered how pleased he was. "There was lots of emotion in my eyes. We dressed Jackie Kennedy a lot every season."

During the Kennedy White House years, Jackie and Diana saw each other occasionally in

Washington and when Jackie came to New York. Soon after the inauguration, in a show of gratitude, Diana invited her for dinner with Adlai Stevenson. Stevenson wrote: "Your party with Jackie Kennedy and her sister was, after the day's struggle through that incredibly tangled jungle at the UN, a little like stepping into some enchanted enclosure."

Just as Mrs. Vreeland always discussed her hostesses' decor in her thank-you notes, commending them on beautiful settings and a perfect ambience, Jackie told her it was "the most perfect evening to have dinner in your apartment," and that "one could feel like a private person again. . . . All I can say is can't you hike yourself over to poor Adlai's apartment and put a few shells, boxes and red flowers around—I think he may ask you to marry him after seeing the charm with which you arrange your house."

On Monday, January 21, 1963, Diana and Reed were invited by the Kennedys to a formal White House dinner. Diana wrote afterward, "Our Monday evening dining with you and the President was a dream of delight and excitement. Loved sitting next to Senator Mansfield 'yep' and 'nope' and felt back on the range with Gary Cooper!!"

In January 1963, after Diana had become editor-in-chief of *Vogue*, Jackie wrote a note thanking her for sending an issue of *Vogue* in which she was featured: ". . . I love watching all the different ways you handle pictures. . . . And please thank Reed for my delicious Rigaud treasures." Diana arranged an evening at the ballet in New York for Jackie, who said she couldn't see anything so beautiful in Washington.

Diana was not the only one in the Vreeland clan who saw the Kennedys while they were in the White House in the spring of 1963. Frecky was back in America for an interim visit between assignments to Germany, where he had been in Berlin and Bonn, and before he was posted to Morocco: "Betty and I went to a social occasion at the White House and I talked to the president about Berlin."

Soon after, he got a phone call from McGeorge Bundy to spend a month on his staff, to work temporarily on national security matters. Betty went back to Bonn to close up the house while he went to Washington and worked at the National Security Council. While there he had sessions with the president. As he remembered, "Very few people influenced JFK. He had an amazing drive to find his own solutions. When Mac Bundy put three courses of action on any foreign policy problem in front of him, he invented a fourth one every time.

"He was preparing for his trip to Berlin that summer. He said to me, 'I want to have a phrase I can say in Germany to express our resolute stand to keep up our part of things.' I chose 'Here is where I am, Here is where I stand. Hier bin ich, Hier bleib ich.' He asked me who said that and I said 'Martin Luther.' And he said 'I will never make a pronouncement of anything that Luther said.' I was surprised at the strength of his Catholicism."

Then Frecky suggested an alternative: "Ich bin ein Berliner"—meaning "I am a citizen of Berlin"—to reaffirm United States support for West Berlin, isolated in the Russian zone.

Jackie wrote Diana to keep her abreast of the situation: "Frecky is here with so many marvelous ideas for Germany. Jack is so impressed."

After John F. Kennedy's assassination, Diana often wrote and sent gifts to console Jackie. Jackie replied to Diana in December 1963, "Dear Diana—Thank you for that most beautiful reproduction of the Sargent painting. How lovely it is and how like you to be so thoughtful and send it to me in memory of Jack.

"And thank you for all the photographs that you did for me for Cambodia and that everyone worked so hard on. . . . Don't you think you spoil me?"

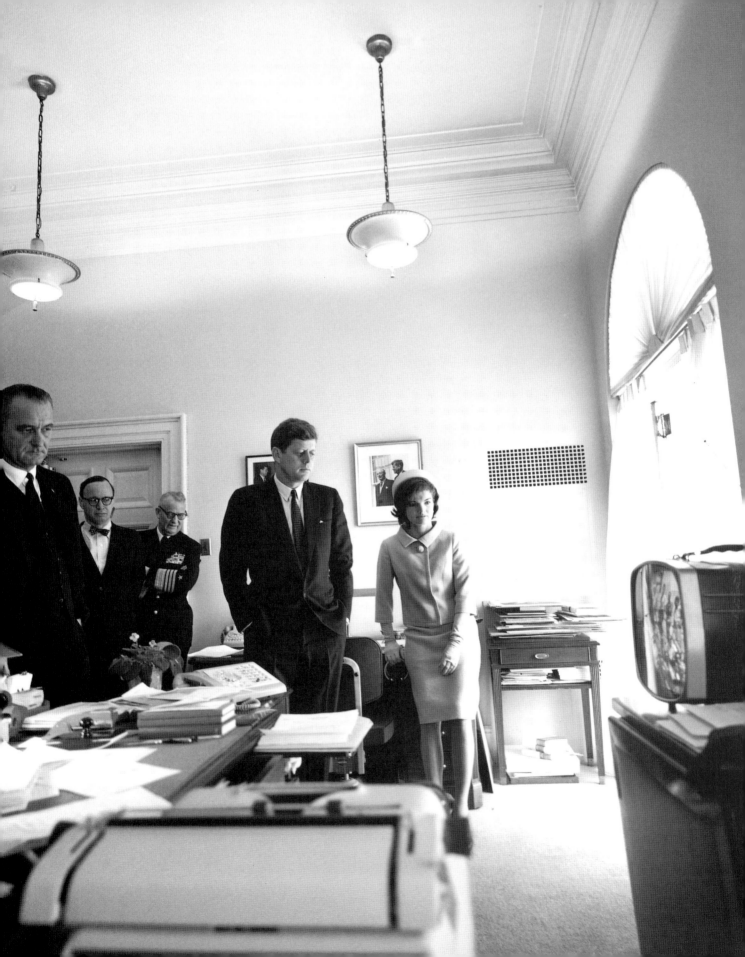

They offered me a large salary, an endless
expense account . . . and Europe whenever I
wanted to go. That's what hooked me. —DV

GETTING STARTED AT *VOGUE*

In early March 1962, the rumor circulated in fashion circles that Diana Vreeland was leaving *Harper's Bazaar* after twenty-five years. Everyone inside the industry knew of the flamboyant editor, but her personality and her work had not been much written about by the press. Now that she was about to make news—she was surely moving on to some great job—Carrie Donovan, a young reporter for the *New York Times*, was determined to interview her and get the story.

Donovan visited Vreeland in her apartment and wrote an article presenting her the way she would like to be seen. She described her outstanding looks, her fictitious European childhood and her power as an editor. Designer Donald Brooks had told Donovan about the time when he showed Vreeland a swatch of bright pink silk of Eastern influence and she made one of her famous proclamations. So Donovan included it in the article: "I ADORE that pink! It's the navy blue of India!"

On Wednesday, March 28, the headline on the Food, Fashion, Family, Furnishings section of the *New York Times* announced DIANA VREELAND, DYNAMIC FASHION FIGURE JOINS *VOGUE*. As Donovan remembered, the article rocked the fashion industry because no one had ever written about Vreeland's career, and the *Times* gave it more than half a page. The story described her as "the most respected editor in the fashion business today. Her appearance at a fashion show is the highest accolade a designer can hope for. At her rare appearances backstage at a fashion show, high-placed executives trail after her as docilely as school girls." Readers were told that at *Harper's Bazaar* "her own taste and fashion theories and her uncanny sense of discerning a fashion trend at its inception seeped into every page."

Why the switch to *Vogue*? Sam Newhouse had recently bought Condé Nast, and one story was that Mitzi Newhouse wanted to have the best editor in the business to head up *Vogue*. So, as a present to his wife, he hired Diana Vreeland. In January 1963 she became editor-in-chief, and from then on she and Alexander Liberman made the editorial decisions for the magazine. Condé Nast needed her because *Vogue* sales had fallen behind those of *Harper's Bazaar*, and Newhouse wanted to lift the magazine to new style heights.

Jessica Daves had been the editor-in-chief at *Vogue* since 1952. She lacked flair in the exciting reporting of fashion and was extremely unprepossessing, but she was an excellent businesswoman and the magazine had at first made a profit during her reign. While she was very intelligent, Daves was not really a fashion maven; rather, she was a good writer who didn't let herself be pushed around by the business side of the magazine.

When Diana Vreeland first got to *Vogue*, the magazine was planning a Marilyn Monroe spread. When the copy was at the printers, barely making deadline, the world learned of Marilyn's suicide. Jessica Daves wanted to remove the article, but Vreeland insisted they keep it in. Vreeland won—and was overjoyed, "for these were perhaps the only pictures of a new Marilyn Monroe—a Marilyn who showed outwardly the elegance and taste which we

learned that she had instinctively; an indication of her lovely maturity, an emerging from the hoyden's shell into a profoundly beautiful, profoundly moving young woman."

The posthumous publication of the Monroe photo would be the first of many photographs of beautiful women Vreeland would show in *Vogue*. She had faith that all women could make the most of themselves, could accentuate their best qualities, whether they were Midwest housewives or the glamorous queens of the best-dressed list. She wanted all of her readers to find continuous inspiration to be beautiful, well dressed, intellectually stimulated, and to keep their standards high.

In her new job at *Vogue*, Diana no longer had to be second to Carmel Snow or Nancy White. Jessica Daves retired soon after Diana arrived, enabling her to use her imagination and her fashion sense to push *Vogue* to the limits. She surrounded herself with young people, editors and models, who had the beauty she always wished she had. Everything in the magazine would be beautiful. Now she would enlighten her readers on what was best in fashion, whether from the past, the present or the future of the iconoclastic 1960s.

In the fall of 1962, Vreeland was listed on the masthead as associate editor, and in January 1963, as editor-in-chief. Daves's and Vreeland's creative differences were evident from the beginning of Diana's tenure at *Vogue*. The photographer Horst remembered sending color photographs of Consuelo Vanderbilt Balsan to Jessica Daves while she was still editor-in-chief. Her response was: "Where are the black-and-white pictures? Surely you know that we

Diana loved being at Vogue *in the sixties. "The sixties were about personalities. It was the first time when mannequins became personalities. It was an inventive time . . . and these girls invented themselves naturally. As an editor, I was there to help them along."*

don't any longer publish portraits of society women in color?" Within a couple of days, Liberman and Vreeland both called Horst and asked him to take photographs of Balsan, in color, and of her houses and gardens as well. Unlike Vreeland, Daves was not incredibly sympathetic to artistic people, nor did she inspire her editors with Diana's commanding flair. In the 1950s the editors of fashion magazines were respectable-looking but dowdy middle-aged women. They did not, as Bernadine Morris says, have that "Look at Me Quality," which Vreeland had and upon which later fashion editors like Anna Wintour prided themselves. The Newhouses wanted to develop *Vogue*, and Diana, as S. I. Newhouse said, was "an outstanding figure, a great personage."

In a document marked "Confidential," *Vogue* outlined its "Offer to D.D.V." Her salary was to be $25,000 per year, with a general expense allowance of $5,000 and a dress allowance of "about $2,000." She was to be reimbursed for entertainment expenses, for those who, "in her judgment, contribute toward the performance of her duties for the Company or benefit the business of the Company directly." Her travel expenses were to be advanced to her; at her return she was to provide an accounting of expenditures so that "adjustment of surplus of funds or deficit owed to her will be made promptly."

Today this salary seems minuscule for the number one at *Vogue* magazine, but it would rise through the years, and Condé Nast gener-

Rowland Scherman caught Diana with editor Cathy di Montezemolo (left) and at other moments of her office ritual.

ously compensated her after she left. There were also the perks—which Vreeland was brilliant at exploiting. The business office may never have visualized her spending—the cars being kept waiting downstairs, the suite at the Crillon in Paris, filled with flowers and transformed into an office for the collections, and the tipping. And then there were the far-flung trips with models and editors, the wonderful photographs rejected or done over and over, and much more—but that all came later.

Cecil Beaton, a *Vogue* photographer and writer since the late 1920s, was thrilled that Diana was coming to *Vogue*. The two shared a highly eccentric taste for beauty and loved to laugh about the mundane and the tacky. Beaton looked forward to the collaboration and urged Diana to telephone whenever *Vogue* gave her "even the shallowest excuse." He was glad Vreeland wouldn't be hampered by Daves, who, "like a good plain cook," ruined everything she touched. "Any ideas I might have given her became clogged down with suet, and I worried that you with your birdlike legerté would find your flights of fancy arrested in mid air and that your wings would have been spattered with heavy oil." He was sure that Vreeland would be able to do "marvels with the mag.; give it some gaiety and authority—a carefree tell tale assurance which it has lacked all the last years."

In May 1963, Cecil Beaton stopped by to see Diana in her new scarlet office, and found her "surrounded by beautiful young ladies and treat-

ing the whole thing as if it was merely a joke." She didn't take herself seriously in the way *Vogue* editors sometimes did, and had "impregnated that dowdy, staid old office with a completely new spirit."

Vreeland's humor and enthusiasm for the job immediately filled the nineteenth floor of the Graybar Building. She was given Condé Nast's office, but she felt it was too big. "I said to Patcévitch, 'Listen, Pat, I cannot sit at a desk and watch someone walk for that length of time into a room. I can't do it. I feel like saying, 'Hurry up, get going a little faster.' So I cut off the end of the room—can you imagine? with a partition. I mean, this was like cutting off part of St. Peter's in Rome."

For all Vreeland's humor, at bottom she was intensely realistic and knew exactly what she was doing. She realized that in order to be creative, to put out the magazine she wanted, she needed the support of assistants who had a practical touch and who understood the business end of things. Early on, she decided the person who could really help her was Grace Mirabella. Mirabella was then the "Fashion Marketing Editor" and had worked at *Vogue* on and off since the early 1950s, shortly after her graduation from Skidmore College. When she started at *Vogue* in her mid-twenties she was bright and ambitious, but her Newark, New Jersey, background made her feel like an outsider. So many of the other editors appeared to be from fashionable "good families" with lots of money and connections.

When Grace Mirabella heard that Diana Vreeland was coming to *Vogue*, she was not thrilled with the idea of having to work for her, as Vreeland seemed flamboyant and "everything excessive." And Mirabella was extremely wary of anyone with a society background like Vreeland's. In addition to her impeccable social credentials, Vreeland was a tidal wave of enthusiasm and power ready to sweep away any

hesitant editor who might get in her way.

Mirabella was so shaken by Vreeland's pending arrival that she decided to take another job, with the bathing suit manufacturer Catalina. She was about to accept the job when Diana stopped her in the hall and said, "It's not the job for you." She was taken aback, for she didn't think Vreeland knew anything about her. "'You wouldn't be happy working in the marketplace. It's too grubby for you. You need style, intelligence, a little pizzazz. I know that. You belong at *Vogue*,' she said. 'We will just have to find the right place for you.'"

A few months later Vreeland asked her to lunch at a restaurant in the Graybar Building, and Mirabella learned what was the "right place" that Vreeland envisioned: Vreeland wanted her to be her assistant. Mirabella didn't know whether to be insulted or to laugh. "If you're looking for another secretary or another assistant, then you've got the wrong girl," Mirabella told Vreeland.

"If I wanted that, I wouldn't have asked you." She told the younger woman that she was looking for an associate, someone to help her with the day-to-day running of the magazine. As she talked, it dawned on Mirabella that this "assistant" job was Vreeland's backhand way of giving her a promotion. "There was something about me that Vreeland clearly wanted to have around. She didn't necessarily want to have it around in a studio or at a sitting, but she wanted to have it around to help her get a magazine out. And buried in there was some sort of compliment."

It turned out to be a winning combination. Mirabella, a real Condé Nast insider who understood the business side of things, could see to it that the flamboyant editor's ideas were realized. To be most productive, Vreeland needed to have this sort of connection, a younger and competent staff to implement her ideas. She lived in a world of imaginative visions and fantasies—possibilities for stories, for fashions, for brilliant *Vogue*

spreads. Her inspiration and energy needed its outlets and transmitters, and Mirabella would be the principal agent.

For her part, Mirabella found herself completely won over. She came to slave for Vreeland, to talk to her for long hours on the telephone every day, even on weekends. She was the first person to take her out after Reed died. And she not only became very fond of Diana but also learned from her how to be supremely organized. Both at home and at the office, Vreeland knew how to make her staff work for her, implementing her own methods of keeping things straight. She maintained an enormous number of books—address books, books of lists, books of menus,

record books as well as Rolodexes—constantly updated, growing more voluminous by the year. Her helpers became used to her yellow legal pads, one for each subject, on which she scrawled ideas in a large hand.

Mirabella also learned Vreeland's philosophy of what she thought her readers wanted. "I remember her saying in effect that you must 'lift them up. They've got enough to worry about. They don't come to you to worry more.'" Vreeland had learned in her early childhood days that the mundane realities of everyday life were not interesting—at least not to her. You had to exaggerate and embellish the world, make it more vibrant and beautiful.

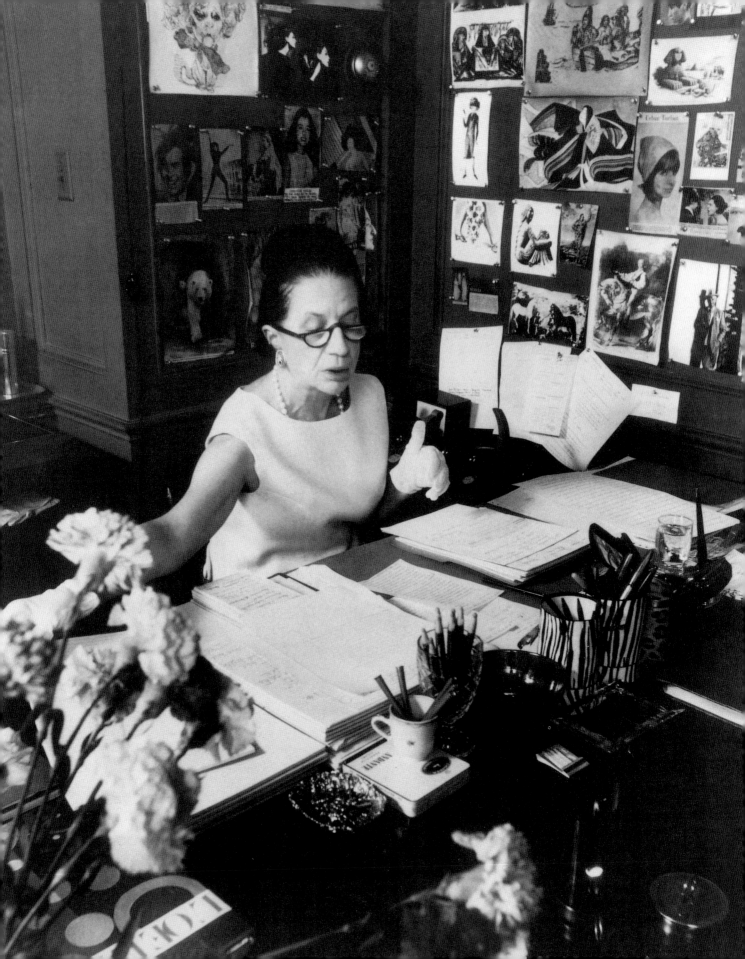

The younger woman encountered the essence of this vision early in her association with Diana. In 1962, manufacturing was divided into suits, coats, dresses and "better dresses," and Mirabella was responsible for covering the last. Mirabella recalls: "One day I brought my stuff in for her because we had a run-through every week, and I went through racks of it, and at the end she said, 'You know that was a very good workmanlike way of doing things, but it really is not what this is all about.' And what she was saying was that she was not about just regurgitating what was in the Ready-to-Wear vaults, but she wanted an idea. What she was playing at was theatre. . . . That's what the fashion world is still playing at—theatre. Entertainment was her thing. She used to say, 'You've got to give them a little something.'" Grace Mirabella learned from her mentor that "the reality [she] wanted to bring [to the magazine] had to have style."

Vreeland's style soon asserted itself at *Vogue*. Former accessories editor Nuala Boylan describes how: "A limousine would arrive, in the late morning or at lunchtime, and the door would snap open, and she would step out dressed in her usual head-to-foot black—cashmere sweater, black wrap skirt, the pointed shoes, now famous, that were polished on the bottoms. The hands were beautifully manicured, the hair just so. It was a helmet. (Once when her maid bumped into it by mistake with a tray, it clinked.) And waiting at the curb, there would always be one assistant. Then up they would go in the elevator of the Graybar Building to the nineteenth floor, where all the offices came off the main corridor, and we

Top: Louise Grunwald, Diana and C. Z. Guest. Right and opposite: "I just had a big black desk for myself. Beyond it was a big, long table of the same black lacquer, where the photographs were stacked. I had my bulletin board. And scarlet walls. It was a very workaday office, no chichi, and lots of space and fresh air."

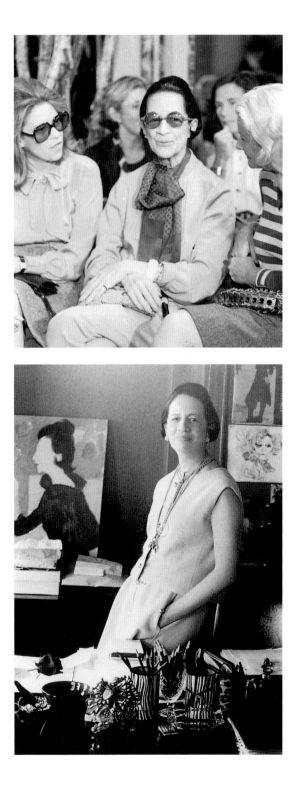

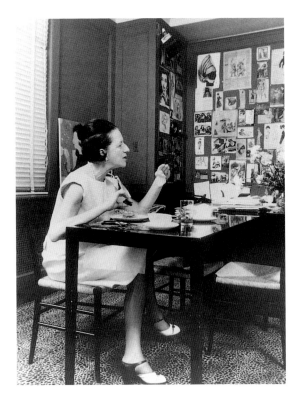

Diana eating her peanut butter sandwich lunch. Her bulletin board caught the eye of everyone who walked in, with its fashion sketches, cartoon of Colette and the killing eyes of Maria Callas. Opposite: *In the art department, discussing layout.*

Felicity Clark, her favorite secretary, who worked for her from 1964 to 1969, was in touch with Diana in the mornings from home. Clark, who lived at Seventy-second Street, started off at about 8:30, walked down Park Avenue, picked up a folio at 550 Park and continued downtown to the office at Forty-fourth and Lexington. Then the phone would be sure to ring "with her on the end of it, and it was never 'Are you ready to take dictation.' It was 'Now, listen . . .'" Vreeland always thought her ideas or train of thought were just as important to her listeners as to herself, and she could be impatient to get the connection made. "Wherever you were you grabbed a pad and grabbed a pen. We had these little shoulder rest things for the phone so at least you had two hands."

Before Vreeland actually arrived at the office, her maid would call ahead and tell them that she was on her way. "Then we would put the lights on in her office and light the Rigaud candles. When she wasn't there, the candles weren't lit, so I think most of her staff, when they started to smell the candles, knew that she was either in or on her way. She would then make this sort of royal progress down the passage, sweep into the office, very often rather late for an appointment but ignoring the fact that she was late."

Often on her entrance to her office she would make one of her pronouncements: "Get me Swifty Levine on the phone! He's in California." It would take her secretary Denise Doyle a while to realize that she meant her agent, Swifty Lazar. And another time, when she couldn't reach jewelry designer Kenneth Jay Lane and was told he was in Egypt: "I don't care where he is. If he's in Paris, call him in Paris. If he's on the moon, call him on the moon. If he's in Egypt, call him in Egypt."

Other pronouncements were ideas that almost instantly made fashion history. As Felicity Clark remembers, "Before Vreeland came in in

would hear the clicking of feet and we would hear her in a loud voice over her shoulder dictating memos at a mile a minute to the two or three people in attendance."

Denise Doyle, her secretary in the later years at *Vogue,* remembers that "she would call in the morning, sort of 9:30 or 10:00, and give us a lot of dictation. She worked all morning on the phone from home. She would expect whatever she dictated to be on the various editors' desks—what books she was talking about, whether she was talking about the beauty, the accessories, the boutique, whatever it was—and then we would take the stuff and put it on the editors' desks by 1:30, when she came in."

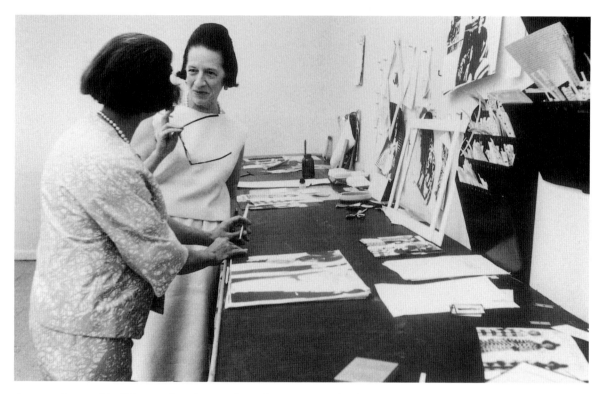

the morning, we'd all be on the phone taking dictation, and suddenly it was the most urgent memo of all, a two-liner saying 'Bring me shoes with chains on them.' Someone would come in swearing, saying, 'What's she on about now? There's no such thing as a shoe with a chain on it!' But you know, in six months' time everybody was wearing a shoe with a chain on it!

"Or she'd say, 'I have a feature for Gloria Schiff. I have a feeling that bright grass green is going to be the color!' In those days the designers were geared up. If *Vogue* went over and worked with the designers, you would get the green you wanted. All the stores would go along with it." A Vreeland one-liner would produce a long spread of models in grass green and soon have everybody wearing her green.

Denise Doyle described the famous Vreeland lunch: "When she got in is when she'd have lunch. It was the same every day, peanut butter

and jelly on whole wheat bread. She thought a three-martini lunch was the biggest waste in the world. One day Chandra came in and said, 'There's no whole wheat bread, only white bread.' And Mrs. Vreeland said: 'How common, you know, flour and water. That's what white bread's made of and that's what we use to make library paste out of.' She was not a food person at all." Another quirk was that the coffee had to be cold. "You're not supposed to put anything really hot in your stomach. And the coffee ice cream had to be like soup because you're not supposed to eat anything too cold. And she would have a couple of Scotches before she did anything. She said, 'Reed taught me that if I have that Scotch, it would get me through until the evening.'"

Fashion editor Gloria Schiff often was called in when Vreeland was in a bad mood—"If she was having troubles or something with 'the boys' [from the business end of the magazine],

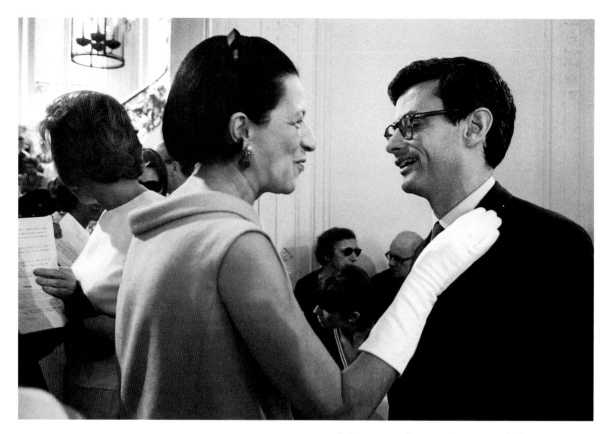

Richard Avedon worked at Harper's Bazaar *with Diana beginning in the mid-forties. When she left for* Vogue, *he eventually followed, and she was delighted.*

she'd go into her office and slam the door and call for me. She'd say, 'We're having lunch.' The two of us would sit at the bridge table with its red oilcloth cover, Vreeland with her usual peanut butter sandwich and a slug of whiskey, and I'd have a tuna fish sandwich, and we'd talk about work and the magazine."

Felicity Clark, a beautiful young English woman, who didn't want to be a secretary when she came to New York in 1964, decided that if she was going to be one, "It might as well be for Diana. I think she liked the idea of having a secretary with an English voice." Clark typed endless memos, did research on obscure subjects for articles—say, for a piece on "Tulipmania" to accompany Irving Penn's marvelous flower photographs, or created a list of neighborhood stores where Betty and Frecky Vreeland might shop in New York, which naturally had to include all Diana's favorite things: Austrian pastries, specially imported spices, special pills from a particular drug store.

Vreeland could be difficult and would "turn" on people and speak to them in dreadful ways. Clark says that "she did drive everyone absolutely to the brink, but she amused me too because she knew precisely when she was about to go too far, and then she would suddenly turn on the charm and pull you back." She was so keen to execute her ideas in just the way she envisioned that she had little tolerance for mistakes, interruptions or sloppy work.

"There were little crises. I always had to fold up one-dollar bills, so that she had tipping money. One Sunday morning we were driving to the airport, Reed was furious because I hadn't done 'the money' right." As Diana got older and her eyesight got poorer, bills were folded in different ways so she could recognize their denominations by their size.

Vreeland's extravagance was legendary. "She really didn't want to know what things cost. If you said once too often, 'Mrs. Vreeland, your car has been waiting downstairs for three hours' or whatever it happened to be, she didn't like it. To my half-Scottish upbringing, it was profligate in the extreme to have a car and driver sitting outside and not send it away and make a decision as to when she was going to need it. She thought that side of it was terribly boring."

Vreeland's enthusiasm ran like a current of energy through everyone. If someone was called a star—one of the editors—she would say, "Oh well, we're all stars." The younger women editors and assistants who hit it off with her could expect warmth and affection in exchange for their round-the-clock, 100 percent enthusiasm, devotion and virtual slavery. It was not a hierarchical bureaucracy. Anyone could have access to the top if she wanted it.

Like other Vreeland editors, Carrie Donovan remembers the fun. One of Diana's many early-morning memos stated that they should all wear bells at the office: "You know the sort of bells. Bells little kittens wear so they don't get lost in closets." So all the young women went to the five-and-ten-cent store and bought little bells that you put on Christmas presents and put them on their wrists, around their necks, around their waists. Everybody was jingling. "By the time she came in we were all walking around with bells on. She pretended she didn't notice anything."

The thing that impressed Carrie Donovan most as a fashion journalist was the abundance of Vreeland's ideas, and the intuitive sense she had for her readers. When Donovan planned to do a presentation using long skirts, which she had just seen in the French ready-to-wear, Mrs. Vreeland admonished her. "'Oh no, Carrie, modern women aren't going to go for that. They have to get in and out of buses. They have to drive kids to school.' She never went anywhere except in a chauffeur-driven car; still, she understood all that."

Cecil Beaton, like Vreeland, had always lived among the rich, but was not really one of them. He was terribly impressed by money and position, as she was, and wanted to be part of it as much as possible. He proved to be a wonderful source for an array of article topics, as he knew every well-connected aristocrat in England, from the bejeweled members of the royal family, to the titled tweed wearers in large country houses, to the promising young talents and upcoming artists.

Vreeland was fascinated by everything English, and she claimed her impressive British connections as enthusiastically as those of her "Parisian childhood." England now became the subject for articles, and Vreeland worked closely with the staff and models at English *Vogue*.

Vreeland was attracted, not necessarily to the status and power of money, but to the beautiful life money made available—the houses, the clothes, the adventurous trips. At *Vogue* she favored stories that reflected this aristocratic glamour. At the same time, she could be intensely modern and in touch with other currents—talented and artistic people and topical subjects. She was interested in personality as well as pedigree. Her palette had many colors and would produce a strange but wonderful cultural pastiche.

She wrote to Beaton at the beginning of her tenure at *Vogue* about a woman he had recommended as a possible subject for a profile. "Is she a character? Are there amusing things to write about her? I do think that, for America,

when we take people from abroad it is essential that they have something very special, and I know you understand this . . . so, do 'fill-in' a little bit on her."

And then she announced her new credo: "The reason I am on this 'character, personality' kick is for reasons that you can easily guess . . . to-day only personality counts, with very few exceptions unless it is a 'new' beauty. I do not believe we should put in so-called society, as it is démodé and practically doesn't exist . . . but, ravishing personalities are the most riveting things in the world—conversation, people's interests, the atmosphere that they create round them— these are the things that I feel are the only things worth putting in any issue for people." Vreeland was ahead of her time in realizing the fascination of making people into celebrities, and she saw that the old, established society of her mother's world was a thing of the past.

From the beginning of her tenure at *Vogue*, she played and replayed the theme of the beautiful but mature and sophisticated woman, the constant principle of the fashion magazines. On January 15, 1963, Jacqueline Kennedy and four other exotic beauties—the half-Austrian, half-Italian Donna Ira Pignatari; Mrs. Howard Oxenberg, whom she called "a new leopard face with a giaconda lilt"; and the sisters Jean Hannon and Mrs. Hannon Kelley, with their "strong faces and clear brilliant eyes"—were the archetypes. The title of the short piece was "The Rebellion in Beauty." Her message had several twists. First, beauty was subjective and it required maturity. Second, rebellion, change and escape from rigidity and convention were virtues to uphold.

For February, Vreeland produced an exuberant Americana issue. In it she showed readers what made American fashion and the women that wore it unique. "American women move—on the longest legs, taking the quickest steps, tuned to

some of the most revved-up exhilarated rhythms in the world."

Consuelo Vanderbilt Balsan was *Vogue's* notable American that February. In the sumptuous spread, she was described by Valentine Lawford as a beautiful woman in her beautiful house, very much in the present. But the reader will remember that "she was twice commanded by Queen Victoria to 'dine and sleep' at Windsor, was hostess for a week at Blenheim to the future King Edward VII and Queen Alexandra, and was begged by the Princess of Wales, the future Queen Mary, to help her out at her first official entertainment for her reigning parents-in-law." Thus Vreeland chose an American with a fascinating transatlantic past, whose fortune was earmarked to finance the upkeep and restoration of Blenheim Palace when she married the ninth duke of Marlborough.

After returning from the Paris collections in January 1963, Vreeland, with her great color sense and passion for pink, put together what she called a "pink primed issue of *Vogue*." That spring, Spanish designer Balenciaga was the featured fashion look. He was one of Vreeland's favorite designers and had created a fashion sensation with his sharp tailoring—"miracles of tailoring in levels—cutting and seaming each piece with such finesse that the effect was of layers of parchment—flat, smooth, not a jot of bulks."

Vreeland not only gave her readers startling examples of beautiful clothes but also was on the lookout for women with interesting lives for feature articles. That June it was the first "American Queen," Hope Cooke, a New York debutante, now queen of Sikkim. On April 5, 1963, Hope Cooke married Maharaja Kumar Palden Thondup Namgyal, prince of Sikkim, a small Buddhist state in the Himalayas, and so became the first American-born queen. Diana Vreeland was enchanted. With visions of cherubic maharaja children, dressed in silken brocade,

At a ladies' fashion lunch Diana points her cigarette past Serge Obolensky, the only man in sight, as she talks to Madame Alix Grès.

dancing across the pages of the magazine, she made immediate arrangements for the Asian enthusiast and writer Nancy Wilson Ross to go to the wedding (she herself was unable to attend because of scheduling conflicts) and write a description-rich travelogue of her adventure.

The article, "I Went to the Wedding at Sikkim," gave a chatty blow-by-blow of the arduous journey—"roughly seven hours [from the airport] over a wildly winding road that rose at a steady pitch to 6,500 feet"—the foreign scenery and the exotic wedding ceremony in vivid detail, bringing this modern-day fairy tale to life for an American audience. The story had elements that really appealed to Diana—a pretty American girl, the exotic "East" and a royal marriage. Hope Cooke had managed to refashion her life in a way that Vreeland admired. The article would prefigure many later articles in which the reader

was treated to a combination of exotic locale, colorful traditions, beautiful clothes and intriguing culture, all of which would stand in contrast to realities that seemed to creep in whether Vreeland liked it or not—the realities of doing the articles or the realities and contradictions in the subjects themselves.

In November 1963, Diana Vreeland, along with a shocked America, learned that her friend Jacqueline Kennedy would soon leave the White House. On the twenty-first, Nicky Haslam, one of Diana's favorite young Englishmen, then in the art department at *Vogue*, had a date with her for lunch at Jansen's, the restaurant in the Graybar Building. As he remembers, "She'd gone down a

little early, and the news came through saying that he'd been shot, not that he was dead. I rushed down and she was already waiting for me. And I said, 'Oh, God, I've got some awfully bad news, Diana. The president's been shot, and they don't think he'll live.' And without a pause she said, 'My God, Lady Bird in the White House. We can't use her in the magazine!'"

More thoughtfully, Vreeland wrote to a friend several weeks later, "We are still under the spell of complete numbness—the death of the President has left the entire country and everybody in it without their 'friend.' It is most extraordinary how everybody felt so close to him. We are proud that we had a Vice President who could step into the late President's shoes for the moment. This country does come to its senses in a crisis, and whatever people thought of Johnson before, the country is certainly behind him now, and we all wish him the best."

The December 1963 issue, which was on newsstands before the assassination, was Vreeland's first glorious Christmas issue. She compiled material all year to go into her December issues, her pride and joy; always luxurious and sparkly and full of art and superb photo essays, they were true Christmas gifts. The covers, most often done under her tenure by Irving Penn and Richard Avedon, showed the head of a glamorous woman who, as the decade wore on, began to look more trendy and unusual, sometimes with enormous costume jewelry, sometimes with real jewelry, like the image of the model inside a gold cage studded with Harry Winston diamonds. They wore Dynel hairpieces or other strange coiffures, and exaggerated makeup. Years later she claimed she wasn't interested in saving any old magazines, no matter how glorious they were. "It's done. It's the working that's exciting." But that didn't mean she wasn't proud of them. "I worked on them sometimes as much as two years. . . . You put this aside, and then

that, and then that." December's contained a photo essay by Bruce Davidson, "The Land of Jesus"; the glorious clothes worn by Audrey Hepburn in the film *My Fair Lady*, designed and photographed by Beaton; and her great friends the Rothschilds and their "vie de château."

In January, Vreeland hit on the idea of featuring the Russian ballerina Maya Plisetskaya. A favorite format was the multipage portfolio starring a gorgeous, famous woman: a movie star, say, Audrey Hepburn, Julie Christie or Mia Farrow; an international socialite like Marella Agnelli; or simply a beautiful model like Jean Shrimpton or her later favorites—Veruschka, Penelope Tree or Marisa Berenson. Plisetskaya would be perfect. She wrote Beaton: "Please send me a wire after you finish photographing Plisetskaya. Naturally, I see a long, exciting folio—and I feel sure she will do anything for you so long as you have a Russian interpreter in the studio, some music (perhaps something that she is dancing in), and the air charged with excitement . . . everything lovely, and making her feel like the enormous star which she actually is. This would be our greatest coup, and I cannot help but feel that you are as interested as I in bringing this off."

Then Vreeland, determined to be in control, even from the other side of the ocean, began to mastermind the shoot in her head and foresaw problems: "I only hope that all goes well, as she is rather mad and wild, and can be sullen. On the other hand, when the lights go on and when she knows that she has a full audience of everyone in the studio (and she knows audiences), then she has everyone rapt and spellbound, and she adores every moment."

From New York she wrote Paris editor Susan Train to have everything ready and laid out, to tell Beaton and the interpreter to do their part to create the drama. Beaton would "have to do the laughing and the 'excitement building.' I also

suggest that you have champagne, or perhaps she would prefer vodka, and caviar. Do ask Susan to get you whatever you need to put on a really big show. . . . And wouldn't it be terrible if she behaved like a mule?"

Susan Train was alerted by telegram:

> IF YOU CAN GET PLISETSKAYA TO WEAR MAXIMILIAN SABLE TO GROUND SUGGEST SHE WEAR EXCITING MAILLOT UNDERNEATH OR A CLINGING LUXURIOUS GRES SOMETHING SHE CAN MOVE IN IN AN EXCITING WAY OR LEAVE OFF COAT IF MAKES BETTER PICTURE STOP ALSO BY ALL MEANS DO HEAD SHOTS SHE MUCH BETTER WHEN POSSESSED AND FRIGHTENINGLY EXALTED STOP SUGGEST YOU HAVE SOMEONE IN STUDIO WITH YOU [AND] BEATON WHO SPEAKS FLU-ENT RUSSIAN STOP

And yet, after all the buildup, the sitting was a distinct anticlimax, lacking imagined excitement. Beaton had never seen Plisetskaya dance and, when he encountered her in the studio, found her "a red-haired little mouse with a long jaw and long nose and sad eyes."

Susan Train remembered that "there was a Russian interpreter (KGB?) with her, as she didn't utter in either English or French. Of course I had flowers on the dressing table. . . . I faintly remember that Beaton didn't 'work to music,' but as I recall she was totally uninterested in any attempt toward luxury or charm—she just wanted to get it all over with and do as she was told. She was completely professional but between the language barrier and the omnipresent interpreter there was no personal contact . . . no giggles, smiles or hugging and kissing on this sitting!"

And Vreeland did use Lady Bird, in the May 1964 issue. She changed her mind, perhaps because she felt she had to or, more likely, once the terrible shock of the assassination had subsided somewhat, she came to admire the new First Lady. Mrs. Lyndon Baines Johnson was someone "people are talking about" and the photograph by Horst showed that she, too, had style. She posed in a deep red gown with a pearl choker in front of handsome blue curtains in the White House. "Mrs. Johnson, a dark-haired, pretty woman with a twenty-inch waist, an easy smile, tense hands, and a direct intelligence, is totally unlike the nation's folksy impression of her." "She is definitely the First Lady, sensitive to the dignity of the country, understanding of other people's problems. She takes to humanity and humans."

Always interested in women at the top of the social or political hierarchy, Vreeland also loved royal subjects. She didn't have to search far to satisfy this hunger: The royal family of Morocco was quite accessible, since Frecky Vreeland was now posted to Rabat. Diana and Reed wanted to visit Betty and Frecky in the spring, and Mrs. Vreeland combined her trip with plans for an article on the royal family.

Letters flew back and forth as Betty made the plans for the visit, and Betty received one of Diana's typical questionnaires prefaced "RUSH—Please fill in this for me Betty and mail it as soon as possible." Her mother-in-law then scrawled questions, in her bold hand, left space on the pages for answers, and sent it off to find out about the clothes required for the trip. The questions offer a glimpse at Vreeland's packing and dressing strategy. Were the required services available—hairdressing, terry-cloth bathrobes? "Are there good cleaners? Do I need a long evening dress? How many?" They also show Vreeland's careful advance planning and her obsession with having the right thing to wear, her desire to look perfect and her emphatic manner.

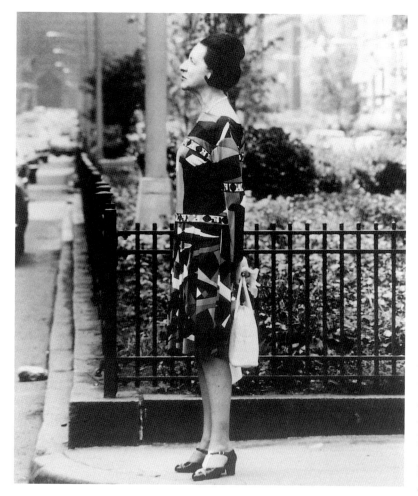

Diana turned out for work. Bill Blass described how Diana's lady's maid, Yvonne, "kept her clothes in a most meticulous way. She polished the soles of her shoes and her bags after every wearing." Like Kitty Miller, Diana wasn't classically handsome or beautiful, but both understood that everything—clothes, coif—had to be immaculate. "Their feet, their nails, the shoes, the accessories, could not have a wrinkle, they could not have a hair out of place. There aren't many women like that in our time."

Betty needed to assuage her mother-in-law's fears that the comforts might not be up to Diana's high standards. "Rabat to Marrakech is a 3½ hour drive. The Mamounia [Hotel] is comfortable. Each

room with balcony, chaises lounges, swimming pool below. Peignoirs in each room so you can go out in your bathing suit. Also dressing rooms by the pool for a change into a day suit. You can have lunch by the pool. In short it is a complete life as in any grand hotel. As I wrote I am against slacks here. The women have been out of the veil a bare 10 years and still over half are covered and it looks quite shocking to see a woman in pants. In spite of Courrèges."

Betty had also done some research for the royal-family shoot. She decided that Cecil Beaton should be the photographer, as "the snob appeal of the royal photographer to the Court of St. James would open almost all doors in the palace and make the whole entire piece a success."

Betty described how of the king's four wives, none was either beautiful or photogenic, but his mother was marvelous-looking, and that "anything you do here is complicated." She added, "The Moroccans have no sense of time and little of formal politics. You may find that unless it is Cecil Beaton and all the accompanying snobbism, they will just disappear and leave the photographer cooling his heels." The writer Mary Henry hoped to photograph in some of the royal palaces: El Bahia in Marrakech and Dar-es-Salaam in Rabat. She also thought that caftans should be featured, since at the atelier of Ghali & Abdelkrim Ben Cherif Frères, in the medina in Fez, the fabrics were hand-loomed on massive ancient looms in dark, cavernous studios.

The visit was a great success. The little boys, now nine and ten, were delighted to see their grandparents. Diana and Reed were also overjoyed. They spent two and a half weeks together, "at a little beach on the Atlantic coast south of Rabat—very cool, perfect sun and beautiful ocean." She found the boys "wonderful company. They ride the royal cavalry horses and take huge jumps over banked rush and very high and one can only be very proud of them as they seem to have no fear from the time they started to water ski, snow ski and adore every sport and talk so many languages. Anyway I am balmy about them."

The country was beautiful and made a strong impression on Vreeland. Frecky described "this paradise country": "The range of variations within Morocco is the most exciting and even in the desert, every minute as you drive, reveals an entirely new color-scheme, a fresh combination of the elements of sky, cloud, hills and plains, and texture of the ground—be it sage-brush or golden yellow sand piled up in mountains like geometric shapes against the sky-line, or again dust-colored, hard-packed earth scattered over with shiny black stones like diamonds reflecting the sun as one rushes past in a car."

Morocco made a great impact on Vreeland's fashion sense. Before long she was wearing caftans, and her friends were wearing caftans. Betty eventually worked with Lord & Taylor on Moroccan fashion. She even found a tailor in Rabat to make caftans for all the friends. C. Z. Guest remembers having one that was silver and very beautiful, which unfortunately got stolen. The magazine did a number of pieces on Morocco: the article on the royal family and "Morocco A to Z" in September 1964, and "The Beautiful People in Caftans" in July 1966.

Vreeland did for the caftan what she had once done for the scarf. In the July 1966 issue, caftans are referred to as "the most becoming fashions ever invented: the languor of the seraglio clings to them; leisure and repose emanate from them. The classic robes of the Near East, they're now, suddenly, all over the contemporary map—the inspiration of great dressmakers and every woman's discovery in beauty . . . they go anywhere." And so they did. Photographs of famous, beautiful women, stepping out on their terraces overlooking Rome, lounging at family châteaux in France, or posing in the colonnades in a villa by the Bay of Tunis, covered eight pages of the issue. Vreeland had declared the caftan chic.

In the 1964 piece on Morocco, beautiful photos captured the rich exoticism that inspired Diana. "Stretching from the Atlantic Ocean to the Sahara, Morocco contains glories as large as the Atlas Mountains under pearl skies, as immediate as sable-brown camels, black sheep, nonesuch roses, and as remote as the horizon eternally traced with still another crenellated city." Included were photos of King Hassan II, his sisters and his children. In August, Frecky wrote, "The advance copy of 1 Sept. *Vogue* has just come and I'm very happy about the Royal Family spread. I haven't looked it over in detail but the over-all effect is terrific and I know will be well received here."

Morocco became one of the many visual memories that Vreeland cherished. Felicity Clark, who began work as her secretary that year, remembers that the image of Morocco was one that she conjured up to relax when things heated up at the office. Reimagining the splendor somehow helped Diana get her mind back into the creative mode. "One day she got in a bad argument with Alexander Liberman. No one else would have gotten that far with her in an argument to get her that upset. She came into her office, closed the door, lit a cigarette and sent for me and launched into a description of the blue men of Morocco riding out of the Atlas Mountains."

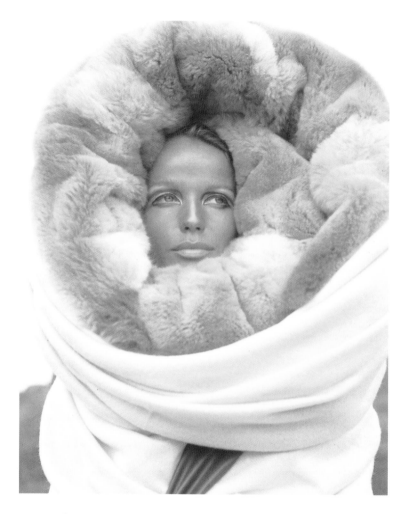

I don't think anyone has ever been in a better
place at a better time than I was when I was
at Vogue. Vogue always did stand for people's lives.
I mean, a new dress doesn't get you anywhere;
it's the life you're living in the dress. —DV

SWINGING INTO THE SIXTIES

By 1964, Vreeland had settled into her new job at *Vogue* and was enjoying herself immensely. As she said, "the real, swinging Sixties" was the best time to be a journalist in fashion because "with fashion goes the atmosphere of a time— it's more than just clothes." She was in close touch with new currents of energy and experimentation—so much so, in fact, that her own position as editor and her judgment would eventually be swept away in the torrents of enthusiasm and excess. But until that happened, she was able to produce a magazine unique for its beauty and boldness.

In these spirited years, imaginative and innovative ways of acting and dressing were transforming women's lives. Vreeland's gift was her ability to recognize change as it was occurring and to capture it for the readers of her magazine. She immediately noticed the new dancing. "Within weeks, all of New York was twisting at the Peppermint Lounge." And it was not just music and dance that were changing— the birth control pill and jet plane made a big difference: "The pill sexually liberated women and in turn fashion was free to express that new-found sexuality." The jet plane enabled beautiful girls, photographers and "long-haired boys" to fly to Rio, Afghanistan, Kathmandu, "seeing things that other generations only had ever read about." And for Vreeland, high-tech advances meant enlarging one's dreams and fantasies: "Night-blooming jasmine, lotus flowers, sun. Everything was suddenly available," and a new "internationalism" was possible.

During the 1950s the *Vogue* look was lady-like, expensive and appropriate to a dignified, conventional way of life. A sophisticated, well-groomed woman was dressed in Paris by Balenciaga, Dior, Lanvin, Pierre Balmain, and later the young Givenchy and Yves Saint Laurent, and in America by Norman Norell, Pauline Trigère and Mainbocher. Under Vreeland, *Vogue* continued to champion the French couture and her favorite American designers. In addition, she started to promote daring new designers and the English ready-to-wear.

In the 1960s America's political, social and cultural landscape also changed. Betty Friedan published *The Feminine Mystique*, a book proclaiming that a woman who lives for her man and stays home with her children is not engaging in a full or even healthy life. The feminist movement, of which Friedan was a major catalyst, debunked popular myths about the "woman's place." Rebellious ideas were surging in from all directions, and Vreeland captured them all in her magazine.

"The idea of beauty was changing. If you had a bump on your nose it made no difference so long as you had a marvelous body and good carriage. You held your head high, and you were a beauty. The throat was long, the wrist slim, the legs long. You knew how to water ski, and how to take a jet plane fast in the morning, arrive anywhere and be anyone when you got off." To be different became an asset. Vreeland personally liked the differences in the "idea of beauty," because they validated her own atypical look.

Early in 1964, Vreeland decided to go all out on the British subject. She had always loved the

English aristocratic traditions, the sense of humor, and now the youth culture madly appealed to her. She wanted to show both the vestiges of upper-class England and the new fresh counterculture—the young, including the Angry Young Men, the boutique scene, the miniskirt, the music and the contemporary talent.

In February 1964, Vreeland sent a memo to features editor Allene Talmey: "I think we are frightfully missing, and I am sure you agree, in English lore." By this time, articles about British youth and its international trend-setting powers had appeared in established journals, such as the *Herald Tribune*, the *New York Times* and *Life*. The Beatles, the Mod scene, and up-and-coming young cultural icons—nineteen-year-old Julie Christie, the emerging Vanessa Redgrave, and the irascibly charismatic twenty-six-year-old photographer David Bailey—were frequently covered in amusing articles.

Eager to seize the lead, Vreeland proposed that an entire issue devoted to the "British Invasion" be published in June or July of that year: an article on acupuncture as a medical fad; a profile of English producer Joan Littlewood; Peter Laurie's "Mods & Rockers"; coverage of Shakespeare's four-hundredth anniversary; "The Secret of the English Confidence" (half drafted in the memo by Vreeland herself). She also began soliciting personal essays from young English writers.

Two important young faces in Vreeland's British picture were David Bailey and Jean Shrimpton. Nicky Haslam remembers when Bailey and Shrimpton first arrived in Vreeland's office at *Vogue* in 1963, soaking wet from a New York downpour and dripping on her oriental rug. Vreeland welcomed them with a booming "The British are coming!"—winning David Bailey's affections for life.

According to Bailey, Vreeland wasn't really interested in photography per se. She was interested in how it made the clothes look, whether it could convey their sheen, drape and a distinct mood. She often rejected beautiful pictures in favor of more plain ones that perfectly represented a dress's line. To Bailey, however, photography was an art form and a source of entertainment. In fact, he often claimed that he was in it just for the girls. A photographer with a winning personality, Bailey would later marry Catherine Deneuve and have a long string of romances with the top models he photographed, including Jean Shrimpton and Penelope Tree.

Bailey often went to Paris with the whole *Vogue* coterie and photographed the clothes from the collections in the evenings. They had a good working rapport, and more than that, he and Diana were "good mates." Whenever she was in London she would hang out with him, and he would do the same whenever he was in New York. In fact, they were together the night of the now-famous revisitation of Vreeland's former London flat on Hanover Terrace, where a drunken Jack Nicholson and David Bailey stole the knocker off the front door to satisfy her nostalgic impulse while Vreeland waited trembling in the limousine with Anjelica Huston.

Now that the youth market was emerging in a dynamic way, twenty-six-year-old Mary Quant was one of the first to capitalize on it. Before the sixties, women's clothing in England looked matronly. Quant took it upon herself to create something she herself would wear. She was unskilled as a seamstress and took night classes to learn how to cut fabric: fabric she bought at Harrods because she wasn't aware that she could buy it wholesale. Her popular designs flew out of her small shop.

Diana sent Henry Clarke and Lesley Blanch to Syria and Jordan on a fashion shoot for the article "Match Me Such Marvel." The article, in the December 1965 issue of Vogue, showed models posed before ruins and contained Lesley's lively text on the Middle Eastern atmosphere.

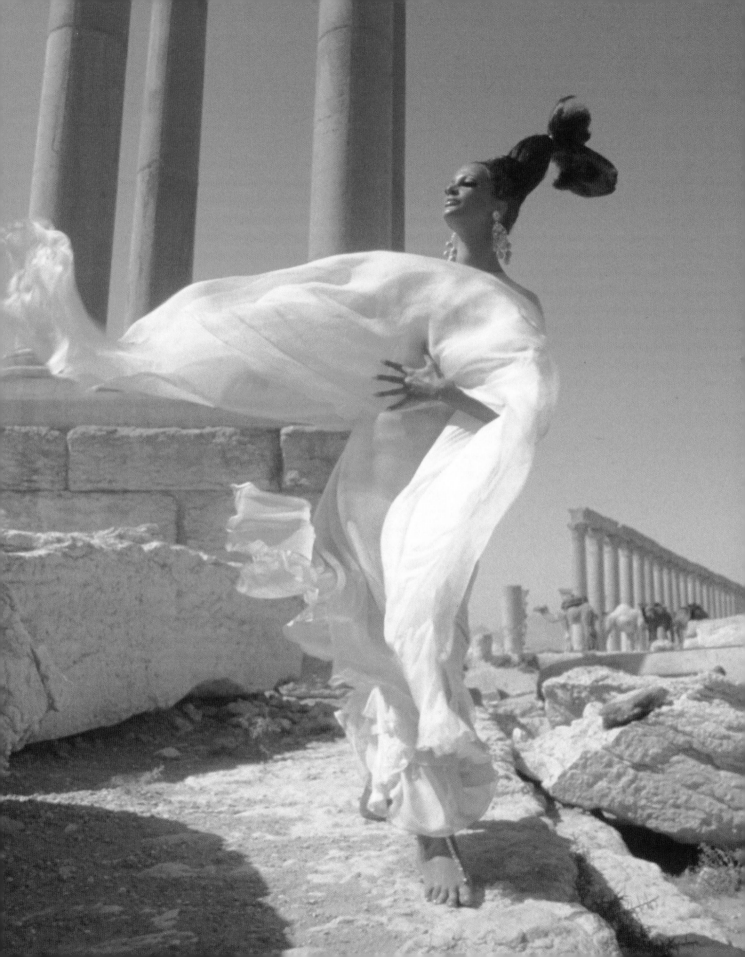

In the August 1, 1963, issue of *Vogue*, Mary Quant was featured as one of "the Adventurous Ones," looking like "one of those wispy child heroines—leggy, skinny, with soup-bowl bangs, very pale painted mouth, heavy black liner on upper and lower lashes." Quant and her husband/partner, Alexander Plunket Greene, made "young, skinny clothes that sometimes have the look of fancy dress." By this time Quant had expanded from her meager beginnings to several new clothing lines and a contract with Lord & Taylor. (Three years later *Vogue* again featured Quant, who claimed the elitism that had existed in fashion for so long was disappearing, that "you will find a duchess jostling with a typist to buy the same dresses.")

Vreeland became fascinated by English boutique life, which really wasn't happening yet in New York. She wanted to bring to *Vogue*'s pages the culture of the little shops, so Carrie Donovan created the "*Vogue* Boutique" section. For its pages young New York socialites were photographed shopping in boutiques and little shops like London's King's Road counterparts.

Vreeland noticed an exciting new Irish writer at English *Vogue*, Polly Devlin, author of a profile on the British playwright John Osborne, which Vreeland published in the June issue. Devlin later wrote that Diana Vreeland had first come into her life "like a genie, via a cable to British *Vogue*, where I had just started work." Twenty years old and keen to become a famous writer, Devlin entered a talent contest at British *Vogue* and won the prize—a job writing for the magazine.

When Devlin first met Vreeland, she was mesmerized: "I was sitting sucking my teeth, when this extraordinary apparition came bobbing, or rather gliding, along above the level of the filing cabinets—the wonderful carved head of a totem pole perhaps, or an Aztec bird woman, or a Kabuki runaway. . . . And its voice

was booming, ricocheting around, a boomerang going back to its sender, only to be spun away again bearing another sibylline pronouncement. Then she appeared through the gap in the cabinets and threw up her hands. There's a word not much used nowadays, 'limned,' which is to illuminate, to edge in color. She was always limned, set in shock against her background. You could hardly see her for the dazzle—the huge mouth; the high bright-red cheeks; the burnished black-on-black lacquered hair; the edge and cut and glitter of her chic; the slanting knowing eyes, like a fox-terrier's, missing many a thing to do with the soul, but nothing, nothing to do with the body. To me she was so ugly I couldn't believe it. Five minutes later the ugliness had vanished under the fascination."

Because Devlin was Irish, Vreeland was certain she would understand real "Irish style," which she saw as "long necks, swans, wrists, Yeats. And of course po-et-ree." "The Irish open their mouths and poetry comes out," said Vreeland. Later, as features editor at American *Vogue*, Devlin saw Vreeland change *Vogue*, "sending it into a spin of extravagance, exaggeration, and fantasy," loving "the whole youth thing to a fault," as the "aloof soignée beauties of tradition in *Vogue* disappeared, to be replaced by the youth-quake." Devlin frequently refers to Vreeland's extravagance with a tone of disdain, but despite all of the moral contradictions of "preaching extravagance during times of war," making icons out of "people who smelled of badness," she remembers her fondly. "At lunchtimes we would all troop up to a fashionable East Side doctor to have a massive injection in our bums to give us energy. B12, I think it was called. I thought it was great.—For me, Diana Vreeland was the Imprimatur, the Governor, the ultimate Boss, and the arbiter of style."

Vogue not only brought England to her readers, but it roamed farther afield as Vreeland's

enthusiasm about the jet plane propelled her into producing fantastic spreads staged in foreign lands. Game photographers went with models to Asia, Africa, the Middle East and other remote destinations. Doing these fashion stories or portraits of royalty in exotic locales took great preparation and the logistics were tricky. It meant contacting key figures, pulling strings, doing research and acquiring all kinds of cooperation that wasn't always forthcoming. Somehow Vreeland succeeded again and again.

Vreeland didn't go on the trips herself, but they seemed perfectly routine to her. Her mother, after all, had gained fame by shooting big game in East Africa in the early nineteen twenties, and Vreeland had visited many of her rich friends in exotic places, in countries we now call "developing." It was like the British visiting their colonies under the Raj, something Diana would have loved doing herself if she had lived in earlier years as the aristocratic English persona she liked to imagine.

It didn't matter that America was becoming involved in Vietnam, that trouble might be stirring in or near some of the locations Vreeland chose for her photo shoots. This was not *Newsweek* or *Foreign Affairs*, it was *Vogue*, and Vreeland was apolitical. To her "the East" meant history, magic, atmosphere and exoticism. The geopolitical problems of the Cold War were irrelevant except for the extent to which they might interfere with the project she had in mind. But now and then she did address the realities of current political events by including articles like one in January 1967, by Frances Fitzgerald, entitled "The Long Fear—Fresh Eyes on Vietnam."

To give her readers another glimpse of a glamorous woman living a fairy-tale life, Vreeland became determined to photograph Queen Sirikit of Thailand, who had visited New York in 1960 and was beautifully dressed by French designer

Pierre Balmain. In February 1964, she wrote to James Thompson, the American president of the Thai Silk Company in Bangkok.

"I would also like to ask you—is the Queen really available? And are you close to her at all? I admire her extravagantly as does everyone who sees her pictures. She is such a delicious, feminine creature, with such an elegance; such exquisite hands and beauty." Thompson replied promptly that "through the queen's dressmaker we found that Her Majesty would like to be photographed." He said, however, that *Vogue* would have to put in a request through the State Department, "who will contact the Foreign Office in Bangkok. This is all just a matter of form and must be gone through with."

After waiting eighteen months in vain for an answer from the State Department, Vreeland wrote to the master of the royal household, using Pierre Balmain's name, and "the thing was arranged instantly." As she told Mr. Krairiksh, she wanted to photograph the queen in her beautiful clothes, with her children, in the gardens, in the palace, and with her family, showing "the life of this Royal Court which is to us in America always fascinatingly beautiful and extraordinarily interesting." Vreeland wanted the photographer Henry Clarke for the job because he adored photographing glamorous women and traveling to remote destinations. He was "very quick with a full understanding of beauty and of history, an extremely charming man and has done several royal personages for us."

Vreeland wanted to capture the particular essence of Pierre Balmain's designs. There was a hitch, however, as the assignment contained a typical Vreeland contradiction—the wardrobe could not appear too costly. Vreeland wrote Henry Clarke on August 17, explaining why she had not wanted to "lay it on" about the queen's clothing and jewels. She had learned through her contacts that "there is apparently an older person

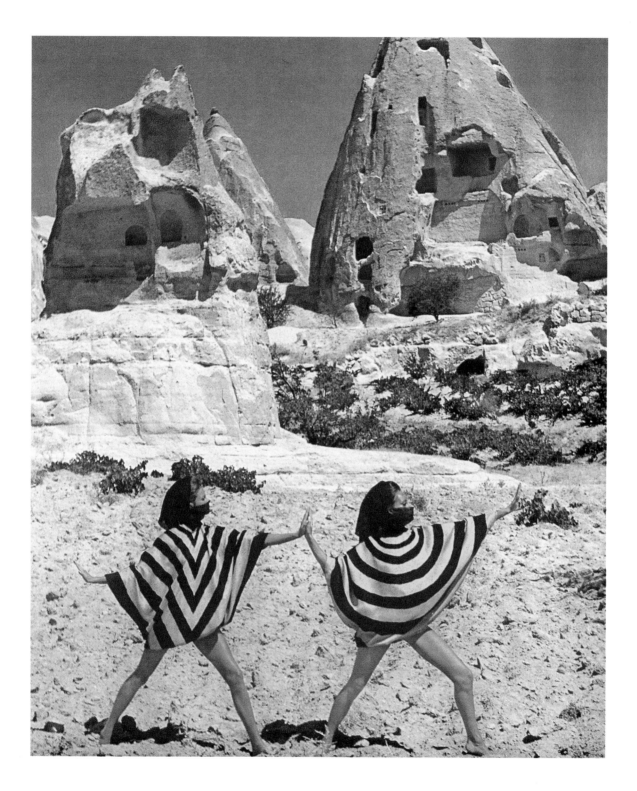

at the Court, who rather frowns upon the Queen's Parisian and Western views and extravagance."

Meanwhile, someone did fast research on "Thai National Costumes" and discovered that they could be described in one sentence: "They consist of two pieces of cloth: *pa-noong* and *pa-hom*." *Pa* means "cloth," *noong* means "to wear on the lower half of the body," and *hom* means "to wear on the top half of the body." These upper and lower parts are combinations of elaborate pleats, tucks and folds, which vary according to the formality of the occasion one is wearing them for. Fabrics ranged from elaborate brocades embroidered with gold or silver silk threads to cotton printed with traditional Thai designs. Silk, both fake and real, was used in both the top half and bottom half of the costume and also for the *pa-kao-ma*, a narrow length of silk to be used as a headscarf when it was hot, a shawl when it was cold, a sash to hold up trousers, a cartridge belt for a knife or two, as swimming trunks, or "as a cradle should the worst come to the worst." The colors of the clothes were warm and vibrant: purple, orange, red, yellow, green, blue and pink. And certain colors were worn on particular days for superstitious reasons.

Vreeland told Clarke what to photograph: "The King playing his saxophone . . . and, apparently, she has a divine water barge, Pierre tells me—and he has made for her a 'sailor suit.' " The queen's hands appear to have been an obsession of Vreeland's. She wrote to Clarke: "Be sure and get the movement of her hands when they turn back, as they are like little flowers." In Clarke's September 8 letter summarizing the Thai photo shoot, he writes in the margin that the queen was opposed to having her hands photographed. "She thinks them ugly, but finally agreed."

Clarke described the royal palace, Chitraladda, as "in a word, ugly. . . . The architecture is that of a local Thai, and if anything, style Beverly Hills." Introductions to the king and queen

Susan Train, Henry Clarke and two models traveled to the Valley of Göreme to shoot these photographs for an article about fashion in Turkey. Train recalled the arduous reality of it: "By the end of several days one feels a close resemblance to a mountain goat, and we have all developed our own methods of climbing up and down bare cliffs which offer no apparent hand or foothold. Our two chauffeurs—Mustafa and Bekir— are invaluable and always manage to appear at the crucial moment with a bunch of grapes to revive us or a helping hand just as cameras, equipment and clothes are about to slide down the ravine." Page 151: The model Antonia leans against "Henry's Heads" at the summit of Nemrud Dagh.

happened that evening. They expressed their gratitude that he had come all the way to photograph them, while he insisted it was his honor. The queen left with Balmain for her fittings and Clarke said it was "suddenly 'The King and I' for three hours."

And then he made a point that Vreeland would later seize on for her theme: "It is said the Queen is his [the king's] smile. When she spoke it was like all the temple bells were ringing throughout Bangkok—softly, slowly, a golden off-key music." Clarke found her manner playful and utterly charming. After two days, however, the queen decided she would do no more. "Quite understandably," Clarke notes, "everything had been photographed out of doors in a heat that is absolutely impossible to describe. Her ladies-in-waiting did nothing but rush to pat the sweat off her brow—wearing the heavily beaded clothing she suffered, after sitting for a while, a sleepy leg."

Although Clarke enjoyed the photographing, he was not bedazzled by Thailand. "Bangkok," he wrote, "looks for the most part, at its worst, like Los Angeles." He felt that a Western influence strangled the visual idiosyncracies of the city: "rusty barbed wire fences replacing hedges of hibiscus—the international eye-sore of Coca Cola signs stuck in low marsh lands between which lurked glazed water buffaloes in chocolate waters . . ."

Despite Clarke's rather unfavorable impression of Bangkok, he managed to portray the royal family as if in a fairy tale. The article, "The Golden Court of Thailand," published in the February 15, 1965, issue, was a display of Thai treasures—costumes, backgrounds, palaces—all gold and sparkly. In several photographs the queen posed formally in Balmain's highly ornate, regal dresses. A photo of her youngest daughter was of the little girl in a small pagoda playing with her toys. The caption read "Barefoot, jew-eled in her own jewels—golden anklets, diamond bracelets, a ruby and diamond necklace—Princess Chulabhorn wears, with her ribboned camisole and pants, a ring of jasmine in her hair." Small photo inserts presented the royal couple sailing, riding in their car and speaking to each other, as well as the palm-filled land surrounding the palace. And the queen's hands, their metallic painted nails shimmering, were featured in a butterfly pose much like Vreeland had wanted.

Although she covered a queen whenever she could, Vreeland did not limit her "internationalism" to profiles of royalty. There were also fabulous spreads of models taken in exotic locales against ruins, palaces, temples and other monuments sometimes unearthed in archeological digs. Susan Train, the Paris editor at American *Vogue* since the 1950s, was often involved: "You'd take a couple of models, and a photographer and a photographer's assistant, and usually a hairdresser—and off we would go for, say, three weeks in India. And then we're sending these pictures off to New York to be developed."

For every shoot in a far-off location, cables would fly back and forth across the ocean to reserve hotel rooms, buy plane tickets, hire car drivers or even mules or camels for transportation, and to arrange for shipping the clothes, which were sent in long black boxes called "coffins." Vreeland controlled the photographing as best she could from New York through "Polaroiding." Every photograph was planned by her creative New York office team in advance, with a model posing in a dress or coat with the desired combinations of accessories: bracelets, neckwear and hats. Only the background was missing. The "Polaroid" was given to the photographer and editors on the shoot with instructions scribbled on the bottom. Vreeland would write something like "You can do this with hat or without hat," so that her directions

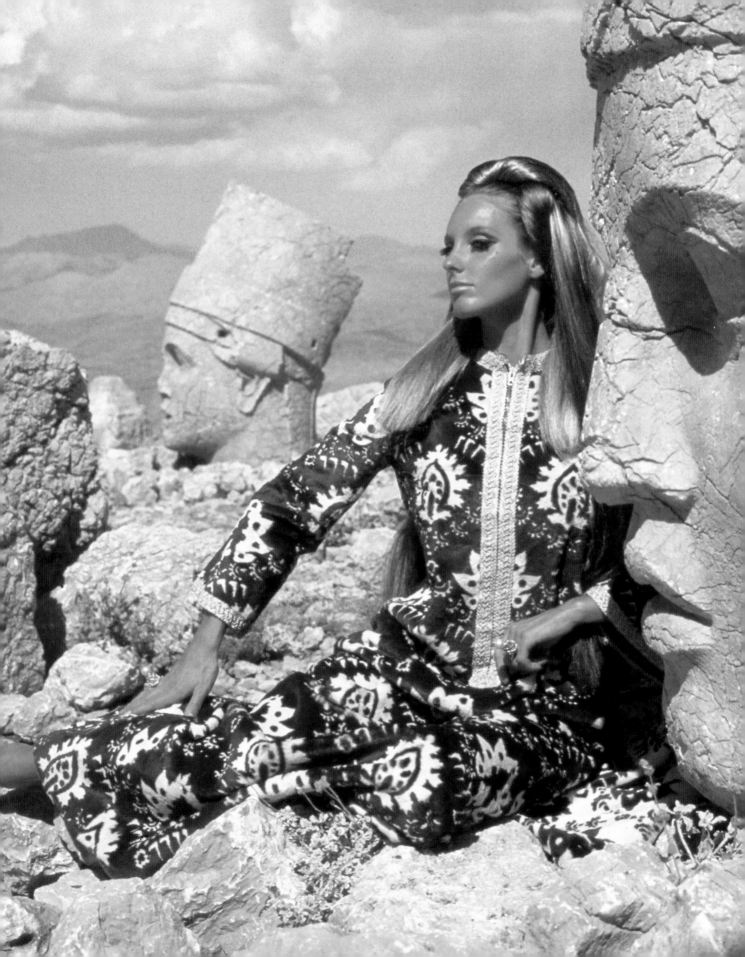

would follow her staff even when she couldn't. Vreeland was usually oblivious to the fact that she was asking her crews to perform impossible tasks, use primitive means of transportation and endure extreme climates. The more challenging the assignment, the more it appealed to her sense of adventure.

In late August 1966, a *Vogue* team set out on a three-week journey to reach the most remote and visually beautiful place in the land that Vreeland called "Turquerie"—beginning in the ancient province of Cappadocia, the valley of Göreme and the mountain called Nemrud Dagh; then the cliffs of Pamukkale on the Aegean coast; and finally ending up in Istanbul on the roof (closed to the public) of the harem of Topkapi Palace. Besides Henry Clarke, the "Turquerie" team also consisted of Nelson, his English assistant; two models, Antonia from Holland and Editha from Germany; Olivier, a French coiffeur from Alexandre in Paris, plus Susan Train, the resourceful leader who made it all work.

After a host of travel problems, including flight delays, foul weather and luggage held up in customs, they flew to Ankara, and then found three cars and drove until 10:00 P.M., to arrive at the Hotel Tusan in Ürgüp, near the Göreme site. There the fantastic scenery and the little monastic cells offered wonderful backgrounds. After five days everyone was in great spirits, and they had used up some eighty-six rolls of film and had shot about half the clothes.

The next location, the summit of Nemrud Dagh, would be more physically challenging. The plan called for camping overnight during the ascent, riding mules most of the way up to the summit, and making the final climb on foot. After clawing and slipping upward on a pathless incline, they found "Henry's Heads," and the dresses were unpacked and hung on a protruding rock. The model Antonia started to make herself

up under the fascinated eyes of the mule drivers. Since at half-past eight in the morning the light was already too strong to shoot the heads on that side of the mountain, they waited for the afternoon sun and photographed from three o'clock to six o'clock in the evening before rolling up in grimy sleeping bags for the night. Once down the mountain the next day, Train and her crew were stranded in Adiyaman, unable to get the flight to Ankara. At the American air force base nearby they found "this young officer was surveying us because we were not supposed to be on this base. He looked at me and asked, 'Are you Peace Corps or something?' And I heard myself say, 'Oh, no, not at all. We're *Vogue*.'" The three days working at Pamukkale were a big improvement. Clarke could only photograph very early in the morning and late in the afternoon, so they could relax and soak in a warm-water natural spring pool. The last night the hotel made them a special Turkish dinner with an enormous cake with "Vogue" iced on it. They left early to drive to Izmir for the flight to Istanbul, where the Hilton Hotel was like "reaching PARADISE."

The Turkey piece with its twenty-six pages of resort fashions came out in the December 1966 issue with a breathless lead: "Adventure: eastward through Turkey. To the edge of the Euphrates. To the very rim of the Fertile Crescent where civilization began. . . . A voyage of fulfillment for the imagination." This adventure, with all the mishaps and Herculean effort on the part of the entire *Vogue* team, was undertaken to show off clothes by Pauline Trigère, Geoffrey Beene, Chester Weinberg, Bill Blass and Anne Fogarty. A Pat Sandler minidress was photographed before Byzantine frescoes. "Through a cavernous half-light . . . deep within Göreme Valley rock, a mosaic of gold and silver lace shimmers in fragile tiers." The result was constant contradictions: the wildly modern clothes—pajama-inspired pantsuits, minidresses, floppy hats,

shimmering and swirling prints—in the primitive Turkish landscape; the models with their strappy, high-heeled sandals perched precariously on the rocks of Göreme; the exposed long legs, arms and necks of the models in a country where Muslim women are swathed in black robes from head to foot. Also in this Christmas issue were Lesley Blanch's companion piece, "Alla Turka," and a spread on Lee Radziwill's London house, which featured faux Turkish interiors.

In other spreads on exotic lands, Vreeland paired the photographer Henry Clarke with the whimsical writer Lesley Blanch. Blanch, who was English, first met Diana Vreeland at the time her book *The Wilder Shores of Love* (1950) was making a big splash. They all went out to Horst's place in Oyster Bay to have a drink with Niki de Gunzburg. Lesley was introduced to a striking woman, a figure in "shiny black from head to foot," and the conversation turned to what was chic. Lesley remembered: "Diana announced that 'the whole thing depends on having a really smashing bag.' I immediately sat on mine."

In 1965, Blanch and Clarke, both Middle East enthusiasts, took off on a *Vogue* adventure to the Valley of the Kings in Syria and Jordan. They slept in caves and the models were posed against camels. In her accompanying piece, "'Match Me Such Marvel,' a Rhapsody on Middle Eastern Themes," Blanch evoked the unique character of the place, with its hospitality, amazing wildlife, great natural beauty and ancient history. The numerous pages of photographs by Henry Clarke, which also appeared in the December issue, featured bronzed models boldly posed between the columns and arches of ancient ruins, swathed in creamy chiffon and silk crepe dresses, with the wind whisking at the delicate cloth of their outfits, creating a truly dramatic effect.

Vreeland was not always happy with the dazzling spreads that her photographers sent in. Penelope Tree remembered: "In England one

time Bailey and I worked really hard on some photographs—three days and three nights. We flew to America—we were always flying across the ocean in those days, and we went right to her office and triumphantly schlepped them down on her desk. She got out her white gloves—she always wore white gloves when she looked at photographs—and she looked through the light box.

"'Bailey, they're great!'" Then there was a long pause . . . "'But we can't use them.'"

"'You fucking old bag! Why not?'"

"'Because there's no languor in the lips!'"

Vreeland always knew what she wanted, and wouldn't settle for less.

"We were furious, but we had to laugh. She rather liked being called an old bag by Bailey."

Another inspired "shoot" that never produced results was Vreeland's assignment for Norman Parkinson in Tahiti in 1965. With a team of two models and two hundred pounds of gold and silver Dynel, false plastic hair, Parkinson was sent off with the boss's instructions: "I wish you to select the finest Arab stallion that you can find in Tahiti—check with some Veterinarian—and caparison him in the manner of The Grand Epoch. I want to see an illustration, as this one here, where the horse's mane and tail are plaited to the ground. Use all the Dynel you want—you don't have to bring it back."

She also wanted him to photograph a "plastic city," worked up by the art department, but it had to be scrapped. "Too large," someone announced, to get in the baggage hold of a 707. But Parkinson left with substitute props, two enormous kites, produced as a rush order by art students from a university in Rhode Island.

Once in Tahiti, only a brown stallion could be found—white stallions had disappeared since Gauguin, Vreeland's inspiration, had painted there. By 3:00 P.M. the stallion was looking very good. "At least 150 pounds of Dynel was on him, one way or another, and he did look very like one

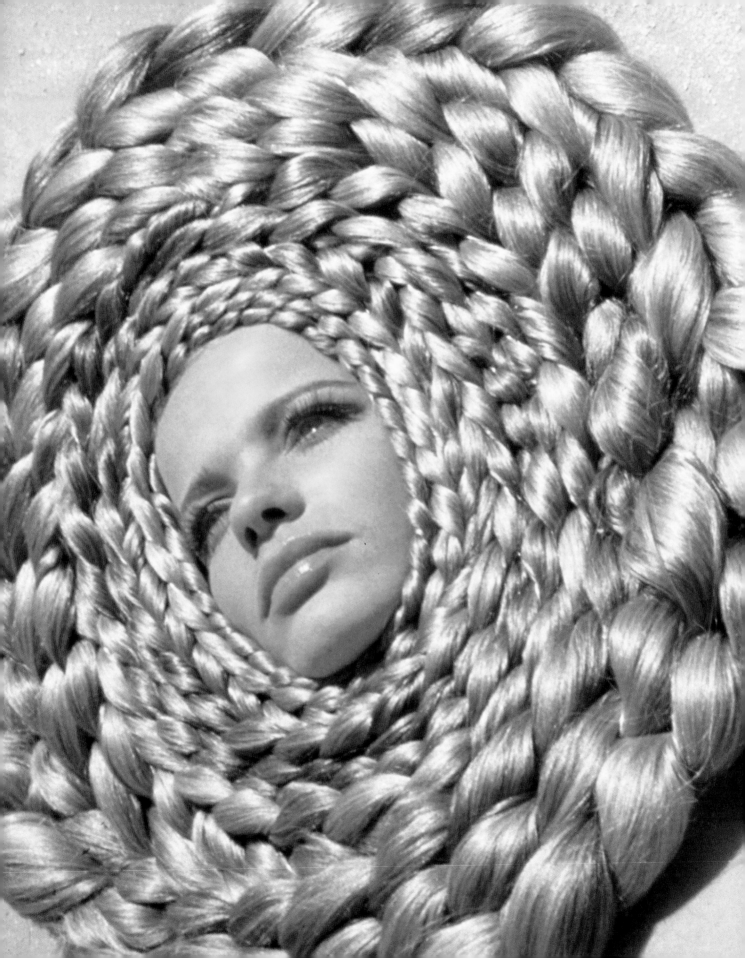

of the Vreeland illustrations. The model was dressed, made up, and ready, and she had told me, 'I don't mind horses.'" But the stallion reared up, tossing the model, and then proceeded to shake himself violently until every vestige of Dynel had been thrown off.

And the kite "shoot" fell victim to what must have been a practical joke by the art students. The first huge kite was launched into an ideal breeze before a tourist group of forty entranced American matrons. Within ten seconds a tremendous hush fell upon the audience, a giggle stifled here and there. As Parkinson recalled, "I had pulled the three ropes that ran through the pulleys, the assistant had thrown his pale pink bundle into the air, and the breeze had done the rest: correctly anchored to the mast, and billowing out at some ten feet from the ground, was a ten-foot penis. The designers had not cheated us with just this simple object; pendulous below were the two testicles."

When they tried the other kite in a private place it turned out to be identical, only pale blue. "The best comment came from my assistant: 'That one is for the cold weather.'"

Failure was duly reported back to Vreeland in New York. As Parkinson later summed up, "Mrs. Vreeland was always in there punching for the impossible and the unattainable. When her ideas succeeded, they were triumphant." If not, "there were no postmortems." Vreeland wasn't interested in compromising, and would not discuss the nuances of success and failure. If she wasn't satisfied, everyone went on to the next assignment.

While planning her assignments Vreeland developed affectionate relationships with the models who appeared in the *Vogue* spreads. She had a way of scrutinizing all good-looking women when she first met them, and when she thought someone might be model material, she doubly scrutinized her to see if the young woman "had it."

Vera von Lehndorff, or Veruschka, one of

Veruschka wrapped from head to toe in front of an exotic landscape was another Rubartelli shot Vogue *published. Veruschka understood that Diana's "way to look at fashion and the way she did it was just such fire. She had this incredible craziness about her which was eccentric, which I loved, of course, the eccentric part in her. But also this very, very deep love for what she was doing, which makes her unique in fashion also, because she was not only involved in the fashion, she was involved in the whole life, which made it for her interesting." Opposite:* Veruschka lay in the sand so Diana's friend Ara Gallant—"a great hair artist"—could create this enormous sunburst out of Dynel rope.*

Vreeland's favorite models, remembers her first encounter with the legendary editor. Introduced by Irving Penn, Veruschka "went up to *Vogue* and there was a big fitting for a huge trip they were going on, in a huge room with lots of luggage and clothes. It was already evening and Mrs. Vreeland was screaming around and yelling, 'Where are the things? We are not ready for this trip!' And then I was introduced to her, and she first didn't really notice. All of a sudden she saw me standing there, and she said, 'Who is that girl?' And then they said, 'Oh, that's Veruschka.' And I was very shy. And then she said, 'Oh, she's marvelous—look at her body!' And she was getting all excited and said, 'Please put her name on the wall.'"

Veruschka was the daughter of Heinrich, Count von Lehndorff, an East Prussian landowner. During World War II the Nazis requisitioned Lehndorff's castle, which was near Hitler's command post. Lehndorff was involved in the conspiracy to assassinate Hitler, and when the Gestapo discovered the plan, he was executed. Veruschka, her mother and her sisters were sent to a camp, but were freed because of her mother's connections. Veruschka remembers: "We grew up like Gypsies in West Germany because we'd lost everything. We stayed where we could, with friends. We were moving every year." The model Denise Sarrault encouraged Veruschka to explore the profession. However, Veruschka's height (she was six feet one) made her awkward to photograph, so she was given the runaround by many agents in Europe and America. But Vreeland adored her, and by the early seventies Veruschka had been on the cover of *Vogue* eleven times.

Vreeland was quite terrifying to young editors and models, but Veruschka sensed that she didn't like people who were scared of her. Veruschka, while intimidated by Vreeland, was careful not to show it. "When we talked about the world, power, and dresses, she didn't like [you to say] 'Well, I

don't know, Mrs. Vreeland. Maybe you're right.' She would say 'Please tell me, Veruschka. What do you think?'"

Before too long, Veruschka became bored going to the studio, nine to five for two or three weeks in a row. So Vreeland made it possible for her to work outdoors, and to get involved in the design of the shoots and the choice of clothes she wore. After Veruschka fell in love with the photographer Franco Rubartelli, Vreeland let them design their own shoots. "I could call her and say 'I would love to do some beautiful pictures at the seaside, in the seaweed, and then have some jewelry.' So then she would say 'OK, great, take the jewelry' and then Franco and I would run to the Hamptons and I would be photographed at the beach for days, and we'd bring the film home and develop it and bring it to *Vogue* and it was published. Just like that! It was fantastic."

Veruschka remembered how Mrs. Vreeland liked everything to be very happy, joyous and never boring: "She said that I had sad eyes, that she didn't like at all. She always was for living in the moment and would say, 'Veruschka, it's *now*. The joy has to come out of your eyes, and your smile—why do you have that melancholy look into the future Veruschka? If somebody asks you about where you are from or where you were born, never say what is true. It's too *boring*! You have to always be dramatic and say, for instance, I'm born on the borderline, you know, between Germany and Poland, near Russia.' I thought it was so great—that it had to be dramatic. She said the people have to be glued to their chairs when you

Veruschka learned early in her career that she must create herself: "It would never work if you are not playing a role, becoming somebody that the others will never forget—the photographers especially. And there were so many pretty girls. It was not how pretty you were, but how much you can impress the photographer [so] that he will not forget you."

talk, otherwise it's so *boring*! You want to do something exciting, *strange*!

"She was an artist. I have known geniuses and for me, she was the genius of the fashion world, because of her incredible intelligence, how she could feel things and see things. For whatever it could be—she could get interested right away if you presented it to her interestingly. Otherwise,

she would say, 'Veruschka, that sounds *terribly* boring.' And then that was it. You couldn't get her interested anymore."

One night when things were not ready for a trip, Vreeland sent all the girls home, but she admonished them. "I am concerned that there is nothing here yet!" she said. "I want you all now to go home—and I don't want you making love

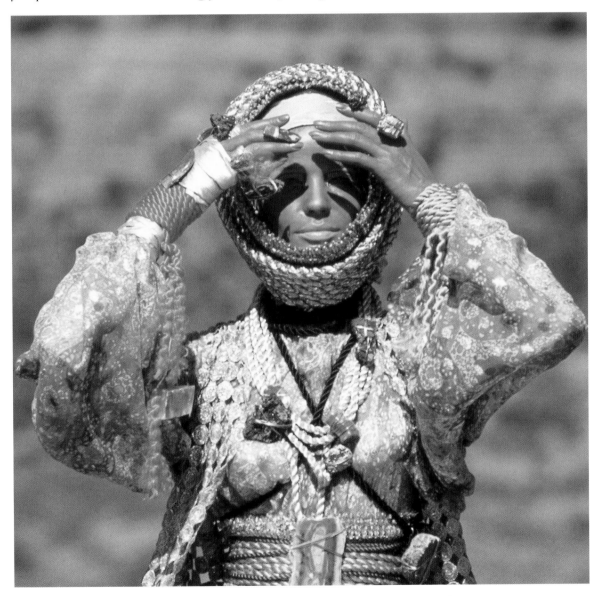

tonight, because I want you here *fresh* in the morning!" Vreeland would also use Veruschka's ideas about landscapes, and the special clothes, after she returned from a shoot: "She would listen and say, 'Oh we should go there.' That was the great thing. That she liked to work with ideas. She would say, 'Please, bring me more ideas. Let me know more.' That's what she wanted."

Veruschka's image in *Vogue* parallels and illustrates Vreeland's creative progression. In the 1963 shots by Bert Stern, the long, lean figure is dressed conservatively with hair coiffed in a small bun. But soon this image gives way to Veruschka in enormous hairpieces; Veruschka with her body painted; Veruschka sphinxlike in Egypt; Veruschka at the beach, her nude body caressed by waves. By the end of the decade Veruschka was the most familiar figure to readers of *Vogue*—her long lithe torso, posing, leaping, stretching—and clothed in marvelous garments ranging from mounds of fur to filmy negligées—Veruschka in a chain bikini or illustrating "The Queen Christina" look, dominating the page in an enormous brimmed hat and a big lace collar over a velvet gown.

The great Veruschka piece of all time, the extravaganza that was so fully charged with Vreeland's fantasies, was "The Great Fur Caravan"—the Japanese journey, which was orchestrated by sittings editor Polly Mellen and photographed by Richard Avedon. It was ambitious in its conception and, for the most part, a total success. It showed twenty-six pages of Veruschka and an enormous Japanese sumo wrestler modeling beautiful furs in the most unusual (even for Vreeland) terrain, the snow-locked countryside on an island off the coast of northern Japan.

Polly Mellen, whom Vreeland hired specifically to work on this fantastic Japanese odyssey, had worked for Vreeland at *Bazaar* in the early fifties and then again in the early sixties. "I had been waiting for the call for so long; and when I

took the telephone, I heard her voice: 'Polly, is your passport in order?' Soon thereafter, we started creating clothes for Veruschka—fifteen caskets of clothes, huge black boxes," which would eventually make up the caravan. There were twelve hat boxes. Ara Gallant did the hair, and one wig was eight feet long. Vreeland's response when she saw this wig was, "'I want twenty feet!'" Mellen also recalls a sable hat that was a foot high. Vreeland insisted it had to be three feet high. As Mellen explains it: "You must exaggerate in photographs to be unique." Despina Messinesi, who made all the arrangements to send out the *Vogue* crew for this trip, guessed it might have cost as much as $100,000.

The high point of the trip was the mock marriage between Veruschka and the wrestler. According to Mellen, Vreeland's method of doing a piece was to "create a fantasy and build you into it." This fantasy featured a gorgeous blond creature who had fallen in love with an enormous Japanese man. It was all supposedly based on Vreeland's favorite book, *The Tale of Genji.*

While Vreeland was working with great creative energy at *Vogue*, something was going very wrong in her husband's life. On June 6, 1966, Reed had checked into New York Hospital. Vreeland told nobody at the office. One day Sarah Slavin, the models editor, went over to New York Hospital to see a friend who had just had a baby. There was Diana Vreeland among the hospital visitors, looking rather bewildered just like everyone else. Slavin wondered what Vreeland was doing there.

Other co-workers caught on that something was wrong, especially when Diana's rituals began to change. For example, Diana always kept staff members working late, but assuaged them at the end of the day by giving them a ride home in her car. In the summer of 1966, however, she went off in her car by herself, abandon-

ing the irritated staff on the sidewalk. She was driving to the hospital.

Reed, who had lost thirty pounds in the last year and had no interest in eating, went into the hospital for tests and he never came out again. The doctors discovered that he had cancer of the esophagus. Diana didn't discuss Reed's illness with anyone. It was one of those deeply disturbing private experiences that she would never share. In 1963, he had been ill with colon cancer, and in 1964, had suffered a heart attack. Still, Diana wanted no one to know.

Talking about his last illness with George Plimpton later, she said, "There is a terrible pain with these things. . . . I'd spend hours and hours and hours in the hospital. I didn't live in the hospital. I didn't live there 24 hours a day the way some people do because Reed wasn't that kind of man at all. . . . He didn't want to in any way be a spectacle. He didn't want anyone to be sorry. He was often in the hall to meet me, you know. Beautifully dressed. . . . He was always very popular with the nurses. He always looked great and made a big point of looking great. He walked and walked—for that's one of the things you can do."

Diana also didn't want Reed to be told that he had cancer, that he was dying. As Diana told Plimpton, "He was very ill. This Godforsaken doctor said, 'Mrs. Vreeland, you're not at all modern. You're very old fashioned. We always tell our patients.' But I said, 'What do you take my husband for, an idiot? Don't you suppose he knows he has cancer?' [The doctor asked,] 'Have you discussed it with him?' 'Of course not, why would he and I discuss cancer? . . . Why tell an intelligent person something they've possibly known for many, many, months—longer than you have?'"

But the doctor persisted and won. Reed was told he had cancer and Diana saw him that night. "Reed had his face to the wall, sort of dopey. 'Well, they've told you and they told me and now it's on the table and now there's nothing to do about it,' he said."

When he died on August 3, 1966, at the age of sixty-seven, Diana was devastated. She drew a little heart in her date book with an arrow through it. She had lost the husband whom she had never stopped loving since they first met in 1923.

Tim Vreeland had come to New York just before Reed died, and went to see his father in the hospital. "His hair was steel gray. The hair I'd seen had always been black. Then I went back to New Mexico—he died soon after. I was shocked. I didn't know he had died. The only reason she told me was that Emi-Lu, who had come to be with Diana, insisted. Mom said, 'I don't want to bother him with that. It's so unpleasant.' Mom and Dad avoided unpleasant subjects. They never liked to face morbid truths."

Susan Train remembers seeing Diana when she came to Paris for the collections the following January. "She adored him and she grieved deeply. We were at one of the couture houses. She always ordered herself two or three things. She found an evening dress she liked. The vendeuse said, 'Do you want it in black?' 'Certainly not. In red. I don't want to remind anyone that I'm in mourning. That's my business.' Although she loved black, that winter she did not have anything in black."

Diana fondly remembered Reed's involvement in her work. Although she was one of the few women in their social set who worked, he thought her job was "part of life." He enjoyed her work. "We used to go abroad—have a wonderful time. It was all part of the fun, we loved all the accoutrements of the job, the amusing people that I knew, the attractive people that I knew, all through work. I should think it would be sort of a problem if the man was sort of poky and sort of wanted to get in on too much, which I think is totally unnecessary. I should think. I don't know. I've only had one husband."

Give them what they never knew
they wanted. —DV

THE HIGH *VOGUE* YEARS

Now that she was on her own, Diana Vreeland was drawn into a crowd that was young, hip and creative. She kept up with the friends she had shared with Reed—the affluent couples and widows who entertained beautifully at their homes in Southampton, Capri or Mallorca, but she gravitated more and more into the new society mixed with fresh, younger personalities. Although Diana was devastated by Reed's death, she was determined to carry on with dignity, and without any outward expression of mourning.

In the fall of 1967, one big party that mixed the old guard with the new talent was Truman Capote's infamous Black and White Ball. Truman, who had spent some five years researching and writing his celebrated true crime book, *In Cold Blood*, had decided to reenter international society by throwing a lavish—and very exclusive—masked ball. As he proclaimed, it was "for Kay Graham and all my friends." For this event, which included a midnight supper of chicken hash and spaghetti, the bill came to between $15,000 and $20,000 (what would be about $120,000 today). It was *the* party of the sixties.

The *New York Times* published the guest list, which named 540 guests: politicians, composers, actors, social figures, painters, writers, diplomats and scientists as well as what Capote called "international types, lots of beautiful women and ravishing little things." Capote included eleven new friends from Garden City, Kansas, the site of the Cutter murders depicted in *In Cold Blood*, a former schoolteacher and a doorman from his apartment building. Andy Warhol, who was just getting "in"

with society, was thrilled to be going. Diana Vreeland was invited, and of course she went.

The party was held in the Plaza Hotel's ballroom, and the dress code was inspired by Cecil Beaton's Ascot scenes in the 1964 film *My Fair Lady:* Men wore dinner jackets and black masks; women, black or white dresses and white masks. Truman said he wanted a visual theme that would unify friends from many different backgrounds. "I want the party to be united the way you make a painting."

Truman Capote and Katharine Graham set up a receiving line in the entranceway to the ballroom, and greeted their guests until after midnight. Capote danced only three times—with Kay Graham, with Lee Radziwill, and with Lauren Bacall—and evidently preferred to stand at the back of the ballroom, taking in the show. It was a spectacular gathering, of the kind of people Vreeland knew from her years as an insider in international society.

That night Diana discovered an unconventional new model, a teenager epitomizing youth breaking with the past. Diana and Richard Avedon had been sitting together, looking at people, when they spotted a remarkable-looking girl in a daring, skimpy, unconventional dress. Tall and slim, she had high cheekbones, enormous eyes and a beguiling face framed by bangs and long hair. Her name was Penelope Tree, and she wore a striking Betsey Johnson dress. As she said, "It was 1966 and everyone else was done up in jewels and feathers and enormous dresses and this was sort of minimalist, so it got a bit of attention."

Penelope had come to the party along with

her sister, Frankie Fitzgerald, and her father, Sir Ronald Tree, and his American wife, Marietta. Patrick Lichfield, a young English photographer and a family friend, remembered: "Penelope appeared downstairs [dressed for the party], and I thought her father was going to have a fit when he saw what she was wearing. It was just the beginning, you know, of that see-through era." Her floor-length black tunic with spaghetti straps had slits up to her ribs and showed a lot of skin. She was the hit of the party, along with the young Amanda Burden, wearing one of Cecil Beaton's *My Fair Lady* costumes.

Tree remembers Vreeland's call the morning after: "'We'd l-o-o-o-o-v-e to photograph you.'" Tree had seen Vreeland, when she was a child, "looking through the balustrades of my house at one of my parents' parties. She looked like this Aztec crow! I took her in, the voice, very loud, very definite, full of adjectives, but they really meant something coming from her." The Vreelands had been good friends of Penelope's father, Ronnie Tree. Her mother, Marietta Tree, on the other hand, "never really 'got' her. If you didn't *get* her—it's like *who* is *this*?" Tree remembered. "She was a great companion one to one. She was interested in everything from the treasures of San Marco to the tilt of a hat. She was interested in life."

As Vreeland began to use Tree in the magazine, a long, affectionate relationship developed between them. For Vreeland, Penelope represented youth, beauty and exuberance. In a 1969 memo, she wrote: "Penelope Tree is one of my

Penelope Tree (above) *and Amanda Burden* (opposite center) *were the hits of Truman Capote's Black and White Ball.*

favorite people—personality-wise and model-wise." And: "Her hair is straight and shiny and looks great. Her body is tall, strong and narrow." Tree believes what made her relationship with Vreeland so wonderful was that Vreeland always tapped into the youth culture. "It was never about the past, it was always about the future."

The years when Tree modeled for *Vogue* were particularly glorious for the magazine. Avedon had been working at *Vogue* since 1965. As Calvin Tomkins writes: "Avedon and Vreeland seemed to stimulate and to push each other to the edge of what was possible in those days, demonstrating again and again Jean Cocteau's famous aphorism that genius lay in knowing how far to go too far." Avedon often photographed the models that Vreeland adored—Penelope Tree, Twiggy, Veruschka, and, later, Marisa Berenson and Lauren Hutton. The first two came across as "offbeat, androgynous, barely preadolescent waif[s]," and they all looked great as they "danced, leaped through the air, rode bicycles, watched TV, bared their breasts, turned cartwheels," and looked perfectly comfortable "wearing the absurd metallic and plastic garments that Courrèges and Rudi Gernreich and other sixties designers cooked up for them, if not for the average Bloomingdale's shopper."

Lauren Hutton first came to New York in the mid-sixties from Florida, where she lived with her mother "on the edge of a swamp," and started as a house model for Christian Dior. Cathy di Montezemolo spotted her and asked her to come

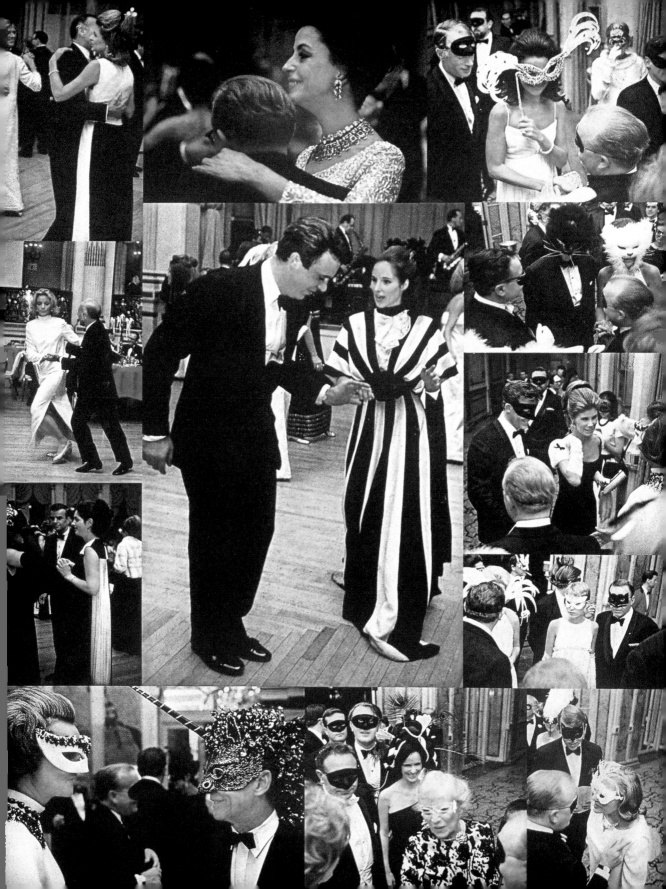

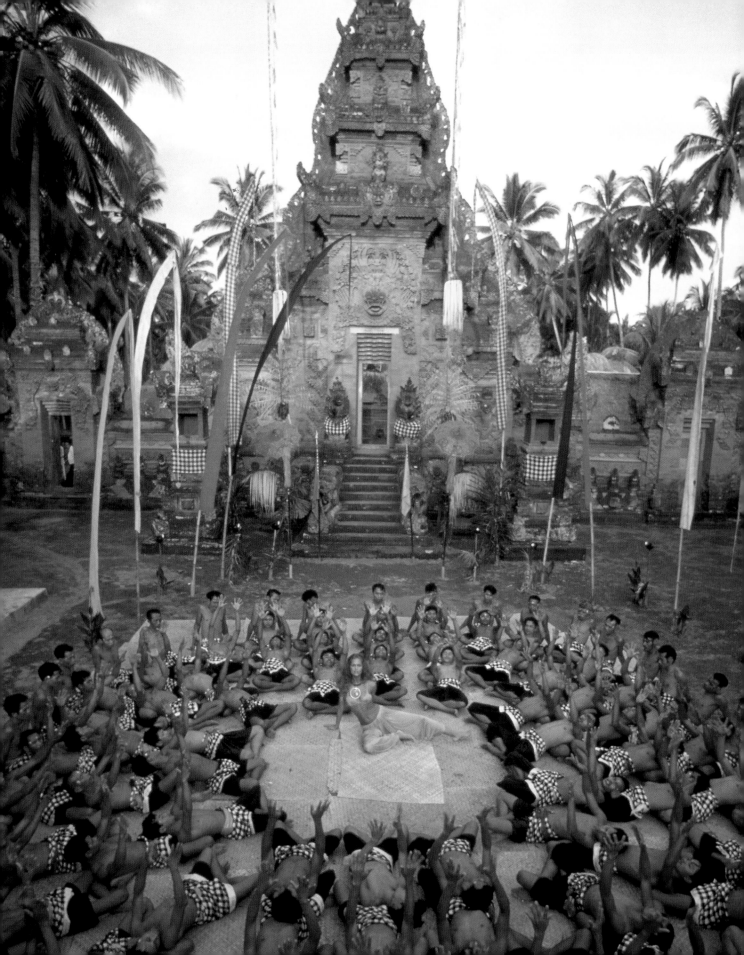

to *Vogue* for a "run through." As Hutton remembered, "To be called to *Vogue* was a very big, big deal, a huge event in a model's life." She found herself in Mrs. Vreeland's long, blood-red office, facing a woman with an enormous nose. (According to Hutton, Diana used to say later about models with small noses, "Wants building up! She has no nose. She needs a nose job, needs to have a nose added.") Her editors sat on a couch near her, next to racks and racks of clothes. Hutton desperately wanted to do what was right, but she ended up retreating to a corner, intimidated, where she could observe what seemed like a scene in a cave filled with alligators.

"She was the ringmaster, cracking the whip, making jokes, saying unbelievable things and playing with people right and left. And I'm sitting here watching this thing and I have no idea how much time went by or what happened, whether it was hours, and suddenly she's looking straight at me with this tremendously long arm and a long finger with a white glove at the end of that pointing right at me. She said, 'You!' I thought I was hidden behind the post. I said, 'Me?' And she said, 'Yes, you. You have quite a presence.' And I didn't know what this meant, but I thought it was good, so I said, 'So do you, ma'am.'"

Diana told Lauren to see her at the end. She looked through Lauren's book of photographs and told her, "I think you'll go to Richard Avedon." Lauren had already been turned down three times by Avedon. She told Diana, "No, ma'am. He said he won't use me." A tiny smile came over Diana's face, then she did something strange with her lips and said, "I think he will."

The next morning Lauren was in Avedon's studio. As Hutton recalls the meeting, he asked her, "'Where did you come from?' And I said, 'Well, sir, I came from a small town.' He said, 'What did you do there?' I said, 'Well, I used to run along the woods and I used to jump over logs.' He asked, 'When you were running, what was it like? What

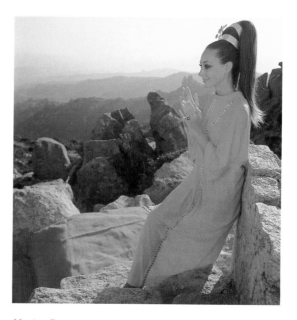

Marisa Berenson on a mountaintop. Opposite: *Lauren Hutton at the center of a male initiation rite in Bali.*

did you do?' I said, 'Oh, you'd have to jump over things.' He said, 'Jump here.' And that was it. Instead of me trying to stand around and pose, Dick was smart enough to use me in the way that I knew how to be used and felt safe. So that first eight pages and the double fold in the beginning came out with me all in the air, running and jumping. And it was the beginning of the running jumping pictures."

Marisa Berenson also started modeling in the mid-sixties as a teenager, when she accepted Gloria Schiff's offer to be photographed for *Vogue*. She had lived abroad and attended schools in Switzerland, Italy and England, and soon after her family came back to New York, her father died. Vreeland, a close family friend, had seen Marisa grow up and felt especially sensitive to the girl's feelings. Berenson had never felt secure about her looks or had a strong sense of self. "I was a very introverted child," Berenson remembers, and her grandmother, Elsa Schiaparelli ("Schiap"), "had been very hard on me." Schiaparelli didn't

Penelope Tree in Diana's office. Opposite: *Twiggy, photographed by Gösta Peterson, on her visit to New York in 1967.*

like the idea of Marisa modeling. "My grandmother was very upset that I was such a success," Berenson said. "She would have liked to have seen her granddaughter marry an aristocrat—and modeling was the farthest thing from that. She never spoke to Diana again, even though they were friends for years and years." Diana used to say that Schiap felt the fashion world Marisa was entering was too much her territory.

As much as Berenson adored her grandmother, Schiap became the jealous sorceress to Berenson, who was a "Sleeping Beauty" of sorts, awakened by Vreeland's kiss of protective maternalism as a fashion mentor and surrogate mother. Vreeland encouraged her to see herself as beautiful, and Berenson blossomed quickly. "Diana made me feel like I could do anything. . . . She taught me a lot about discipline. She took me under her wing and I felt so protected. She was so

much like family. I was closer to Diana than to my grandmother." Soon Berenson was on the cover of *Vogue*, working with Irving Penn, Richard Avedon, Bert Stern, David Bailey and Helmut Newton, and she often went to Paris to be photographed in the clothes from the collections. Lauren Hutton and Marisa Berenson now joined the stable of Vreeland's favorite models along with Veruschka and Penelope Tree.

As Vreeland said later about Twiggy: "I didn't discover her—not actually." Before Vreeland used her, the striking young model had made an instant hit in England and was named "the face of '66" in the *Daily Express*. Although Irving Penn turned her away and told her to come back in ten years, Bert Stern photographed her for *Vogue* at the Paris collections in 1967, and Diana was delighted with the results. Twiggy went on to work with Avedon, and this experience became her "passport to American advertising." Twiggy's popularity in many ways redefined the public's conception of the model; unlike her more mature, ultrafeminine predecessors, Twiggy was slightly androgynous, with a wide-eyed, decidedly adolescent effect that appealed to fashion-conscious youths. (Her long, skinny limbs and babyish demeanor foreshadowed the "waif" craze that continues to dominate contemporary haute couture.) Twiggy's subsequent trip to New York turned out to be a major media event and made her an instant American star. She was received like the Beatles as crowds thronged to see her all over the city. She was interviewed by Woody Allen and given a ticker-tape parade up Fifth Avenue.

Like most of Vreeland's models, Twiggy immediately responded to Diana. "Going to meet her was like going to meet the Queen. She was over the top, and would go on about how she 'adored' me. I know I probably owe most of what happened in New York to her."

The British theme continued to fascinate Vreeland and in the November 15, 1967, issue

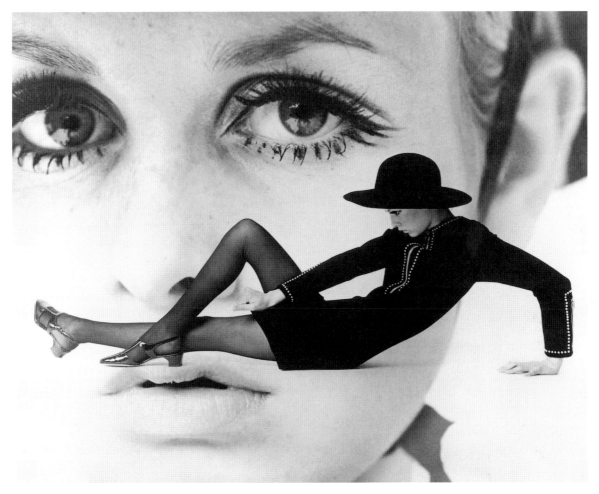

she included features on both youth and age. "Men Now" featured Patrick Lichfield, Don Jaime de Mesia, Viscount Gormanston, Lord Herkuth, Christopher Sykes, and Stella Astor.

Another obvious British subject was the Duke of Windsor, and Vreeland summoned Patrick Lichfield from Sardinia especially to photograph him. Lichfield, who was young and ambitious, was delighted to be given his first contract by this powerful fashion editor. He had been working for *Queen* magazine in England, and was engaged in a shoot for the Aga Khan in Sardinia when he got the telegram asking him to meet "Vreeland" at the Crillon in Paris. Lichfield

asked Jocelyn Stephens, then the proprietor of *Queen*, who Vreeland was. "If it's her you'd better swim off this island!" Stephens replied. "Get there just any old how."

Lichfield hitched a lift from the Aga Khan on his jet and headed straight to the Crillon. Vreeland and her assistants were in their flower-filled suite when the assistant director of the hotel came in looking rather like an undertaker in his black suit. He reported that Mr. Lichfield had arrived, and he was extremely agitated because the new arrival had long hair, was dressed in jeans and a T-shirt, and had no luggage. Many strange-looking people came to see

Diana Vreeland, but arriving at the Crillon was strictly a suit and cravat affair.

The assistant director asked Mrs. Vreeland if she knew Mr. Lichfield, at which point, as Susan Train remembers, Mrs. Vreeland rose out of her chair, made herself tall and delivered: "'Of *course* I know him. The *Earl* of *Lichfield* has arrived on the private plane of the *Aga Khan*. His luggage will doubtless follow. And by the way, you might want to *know* that *the Earl* of Lichfield is a *cousin* of the *Queen* of England.' At which point, this man bows from the waist and backs out of the room. As soon as the double doors were closed, we burst into laughter and tears ran down our faces. Mrs. Vreeland sat there, dignified, and then finally, she let out a huge guffaw."

Lichfield was waiting at the bar when the legendary Diana Vreeland walked in, introduced herself and sat down. She said to him, "Who's the best-dressed man in the world?" Lichfield was so terrified that he said, "Me." And she said, "First question right. Who's the second?" Thinking of her age and trying to pander to her taste, he replied, "The Duke of Windsor." And then she ordered Lichfield to go and photograph him the next day, and to be back at the Crillon by evening. "I want to see ten eight-by-ten glossies."

The next day was July 29, 1966, and England was playing Germany for the World Cup. Lichfield had contacted the duke's secretary, who agreed to tell the duke and duchess that he was coming, but warned that the duke might not let him take photographs because he would be watching the World Cup.

Lichfield went to the Moulin de la Tuilerie, where the Duke of Windsor was watching television and didn't want to be disturbed. He quietly took a few photographs from behind the duke while he was watching the little black-and-white set. "There was the king of England, ex-king of England, watching his former country beating the Germans. There was something very ironic there.

It was thirty years after the whole Hitler thing was stirring, and there we were beating the Germans." Lichfield photographed His Royal Highness tying the Windsor knot. Those were the pictures he gave Vreeland, and she gave him a ten-year contract. When he gave her the prints, he didn't show the duke's face, he just showed him tying the Windsor knot. "There you are, the Duke of Windsor," he told her, and she said, "Right. That's witty and intelligent."

Lichfield often saw Diana sitting in state in her red living room at 550 Park Avenue, "with her nose in the air, smoke rings going up, in that red, red room, that lush room." Once, when he and David Bailey had finished a job, they gathered there with Jean Shrimpton, Bailey's girlfriend, and Lichfield's girlfriend, Britt Ekland. Vreeland said, "Now, Lichfield, you've just done some great pictures, and I love what you're doing, and now we'd like you to go on doing it." The photographer said a sort of polite "Thank you, Mrs. Vreeland, for your kind words, and I love working for you." And then she said, "Now, Bailey, you're better than Lichfield and you take much better pictures than him," and Bailey was flabbergasted. And there was a long gap, and then he made an immortal remark that only she, a woman with her style, could have taken the way she did. He said, "Gosh, Mrs. Vreeland, if you were twenty years younger, I'd love to fuck you." As Lichfield recalls, "She just loved it. A lot of women her age would have been shocked and horrified, but she had this amazing style."

"We used to feel, if we wanted to go out to dinner, us boys, and we wanted a spare girl, Vreeland would be fine because she was one of us, one of the boys," said Lichfield. They took her to funny little restaurants in the Village, they took her to rock concerts. If she took them out, they

Mary Quant, an important "youthquake" designer, helped extinguish fashion elitism. Now "you will find a duchess jostling with a typist to buy the same dresses," said Quant.

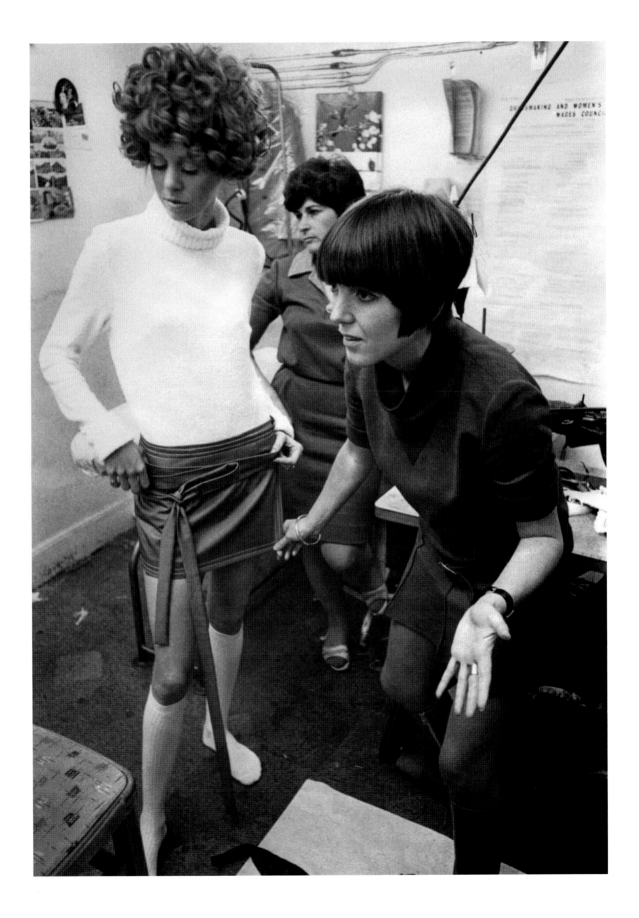

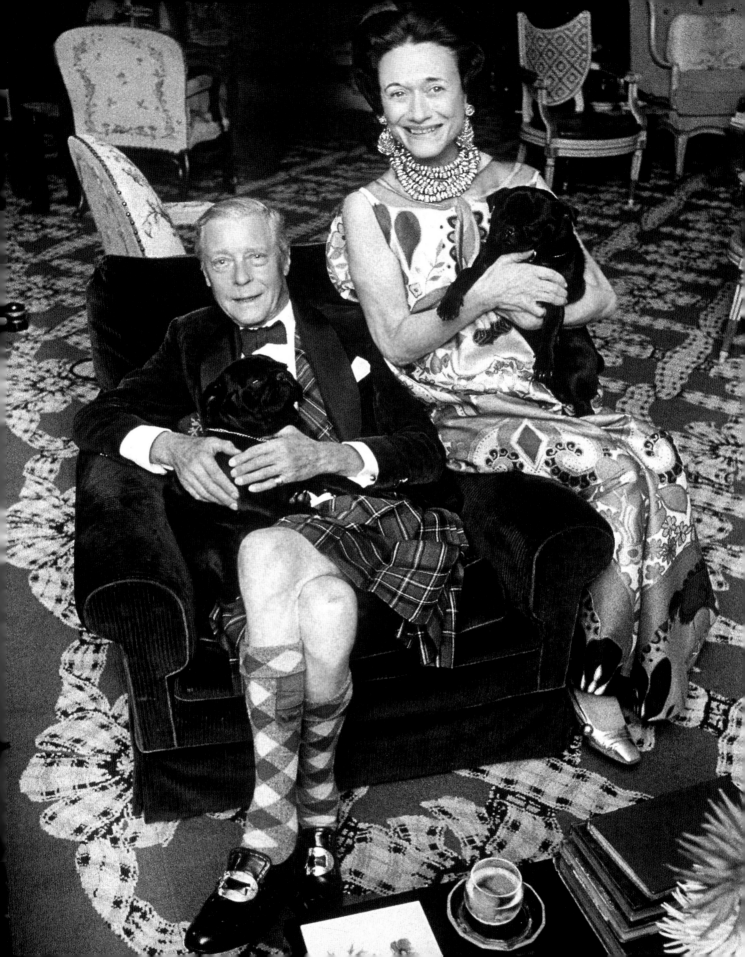

had to dress up and go to La Grenouille. "I think that anyone who has been touched by a woman of such originality as Diana never forgets it."

After Reed died, these young men filled up the void in Diana's life. The jewelry designer Kenneth Jay Lane met Diana when he first came to New York just out of college in the mid-fifties. "The first thing I told her was 'I've got these shoes and they are waxed calf and they don't take polish. I'm afraid they have to be boned.' She said 'Oh my god!'" She added, "'You know that in the entire city of New York, you cannot find a rhinoceros horn!' It was love at first sight!"

Both intensely creative, they liked the same combination of the elegant and the funky. Lane remembers: "She made me realize the importance of positive thinking. She would say, 'Don't look back. Just go ahead. Give ideas away. Under every idea there's a new idea waiting to be born.' What she wouldn't bear was complaints."

After Reed's death, Kenny accompanied Vreeland to movies and parties. "[Diana] became quite disinterested in society with a capital S." As

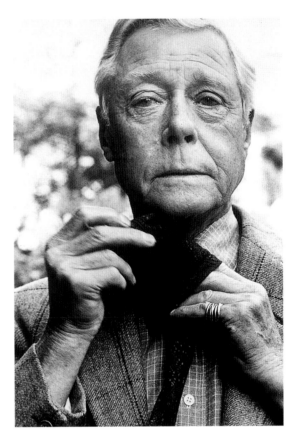

The result of Patrick Lichfield's visit to the Windsors' was a Vogue spread entitled "A weekend with HRH the Duke and Duchess of Windsor." The aging couple was seen lounging on a garden bench with their black Labrador in the foreground, and in evening dress clasping their pugs (opposite), which Vreeland loved because "their faces look just like roses." At the end was a shot of HRH tying the Windsor knot, as well as a view of the ducal closet (an enormous room) full of plaid kilts and coats, open for the reader to see.

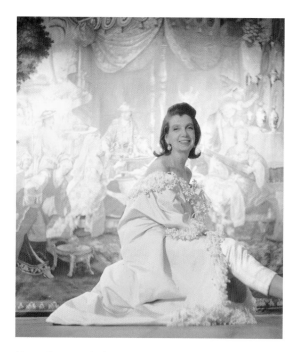

Horst photographed Pauline de Rothschild for Vogue *(above) and with her husband, Philippe (opposite). She dedicated her extraordinary book,* The Irrational Journey, *to Diana: "It has your strength."*

Kenny remembers, "She would see Marisa Berenson, Patrick Lichfield, David Bailey, Andy Warhol. She wanted youthful energy—Halston, occasionally Jack Nicholson. She didn't want to go to Brooke Astor's dinners anymore."

One of Diana's favorite English connections was Tony Snowdon, who did many photographs for her Christmas issues—white swans for December 1965, white horses for 1967 and, as she was fascinated by the novel *Moby-Dick*, white whales for 1968. Snowdon was primarily known for serious photojournalism, and Diana gave him a chance to be artistic. He drew the line, however, at being politically incorrect. One time she phoned him and announced to "Tony dahling" that she would love some photographs of white tigers in India. "They're so *aristocratic*, so *ravishing*." "*But, Deeanna*, there's a war going on between

Pakistan and India. All my photographer friends are going to shoot that. I can't take *white* tigers!"

Diana's old friend Horst now started a new career at *Vogue*, capturing the houses of jet-setters on film, in brilliant photographs that made lush, colorful spreads. He was producing for Diana "articles about people in their houses and gardens, where they felt the best and most natural." It was their "lifestyle" that she wanted captured—a new concept at that time. Horst also did four *Vogue* articles on Diana's friend la Baronne Pauline de Rothschild, at both her château and at her apartment in Paris. He found that visiting Pauline and her husband, Philippe, whose housekeeping was famous for its fastidious, artistic perfection, was like "playing a minor role in a famous novel or looking on while a future masterpiece was in the making."

For the February 1967 issue, Vreeland assigned Horst and Valentine Lawford to photograph and write up the White House gardens to show the restoration of the whole garden that President Kennedy, who was a great admirer of Thomas Jefferson, had done. The piece began with Jefferson's enthusiasm for planting, and gave the entire history of the White House gardens, from James Monroe's fear of guests falling into holes on the grounds, to Theodore Roosevelt's destruction of a greenhouse where the executive wing now stands.

In the late sixties Vreeland continued to send her young models and photographers to many exotic lands for shoots, such as the one for which Lauren Hutton and Pilar Crespi were sent to Bali. The climax of several weeks of work there was a religious procession that wound from "temple to sea." The frightened young models realized midway through the procession that they were posing for *Vogue* in the middle of a Balinese male initiation ritual! As Arnaud de Rosnay snapped photographs, panting men crowded around Lauren and Pilar until it became alarmingly clear that women were not

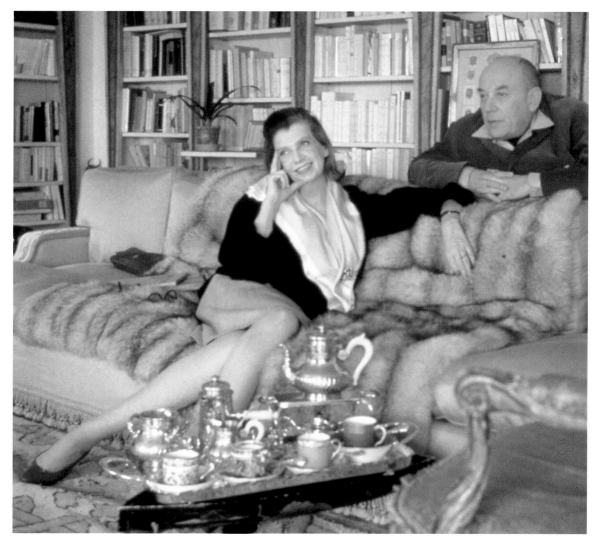

intended to watch that particular ceremony. Frustrated and overwhelmed by the "waves of testosterone," both models walked off the shoot early.

While Lauren and Pilar went to Bali with Arnaud de Rosnay, Penelope Tree and David Bailey were still jetting around the world together. But by mid-June 1969, Vreeland was cutting back on her far-flung junkets. She wrote to Tree: "I feel that we have been doing deserts and great monuments too much lately and for a while are calling a halt. . . . I only wish we could get you

both to the moon and that will be a great relief. It won't be far off. . . ."

As the decade wore on, issue after issue was filled with rich Vreeland delights: Penn's photo essays of beautiful flowers accompanied by an article by Anthony West; photography paired with fine art, as in four white horses by Snowdon with horse paintings; a photo essay on Nureyev by Avedon amid drawings by Michelangelo, again showing Vreeland's gift for responding to the new while situating it in the context of the past.

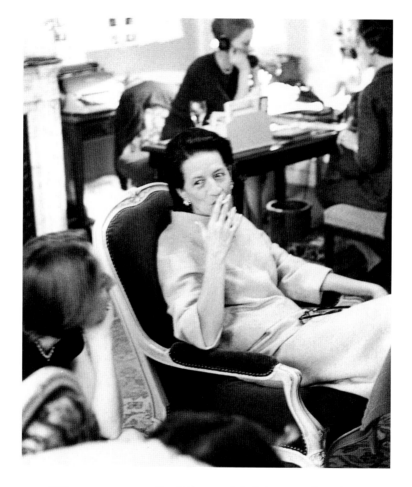

*When our new fashions—high boots, leather
clothes, scarlet, green and gold stockings, streaming
hair, etc.—arrived in the provinces, then
the deluge came, with letters reading, "When are
you going to publish the clothes for the
real women?" R-E-E-L—that's how I spelled it.
—Diana Vreeland, in* Rolling Stone

THE LAST COLLECTIONS IN PARIS

When Diana moved up at last from being number two at *Harper's Bazaar* to number one at *Vogue*, one of the privileges she most enjoyed was representing *Vogue* at the grand couture shows in Paris every July for fall fashion and every January for spring. There she and her retinue occupied a large suite at the Crillon, working through the night to photograph models wearing the fantastic clothes Diana had picked out that day.

Diana commanded the greatest respect among the designers. As Yves Saint Laurent, whose work she had championed since the 1950s, later said, "Mrs. Vreeland was one of the most exceptional people I have met in all my life. Her force of character, her glamour, her intelligence, her innate sense of elegance and her exuberance energized all those who met her." To this day a Bérard watercolor of Diana hangs in the place of honor over the mantelpiece behind his office desk. Pierre Bergé claimed that Diana Vreeland "belonged to that breed of women who take fate by the throat and oblige it to surrender"; he recognized "the elegance of her soul and the elegance of her heart."

Being number one at *Vogue* meant that Diana Vreeland was a high-voltage presence at the collections, and the impression she made was not accidental but resulted from meticulous preparations. Denise Doyle remembered her leaving from New York with trunks of accessories for the sittings—hundreds of pairs of shoes and hundreds of bracelets and earrings and hats and hairpieces, all packed in large black boxes by her loyal staff. She also took everything she needed for other *Vogue* business, as well as pieces upon pieces of her own Louis Vuitton luggage.

Paris was Vreeland's spiritual home, and the beautiful city with its cosmopolitan grandeur never disappointed her. Her enthusiasm infected everyone around her. Once, when she took Felicity Clark to the collections and discovered it was Clark's first visit to Paris, she decided to educate her. On their way to lunch, she told the driver to stop the car. "This child has never been to Paris!" she shouted. As Clark remembers, "We stopped so that we could see that arch that goes through to the Tuileries, and to the Arc de Triomphe. I never ever go past that now without thinking of her."

Vreeland worked ceaselessly. Her young staff began early each morning, and the activity continued into the early hours of the next day, as the clothes were photographed at night. Her bedroom and bath were adjacent to the suite/office, so the young women became aware of her curious work habits. Susan Train remembers how Diana would start to work the minute she woke up. "Coffee. Bowl of porridge. Then she would go into her bathroom, where she spent more time than any living human being. I have no idea what she was doing in the bathroom," Train recalls, "but it was an hour. When she came out, she wasn't made up, mind you, but there were little scratch pads everywhere in the bathroom; every available surface had a scratch pad, and as the ideas would come to her, soaking in the bath or whatever she was doing, she'd write things down." Telephone messages were shouted through the bathroom door, "and finally she would emerge from the bathroom in her little slip, the face shiny with cream, I suppose,

and then she would sit down at her dressing table and put on her makeup, and I'd sit beside her taking notes. . . . So we'd go over the collections and things and the day would go on."

Train also observed Vreeland's instinct for the beautiful. At the end of a Balenciaga show, when they were discussing what they had seen and which things to photograph, Vreeland mentioned a red dress with an interesting cut on the bias. The vendeuse came in and asked if they wanted to see any-thing, and Train asked for the red dress. A strange look came over the face of the vendeuse. When Susan went back to the dressing room to find it, there was not one red dress to be seen. She decided to take down a green dress, one that she had admired from the start. She took it out to Vreeland, who said, "Yes, yes, that's the one." As Susan remembers, "She didn't worry about the fact that it was green instead of red. She didn't like it in green; she didn't want it in green; she didn't think that green was a good color for evening. Black, white and red are for evening. She looked at the dress and thought it would be a great dress in red, so she saw it in red."

When not occupied with the magazine, Diana was entertained by old friends and would later regale the girls with stories about Parisian evenings. She might dine with Chanel at her house with the mirrors and beautiful screens. Or she would enjoy, along with the others, Philippe de Rothschild's own champagne sent by the case to the Crillon especially for them.

Diana's close friend, the Baronne Pauline de Rothschild, recalled seeing her at dinner in Paris in 1967. "Diana of the two coats, what a lovely image to carry with me. The eye's memory cannot tire of all that color, the delightful outline of the black hair against the white wall, like that of a fashionable samurai, the intense femininity of gestures, the intonations, the unexpected turn of each story told, all these will protect one from any grayness, any distaste, and take one straight back into a special sort of perfection."

Pauline Potter, the wife of Baron Philippe de Rothschild, and Diana had a lot in common. Just three years younger than Diana, Pauline grew up in France —the same childhood Diana had imagined for herself. Like Diana, Pauline was a debutante, but came out in Baltimore, not in New York. Both women had ample personal magnetism that compensated for their lack of conventional beauty. Both were marvelous dancers.

Their enthusiasm for clothes brought them together. Like Diana, Pauline had a way of enhancing whatever she wore: "Maybe she would add one flower or maybe carry an extraordinary bag," and the result "was a very personal style added to great simplicity." Both were notoriously late for appointments. Both had experienced financial difficulties to which they responded in a similar way, Diana by opening a shop in London for lingerie, Pauline, in Mallorca for local handicrafts. Both succeeded famously in the fashion world, Pauline working for Schiaparelli and designing for Hattie Carnegie. Finally, Diana and Pauline both had husbands

famous for their impeccable wardrobes. But the core of their friendship was their shared love of beauty, fashion, literature and each other. One of the many affectionate letters to Diana that Pauline wrote reads: "My Dearest Diana, There are people in the world with whom one is radiantly happy. You are one of them."

The Duchess of Windsor was another good friend of Diana's in Paris. Wallis was an attractive and stylish woman from Baltimore, like Pauline Potter. But unlike Pauline, she didn't like living in France. In 1967, she complained to Diana that Paris was often "dull." While she liked dancing at balls, she was tired of the dressy "premières" of theatre and music, as she felt that she and the Duke of Windsor were "too old to go anyway." She couldn't stand listening to the loud French on television; and she complained that the French drove too fast. In a poignant letter to Diana, Wallis tried to get to the heart of her unhappiness: "I find this a lonely country for foreigners whereas the U.S. is not." Wallis, however, was cheered up by visits that Diana described so affectionately: "The Duchess looked too beautiful, standing in the garden, dressed in a turquoise djellaba embroidered in black pearls and white pearls—marvelous—and wearing all her sapphires. She was so affectionate, a loving sort of friend—very rare, you know. Women are rarely that sort of friend to each other."

In June 1969, Vreeland got wind of an exciting Parisian happening that she was sure would make a terrific article—a sumptuous costume party with an oriental theme, to be given by the Baron Alexis de Redé in his palace, the Hôtel Lambert on the Ile-Saint-Louis. To create the kind of spread she wanted, preparation was the key. Her memos show Vreeland at her best, marshaling her staff, activating her network, combining research with on-the-spot reportage to get a dazzling story. She wrote to Susan Train to make a list of costumes, many of which were by Dior, Saint Laurent and other designers. "It will be Persian, Chinese, Indian, etc. I think you should know well before the ball who will have the most interesting and amusing costumes." She wanted Susan to see the house the day before the ball. "Details and spellings you must have at the tips of your fingers and all titles, so that the information can go out very, very fast." Research was done into past *Vogue* spreads on fabulous costume balls. The piece would capture the sort of ritual Vreeland adored—the Parisian costume party with its historic, distinguished tradition.

Valerian Rybar and Jean-François Daigre decorated the Hôtel Lambert for the de Redé ball. Musicians were part of the decor, dressed as mandarins in red with gold-embroidered dragons. The guests arrived and were escorted through the courtyard "by servants in magenta silk holding huge pink and gold parasols, and greeted by volleys from Indian drummers in palanquins on top of two life-size elephants, richly jeweled and caparisoned."

At one in the morning the nightclub in an adjoining apartment opened to reveal a "Turquerie" in rotunda shape: hemispheric ceiling in ultramarine blue starred with gold, held by columns decorated as palm trees, alcoves in ruby red velvet, lined with mirrors and *moucharabiehs*, multicolored Turkish lanterns. The guests danced to loud discotheque music, a sharp contrast to the Japanese and Chinese orchestras, which played in the Galerie d'Hercule, where the baron greeted his guests.

Vreeland did not go to the ball and had masterminded reportage from New York. She did not go to Paris for the collections in the winter of 1970, either. The strain of the shows was getting to be too much for her, although she would be the last to admit it. She was sixty-six years old. But she did go back to her favorite city in the summer of 1970, for what would be the last time as *Vogue* editor.

As always, she was struck with the overall excitement of the spectacle. In the atmosphere of an international, cosmopolitan bazaar, the collections were the ultimate realization of Diana's fantasies when she was a bored and frustrated New York teenager. As she described it: "To go into a great French fashion house with its high ceilinged room, filled with massed flowers and ferns is always an event of refreshment and excitement. . . . There are dashing personalities of every nationality, rich merchants' wives from Beirut and Kuwait, jewelers and diamond merchants, and the great fabric makers of Switzerland and Italy, France and En-

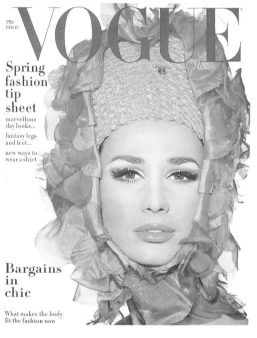

gland." Clearly, Diana reveled in her stature, in being part of the world she dreamed about when she was an adolescent.

While in Paris, she bombarded her New York editors with memos brimming with her unflagging enthusiasm, her sense of teamwork, and the story ideas that were taking shape in her mind. Each day she reported on everything from capes, jacket lengths, knits, nose surgery and hair lengths, to the different blues of denim. This correspondence captures Diana's irresistible enthusiasm, as much as it hints at her aloofness about the world and how it was changing. The 1960s were coming to an end and women were about to enter a new period.

Vreeland always felt that what European women —and particularly young women in Paris—wore on the streets, in the restaurants, as well as on the runways, exhibited great style. Now she looked around her and fired off telexes proclaiming her observations. On July 21, 1970, she wrote to her editors, Blackmon, Gross and Canné: "Want to tell you—girls are prettier more feminine and less tired. Seem full of secrets and sweetness here." She commented not only on an inner quality, but on what women were wearing—noting the continuing popularity of boots, and particularly the strapped look with a heel.

On July 23, she informed her editors about her disappointment over the Carita liquid eye makeup. The look of one girl, however, really wowed her—"with ink black hair full straight and cut to middle of neck." She had "fuchsia exactly

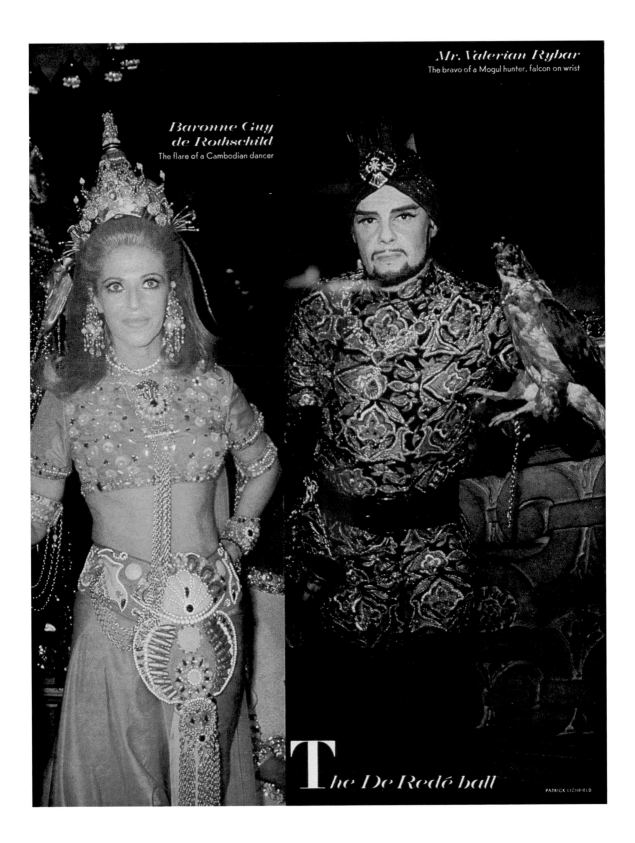

Mr. Valerian Rybar
The bravo of a Mogul hunter, falcon on wrist

*Baronne Guy
de Rothschild*
The flare of a Cambodian dancer

The De Redé ball

PATRICK LICHFIELD

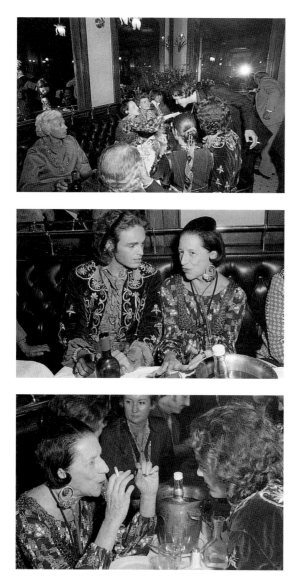

Diana with Patrice Calmettes at Maxim's in Paris.
Page 179: The de Redé ball was a fabulous spectacle and
a great Vogue subject. The guest list included the world's
social elite who arrived complete with jeweled head-
dresses, bare midriffs, elaborate dresses, and feathers.
Baronne Guy de Rothschild came as a Cambodian
dancer and Valerian Rybar came as a Mongol hunter
with a falcon on his arm.

fuchsia eyelids by mixing coral pink and a shot of deep green blue and was smashing." For Vreeland, who painted herself with rouge and loved such experimentation, this was the "first news in makeup since no eyebrows."

As noses were important to Diana, she suggested that there be definitions of technical words in an upcoming article on nose surgery: septum, columella, iliac bone and mucus. "Think captions beside each nose picture very important. The nose itself is the instrument of sensuality that controls the entire face. It is the interesting larger nose that expresses the senses and the character and projects the person more than the smaller nose."

The hairstyles at the collections that summer were decidedly short, and being practical, Vreeland admired this trend. "Mary Russell with marvelous layer hair done by Christophe also Talitha Getty who before prided herself on her marvelous long honey hair has now hers cut and layered to the shoulders." She also noticed how the short hair styles looked rather like hers, but were "closer on head and sides but always loose and naturally full. Makes necks very long and gives faces a flower quality on a stem." She particularly liked the collections of Valentino, Bohan and Saint Laurent. The clothes of Chanel, Cardin, Dior, Grès, Courrèges and Ungaro were also photographed for the magazine.

While in Paris for the collections, Vreeland saw her friend Patrice Calmettes, a favorite young photographer she had met at a party given by Arnaud de Rosnay on a boat in the Seine. At the end of her stay, he took her to the airport. She wrote from New York: "Here I am sitting in my little flat surrounded by the spoils of Paris—boots and shoes and belts and bags and a few dresses that I had time enough to fit." She remembered Paris as a city of many facets, with the power to liberate one from the mundane and "with the most beautiful boys and girls in the world. After two weeks of solid fashion one realizes that come

hell or high water fashion goes its merry way and the view and appearance of fashion this summer showed this to me again as it has all my life." She had been at the epicenter of fashion—an experience that always made her feel centered herself. But what she considered central was not necessarily that important to the new American woman who was reading *Vogue* in the 1970s.

For the 1970 Christmas issue, which would be Diana's last, she gave Tony Snowdon, or "Snowshoes," another assignment that got the two of them into trouble. Vreeland wanted Snowdon to photograph Charles Engelhard's Canadian-bred wonder horse, Nijinsky, who had won the English Derby. Snowdon went over to Ireland, where Nijinsky was training, and when he couldn't get a good shot of the horse, the trainer's wife suggested he take some photos of Nijinsky's half brother, Minsky. They turned out wonderfully. Undaunted, Snowdon also got a shot of Nijinsky by setting up a camera in front of the television in his living room and waiting for Nijinsky to cross the finish line on the afternoon of the St. Leger race. As Snowdon tells it, "There were lines that came on it—it was sort of arty." When *Vogue* called for the prints, Snowdon was away. His assistant sent off photographs, filed under "Nijinsky," which were actually the photographs of Minsky. Six pages of the wrong horse were printed in the December 1970 issue.

"Nijinsky, the $5,440,000 wonder horse" was billed as having been photographed by Snowdon and written about by G. F. T. Ryall. On December 3, Vreeland received a letter from Charles Engelhard thanking her for "her interest in Nijinsky." But he had to tell her that "someone had goofed in a big way and had used MINSKY's very chestnut head instead of NIJINSKY's." He then told a joke on himself: "In point of fact, on the Q.E. 2, I was given an attractive book of short stories on racing, including an extremely nice one on NIJINSKY by John Lawrence." He ordered

fifty of them to be sent to the members of the Nijinsky syndicate. "To my horror, I received a cabled reply that in case I did not realize it the horse on the front picture was not NIJINSKY but RIBOFILIO. Perhaps you might like to pass this on to whomever made the error as it might make them feel a little better."

C. Z. Guest was at the hairdresser's when she picked up *Vogue* and saw the picture. She recalled, "It said 'Nijinsky,' and I looked at the photograph and knew it wasn't Nijinsky because we had a horse running against him." She called up *Vogue* and said, "'Diana! I've just seen the picture in *Vogue* of the Season at Belmont, and it isn't Nijinsky.' She said, 'You're the only person who knew what he looked like. It's so terrible. I don't know what to do. I don't know what to tell Charlie Engelhard.' I said, 'Well, it's just a mistake.' I'll never forget it. It's the only time I ever caught her in anything. She was so upset."

The time had come when the powers at *Vogue* were becoming more critical of Vreeland's performance. When Carrie Donovan was recuperating from surgery in Texas, she sensed that trouble was brewing at the magazine. She repeatedly got phone calls from Alexander Liberman at the magazine saying, "Please, dear, when are you coming back?"

Then Carrie was sent to the collections in Paris, and when she got back, Perry Ruston, president of Condé Nast, called her into his office and questioned her about the expenses of the *Vogue* office at the Crillon—how many people's desks and telephone lines were moved over for the collections. Did she think it could be done more economically? "I was trying to play both sides in that conversation," Carrie recalled. "When I came out, I was very disturbed. I asked Mrs. Vreeland to have lunch that Saturday. I was worried that these business guys were getting out of hand."

Even though Carrie Donovan tried to warn her boss that the businessmen at Condé Nast

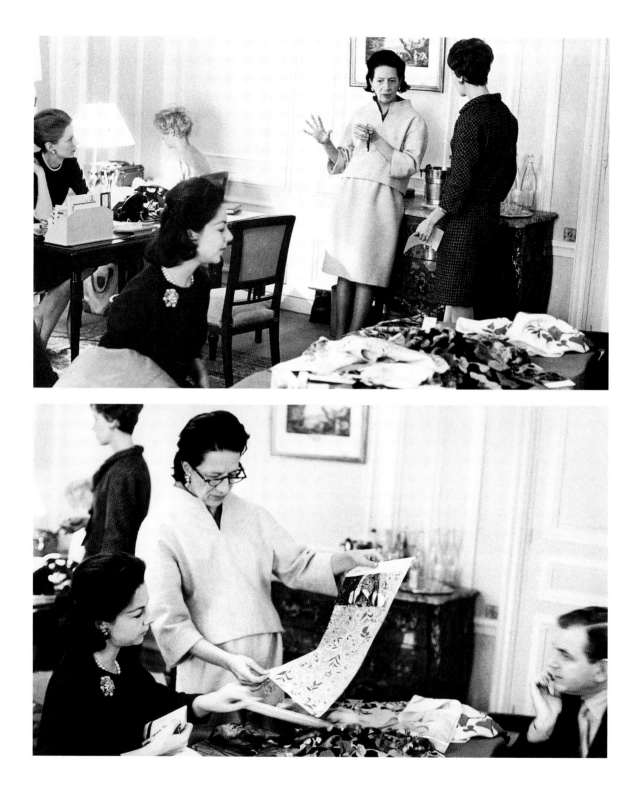

were finding Diana's editorial style too costly, and her message out of touch with the times, the older editor didn't hear her. She only replied, "Oh, I'm used to it from the Hearst years. I know how to handle those men. When they get this way, you just give it to them back." She thought that by being more tyrannical she could handle them. She was wrong.

There are a number of stories about Vreeland's being fired from *Vogue*. Although slightly different in their details, they all tell how Diana was taken by surprise. One day in the late winter, Donovan went by the famous office looking for her boss. Her secretary told her that Mrs. Vreeland was in Mr. Ruston's office. According to Donovan, Diana came back upstairs, went into her office and closed the door. Although she did not discuss at length what had happened between her and her employers, Carrie Donovan knew that she was "totally unprepared" for what happened. Grace Mirabella remembers getting a call from Perry Ruston when she was out in California; he told her to be in his office the next day at nine o'clock. She came home and they offered her the job. She, too, was completely surprised.

S. I. Newhouse, who had become publisher of Condé Nast in 1964, was asked to talk to Diana after she had gotten the bad news. He found it very awkward. He found himself facing this very accomplished and impressive woman. "I sat and looked at her and she looked at me for what seemed like a long time. I said I was sorry things hadn't worked out. She was very fine and elegant about the whole thing."

The announcement was not made public until May, but colleagues at the office found out earlier. In April, Cecil Beaton received a letter from his good friend Margaret Case: "Never more unhappy or frightened in my whole long existence. The joy and inspiration of work has gone—life in its most cruel terms seems closing in on me. A month or so ago a printed inner-

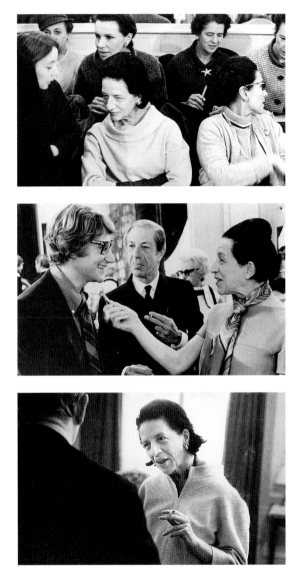

In Paris the Vogue *office was moved to a suite in the Crillon for the collections.* Opposite: *Diana talking to Susan Train (top) and Consuelo Crespi (bottom).* Top: *Diana at a fashion show with* Vogue *editors Françoise de Langlade, later de la Renta (back row, leaning forward), and Babs Simpson (front row, left), and Edmonde de Charles-Roux, editor of French* Vogue. Middle: *Diana with Yves Saint Laurent (left) and Niki de Gunzburg.*

office announcement said Miss Grace Mirabella had been appointed Editor of *Vogue* (an assistant to Diana, devoid of editorial ability, personality, education, or sophistication). . . . Now I hear the awful truth from her—Diana will be relieved of her active duty and become Consultant Editor of *Vogue* (on full salary until Jan 1972, then on a greatly reduced retainer). Do not tell anyone or indicate to Diana in any way you know this terrible fact. When I asked if I could write you she said 'no. Please wait until officially announced just before I leave for Europe which will be within the next two weeks.' As she expects to remain abroad for two months you can find out more from her personally. What fools the new powers that be are. Before stupidity even the Gods quail. Off stage the shades of Condé Nast, Frank Crowninshield, you, and me. Can you hear the axes beginning to chop down the trees in the cherry orchard!"

The way it was told afterward by some *Vogue* staff members, like longtime editor Babs Simpson, was that Vreeland was a wonderful editor for her first four or five years at *Vogue*—"the greatest fashion editor that ever lived"—but then "what brought us down was that she persisted in doing flower children and blue faces and orange hair after all that was over. . . . Seventh Avenue designers were up in arms—Adele Simpson didn't want her name in our pages." Vreeland only went to the Paris collections that amused her—Balenciaga, Givenchy and Saint Laurent. The other designers were furious.

Alex Liberman said, "It was like trying to catch up with a wild horse. Everything was extravagance and luxury and excess. She was given too much power; she took too much power. I was the editorial director. I would be presented with a layout that she had done with Priscilla Peck [who adored her], and I would say, 'We can't give sixteen pages to this, it's too much.'" Her court of admirers would defend

her and it made Liberman feel "sort of impotent. The business side was very upset. Circulation was dropping, there were complaints from the stores, we were losing advertising—the whole thing just got out of control." In the first three months of 1971, *Vogue* had suffered a 38 percent loss in advertising pages. (*Bazaar* also suffered a 37 percent loss, but *Glamour* lost only 3 percent.) Former *Mademoiselle* editor Betsy Blackwell was quoted as saying, "Perhaps *Vogue* should be less haute, and more in keeping with today's attitudes."

When she first came to *Vogue*, Diana was seen by S. I. Newhouse as "quite an exotic figure, charged with an animal nature." Her walk, the way she moved and talked with her hands fascinated him. As he explains it, her leaving came about when the "recession had hit the fashion industry." Women weren't interested in instantly reacting to new fashion trends. "One year when Paris hiked up skirts, everyone rushed out to get short skirts. Suddenly the next year they went down. Women didn't like to be in a position where you spent a lot of money on clothes and then you couldn't wear them.

"Diana's *Vogue* was out of date. There was a shift away from the exotic world that she captured and in part created. *Vogue* started to do badly," and the whole industry was doing badly. "Alex decided to make a change."

When business began to fail in the early seventies, someone had to be blamed, and Vreeland became the one. Although Liberman was editorial director and Diana was editor-in-chief, he was a big presence at the magazine, and had a vision for it that was different from hers. If Grace Mirabella were editor-in-chief, then Alex Liberman could fashion the magazine the way he wanted. Diana felt betrayed by Alex Liberman, with whom she had worked closely and well for years. Her often quoted remark was: "I've known red Russians, I've known white

Russians," but until then she had "never known a yellow Russian."

When they realized that Diana was leaving, her devoted editors were devastated. On the day they were told, Polly Mellen hid in the bathroom, weeping, knowing that she couldn't stay at *Vogue* without Vreeland and wondering where she could go. "Mrs. Vreeland left that day. Her office had always been wonderful. When you came in to see her, there she was in the bright red office with the leopard skin rug and the bulletin board that inspired you with all the pictures. The next morning the office was beige, the rug was beige and *Vogue* was beige." And Mellen added: "This kind of firing is not unusual in our business," perhaps thinking about how years later Grace Mirabella, after a long, very successful tenure at *Vogue*, turned on the television news one evening and learned that there was a new editor-in-chief of *Vogue* and that she was fired.

Donovan described how *Vogue* sent Vreeland on an all-expenses-paid trip to Europe: "They paid for all the cars and the drivers in Rome and Milan. Everyone was in a state of shock." A smaller version of her office was built on the floor above in the Graybar Building. "Everyone compared Grace Mirabella to Mrs. Vreeland."

When Diana left *Vogue* after almost a decade, the magazine had been transformed. The pages expressed her fantasies and passions. Page after page presented startlingly beautiful, healthy, athletic young women—Twiggy, Jean Shrimpton, Penelope Tree, Marisa Berenson, Veruschka. Movie stars, ballerinas, women who looked happy, involved in life, but always representing the standards that Vreeland had—never what she might consider *boring*.

The photography by the old regime—Avedon, Penn, Bert Stern, Horst, and the newer generation, Tony Snowdon, David Bailey, Henry Clarke, Patrick Lichfield—in both black-and-white and color, capturing the latest fashions in large-scale images on the big pages, was visually breathtaking. Articles on personalities in the arts, theater, the glamorous homes of the rich and famous, and health—everything from the pill and face-lifts, to meditation and cell replacement—also bore Vreeland's signature. And there were changes reflecting the times. Some nudity was now commonplace—the revealed navel, a breast here and there. In the April 1970 issue, Marisa Berenson appeared totally nude covered only by strands of a long chain necklace.

The clothes Vreeland featured embraced an enormous range of taste—from the classic to the avant-garde. They included Paris couture—Yves Saint Laurent, Givenchy, Grès, as well as Courrèges, Cardin—and new British designers like Zandra Rhodes and boutique discoveries like Mary Quant. She championed the Americans—Mainbocher, Norell and, later, Oscar de la Renta and Bill Blass and a host of Seventh Avenue designers. There were very short skirts and wonderful huge dresses—vests and dirndl skirts and garments of ethnic diversity. Enormous hats, patterned stockings, knee socks, capes, pantsuits. Hairpieces were de rigueur. Black models were featured more often. There were the hyperbolic Dynel-wig extravaganzas, and the makeup was colorful, glittering and crazy.

Each issue came with an enormous helping of fantasy, which included Vreeland's take on the exotic in foreign countries—everything from the allure of the "East" and Scottish fairy tales, to photo shoots of ritual marriages and sumo wrestlers and sumptuous coverage of the rituals and lifestyles of international society. For years, *Vogue* readers were given "what they never knew they wanted." It was a decade of mesmerizing young women swathed in beautiful clothes—chosen by the person who of all people would choose the best, in the fulfillment of her ideal. The problem was that the ideal was no longer what the magazine wanted or what it thought its readers wanted.

Is there anything *beyond fashion?* —Allure

THE ENTR'ACTE

On August 13, 1972, Diana Vreeland wrote in her date book, "Life is a performance. There are entr'actes." Her own entr'acte had begun in the spring of 1971, when the curtain crashed down, ending her center-stage performance as editor-in-chief of *Vogue* and giving her a terrible shock.

She was at the Crillon in Paris in May when the magazine's public announcement of her "retirement" was made. Perry Ruston announced "with regret" that "Mrs. Vreeland is giving up the duties and responsibilities of Editor-in-Chief of *Vogue*," and that "she will maintain her close association with *Vogue* as Consulting Editor." No one at the magazine was fooled.

But Diana wasn't going to admit how she really felt. The same day she wired Grace Mirabella in New York:

MILLION THANKS WIRE. PLEASE BE SURE TELL EVERYONE ON 19TH FLOOR, PECK, SIMONA, GROSS, BLACKMON, AND ALL THE FASHION DEPARTMENT AND SEC-RETARIES THAT I KNEW WELL, MISS THEM VERY MUCH AND WISH THEY WERE SHARING WITH ME THIS BEAUTIFUL, SUNNY GREEN MAY IN PARIS WHICH IS MY MAR-VELOUS AND GOOD LUCK. DON'T FORGET BEST LOVE TO ALL.

The press took up the story, paying their respects to the great fashion star and speculating why she had fallen. The *International Herald Tribune* called her "irreplaceable." Hebe Dorsey went into her origins, her career and her personality: "Although she warned her copywriters against using the word 'elegance as if it were salt sprinkled on everything,' she had her own, very personal idea of elegance. 'It's a thing of bone and spirit. It exists in animals like the gazelle. Audrey Hepburn and a few people have it.'"

At the Crillon, Diana received notes of praise from friends and colleagues like Pauline de Rothschild, who wrote her: "You know all the shapes and by-ways of beauty. 'Lovely anarchic Aphrodite,' Auden says, and you applied this all along the line."

Upset but wanting to move on, Diana began a frantic trip around Europe. By the end of May she was in Mallorca, staying with Kitty Miller. Then in Madrid she saw Aline Romanones, who sensed that she was upset. They went together to old haunts, such as the shops where the embroidery was done for bullfighters' suits and capes in the old part of Madrid. Kenny Lane joined Diana in Madrid. One night he sat with her in the dining room at the Ritz. The little orchestra started to play "Fascination." "She started to bawl," Lane recalls. "When she sneezed, it was a big sneeze. When she cried, it was a big cry. She couldn't stop. It was like a fountain—not just a little sniffly. It all came out. No Reed, no job."

From Mallorca she wrote to Kay Graham: "Your charming letter written in your own hand touched me more than you can imagine—I can see that you know exactly how I feel and the thing I will miss the most is the camaraderie of the people so many years around me, many for 20 years."

Vreeland continued on to Barcelona, London, Rome, Porto Santo Stefano, Capri, and back to Paris. There on August 25 she heard of Margaret Case's death, and flew home the next day. As *Women's Wear Daily* reported, Margaret Case "either jumped or fell to her death from her 16th floor bedroom at 550 Park Avenue about 7:45 a.m. Her body was discovered in the courtyard of the building. Miss Case left no note, according to the police." In fact, she had—Case had written Cecil Beaton on August 22: "Dearest Cecil. Forgive what I am about to do—I have a cancer and do not wish to live any longer to become an object of pity poor Maggie and a care for my friends. You are one that I loved the most— Thanks for your love loyalty and friendship and always being the best companion in the world."

After forty-five years at *Vogue,* as society editor, special features editor and contributing editor, Case had been let go at the beginning of August. She and Vreeland lived in the same building and were close friends.

The blow of being fired was terrible, and the apparent suicide of Margaret Case made it even worse. Without a job, floating free and lacking a position, Diana now had no arena for her theatrical performances, no reason to draw on her extensive knowledge, no situation in which to wield her power. As a powerful fashion editor she had been able to make a style or a new fashion hit—whether it be short skirts, sexy sandals or caftans. She had helped dozens of young designers. She had gotten jobs for people at the magazine and in the fashion industry. She had pulled *Vogue* out of the doldrums and charged it with energy, and after all this, she had been dropped. Although she had a busy social life, her life had been her work and, moreover, ever since childhood, the experience Diana dreaded most was being rejected.

Perhaps the time had come for her to get out of fashion journalism. Her concept of fashion as theater, even life as theater, was no longer a fantasy her readers wanted to share. Grace Mirabella wanted to "give *Vogue* back to real women." The new young editor-in-chief would show "women working, playing, acting, dancing, doing things that mattered in the world and wearing clothes that allowed them to enjoy them." Women were flooding into the workplace, and they needed clothes to wear in their new lives. Mirabella wanted to make *Vogue* democratic, she said, and Mirabella's *Vogue* would be successful. After Grace came in and championed separates and sportswear and clothes for the office, *Vogue*'s circulation shot up from three to four hundred thousand to over a million readers.

Diana Vreeland needed a job. As she had sought the help of her friends for Reed, she now approached them for herself. Jeanne Vanderbilt, former wife of Alfred Gwynne Vanderbilt and a member of the New York and Southampton set, remembered when Diana called her up at the office of David Frost's show. It became clear to Vanderbilt that Vreeland was looking for work. "I said to her, 'Diana, there is no way here.' We were working for Westinghouse and they wouldn't hire anybody else. I tried to say it nicely and genuinely—but after I hung up I thought, 'My God, this woman after all these years was down, looking for work, and calling me.' I mean, I really didn't know her that well. So I guess she was calling around. I thought that was terrible."

The writer and editor Rosamond Bernier, suddenly cut off from her former life, divorced and having to leave Paris and her position there at *L'Oeil*, often saw Vreeland during these days. "Diana, you see, had been thrown out of *Vogue*, and she identified very much our two dramas. And I used to go around the corner and have tea with her. I told her that in Paris, every day when I came back from my office I had half a bottle of champagne. She said, 'Well look, of course that's the only way to do it. In our house, if there was

any problem that was unpleasant that we had to discuss, or having to go to the dentist or some unpleasant decision, Reed and I would sit down and have a glass of champagne.' We would talk about everything, about Pauline Rothschild, about life, about problems, and she was always wonderfully gallant. She believed in doing things with elegance and style regardless of how catastrophic the circumstances were. And often, as you know, there was very very little money."

Money had always been a problem. After her marriage Diana became the parent whose income from work—although small—could be depended on. Although Reed always worked somewhere—in banking, in investments, for Rigaud candles, for Pucci—his jobs didn't bring in much money. Their net worth could not bear comparing to that of their friends, like the Gilbert Millers, Mona Bismarck, Pauline de Rothschild, the William Hearsts, glamorous couples with houses in resorts where the rich gathered together. Whenever the Vreelands vacationed, their itinerary was planned to include stops with their friends—who were always glad to extend an invitation. By keeping up appearances—with her fantastic elegant presence, clothed by Paris couturiers; Reed, strikingly handsome, in Bond Street apparel; each smoking cigarettes, both using a holder—they managed to hide their financial situation from all but their closest friends. Now Diana dealt with this latest financial crisis by using all her ingenuity.

She began to do shopping for friends. With Katharine Graham she went to Orbach's, where they did knockoffs of the Paris designs, and Kay would try them on. Graham was delighted to get the best advice in the world. Then Graham would send her a check for her help. Vreeland wrote to her in October: "What a generous totally thoughtful girl you are. Do you need shirts for Chanel suit? White? Do you want your mink coat seen to? Later will you need bathing-suits-resort? etc. to take you through spring. Stockings? Boots?"

As Graham remembered, "I was no good at choosing dresses. I used to go to this dressmaker on Wisconsin Avenue and perhaps to Halston. I asked her to go with me to Orbach's and Alexanders, because I was baffled about what to buy. I remember quite a daring black evening dress that I never would have conceived of buying and she said that it would be perfect."

Diana had all the confidence and style which Kay felt she lacked. "Her own concept of style and her language went together, it was all at the outer edge—outer edge of humor, outer edge of the use of English, outer edge of dressing. She could do what nobody else could do. And it all went together, the extreme language, the accent and the voice."

Katharine Graham was running a newspaper and didn't have time for shopping. Vreeland wrote in February 1972: "I ordered at Oscar de la Renta a blue organza dress, with long sleeves, very, very full bright, bright blue, which I thought would be pretty in a back garden in Washington this summer. . . . If the idea of blue haunts you with horror, be sure and let me know." She ended by saying, "I was delighted to see that you were such a smash in your black velvet!!"

Vreeland shared her own fashion secrets with Graham. On summer dresses: "There is a shirt house in Rome called SAMO. I have all my summer dresses exactly the same, that is to say, the sort of dress that I wear in town to work. They are like a man's shirt, in one piece as long as you want to wear them, buttoning down the front, men's cuffs and a very well mounted collar on a band. I have this dress in bright red shantung, off white shantung etc., including black jacquard, bright purple jacquard and so on, to wear in the evening." Summer dresses were "madly unbecoming unless one is very, very tanned and that hardly applies to a person who works as they never have the opportunity to have an even tan."

Diana honored the memory of designer Cristobal Balenciaga (above) with a dramatic exhibit. Visitors found themselves in a theater of sorts. Velásquez, Picasso and Goya's Red Boy—*which Kitty Miller threatened to take back because nobody could see it—hung on the walls completing the* mise en scène. *Opposite: A Balenciaga ensemble.*

Vreeland spent the Christmas of 1972 in California with Tim and Jean Vreeland. Despite her efforts to carry on, her body was beginning to let her down, and in February she was stricken with an infection in two of her vertebrae, which landed her in New York Hospital for two months. When she left at the end of April she was still wearing an uncomfortable back brace and taking strong antibiotics. She was relieved to be home and free of the intravenous medicines that had helped with the pain but had dimmed her mind and memory.

As usual, she minimized the discomfort. To Felicity Clark she praised the view from her sixteenth-floor hospital room, overlooking the East River. Her many friends would come by on their way to dinner and give her the news of the real world as she sat listening on the bed, her feet in colored striped socks hanging over the side.

The florists, at least, were "far richer and my friends are far poorer. I have never been so spoiled in my life."

Back home she felt happy, "sprung out of a trap. Although I never really felt trapped." She wrote to Mainbocher in August: "In the last two months I have been more or less reconstructing my life, my way of living and it has taken all my time and imagination."

By the spring of '72, things were looking up. After all her casting around, it looked as if she had a job. Her lawyer, Peter Tufo, had approached Ashton Hawkins, counsel to the Metropolitan Museum, about her working with the Costume Institute. Hawkins contacted Ted Rousseau, curator of European art. On July 21, she wrote to Mary Warburg, whose husband was then the Met's vice director for public affairs: "Perhaps Eddie has told you my news, it is all very secret but I am very happy."

Probably unknown to her, Ashton Hawkins had assembled a war chest of about $15,000 from a group of Vreeland's friends, who had agreed to sweeten her salary. In a memo dated December 1972, a list was drawn up that included Mrs. Douglas Dillon, Frederick Melhado, Mrs. William Paley, Mrs. Aristotle Onassis, Mme. Pierre David Weill, Mrs. Watson Blair, Marella Agnelli, Lily Auchincloss and Mrs. Umberto de Martini (Mona Bismarck).

Ted Rousseau met with C. Z. Guest and told her that they were thinking of making improvements at the Costume Institute. He asked her, "What do you think about Diana Vreeland?" She replied, "Well, if you don't have her, don't bother to open it. Because nobody else can even do it." The entr'acte was over. At sixty-nine, Diana was about to begin the most successful act of her long, dramatic career.

When Diana began her new career in 1972, the Metropolitan Museum was going through a period of major changes. Under Tom Hoving's

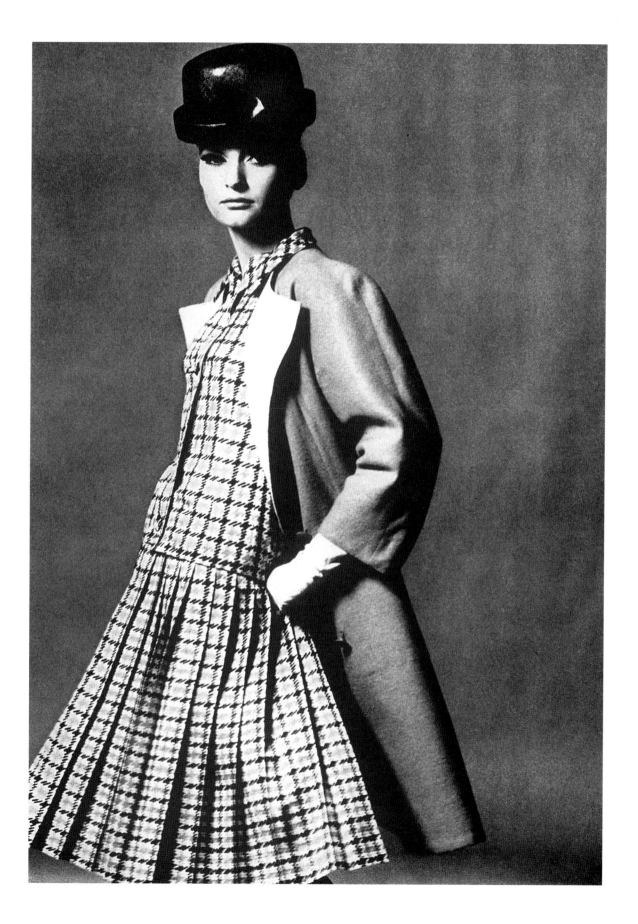

In the center of the Balenciaga show was "the armour of Charles I on a huge white horse—flamenco music plays faintly and one hears heels and castanets clicking." The designer's perfume enveloped the galleries, which were painted in the master's favorite colors—acid green, magenta and Spanish yellow. "Lola Flores's beautiful flamenco dress is mounted high on a mannequin, complete with her combs and apple green dancing shoes and little fringed scarf, all of which she sent us. The show opened the end of March, and we have already had 40,000 people visiting." Following pages: A Balenciaga pink silk coat and Balenciaga blue silk gown provided by Pauline de Rothschild.

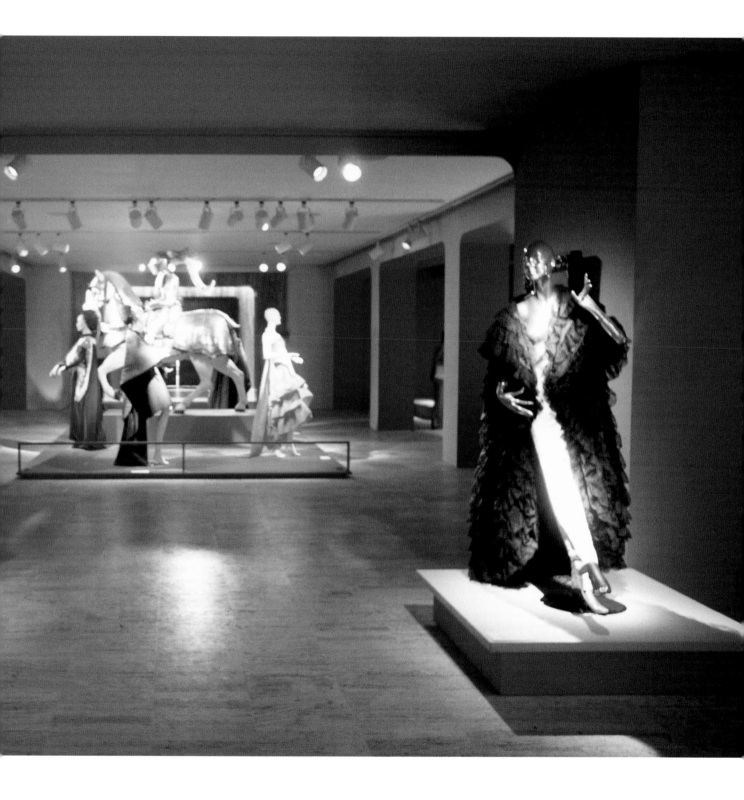

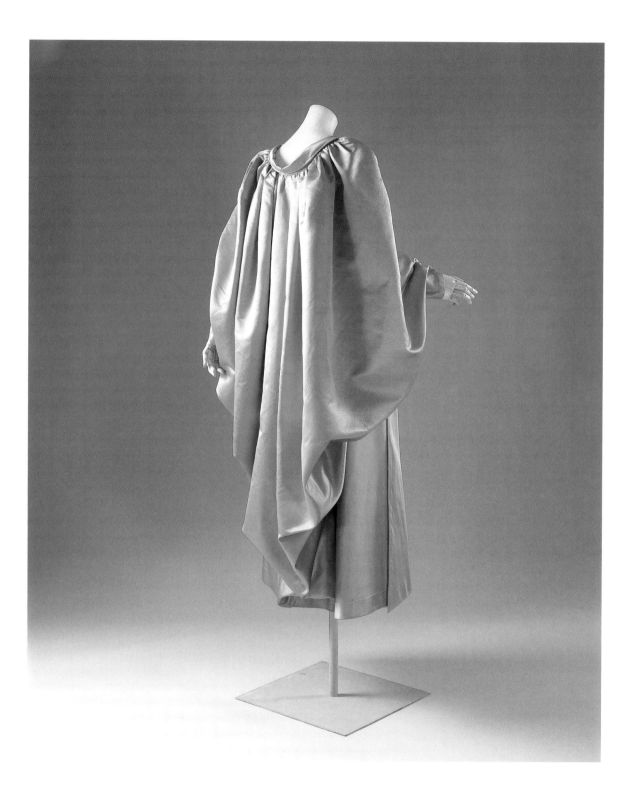

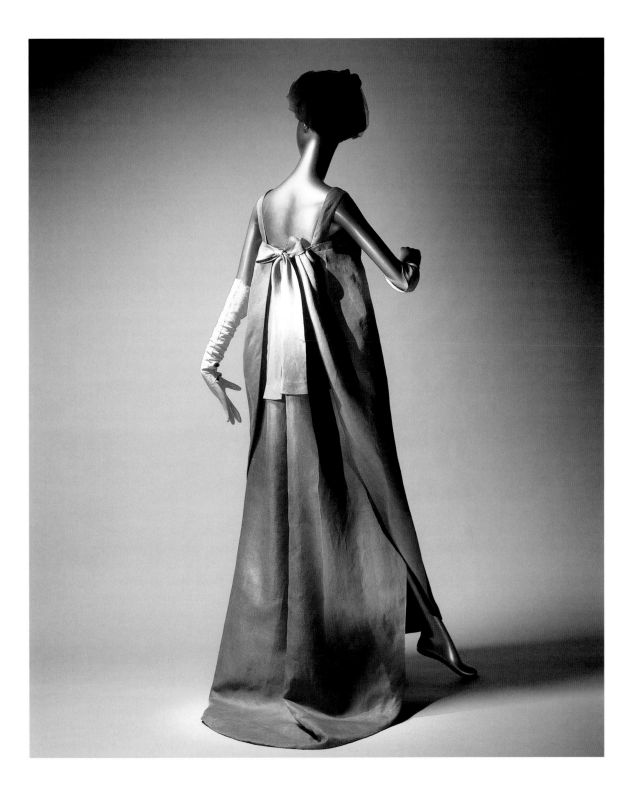

reign, which had begun in 1966, nine acres of Central Park were being added to the museum's footprint. Several new galleries were being built, including, most conspicuously, the large enclosure for the Temple of Dendur and space for the Michael Rockefeller Collection of Primitive Art and the Lehman Collection. These additions were called for under the ambitious Master Plan that had been announced in the Met's centennial year. Exciting acquisitions of art were made. Hoving thought big—"No more footnotes"—and he had big ideas for the Costume Institute as well.

The Costume Institute had been part of the museum for twenty-six years but had not attracted much attention. As former Met designer Stuart Silver puts it: "It was essentially a sidebar—sort of like musical instruments." It had been started in 1937 by Irene Lewisohn and her sister Alice Lewisohn Crowley, founders of the experimental Neighborhood Playhouse. The Lewisohns wanted to use original costumes at the playhouse and also to develop a collection of garments from different periods of history and different geographical and cultural backgrounds that would show the importance of dress in the development of the human race. They hoped that the study of costume history and the awareness of beautiful clothes would influence and inspire future creativity in America and be reflected in the work of historians, artists and designers.

The Lewisohns' Costume Institute—about ten thousand costumes and a small library about fashion—became part of the Metropolitan in 1946. In the mid-forties, Eleanor Lambert and Dorothy Shaver approached the Met when American designers were, as Lambert says, "beginning to do their own thing" instead of copying European designs. She knew that a good costume collection would have a big influence in the fashion community. Needing to raise $150,000, Lambert and Shaver wrote to the big textile companies and merchandisers and to members of the garment

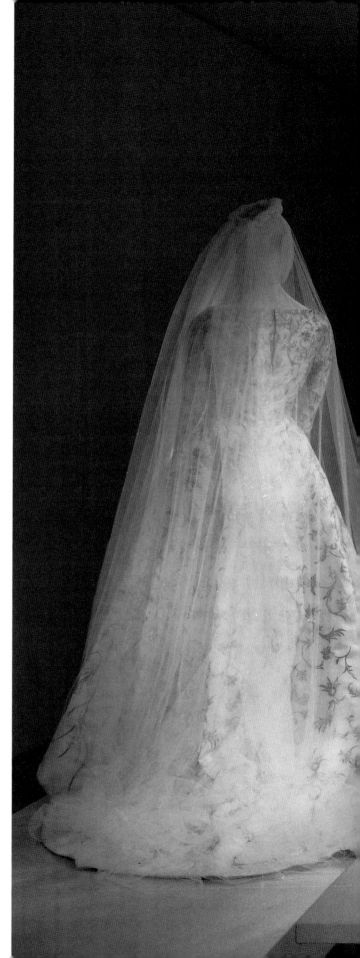

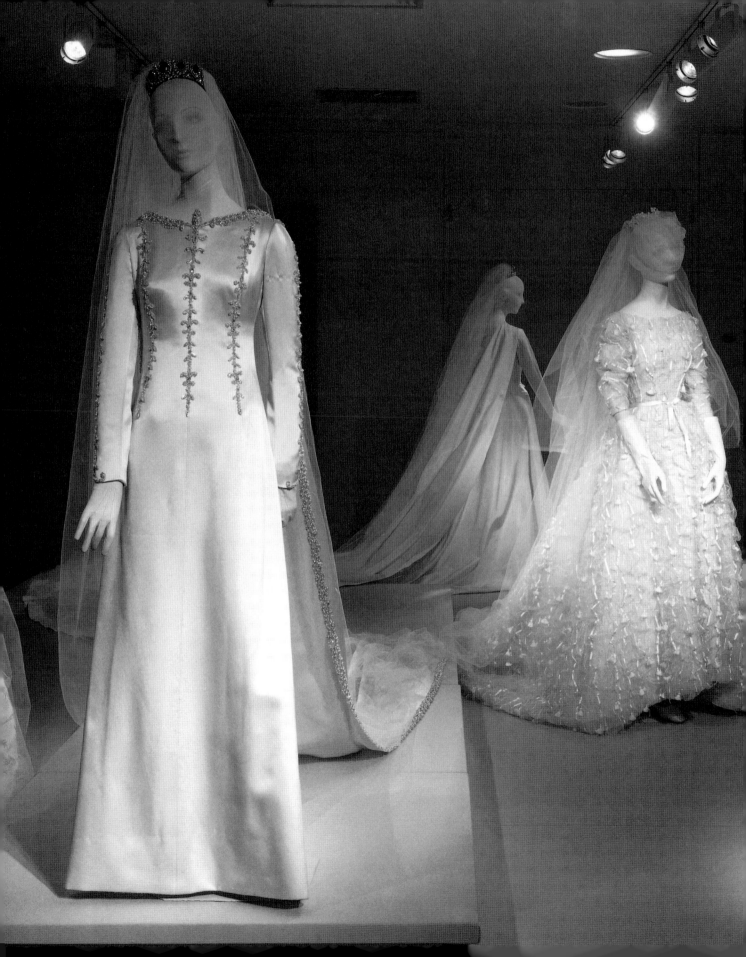

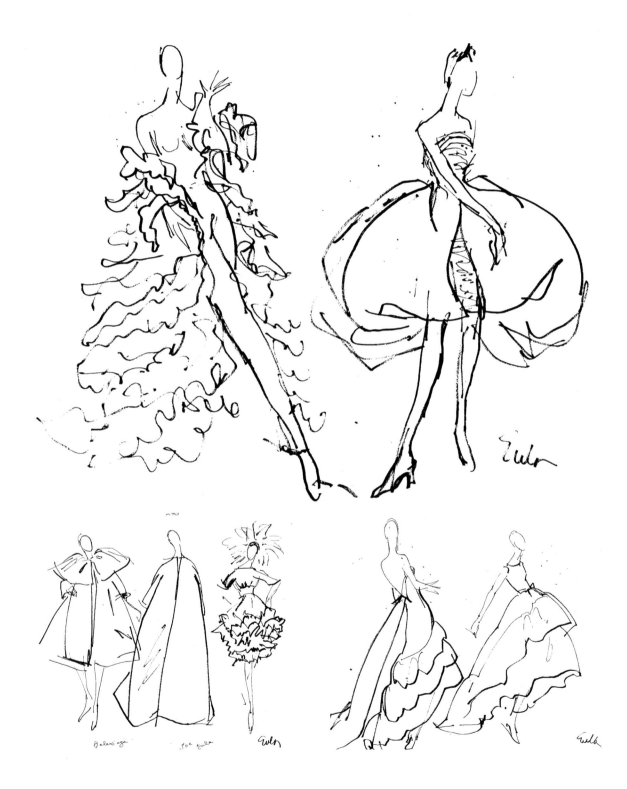

industry and asked for donations of $10,000. They raised $350,000 to finance the transfer.

In the first exhibit at the Met, five thousand years of dress and fashion were shown: gold sandals from Thebes, belt buckles and breastplates from various wars. In 1948, the institute began the tradition of the Party of the Year to raise money to pay for itself. Over the years the event has become a dazzling celebrity affair and has helped to keep the institute solvent and connected to the fashion industry.

In the fall of 1971, the year before Vreeland started work, what Hoving called "an expanded Costume Institute" opened after thirteen years of on-and-off construction with Adolph Cavallo, a textile specialist, at its head. Eleanor Lambert had raised money from the fashion industry for the creation of new galleries, cavernous rooms in an enormous space in the cellar. By 1972, Cavallo had resigned and Hoving was looking for a new head. He was determined to give the public something great, and this is where Diana Vreeland came in.

By now, the collection was rich and diverse. There were magnificent robes from the Far and Middle East, clothing from Europe, Latin America and Africa. The "western urban collection" dated from the sixteenth century. A collection from the eighteenth century included clothes worn for a wide range of special occasions—christening clothes, wedding gowns, court trains, ball gowns and mourning dresses—as well as everyday attire.

The exhibitions up to this time had been dry in comparison with what was to come. They were

Drawings of Balenciagas by Joe Eula. Page 197: Balenciaga wedding dresses, including (center) a white satin princess dress for Maria del Carmen Martinez Bordiu, granddaughter of Generalissimo Francisco Franco, the only dress Balenciaga made after his retirement. On the wedding day the bride wore a tiara of diamonds and large emeralds set in gold.

historically correct, with mannequins purported to look lifelike, with flesh colored "skin" and wiglike hair, and set in a display of the period. Vreeland would change all that, as her method of presentation was flamboyant and theatrical.

Before his tenure as director of the Met, Thomas Hoving had been a curator for the museum's Medieval Department and for the Cloisters, and later had served as commissioner of parks for New York City, where he made a name for himself creating "Hoving happenings." As director of the Met, Hoving transferred his mission to the art world. He thought museums should be places "for people to battle against the blows of technology and the miseries of life" and "where you can have your mind expanded, not by drugs, but by seeing things in a way you had never seen before." Hoving and Vreeland shared one vision: that the museum was a place for theatrical presentations to attract people and entertain them.

Although at first he was reluctant to hire her, Hoving soon saw that Diana was a hard worker who could put her magazine experience to good use and also that he only needed to see her for ten minutes each year. She had good ideas, he recalled, and "knew what we wanted. The more professional a staff member is, the less you see them." Hoving's eventual assessment of Vreeland was that while she always wanted to put on a glamorous and exotic performance, underneath all her stylish façade and her amusing talk she was "this really excellent professional. She was really mundane." He very much admired her abilities as an executive. "She never, never took credit for herself. She was an excellent CEO." To Hoving, she had a particular kind of creativity that "had nothing to do with book learning. She acted her entire life to hide the fact that she was mundane." At the same time, he recognized her gifts. "She had the artist's eye," he said.

Vreeland was brought in under the title of "special consultant" to the Costume Institute. Although she was not trained in the field of cos-

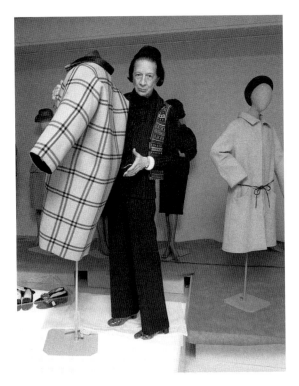

Diana at her Balenciaga show, 1973. Opposite: *Marisa Berenson and Diana with Schlaeppi and other mannequins. Vreeland detested lifelike mannequins—"We don't want to look like Saks or Galeries Lafayette."*

tume history, she would be in charge of the exhibitions at the Met and work with the trained staff. Vreeland had an extensive knowledge of fashion history dating back to her childhood; she was twelve years old in 1915, when Coco Chanel began to change the way women dressed. She had known the great designers of the mid-twentieth century, such as Chanel, Schiaparelli and Mainbocher, as well as the later ones—Balenciaga, Givenchy and Yves Saint Laurent—both personally and professionally. She covered their work in the magazines, wore their clothes and saw them socially. With her unusual eye, her wealth of historical and aesthetic associations, she was a great repository of fashion history. Used to packaging her impressions in a magazine

format, she would now make a different but brilliant use of her talents at the Met.

After Diana's death in 1989, the Met's director, Philippe de Montebello, claimed that "until the spring of 1973, it could be said that the field of costume had been a sleepy and rarefied one. . . . An aura of antiquarianism seemed to enshroud every costume display, and they had, for all intents and purposes, no audience beyond a few specialists." Then Diana Vreeland appeared at the Costume Institute and an entire field was transformed, with "an uncanny sense for drama and style."

Her colleagues came to their subject from another direction—from working with and studying great clothes in a context of past centuries and cultures within the museum setting. Although they would have disagreements, Diana Vreeland and the Met curators would produce beautiful exhibitions. A crucial contributor to Vreeland's success was Stella Blum, the Costume Institute's top curator, a museum professional who had the training and expertise that provided the scholarly basis for Vreeland's shows from 1972 until 1985. As Hoving said about Vreeland and Blum: "Together they could produce something accurate with flair. Without Stella Blum, Diana Vreeland would have been gone in a week."

Diana Vreeland joined an impressive staff of museum professionals, each of whom had a specialty. Stella Blum worked with students in the design and costume history field. Mavis Dalton took care of designers who wanted to view the collection. There were also Judy Straeten McGee, the assistant curator in charge of acquisitions; Elizabeth Lawrence, in charge of conservation; Irja Zimbardo, the housekeeper; Dominick Tallarico, departmental technician; and Gordon Stone, the librarian. They had kept things going during the years that the renovations were taking place. This staff would now have to cooperate with the new "special con-

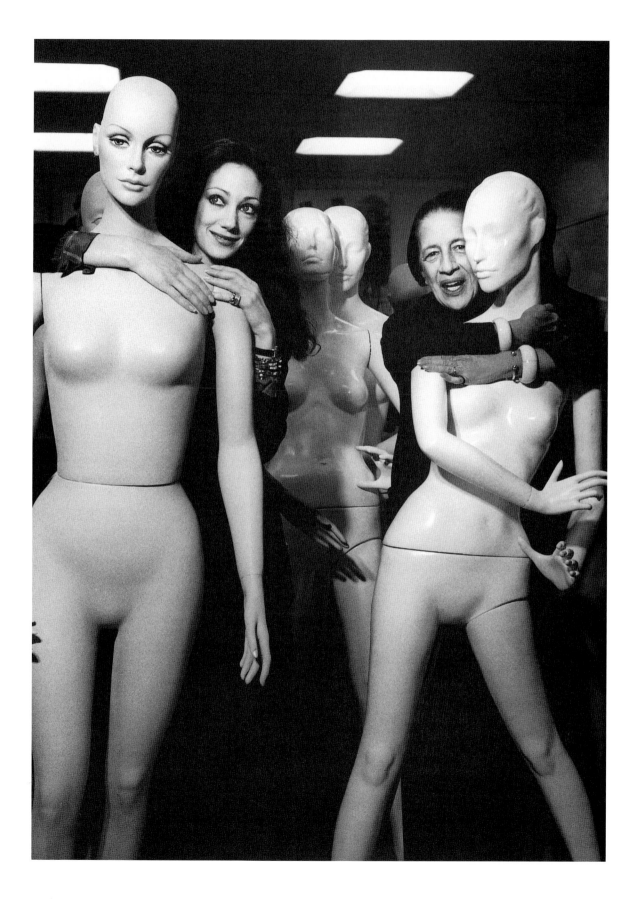

sultant"—she did not have the degrees to be called curator—to mount costume exhibits that would establish a new style, not only at the Met but in the field of costume history at large.

Diana's first idea for an exhibition theme at the Costume Institute was the Duke of Windsor's wardrobe. She began working on it in July 1972, a month after the duke died. Vreeland had always admired the way he dressed. The duke had died that spring in France and his body was brought home to England for the funeral. Cecil Beaton witnessed the ceremony in St. George's Chapel, and described it to Vreeland, a description Diana often related to friends: "It gave me a mixture of emotions—The service with all the pomp and splendor that we know how to do, seemed to contradict the spirit of all he stood for. But what a heritage he gave up. [The duchess] was like a galvanized marionette—jerky, staccato, mumbling and talking all the time—Is this where I sit? What do I do now? Is this my prayer book? The Queen put a hand on her—as a nanny or mother might. Very touching and terrible."

In the summer, Douglas Dillon contacted the duchess on behalf of the Costume Institute, and the idea of an exhibit appealed to her. Vreeland immediately made a list of the types of clothes she wanted: ceremonial dress (including robes he wore when crowned Prince of Wales), uniforms, civilian clothes (including overcoats), golf clothes and the morning coat in which he was married. Kilts, hunting clothes, dinner jackets of various eras, were on her list, as were the smaller things—hats, socks, shoes, gloves, umbrellas and ties, which "had a special cut and lining," as she remembered, "and that is why the knot was always of such perfection." And, she added, "he claimed he did not invent the Windsor Knot."

To start her work, Diana went to Paris in September and set herself up in the Crillon in a

less magnificent style than before. Her aim was to explore the ideas for several shows and to visit other costume collections in Paris. Naturally she went out to the Windsors' villa and looked through the duke's clothes. Alas, the Windsor wardrobe would never come to the museum in the form of a big exhibition, as Buckingham Palace was against it and they quashed the plan. The palace did not want the official English segment of the duke's life documented in a costume exhibit.

Realizing that the Windsor show was problematic, Vreeland activated her enormous fashion networks—friends in Spain, Italy, England and Paris—to find costumes for the next idea, one on Balenciaga, and one can see from her notes that a third possible exhibit was materializing in her fantasies: "The Tens, the Twenties, the Thirties: Inventive Paris Clothes 1909–1939."

The Spaniard Balenciaga would be a great subject. His career began in the 1930s, when fashionable women dressed and lived in an entirely different way, and he continued to dress the rich and privileged until the late sixties. He had just died, so the subject was timely and would be a retrospective to honor his memory. Balenciaga and his achievement had special meaning for Vreeland. At a time when only the richest women were patronizing haute couture and others were dressing in a more practical way, reminding everyone of Balenciaga's genius would keep the high standards of craftsmanship and style alive. She was intimately connected to her subject, as she knew Balenciaga's patrons, had been to his collections and had recently visited his beloved country.

As she said later about his thrilling collections: "One never knew what one was going to see at a Balenciaga opening. One fainted." At one show in the early sixties, "Audrey Hepburn turned to me and asked why I wasn't frothing at the mouth at what I was seeing. I told her I was

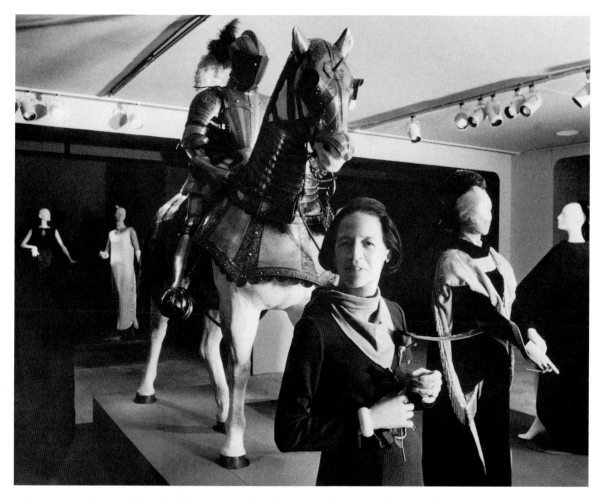

trying to act calm and detached because, after all, I was a member of the press."

Working at the Crillon, where Vreeland felt very efficient in a small room with an entryway for her secretary, Ellen Alpert, she began her research. In addition to going to the Musée Carnavalet and other costume collections, she sought out colleagues of Balenciaga—Ramon Esparza, who designed hats for Balenciaga's collections, and Fernando Martinez, who sketched the details of fabric.

Madame Feliza, who worked with Balenciaga for twenty-one years, told her interesting details: He used to say, "'Do not torture the fabric' and,

referring to skirts, 'When women walk there must be music.' He was the most human, the most generous . . . but very severe in his work. He had the precision of a surgeon." Madame Feliza remembered how Balenciaga came in to view the first collection of his protégé Hubert de Givenchy. After eyeing a dress, with a quick motion he gestured with his hand for the scissors and before anyone could say anything, he cut. The long dress was now a shorter one—designed by the protégé but perfected by the master.

In addition to working in Paris, Vreeland and Alpert went off to Zurich, where their days "were just delicious," and the ideas for the show

began to materialize. The Musée Bellerive offered to lend its collection of Balenciaga's work. They found a film by Tom Kublin showing Balenciaga at work. Yves Saint Laurent is seen sketching and fitting, Gustave Zumsteg choosing fabric designs, and Balenciaga working on models in his atelier. The reclusive designer was caught practicing his great craft.

In Zurich, Vreeland began to address the issue of mannequins, a subject of great importance to her. She was drawn to the Schlaeppi mannequins she saw there, with their "abstract body, extremely elongated limbs, and tall height." They appealed to her because they did not try in any way to be realistic, having no hair, no facial expression or makeup. She wrote back to her new colleagues at the Met, the curators Stella Blum and Mavis Dalton, that she wanted

to cover the mannequins' heads with fabric, "which might give an amusing effect in some cases of projecting fashion. As you know, one of my great worries is the whole mannequin situation as we don't want to look like Saks or Galeries Lafayette or the department store in any town or city in the world. Most life-like mannequins are rather creepy and unattractive and distract from the look of the dress." An abstract mannequin was handsome but unobtrusive, vanishing from one's consciousness to make way for the image of dazzling clothes.

At the end of her stay in Paris, Vreeland sent out letters to the European society figures who owned the Balenciagas. She wanted wedding dresses from Señora de Martinez Irujo and Señora Dona Carmen Martinez, who owned the last dress Balenciaga ever made. (This would give her gar-

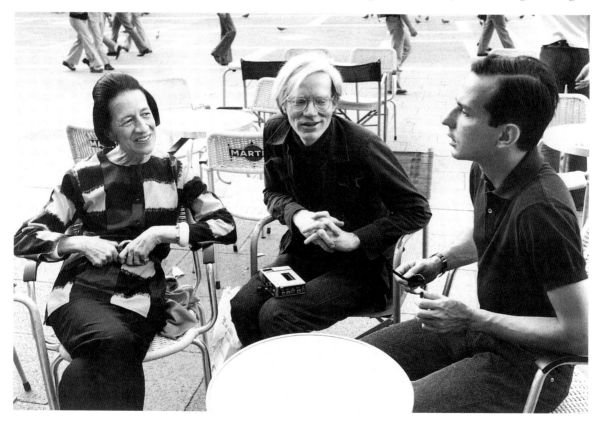

ments that had been worn by three generations of Generalissimo Franco's family.) She wrote to Pauline de Rothschild: "Please do remember hats, the big horse collars, the Black Tulip, and most of all, the divine beige gathered dress that everyone agrees was the most beautiful of the feathered group. Also the grey platinum embroidered tunic that I saw you in in London."

Along with the clothes, she planned to display the art that had influenced Balenciaga—paintings by Velásquez, Goya and Picasso, as he was "the true son of a strong country filled with style, vibrant color, and a fine history . . . his inspiration came from the bullrings, the flamenco dancers, the fishermen in their boots and loose blouses, the glories of the church and the cool of the cloisters and monasteries."

While working on her exhibit, Vreeland also saw friends in Paris and dined with Frecky, now working in the American embassy there. His marriage to Betty had broken up in the late sixties, and he had a new woman in his life, Vanessa Somers. At Diana's request, she invited the Duchess of Windsor for dinner. As Frecky remembered: "Mom curtsied and Vanessa did not, but it went off well." Diana liked her son's new girl, an artist who had once been a beautiful model herself.

Vreeland left behind Gardner Bellanger, now the publisher of French *Vogue*, but then a young housewife, in charge of shipping the clothing to New York and hunting down Balenciaga outfits. As Bellanger remembers, "She was not so good on the detail side, so you had to do an enormous amount of detective work. 'Gardner, I think there's this lady, I think it might be in London, and there are a lot of Balenciagas and you have to find them for me.'" Miraculously, Bellanger did find "this lady," and in her collection were the great culotte dresses, many of which had never been worn.

At one point Bellanger's telephone bill mounted to an enormous sum, as she had to call all

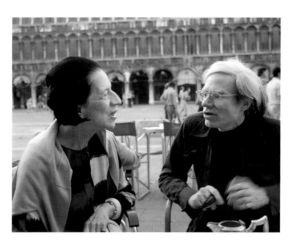

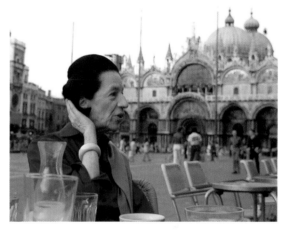

After finishing her work on her Balenciaga exhibition, Diana, now feeling refreshed and victorious, went to Venice for the Volpi Ball in the summer of 1973. Here she talks with Andy Warhol and Fred Hughes (opposite) in the Piazza San Marco.

over France and to Vreeland in America. She reported this problem to Vreeland—that her phone would soon be cut off, that her husband said she couldn't afford to work for her and that their relationship was in the ditch. She got a telegram from Vreeland in New York: "Darling Gardner, I have TOLD them that your husband has LEFT, that you and your babies are in the STREET! The money will be there soon. These people here—the only thing they only understand is DRAMA!"

In the first week of October, Diana flew home, flush with the excitement of what she had accomplished in Paris. She was off and running. The new job would not only be her most successful, it would also have a large influence in the world of fashion exhibitions. As Douglas Dillon remembers: "The Costume Institute was the stepchild of the museum before she came. She lifted it up to an entirely new level. We got new publicity and raised enormous funds. She engaged the dress design fraternity. She was entirely in tune with the times." Bill Blass also remarked that "her exhibitions were so exciting; they took your breath away."

Using her impressive network, Vreeland now masterminded the ingredients for the Balenciaga show. Priscilla Peck, the art director of *Vogue*, laid out the exhibition book. She used the eulogy of Balenciaga's parish priest, Father Pieplu, appreciations by Pauline de Rothschild and Gloria Guinness, and never-before published photographs of Balenciaga himself. She made sure that Eugenia Sheppard and Suzy Knickerbocker were notified about the exhibit, and that publicity material was sent all over. She arranged for jewelry, gloves and 150 or so furs, flamenco music for the showroom, and Balenciaga's perfume to be sprayed daily. And she procured all this for nothing. Halston put up $12,000 to transfer sixteen hours of Kublin's 35mm documentary film on Balenciaga to 16mm to be shown as part of the exhibit. And, Diana noted, "When many of the designers asked especially for the film to be shown on Saturdays, as this was the only time they could be away, I arranged for $2,000 needed to pay the boy who would run it for 13 weeks. I do not feel that the program cost the museum more than the paper and printing and binding—plus Kublin's fee of $1,200 [for his film rights]."

When the Balenciaga show opened in February, it became clear that Diana Vreeland had triumphed. The critics loved it, and the public loved it, too, and poured into the basement galleries. She had "created a show that made the Costume Institute glow as it never had before." Over a thousand guests gathered for the preview, and to welcome Vreeland back to the fashion world. The elite were in attendance—designers, artists, foreign dignitaries and socialites alike. The crowd included the consul general of Spain and friends and fashion personalities like the Robert Sculls, Andy Warhol, Halston, Kitty Miller, Calvin and Jayne Klein, Marion Javits, Anita Loos, Stan Herman, Vidal Sassoon, Chester Weinberg, Kasper, Deeda Blair, and Diane and Egon von Furstenberg. They were to experience Diana's flair at its best.

Billy Baldwin, surveying the evening with a decorator's eagle eye, summarized the situation: "This show makes all the women who are not mannequins look like peasants." Still, reviews of Diana Vreeland's first show were not unanimous. Kennedy Fraser in *The New Yorker* described the exhibit as a useless pining for "haute couture" days long gone. She didn't like the "Mamie Eisenhower prettiness" and the clothes' "studied contempt for the shape of the female body," or "the bald mannequins or loud piped-in flamenco guitar music."

Designers at the preview questioned the relevance of the Spaniard's style to the woman of the early seventies. "Most of it looks out of date," said Calvin Klein. . . . "Attitudes have changed and so have life-styles. The architectural shapes [Balenciaga] devised have given way to soft clothes that take their shape from the body. Women today are more interested in comfort and convenience than grandeur." There is no doubt, "everybody was influenced by him, but I'm not sure it's where we're going today," said Mollie Parnis.

The illustrious guests wearing Balenciaga dresses that evening had differing opinions. Mrs. Scull admitted to feeling "silly in her long

green taffeta gown with a low flounce, but Mrs. Jack Saunders was perfectly happy in her two-piece pailletted dress . . . and Mrs. William McCormick Blair Jr. in an eight-year-old white satin coat over a ten-year-old beaded top dress said she had a lot of other Balenciagas in her closets that she uses all the time."

Vreeland was ecstatic. In April she wrote to Mona Bismarck: "My winter has been entirely dedicated to the show of Balenciagas. The show is a total success—men love it and all sorts of types find it good enough to come back two or three times. Hopefully I am not blowing my own horn too much, as I had such great assistance from the wonderful museum technicians." She ends by thanking "dearest Mona" for "arranging with the Smithsonian for us to show your clothes. They look beautiful."

Her life again had form. She had situated herself in a place where she could be creative and wield her power. She felt well supported by the young people at the museum; she was extremely focused. She was selective about seeing friends, however, for when she was busy she did not have the same taste for social life. As she had written to Mona Bismarck: "How divine to see you for only those few moments the other afternoon and I wish that I had been in a more interesting mood but you know, when I am on a job, I am the most boring person in the world."

In January, Cecil Beaton came to town. She saw Penelope Tree, who was living in New York, along with Jonathan Lieberson, a brilliant young writer/philosopher who came often to the apartment. She dined and went to the theater with Johnny Galliher, saw Kenny Lane, Joe Eula, and old friends like Kitty Miller and Madame Grès. Françoise and Oscar de la Renta were regulars. She saw a lot of Bill Blass, as she had on and off for the last twenty years, Suni Ratazzi, the Guests, and occasionally Rosamond Bernier and John Richardson.

In the summer she made plans to go away. It was an effort to do so without Reed, her helpful and entertaining traveling companion. Although she hated to admit it, she was almost seventy and things were more difficult. She wrote Beaton: "I am sitting here on a Sunday in the thinnest of Jhelabas. So hot writing on this table with 3 bowls of divine garden roses from Cizi. I'm not good at week-ends—travelling too far on hideous sky-way-throughways, parkways in mechanical chain. I stick very close to our little Balenciaga exhibition as we have to be sure nothing fades and looks dark from the humidity and the music dies down. The lights blow—who cares but me. It must remain as fresh as the first day in order to retain a real success. It really is a success which is to me staggering as we have passed since two weeks, 100,650 thousand—well, am working on the next 2 shows. I am always super ambitious and hope they will be popular."

On August 19, she went to Sidi Bou Said, near Tunis, and then on the thirtieth flew to Rome. The next day she was in Venice for the Volpi Ball. Andy Warhol was in Rome working at the Cinecittà film studio on his movies *Flesh for Frankenstein* and *Blood for Dracula*. He was with his group—Fred Hughes, Bob Colacello, Judd Johnson and Joe Dallesandro, living in Roman Polanski's house, the Villa Mandorli, on the Via Appia Anitca. Fred and Andy went up to Venice to see Diana and go to the ball.

By this time it was clear that Diana was beginning to feel like her old self again. As her grandson Nicky remembered, "She went to the Volpi Ball in Venice that fall and she began to feel she was coming back to life." Nicky, who had come to New York to go to film school, first stayed at 550 Park and then moved to his own place downtown. He became her primary caretaker and would watch over her as she launched the most successful job of her ever-changing career.

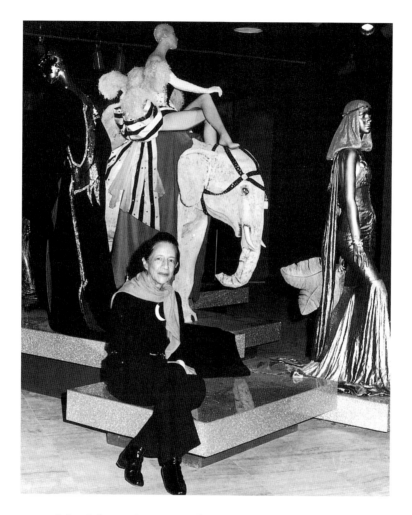

I had been interested in nothing but today,
tomorrow, and beyond the horizon,
and suddenly I realized that I was in the
halls of history. —Diana Vreeland

THE COSTUME INSTITUTE

Diana would mastermind twelve exhibitions—one a year, beginning with her Balenciaga show, which opened in the winter of 1973, and ending with the 1983–1984 exhibition on the career of Yves Saint Laurent. Several later shows, "Man and the Horse," "Costumes of Royal India" and "Dance," contained her ideas, but were organized when she was not well enough to come to the museum.

The subjects of the exhibitions were rich and varied. Tom Hoving found that her ideas were so good that she only needed to mention a possible subject to him and he would quickly approve it. Her exhibition themes ranged from the careers of particular designers such as Balenciaga and Yves Saint Laurent in separate shows, to groups of designers like Chanel, Schiaparelli and the others covered in "The Tens, the Twenties, the Thirties: Inventive Paris Clothes 1909–1939." She also staged exhibits developed around a central idea, such as "Romantic and Glamorous Hollywood Design" or the costumes of different countries or empires ("The Glory of Russian Costume" or "The Fashions of the Hapsburg Era—Austria-Hungary"). Different personalities were highlighted in "American Women of Style" and "The Eighteenth-Century Woman." Some exhibitions, like the Russian and Hapsburg exhibits, arrived from out-of-house pretty much complete, while others were entirely worked up by Vreeland and her staff, borrowing from many sources, both costume collections and private wardrobes. Her greatest contributions were the exhibitions like the Russian show, which showcased clothes that were not only

unfamiliar, but were also breathtakingly beautiful and of great historical interest.

Her displays, which often included as many as one hundred mannequins, would appeal to the imagination and plunge the viewer into a milieu—perhaps a celebration of a great moment in Hollywood, or her version of the eighteenth century. She wanted the clothes to appear fashionable to the contemporary viewer. As Susan Train remembers, "These shows were not history—they were fashion. They were people wearing beautiful clothes." The viewer might see a mannequin representing Grace Kelly in a movie gown, a figure of pop star Cher, or Garbo as Queen Christina. Figures wearing the garments of Peter the Great and Catherine the Great of Russia, the children of the Hapsburg court, all would appear in impressive groupings in the basement of the Met. As she had done in her magazine pages, Diana Vreeland would give the viewer something more.

Ostensibly, this seasoned magazine editor with no museum experience had been hired to persuade people to give their high-fashion wardrobes to the museum; she would get a lot of people to open their trunks. It soon became clear, however, that she would also orchestrate the exhibitions in a new way, and that they would be the number one priority. Everything else—including education, cataloguing and maintaining the permanent collection—would take second place. Phyllis Magidson, current curator of costumes and textiles at the Museum of the City of New York, worked on many of the early shows. She remembers that Vreeland

worked like a film director producing a spectacle and then the trained museum staff would help to assemble the pieces into "museum" exhibitions—emphasizing the chronology and accuracy often ignored by Vreeland.

Working with Vreeland was rather frustrating. While the staff members wanted the costumes to appear as they would have in the time period they represented, Vreeland wanted the clothes to look *now*. As a result, the representations were often historically incorrect. For example, a sleeveless Balenciaga sack designed in 1956 for Beth Levine became a minidress when it was put on a tall Schlaeppi mannequin by Vreeland.

She often created displays filled with anachronisms. When a mannequin was being dressed for a historical show, Vreeland might say, "Oh no, those shoes are wrong," and insist on better-looking shoes. Stella Blum would say, "Actually those shoes were meant to be worn with that dress, and the shoes that you want were designed thirty years later." Vreeland would say, "It may or may not be the case, but if this woman looked like this mannequin, she wouldn't want to wear those shoes. She'd want to wear these shoes." The curator would reply that "these" shoes hadn't existed then. Mrs. Vreeland would say, "Well, she would have thought of them." While it was obvious to Diana that the shoes were wrong, she would always choose the right look over the accurate representation.

At the party for the opening of "Vanity Fair," an exhibition that used the Met's own collection to celebrate many periods of costume and was organized according to appearance and not chronology, a former Met curator confronted Vreeland and scolded her for rewriting history. Vreeland replied, "Who cares about Schiaparelli 1939 gloves with a 1974 black velvet Grès gown. The public isn't concerned about ponderous accuracy—they want spectacle, the illusive spirit."

In addition to coping with Vreeland's single-minded vision of costume history, the curatorial staff found that their workload had tripled because her own brand of curating did not jibe with the museum's usual procedures. The curators had their customary tasks to perform: Everything that came into the museum had to be tagged and numbered. A condition report recorded spots, rips and the general condition before a garment went on a mannequin. Then added to the curatorial work were Vreeland's demands. Before the one hundred final choices were made, Vreeland usually dressed three hundred mannequins, as she could never envision the results until she saw a costume on a mannequin. She was highly critical, afraid of the clothes looking dated or shabby, and she would go through galleries singing, "Secondhand Rose. I hate old clothes."

Certain techniques she had used to edit the magazines hindered the current task. For example, safety pins and masking tape were trusty tools when dressing models for magazine shoots and adjusting clothes to fit models. At the Costume Institute, fashion editors' devices of this sort were out of the question.

While light was essential in a magazine shoot, it could not be used in the museum because it ruined the older garments. When the light was dull, she would protest, "It's too dim. You can't see it." Undaunted, she found other solutions. For example, she put the Balenciaga wedding dresses, complete with beautiful trains (which were white anyway), into a gallery that had sliding glass windows onto an airshaft that provided precious daylight.

Her lighting was always dramatic and experimental: Stuart Silver remembered that for the Hollywood show, "She let me do certain marquee lights and whatever I suggested: 'Let's have glittery shreds of tinsel curtains.'—'Fine.' 'Let's put Marilyn Monroe on a pink elephant.'—'Fine.'"

She wanted viewers to have intimacy with the costumes. "We took away the museum feel

and turned it into a showroom." The curators did not want the public to get too near the costumes, and Vreeland did not want them behind Plexiglas, as that made them too remote, so the solution was platforms. You needed four feet in diameter of space for a mannequin, so it was out of reach of the viewers. Beginning with the Balenciaga show, platforms were built against the walls and covered with fabric or mirrored. As Silver remembered, "It wasn't a museum, it was a series of stages. You could see all the way around the figures. And by putting them on a platform you made them bigger than you are, which is always a very dramatic trick and separates you from them." Like Silver, Vreeland displayed the clothes to illustrate the idea behind the show. "What we did for Balenciaga was reserved and elegant, and for Hollywood it was over the top." Another spatial component of each of Vreeland's exhibits was an ornate centerpiece. The centerpiece for the Balenciaga show was one of Diana's more interesting conquests: Vreeland was able to charm the head of the Armor Department into allowing her to use the priceless armor from the Met's collection in her show.

Vreeland also had very strong ideas about her wall colors. Once she was given a book of color samples and she said, "Those are colors that supers paint back service stairs." She could visualize such a variety of nuances of color that she couldn't make up her mind and the staff never could count on her choice being final. When she finally settled on the color, her staff painted it on a large piece of cardboard; Vreeland then scrawled a large DV on the back to make sure everyone knew that it had her final seal of approval.

After the Balenciaga show, it became clear that the curatorial staff was too pressed and that Diana needed more help. Volunteers became the solution. Just as she did at *Vogue,* Diana surrounded herself with disciples and gifted professionals

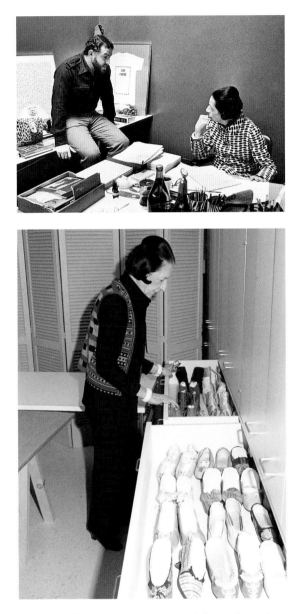

Top: *Diana and Met designer Stuart Silver in her red-lacquer office.* Above: *Diana examining the collection. Irving Penn was fascinated by the clothes in the "Inventive Paris Clothes" exhibit and felt a thrill at realizing "a luxurious clothes world once existed," in which "no designer's fantasy was too extravagant to realize." His photographs of the clothes became a book for which Mrs. Vreeland wrote the text.*

who tried to execute miracles and thereby became her adoring protégés. Some even became paid staff members. When she was a teenager, Tonne Goodman, now fashion director at *Vogue*, helped her to mount the exhibitions, first as a volunteer and later as Vreeland's chief creative assistant. Like many of the young, talented workers, she was the daughter of family friends.

Vreeland had her own approach to everything, including her particular pattern of staging an exhibit. To begin with, she devised a schedule far in advance. Since after the Balenciaga show the exhibits opened in the late fall, the research for the show would start in February. Vreeland and her staff first located the clothes they needed, and in the second half of the process they would design the galleries and work on the installation. The costumes often required restoration. Seamstresses would work on the pieces; they'd painstakingly replace all the sequins on a sequin gown. In the final months, the costumes would be draped on mannequins. When the man-

Vionnet dresses in the "Inventive Paris Clothes" exhibit. Opposite: Irving Penn's photograph "Vionnet Dress with Fan of 1925–26."

nequins were dressed, they would go into a holding room in the galleries. Before the installation, the galleries were painted and designed.

In the final months before the installation took place, Vreeland assembled talented people from all disciplines. Kenny Lane did the jewelry. Ara Gallant helped with the hairpieces. Arnold Scaasi and other designers supplemented museum holdings. Giorgio di Sant' Angelo gave advice. Sam Green found jewelry or anything else

from the current art scene. The volunteer helpers added youth, energy and good looks to the effort. When Sam Green found a wonderful-looking young hippie to be the courier for turquoise jewelry to adorn the Millicent Rogers mannequins in the "American Women of Style" show, Diana was entranced. "He's so good-looking! What hair! And the most beautiful clothes! I am entirely superficial and I mean to stay that way!" And she told Sam, "I just adore the people you know."

As the great evening approached, other elements had to come together. The air was scented; the color of the rooms was perfected for weeks and weeks. Diana was determined to work with the best and once brought a painter out of retirement because she was convinced he was the only person who could do the job. She also had a favorite lighting man. As Tonne Goodman remembered, "It was quite something to see these guys who were museum trained—again, academics. They knew how to light an object perfectly, without discussion, without incident, without anything, and she would then draw something out of them that had never been asked of them before. They looked at her with humor and they really loved her."

These professionals sometimes had different ideas, however, on how things would be done, and often changes would be accompanied by a quip. Jean Druesedow, who took over Stella Blum's job in the early eighties, remembered how they were setting up the galleries for the Yves Saint Laurent

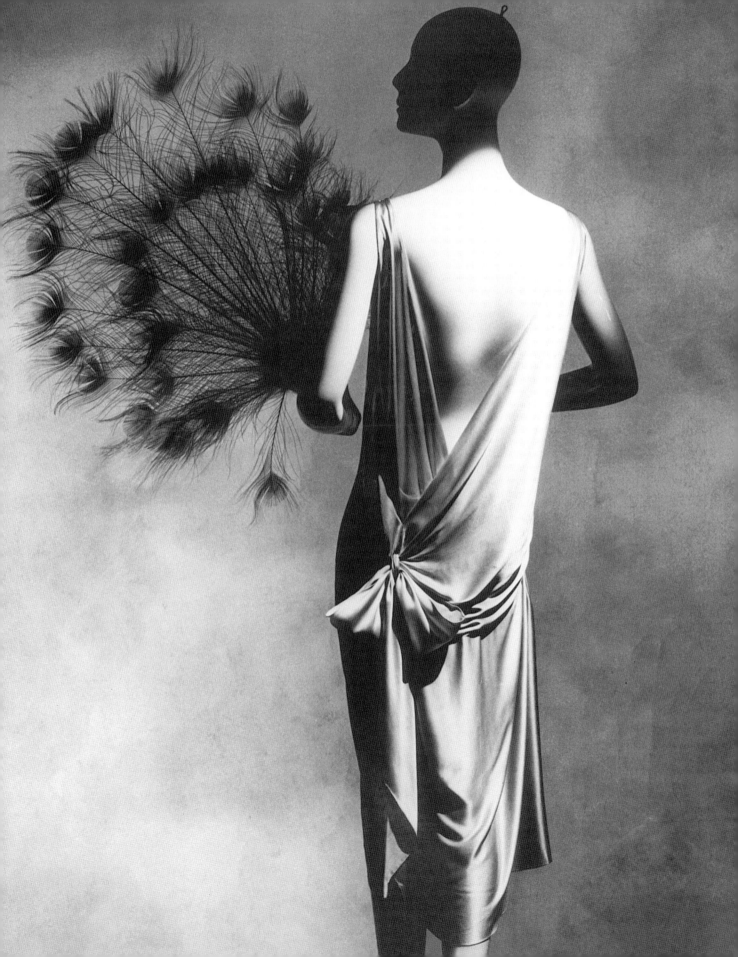

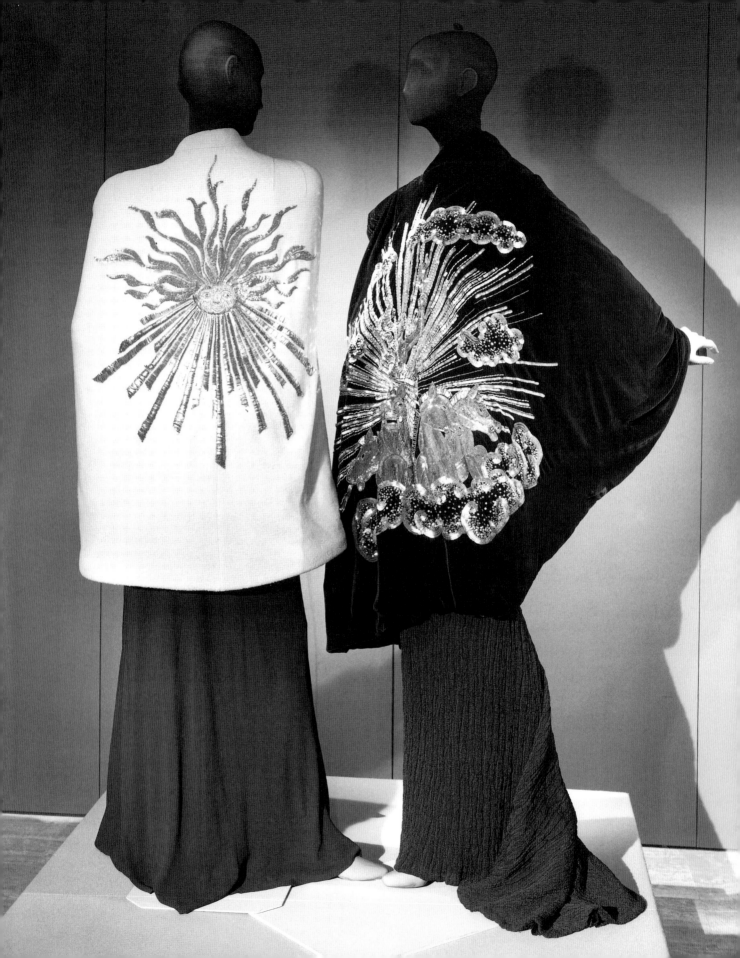

show, and there was one mannequin waiting to be put on a platform in the Black and White Gallery; it wore a white vinyl raincoat with black knitted trim. Mrs. Vreeland came through with Stephen Jamail and looked at the mannequin. "Well, it IS black and white, and some people have orderly minds!" Even without actual instructions, then, Mrs. Vreeland made obvious her views about how the exhibits should be run: the mannequin went back into storage.

Reporters came in for previews before the openings. Bernadine Morris, who covered fashion for the *New York Times*, enjoyed Vreeland's marvelous performances. For the "Vanity Fair" show, Vreeland waved her arms in the air proclaiming: "It's the souks. It's the souks." Bernadine says, "I didn't even know how to spell 'souk.' I always waited for her to say something like 'Pink is the navy blue of India,' but she never did." To get the exact details for absolute accuracy, reporters knew that an interview with Stella Blum was a must.

Elsie de Wolfe in her Schiaparelli cape with Jean Cocteau's design before she gave it to the Costume Institute, which later exhibited it for the show "The Tens, the Twenties, the Thirties: Inventive Paris Clothes 1901–1939."

The exhibits were tough on the staff. Vreeland was particularly critical when her subordinates produced sloppy workmanship or were not able to communicate ideas as swiftly as she could. Tonne Goodman, however, felt "that was a fantastic lesson for a young person to learn. She taught a standard." When Judy Straeten left the Costume Institute years later, she missed Mrs. Vreeland the most: "She was not like anyone else in the world. She drove me nuts when I was there. But you get used to a certain kind of response to a comment or conversation. It's like when you throw a football. You don't know how it's going to hit, where it will bounce. Her responses were totally surprising—she might say something that had nothing to do with what you were talking about. You miss that."

Diana also knew how to relax her staff when things got hectic, and how to put them back in her pocket when the frustration level became too intense. She would make them feel important, as if they were all of a sudden in the center of her thoughts. Of course, all involved felt grateful for any attention Mrs. Vreeland might give. For Goodman, as for so many others, all the hard work was worth it for what she got in exchange: "I will always remember her being able to refocus somebody by gifting them with something. It was like a big present to sit with her quietly, to have her all to myself. She could focus on you and make you feel as if you were the only person in the world." Goodman went to Vreeland's office, where Vreeland told her the story of the *Spectre of the Rose* performed by Nijinsky, and Goodman said that "it would absolutely take me to a different place."

Throughout the winter and summer of 1973, Diana worked on the exhibition ("The Tens, the Twenties, the Thirties: Inventive Paris Clothes 1909–1939") that was scheduled to open in December and run into September 1974. Kenny Lane remembered preparing the jewelry for the show, which included about ten Chanel figures.

He threw a single string of pearls around one mannequin wearing a full-skirted, puff-sleeved tulle evening dress from the late thirties, which Lane had only seen the likes of once—worn by Princess Dumpy Lichtenstein on Cap-Ferrat and accessorized by only a pair of small diamond-stud earrings. Mrs. Vreeland screeched, "My God! She's not a debutante!" Even after Lane put more jewelry on the figure, she came through again and insisted that such a woman, whose lovers no doubt included maharajas and zillion-aires, needed more. The piece wound up with not only three diamond stars but masses of pearls and rubies and emeralds, cuffs, a hat and "God knows what else." Lane spoke of one encounter in which a very young journalist approached Diana and asked, "'Mrs. Vreeland, don't you think that might be considered bad taste?' Vreeland looked at her and said, 'There are a lot worse things in this world than bad taste.' Which could have meant stupidity, no taste, imagination, being boring, you know, that's all she said."

In December, the "Tens, the Twenties, the Thirties" show was launched with a dazzling party. As Philippa Toomey described it: "The door opens, Mrs. Vreeland dressed in red, with a great necklace of red and green, appears and is warmly embraced by a charming young man (her grandson)." She is photographed with a magnifi-cent Poiret evening coat as the audience applauds. "It's a great moment, starring another legendary lady of whom it may be equally truly said that age cannot wither her, nor custom stale her infinite variety." In her red dress with Pier-rot ruffles from Yves Saint Laurent, Diana grace-fully accepted compliments and guided people around the rooms.

The importance of this second exhibition was that it showed the clothes that had inaugu-rated the line of the century, clothes of fantastic workmanship and style interpreted by someone who had worn them herself. This fashion revolu-tion had liberated women, changed what they wore, how they looked and how they felt about themselves. For centuries women had been corseted and covered with long skirts, their legs completely hidden. As Vreeland put it, before this time a woman "was a confection of leg-o-mutton sleeves, flounces, girdles, stays, and bustles into which a body had been squeezed, with a head attached. The dress entered the room, not the woman."

In this exhibit the clothes showcased would be "rocking with" the excitement of the new cen-tury. And, as the iconoclasm was not limited to fashion, the exhibit would represent the spirit and flavor of Matisse, Picasso and Braque, the pulsa-tions of Stravinsky, Debussy and Ravel, as well as the excitement of the Ballets Russes, which, as J. B. Priestley said, had burst on the world "like a bomb filled with silks and colored lights."

Entering the exhibition, the viewer found the first gallery filled with Schiaparellis—on mannequins appropriately placed against the backdrop of walls painted in the designer's shocking pink. Lavished onto Schiaparelli's cre-ations were the Art Deco designs of Jean Cocteau and others. Also featured were her wild patchwork coat and silk-screened "circus" series, vintage 1975.

There were Vionnet dresses—of lamé, of crepe, of satin. Visitors learned that Vionnet was the mistress of "bias." As Vreeland explained it, "Instead of starting with the mate-rial straight on, with the threads going horizon-tally and vertically, Vionnet tilted her fabric sideways, so the threads ran at an angle. Then she began to cut." Diana had visited Madame Vionnet in Paris in September of 1972, and found her at ninety-seven years old "delicious,

Diana Vreeland and Gloria Swanson in the central gallery of the Hollywood show.

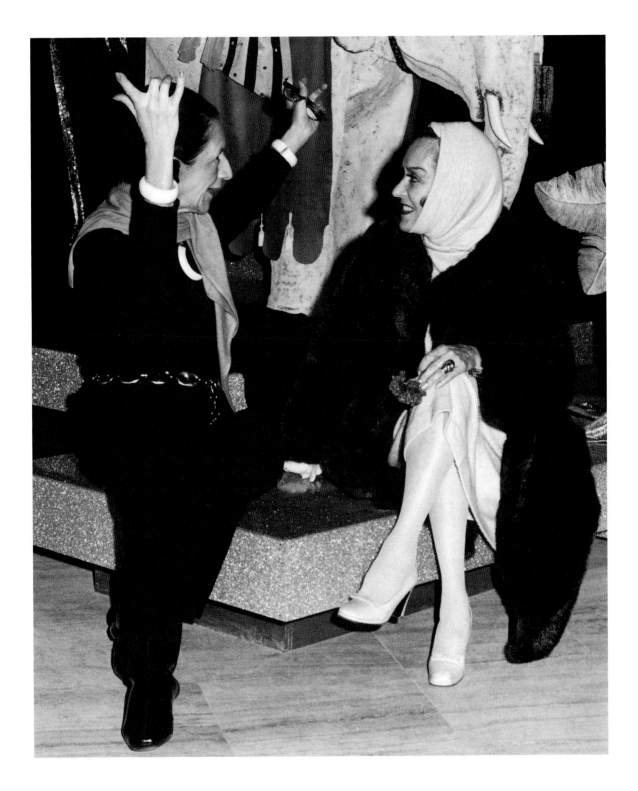

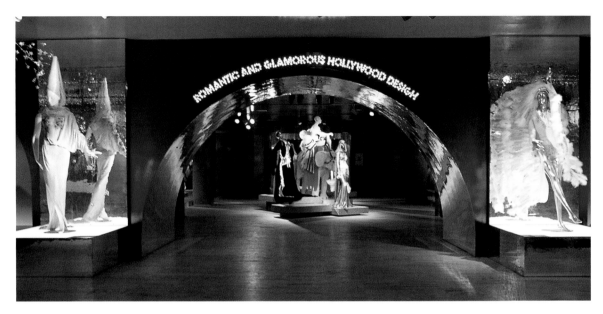

In the Hollywood show, music, scent, artworks, suggestive lighting and rich wall colors complemented the dramatically positioned mannequins to make it both exciting and intimate. Below: "Marilyn Monroe" in a showgirl costume of black velvet and white faille with a bustle of plumes on an elephant lent by Andy Warhol. "Claudette Colbert" as Cleopatra (1934) in gold lamé.

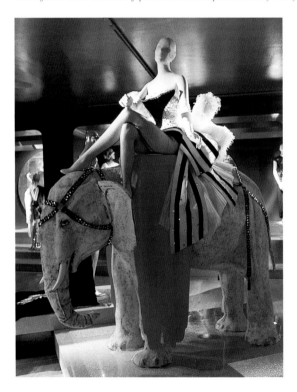

fresh as a pink rose, totally alert, totally under-standing everything that is going on," and immensely interested that her clothes would be in Vreeland's show. The older woman held on to Diana's hand very tightly and said, "Listen to me. I never knew anything about fashion. I only made what I thought was correct." Vionnet recalled that "bias came from my head maybe because everyone made dresses that flowed in the same direction. But I saw that if I turned the fabric on an angle, it gained elasticity."

Viewers were enchanted with the oeuvre of the three Callot Soeurs. They designed afternoon frocks, tea gowns, late-afternoon ensembles and theater coats for a time when a woman changed her outfit many times a day and had her hair done three times, as Wallis Windsor and Daisy Fellowes did. Their 1920s dresses showed luxurious forms of embroidery. The sisters were the daughters of a lacemaker, and their early clothes were covered with lace.

Poiret was the first of all the innovative revolutionaries, "the first modern dressmaker." As Vreeland repeated her theme to her viewers, "A woman's body was seen for the first time as it really was." Poiret dressed Ida Rubinstein, Isadora Duncan and Sarah Bernhardt. Viewers learned that he was the first to launch perfumes and cosmetics, to open a school of interior decoration and to take his collections abroad on tour. Rosamond Bernier recalled that Diana called her about a lecturer: " 'Now, darling, who should I ask to lecture on Poiret for my exhibition?' And I said, 'Diana, I don't know. But remind whoever's going to do it that Dufy designed materials for Poiret, and that he had Matisse design something, and that he himself was a collector.' She said, 'Well, you know what I want, darling, you've got to do it.' I said, 'I can't do it.' Well, I did it. She just persuaded one."

Bernier's lecture focused on Poiret's innovations. "The single fact that Poiret threw away the corset makes him rather responsible for the new 20th century woman who wanted to move and act. Since the Middle Ages, women had had an artificial shape, a beetle-like shell imposed on them. Getting rid of it was almost like giving women the vote." In addition, Poiret is credited with the invention of the bra, the girdle and flesh-colored stockings. The visitor could marvel at the designer's range—a black sequin evening dress; a black lace dress with a ruffled gypsy skirt, worn with a violet Venetian shawl; a dress of silver lamé under a long, regal velvet train, worn by Princess Maria Jose of Italy in 1930 at her wedding to Crown Prince Umberto.

When you entered the Chanel gallery, you saw Vreeland's favorites, for she thought Chanel was the greatest designer of all: "She perhaps best understood the twentieth century." The visitor was to put everything out of her mind "except that you're in long skirts, in the mud, in the rain, and someone comes along, and her name is Chanel, and she cuts off the skirts, giving you the opportunity of leading a comfortable, clean attractive life in fashions she created precisely for you." The viewer should notice number 140 against the lacquered red wall on the far right. "It consists of a little jersey pleated skirt, a sleeveless striped pullover, and a cardigan. These actually are not really old. We had them made for us by the House of Chanel from the original 1926 pattern," because it was "the classic costume of the 20th century. Chanel believed in jersey and was the first to use it for fine clothes. She believed in luxury, luxe, and the look of the gypsy, the extreme, and while she threw ropes of costume jewelry onto everything in this wonderful way, she kept her clothes very nice and vivid and controlled." Vreeland had come of age with Chanel and Schiaparelli, and she approved of their desire to outfit healthy, active, modern women.

Strolling among the displays, viewers

enjoyed a fantastic musical medley—Astaire singing Cole Porter, Dimitri Tiomkin's arrangement of "Laura," plus a dash of Gershwin playing Gershwin—and even sprays of perfume. Which scent? Chanel No. 5, of course, which was piped in through the ventilation system. And there were the high-fashion Schlaeppi mannequins, many with stockings over their faces. Judy Straeten remembered overhearing two old ladies talking in the Callot Soeurs gallery. One said to the other, "Oh, these are so pretty. Remember when we wore dresses like these?" The other said, "Yes, but I don't remember wearing stockings over our heads."

Covering the show, costume historian Anne Hollander immediately saw that Diana's presentation was show business. Her galleries were designed "to do away with any waxwork-museum look of dressed up corpses under glass. Wired for sound and magnificently lighted, these rooms with their variety of stepped platforms resemble a stage set through which the audience may freely move, so that the clothes can be seen almost at eye level and from all sides." Diana Vreeland insisted that "everything must look 'Now'": dramatic presentation as if at a fashion show. She found that this worked wonders "because it gives some quality of living movement . . . so essential to the look of fashionable dress at any date."

The exhibition also told Vreeland's own story. In 1910 she was six and just becoming conscious of fashion. She had watched what her mother wore, not always with approval, and by the 1920s she was a glamorous young woman at the same time that Chanel was making a name for herself. Diana saw her mother give up the S-curve shape of Charles Worth's magnificent dresses, and witnessed the liberation of women's bodies by Poiret. She patronized these couturiers herself, and she showed their clothes as fashion editor of *Harper's Bazaar*.

The exhibition was fantastically successful and brought almost 400,000 people into the costume galleries. The public loved the show. The young were enchanted by the style of the designers' creations, and the old reminisced about wearing the clothes. Designers were fascinated by the earlier styles, particularly Vionnet's bias cut. As Richard Martin and Harold Koda wrote: "The foremost accomplishments of Halston in the mid- and late 1970s seem so clearly predicated on his interpretive engagement with this show."

Vreeland's next project was an exhibit on the creations of Hollywood's designers, and for this idea she encountered some resistance. Was this truly art? Did Hollywood costumes belong in a museum? Vreeland maintained they were as impressive as the costumes of any other era or designer—and she prevailed.

Vreeland's preparations took her to Hollywood in March and again at the end of June 1974. Tim Vreeland, who was an architect in Los Angeles and was teaching at UCLA, remembered her visit well, particularly the outings with her movie star friends: As she left him and his wife, Jean, behind for an evening out, she would apologize. "'Timmy, I wish I could invite you. I'd introduce you to my friends out here but they're all so much younger than you. You are simply so much older than this group I'm seeing.' In the evening Warren Beatty used to come and pick her up and drive her off into the hills where they all lived with Jack Nicholson and Anjelica Huston and Cher, and she would spend her evenings with them and come back the next morning at breakfast and tell us about the wild party that they just had.

"One day I had to pick her up at this large, fantastic house. I was quite embarrassed because I wasn't dressed the part. In fact, I looked like a college professor, all in tweeds. As I went inside this grand palace to look for her, there she was talking to Governor Reagan. Later she said to me, 'You know, he's a very attractive man.'"

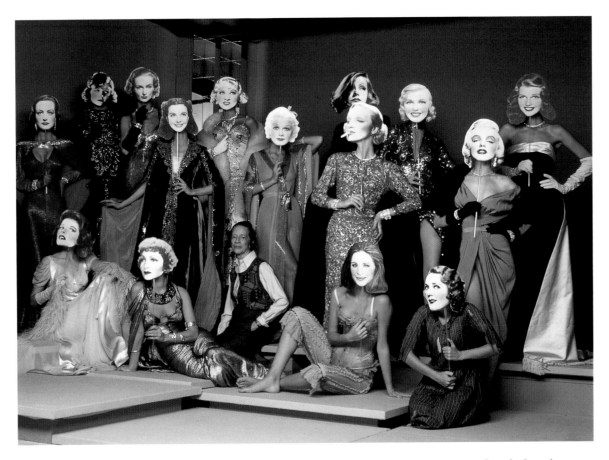

Vreeland's friend Francesco Scavullo photographed her staff at the Costume Institute in costumes and masks from the Hollywood show: in the front row Katharine Hepburn, Claudette Colbert, Barbra Streisand, and Mary Pickford.

In addition to seeing friends and family, Diana worked hard in Hollywood, scouring the studios in search of the clothes worn by the stars—she focused primarily on Universal, Warners, Columbia and Paramount. They could not find the costumes from MGM films—the great films of the thirties—as the company had been sold and the clothes scattered. They were able to borrow important costumes from the families of David Selznick and Cecil B. DeMille and from Paramount and Warner Brothers, and a few costumes by the designer Adrian from F.I.T. in New York. Edith Head had a priceless collection of Travis Banton costumes, and the Selznicks had carefully kept Walter Plunkett's *Gone With the Wind* clothes.

Many of the clothes from Hollywood's heyday had been cut up and changed or, she claimed, used in New Orleans for the Mardi Gras. Some belonged to private collectors who would not lend them. As they had not been worn by individuals, Vreeland couldn't just contact helpful friends like Pauline de Rothschild and have them look for garments in their own closets. She acknowledged that everyone was terribly nice in Los Angeles, but she did run into problems. The studios hadn't

preserved anything, and actresses didn't have anything because they never owned the clothes. She found so few costumes at the studios that she was shocked. "I told them, 'You are doing to your industry what Watergate has done to this country.' I was scandalized. Simply shocked."

But Tim drove her all over town, and they discovered some gems. As Diana later recounted about the Los Angeles County Museum of Natural History, "I'm there with the fossils and God-knows-what, and this gentleman is showing me Mae Murray's dress [from *The Merry Widow*], and he said, 'Would you like Mary Pickford's curls? We have Mary Pickford's curls.' And I said, 'Of course, *enchanté*'—and so we have Mary Pickford's curls."

She and Tim drove to Pickfair, Mary Pickford's house. "We never met Mary Pickford," Tim recalled, "because by that point she was an invalid, but she allowed Mom to come and we went through the attic of Pickfair. It was like every attic, but there were these long wooden rods and on wire hangers were costume after costume after costume. There must have been a thousand little girl dresses and Mom went through each one." She was very impressed by the quality of the costumes. When asked later if these clothes measured up to the high standards of the haute couture represented in the other exhibits, she raved about their beauty and the meticulous workmanship.

They found themselves in obscure sections of Los Angeles where fanatics of the "golden era" of film still collected memorabilia. "There was a dress she remembered from a movie Marlene Dietrich had made. At the end of the movie, she went across the desert on a camel with this chiffon blowing. Mom was determined to find that dress."

They discovered a young man who "had file cases after file cases of movie stills. You could hardly walk through the house for the racks of clothing, which were movie stars' clothing, and all these metal files. And Mom went through all of these." When she couldn't find an item she considered important, she got designers to make them for her. "Jean Louis was responsible for Rita Hayworth's strapless top black silk she wore in *Gilda*, and she did finally have Marlene Dietrich's trailing blond chiffon from *The Garden of Allah* copied by Bill Blass."

The Hollywood show, which was American through and through, appealed to viewers' nostalgic memories and fantasies. The stars that everyone remembered were there—Esther Williams in a salmon-colored bathing suit; Marilyn Monroe in the famous cream-colored crepe dress of *The Seven Year Itch*; Audrey Hepburn as Eliza Doolittle in *My Fair Lady*; Cary Grant, Garbo, Mary Pickford and Grace Kelly.

When you entered the exhibit, there was Marilyn Monroe, riding her elephant in Mike Todd's circus, and also standing on a subway grate in *The Seven Year Itch*. Suddenly, swoosh, the breeze takes over. As Vreeland said in her AcoustiGuide tour: *"Glorious."* Monroe's costumes had to be shown behind glass cases to protect them. They also had the nude-colored sequin sheath in which she sang "Happy Birthday" to President John F. Kennedy.

As Eleanor Lambert found out, Diana's method in putting together the Hollywood show perfectly articulated the essence of an industry that "created a world that never was, that opened a new universe for millions. . . . No woman ever crossed the desert in those chiffons Marlene Dietrich wore in *The Garden of Allah*—but what a way to dream of crossing the desert!"

Since Diana herself had a rich imaginative life, she was convinced that American moviegoers did as well. When they went into the dark theaters, they *became* the characters in the celluloid stories. When "the delivery boy in the front row" went to the movies and saw Valentino as a gaucho dance the tango, he became a Latin lover. As she said in her recorded lecture,

every housewife at a matinee became Marlene Dietrich as the Scarlet Empress, "covered with sable, standing on the ramparts with her soldiers and her horses, in the blue-white snow." According to Vreeland, extending fantasies and horizons beyond our wildest dreams was important to Americans, "who could not make it out of their small towns, off the back porch in Kansas." At the movies one could be in the deserts of Morocco, on the banks of the Nile, in the Orient, on the "wind-swept Russian steppes," or the gold fields of Alaska. "Movies were the big trip of the twentieth century, and put magic in our lives."

In the publication that complemented the exhibition, Diana gave her readers plenty to think about as she recalled the history of costume in film. The history of movie costumes started with simple outfits made or bought by the aspiring stars. The actors of the silent screen dressed themselves before going in front of the camera. Vreeland explained, "They would be told: 'Come as a tramp, come as a vamp, come as an orphan—your mother has died and you have to keep your three little sisters from starving.'"

As movies became more elaborate, designers had to dress up the stars for exotic settings, stories from the Bible, or scenes in ballrooms, at royal courts, in the forests of Shakespeare. No expense was spared, for all was gold and glitter. Every costume was flawless in its construction—embroidery, beading, or appliqué was hand-sewn by one of the over two hundred seamstresses then employed by the studios who juggled the demands of fussy producers, directors and designers. The final result: The costumes could withstand the scrutiny of the "all-seeing eye of the camera."

In Hollywood's heyday some studios produced up to two hundred movies a year, eight or nine simultaneously. They had their own dress factories where they kept dummies with the names of each star and stacks of patterns and sketches, along with the army of dressmakers.

Vreeland considered Gilbert Adrian, Travis Banton and Walter Plunkett to be the most important designers. Banton dressed Marlene Dietrich, Plunkett designed clothes for *Gone With the Wind* and Adrian transformed Greta Garbo—his greatest inspiration—into a character evoking perennial mystery. With ease, Garbo went from wearing the cavalier garb of Queen Christina of Sweden to playing Mata Hari in "a variety of pseudo-oriental gowns." For his most lavish production, he constructed "six-foot-wide panniers and towering court wigs draped with pearls and massed with roses and diamond stars" for Norma Shearer's Marie Antoinette.

While Adrian thrived upon these feats of grandeur, Travis Banton distinguished himself as a craftsman. He stayed true to the "elegant, understated, and seemingly simple" aspect of dressmaking. In addition to Marlene Dietrich, his gowns graced the likes of Carole Lombard, Mae West and Claudette Colbert. Banton's trademark remained his endless use of fur, hundreds of yards of sable and ermine and thick white fox. For the exhibition, Vreeland got furriers to donate all the fur she needed to replicate this look.

While Diana was preparing the Hollywood exhibit, a new volunteer—who would later become a friend—appeared at the Costume Institute. André Leon Talley had idolized Mrs. Vreeland since he was a young boy, when he first became enamored of fashion. At twelve, he pinned a picture of her on his wall, and in 1974 he left Brown University, where he was studying French, and headed straight to Mrs. Vreeland, armed with a letter of introduction from a friend's influential father.

On his first day he was told to reassemble a costume Lana Turner wore in *The Prodigal*. "It was a box with all metal pieces, interlocked like chains. And they gave me a pair of pliers and said,

'Take this and put it together.' I had never done anything like that in my entire life. At least there was a foundation. I just had to follow through putting a few chips here and there. So I spent one day in a corner. And the next day Mrs. Vreeland walked in. I hid behind a column. I wanted to see her but I didn't want her to see me. And she passed this costume which was now mounted on the mannequin. She walked by it and she said, 'Who did this?' And the way she said it was not like approval; it was more like 'Who has touched this?' And I didn't know what was happening. She walked into her office and about fifteen minutes later someone came to me and said, 'Mrs. Vreeland would like to see you in her office.' And I thought, 'Well, here goes the ax. She hates it.' And I walked into her office and I sat down next to her and she said, 'Now what is your name?' And she wrote my name in huge letters on a yellow legal pad. It was so big that she could sit at her desk and I could see it. She wrote 'André' and then '— the Helper.' And then she said, 'Now you will stay by my side until the end of the show.'"

Talley quickly learned about Diana's high standards and her eccentric approach. She decided that blue paillettes were necessary to cover the eyes of the Marilyn Monroe mannequin. She had brought some paillettes to her office, but decided they were the wrong shade of blue, so she prevailed upon Talley to change them. He was instructed to pick out all the correct blue paillettes from a container of multicolored paillettes, a job he refused to do. On the night of the opening, there, covering Marilyn's eyes, were the blue paillettes. "I finally got the paillettes for Marilyn Monroe. I had to go to Elizabeth Arden," André explained. "I must say, it is a very deft effect."

Three costumes worn by Mae West in (left to right) *"I'm No Angel" (1933), "Belle of the Nineties" (1934) and "She Done Him Wrong" (1933). Page 226: Diana in the galleries, 1982, photographed by Patrick Demarchelier.*

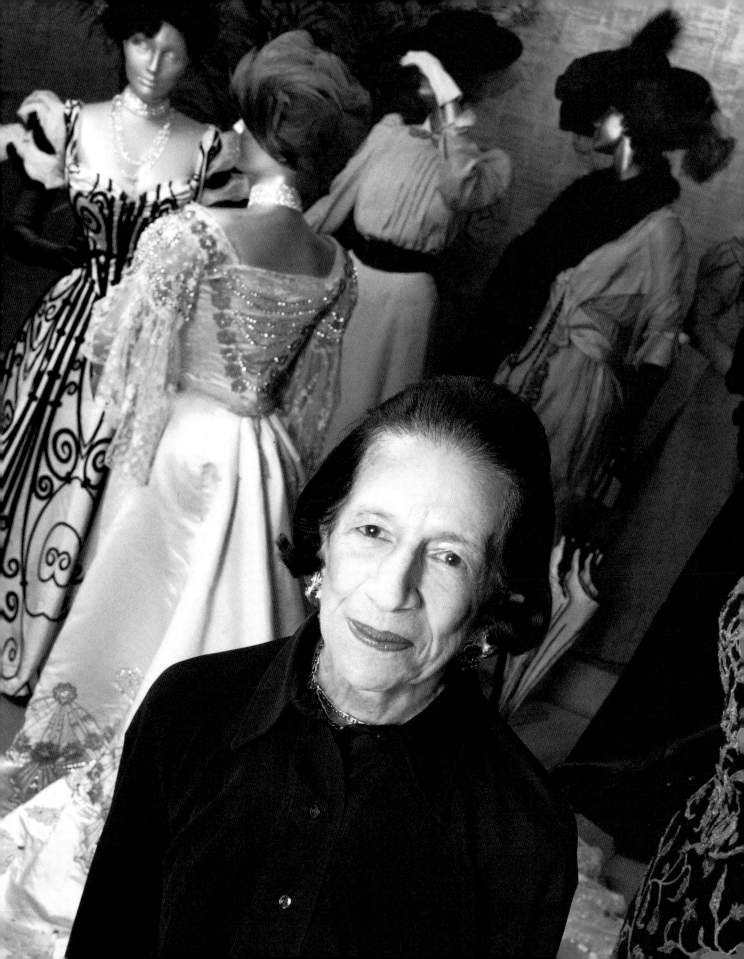

The critics greeted Vreeland's Hollywood exhibit with enthusiastic applause. One said that only Hollywood, as they used to say at MGM, could "Do it Big. Do it Right. Give it Class." And only Vreeland could bring it back. Another critic drew parallels between Vreeland's attempt to flesh out female fantasies in the 1960s through her work at *Harper's Bazaar* and *Vogue* and the way that MGM musicals fed the Depression hungers of the 1930s.

To give the exhibition a contemporary feeling, Vreeland included items worn by Cher. When criticized for including the clothes of a TV personality, Vreeland replied, "It's a show stopper. People say, 'But that's television!' I say, 'Look at the title of the show. It's Hollywood design—not just Hollywood film design.'"

The party to launch the show was like the pages of a Vreeland issue of *Vogue* come to life. An armada of limousines pulled up to the enormous Beaux Arts building, and out stepped the stars. The celebrities dined first and then spilled out into the great hall. It was a big party, the kind of party that "sets the tone, crystalizes a look," wrote Carol Troy in *The Village Voice*. In this case, the look was luxury. So many beautiful girls wearing expensive evening clothes "with a studied languor." Marisa Berenson came with her sister Berry and Berry's husband, Tony Perkins. Cher wore a white Indian dress, created especially for her by designer Bob Mackie, who brought her to the party. It was completely see-through. As Hoving said, "You could see everything." And there were beautiful young men as well, "jawlines distinct, hair slicked back in a 20s curve, evening clothes just so. An *Esquire* cheesecake spread."

And then there was Vreeland, the most glamorous of them all, in a black velvet dress by Madame Grès, moving through the exhibit "like an eccentric raven, every gesture oozing glamour"— echoing the richness, the bigger than life presence of the movie costumes she had assembled.

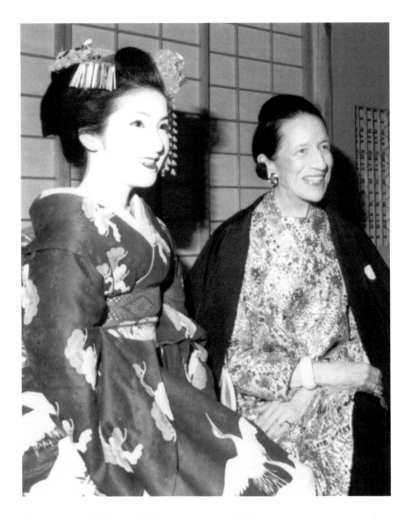

*I went to Tolstoy's house. . . . There was no one else
there, and I thought it was the most divine thing
in the world. And when I saw these lilacs—
like great big bunches of grapes—falling over the
walls like bombs . . . I died. —DV*

EXPEDITIONS TO THE EAST

Diana's job at the Costume Institute took her all over the world. She traveled to see one of her shows in Kyoto, Japan, and she visited countries in Eastern Europe to negotiate for costumes. She was often accompanied by friends and family, including her grandson, his girlfriend and her new close friend, Fred Hughes.

In March 1975, Kyoto's National Museum of Modern Art mounted her exhibit "The Tens, the Twenties, the Thirties," which had been at the Met in 1974. Issey Miyake, then a young designer and a great fan of Diana Vreeland, had convinced Kouichi Tsukamoto, a founder of the lingerie company Wacoal, to bring the exhibition to Kyoto. He had seen it in New York and, according to curator Jun Kanai, "was just bowled over. He couldn't believe how beautiful the clothes were, especially those by Vionnet." As it turned out, the show was such a hit in Japan that Mr. Tsukamoto set up a Japanese version of the Costume Institute in Kyoto.

In Kyoto, Diana was terribly happy with the presentation of her exhibition. It was mounted in the modern art museum, and walls were built and covered with pink fabric. Every morning the gardeners would come with their wheelbarrows filled with masses of "little potted flowering things and they were exquisite and beautiful." Although it was spring, it was very cold and she wore her fur coat most of the time. According to Issey Miyake, everyone remembered later that when Diana Vreeland came to Kyoto, although the cherry blossoms were in bloom, it snowed at the same time—a rare occurrence.

She loved the colors of the show. There was a lovely pink carpet going into the museum, a bright Schiaparelli pink. "It was the sort of pink that only the French and the Japanese understand."

The mayor of Kyoto, Motoki Funahashi, and the president of the Kyoto Chamber of Commerce and Industry, as well as six hundred guests including financiers and Tokyo art and fashion luminaries, all greeted Diana at the reception before the opening. The men came in traditional formal Japanese dress, a gesture she felt was the height of compliment.

Diana had always been entranced by the idea of geishas. Literally translated, the Japanese word *geisha* means "person who lives by the arts"; it is not surprising, then, that Vreeland, a woman whose entire life was an artwork in progress, had become fascinated with the highly stylized entertainers and even included a geisha makeup spread in the December 1964 issue of *Vogue*. Traditionally, the geisha wears heavy layers of kimono, white face makeup with black-on-red eyeliner and deep red lipstick, and an oversized black lacquered wig decorated with jewels. Her unemotional veneer is calculated, and she takes the utmost pride in the exhibition of her doll-like artifice. There were around seventeen thousand geishas working in Japan in 1970 and most lived in the cities of Kyoto and Osaka.

Now, as a guest of the Chamber of Commerce, Diana dined in Kyoto with her hosts while geishas entertained them. She watched their every move, entranced by their grace and charm. They moved like butterflies around the room and took their positions on their knees. As Diana said

229

later: "There is nothing quick about the way they move—it's all very quiet. They laugh and they talk and you don't feel out of it not knowing what they're saying because, whatever it is, it's full of charm." When the dinner was finished, Diana, curious as to what the geishas' skin might look like under their white masks, asked what kind of makeup they used. She was shocked to discover that like so many American women the geishas used Revlon.

On this trip to Kyoto, Nicky Vreeland saw a side of his grandmother that he didn't know existed. He knew that she had a broad knowledge of Japanese history, literature and art. She had read all the Pillow books. She knew details about Nō theater and adored Kabuki. But he was surprised that her interest was almost exclusively in the Japan of the past, not the Japan of the present, which she found vulgar. Nicky and Priscilla explored Kyoto and its outskirts—spending time on the roof of the Takashimaya department store, which boasted Pachinko and new video games. They showed her photographs of their contemporary Japan. Diana, however, found Nicky's photographs ugly and preferred a Japan that had existed for centuries—represented by the Temple of the Thousand Buddhas and Nara, and the ancient Japanese gardens.

During a big party for the New York visitors that took place in a house outside the city, everyone was brought into a room where there was a huge box with a big ribbon. Diana couldn't imagine what was inside. She was led forward and asked to open a paneled door. To her amazement, two sumo wrestlers stepped out of the box! "They were in full regalia, which is very little, especially in the back. The two were totally glorious. But if looks could kill! They didn't enjoy being on exhibition. I was so on their side." Not knowing what to say, she said, "The pink babies!" and she walked right up to one of them and pinched him. She maintained her good

humor, but was horrified at what they had been made to endure just to entertain her.

That spring she and her staff began work on an exciting exhibition that had been anticipated since the early seventies. It was part of a five-part series of exchanges of treasures between the Soviet museums and the Metropolitan, engineered by Tom Hoving soon after Diana had come to the Costume Institute. The first Met exchange show was an exhibit of ancient Scythian gold and silver objects from the Hermitage and the State Historical Museum in Kiev. In 1975, the Met sent a selection of one hundred European and American paintings to the Hermitage in Leningrad and the Pushkin Museum in Moscow. In August 1976, a collection of pre-Columbian gold would go to Russia from the Met. But it was the Costume Institute's mounting of "The Glory of Russian Costume," one hundred fascinating "ensembles" and many accessories focused on two hundred years of Russian history, from about 1700 to 1900, which Hoving would later consider the most successful of the five shows. It dazzled enormous crowds (835,862 was the final count). Fifteen years before glasnost, visitors poured into the Costume Institute to marvel at what had been worn by the forebears of those enigmatic people behind the Iron Curtain.

The real work began with the search for costumes in August 1975, when Hoving joined Vreeland in Moscow. He was exhausted by the long plane trip, but Vreeland, who had come by way of Paris, was fresh as a daisy: "Dressed like a lacquered black-and-red Japanese doll, her skin glistening with Vaseline, she strode through the airport like an exiled aristocrat returning to regain her rightful property. She didn't stop for a week." They had come to look at costumes at the Moscow Historical Museum and the Kremlin. But they had fun, too. The Metropolitan group spent the evenings in an Uzbek restaurant. The food and music were good, and there was a prix fixe for

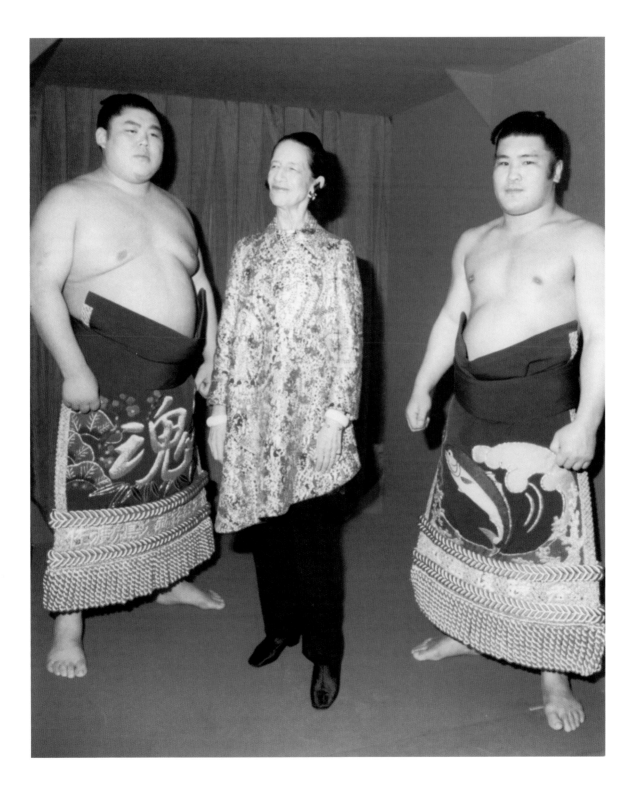

the equivalent of $20 for all you could eat. They closed the place down every night, listening to nonstop music until three in the morning.

From the start, Vreeland loved Russia and the Russians (to whom she referred as "les russes"). She already had imaginary yearnings for anything Russian, having been exposed to elements of Russian culture through the émigrés in London, Paris, Lausanne and New York. In Russia everything seemed to delight her—the wide

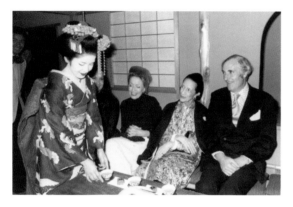

skies, the architecture, the vodka, the blinis. But most important for the exhibition, her powers of imagination swept her past the dreary, humdrum life of the present into an imaginative awareness of the lavish grandeur of the Russian past. She envisioned herself as an Anna Karenina figure moving mysteriously through the drizzle and fog of the Moscow night.

Her party stayed at the National Hotel, facing Red Square. Everything about this home away from home charmed her—its grand lobby bustling with people, its large rooms and even the details of her breakfast china. The china was so much thinner than hers at home, the teapot white with red polka dots with a dark blue top and a red knob. She concluded that "the Russians are the most luxurious people in the world."

Part of the fun was the romantic excursions with Fred Hughes, a member of the Warhol set whom Diana now saw constantly. Fred had been

working for Warhol since 1967, when he came to New York from Texas to do some work for the Menil Foundation. Fred enjoyed life at Warhol's Factory so much he stayed. As a companion, he offered Diana an urbanity and sophistication that she was drawn to, and even though he was forty years younger, they became close. Friends thought she had a crush on him. "She liked his style, the cut of his jib," Kenny Lane remembered. Some thought she saw something of Reed in Fred. André Leon Talley recalled that "no one could dance with Mrs. Vreeland the way Fred did. While everyone else was doing disco, they were waltzing together in this very elegant air, in this cloud, a kind of dancing from the old days." Like Reed and Diana, Fred presented a polished, beautifully rehearsed exterior that concealed his sensitivity. She saw Fred three or four times a week. He dined with her at her apartment and traveled with her.

Now the two ventured out on day trips to

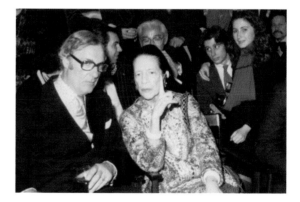

such places as the Yousopoff family palace, located on the edge of Moscow. There they picnicked on caviar, bread and vodka, and strolled through the grounds.

However, she was in Moscow to work and the negotiations were tricky, as the Russians were reluctant to lend pieces from their priceless collections. But with her typical balance of ease and resolve, Diana was well prepared for

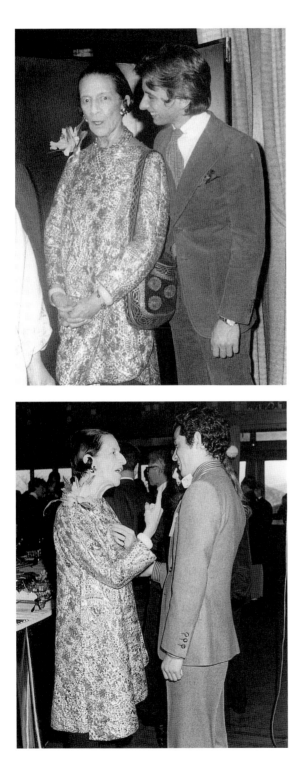

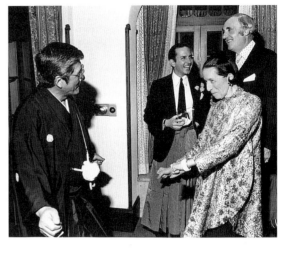

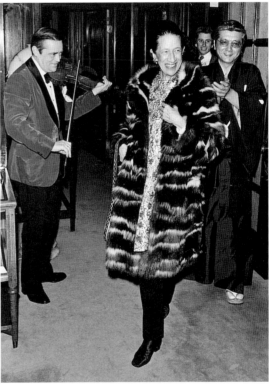

Clockwise from top left: *Diana with Nicky; greeting Kouichi Tsukamoto with Fred Hughes; being serenaded; and with Issey Miyake.* Opposite left: *Diana in Kyoto with Elizabeth Lawrence and the British ambassador;* right: *Nicky Vreeland and Priscilla Rattazzi* (at right).

the complicated diplomacy that followed. The first crucial meeting at the Kremlin was set for nine in the morning with officials at the Ministry of Culture, an hour at which Vreeland never appeared in public. She told Hoving to go "talk about all those 'museumy' details and I'll be there—on the dot of eleven." Doubting that Diana would show up, Hoving went to the Kremlin and talked and wasted time. His Russian colleagues, "sitting in the fly-specked room with fluorescent lights, were getting more and more nervous." To Hoving, it looked like a place you might be inter-rogated by the KGB. They asked him what was she really like and whether she would come. "Of course," Hov-ing replied smoothly.

Hoving remem-bered that just before eleven Vreeland swept into the room, radiant in crimson and shiny black, her hair looking like a painted surface, her neck arched. Supremely confident, she slowly and studiously gazed over the heads of the anxious Soviet officials. She sat down, placed one arm on the table and pushed herself back. "Her stupen-dously chic head turned majestically. The Russians blinked first. 'Ah, Mrs. Vreeland, what do you think of the Soviet Union?' It was a kind of Last Judgment moment. Diana breathed deeply.

"'Ah, marvelous! God! marvelous!' she said. 'I have been up walking since dawn, ab-so-lute-ly reveling in the vast beauty of this city. God, the women are so beautiful. I mean these complex-ions! The land is so vast. So . . . awe-in-spir-ing!

In Moscow Diana worked hard to find the costumes for her exhibition "The Glory of Russian Costume."

So grand. The women are so gorgeous!' And she meant every word, too, except, perhaps, for what I always kidded her as her 'dawn patrol.'" Terribly impressed, the Soviet contingent all stood up to shake her hand.

The Russian personality who was key in the negotiations was Vladimir Popov, described by Hoving as a "trim, six-foot-six-inch, tennis play-ing, and smooth talking under secretary." He adored flattery, gifts and privileges, and was easily snowed by the cheap Popov vodka that Hoving brought, claiming it was bottled especially for him.

She had won them over, Popov and all. Among the ethnic costumes on display at the Kremlin, Diana spotted what she was convinced was the archetype for Coco Chanel's great classic suit. Chanel had spent some time in Moscow with a Russian lover, the grand duke Dimitri Pavlovich, in the early 1920s. Diana announced to her new Russian acquaintances, who were now respond-ing to her every pro-nouncement as if Lenin himself had said it, "Let us all keep this our little secret."

The exhibition would display the dress of three classes of Russian society—the peasants; the so-called "rich peasants," who owned their land and were craftsmen and merchants; and the aris-tocracy and monarchy during the two centuries before the Revolution. At the National Historical Museum in Moscow, they found many accessories and paintings of "rich peasants" as well as women's court dresses and folk costumes. Vreeland

went to the Kremlin to view the lavish coronation dress of Catherine the Great and the wedding dress of Empress Elizabeth with its long, silver-lace train. In the room of ecclesiastical robes, she saw hundreds of pearl crowns. The next day Diana met with the officials from the Ministry of Culture to approve the costumes. They saw how the Russians stored their wonderful collections in handmade, acid-free, totally pure paper. It was absolutely pristine, especially so in contrast to what Hoving called "the filthy, dirty, horrible Soviet Union."

On August 28, the show of Old Masters from the Metropolitan's collection opened at the Pushkin Museum. On September 2, the Metropolitan Museum group left for Leningrad to see the costumes in the Hermitage. Hoving described the train trip: "I went so many times on that train that they all blur into one marvelous railroad journey. It started at eleven o'clock. If you woke up in the night and looked around, it was a wasteland. Why anyone bothered to invade, I don't know. What would they get?"

With the help of Fred Hughes, Diana investigated costumes during the day, but she had time to see the great sights as well.

To the contrary, Diana's impression of Leningrad was that of pure magic, even before she set foot inside the city limits. She left Moscow at midnight on the train in a slight drizzle, the atmosphere mysterious and foggy.

In Leningrad, Vreeland continued her quest for the great imperial costumes. She was not disappointed. Her first day in Leningrad she visited the director of the Hermitage, and under his guidance she discovered the incredible dressing gowns of Peter the Great. "By this time, my infatuation with Peter the Great was so great that when I hit his dressing gowns in the Hermitage, I almost lost my mind! They were so glorious—Oriental in cut and made of very, very thin quilted silks and brocades." Among her discoveries was one of Catherine's regimental costumes. She found a wealth of objects—men's folk attire, men's uniforms, accessories, ladies' court dresses.

Vreeland was enraptured by Russia, a reaction that she used to flatter the Russians and expressed repeatedly upon her return home. "Russia is a land of splendor!" she wrote later in an article for *Vogue*. "It has a high, enormous sky—it has beautiful houses—it is immaculately clean." She also held a deep regard for its people. "They are terribly strong—if you want one word that describes the Russian people, it's strength. They can take their winters and they can take their history—and they have survived totally. . . ."

This upbeat description of Russia shocked many people. In those days Westerners seldom visited, and the few who went found it a dreary, sad country completely lacking in charm, with people hardened under the yoke of a rigid, harsh dictatorship.

After Vreeland got back from Russia and the "Women of Style" show had been installed in the late fall of 1975, she and her inner staff at the Costume Institute—Candace Fischer and Tonne Goodman—began to visualize the Russian exhibition in the big galleries at the Met. Vreeland's

dream was to display "the scarlet of the cossacks, the liveries of the servants, the children, and some of the paintings of the nobility and the rich peasants." And while she was drawn to the grand-ness and luxury enjoyed by the Russian aristoc-racy, she also admired the gaiety and spirit she came to associate with all Russia. She later told her museum visitors that Russians were "basi-cally a very gay people. They love to dance, they love to sing. They love to drink wine." They also loved their feast days, celebrations and entertain-ment, and perhaps, above all, visitors would learn, they loved their land.

This exhibition was unique, as almost all of the objects to be displayed—both accessories and costumes—were from out-of-house. This pre-sented new problems. The Met staff could not dress mannequins months in advance or have a chance to observe the costumes in the galleries until the last minute, and they had to work with the curators from the Russian museums, who were very protective of their treasures. Knowing that the costumes would arrive only six weeks before the opening, Vreeland's staff busied them-selves on the design and layout.

It was a challenge to get the proper chande-liers to create the grandeur. They also had to do research on orders, a subject of great interest to Vreeland. The correct ribbons had to be found. And then there was the question of the snow machine. Should they use confetti snow or poly-ethylene snow? It was decided Styrofoam snow was the most realistic. Mrs. Vreeland could not visualize Russia unless it was snowing continu-ously, as in the film *Dr. Zhivago*, one of her favorites. They searched for the right hosiery for the mannequins' faces and legs, and as always the colors of the galleries were crucial. Chanel donated ten gallons of Cuir de Russie, one of their most famous perfumes, which they revived espe-cially for the exhibition so Vreeland could "fill the air" with the aroma of Russia.

On greeting the staff at the Met on her return, Vreeland had repeated her rapturous reactions. Judy Straeten, the assistant curator, hoped to get some idea for the planning of the show. She asked her what Russia was like. The fashion maven stopped, and thought, and then delivered: "The wide skies," an answer that frustrated Straeten. This did not mean, however, that Diana could not be businesslike. She drew up and submitted a list of requests to the museums she had visited. It included the clothes of the aristocracy, many of the clothes of the "rich peasants" from the Moscow State Historical Museum—and also flags.

While working on the exhibition in New York, Diana learned that Catherine the Great had fourteen thousand dresses, which were found after her death. Realizing that none of the dresses were part of the exhibit, Diana decided to return to Moscow in the spring to finalize details and find more costumes.

Jackie Onassis had been involved with the exhibition from the beginning, as she was editing a tie-in book for Viking. Diana felt that Jackie should also go to Moscow, accompanied by Tom Hoving, who was in Egypt at the time. Vreeland reached him there and told him that Jackie was demanding to see at close hand the subject of her book, which would have essays by specialists and illustrations of the costumes. But Diana probably wanted Jackie to go as extra assurance that she would get the beautiful dresses of Catherine the Great and Empress Elizabeth.

Before she went to Russia, Diana counseled Jackie on how to enjoy Moscow. She should go to the Bolshoi and see Plisetskaya, and the new young male dancer who is "madly in love with her. She is as great again as she was 15 years ago." She also urged her to go outside Leningrad to see the palaces that Diana had explored with Fred Hughes and to take a picnic with her. "The only things you need to take are caviar, brown bread and vodka. The vodka is 40 proof and you can drink it like sake."

She had loved Tolstoy's house in Moscow, with the tall mound of earth and grass in the middle of his apple orchard. She had walked up the mound and "found myself in the skies. It is quite exalting and remarkable. I realized how much it meant to him to get away from everything and feel the great space of his country." She was also specific about what Jackie must do, as there were a few additions "necessary to balance the show"—the clothes of the two empresses that were "essential to the beauty and the excitement" of the exhibit.

In late July Hoving met up with Jackie in Paris. That night he invited her to what he thought would be a modest dinner with him and his daughter. During the taxi ride to the restaurant on the Left Bank, Jackie was "charming, bubbling with excitement about going to the Soviet Union, where she had never been." Hoving didn't suspect that someone had tipped off the press about Jackie's trip, and they were waiting to ambush her.

The two blocks around the restaurant looked like a disaster area. The press was everywhere, and cars jammed the street. As soon as people saw the taxi with Mrs. Onassis, they began screaming, "Jackie! Jackie!" After she, Hoving and his daughter made it into the restaurant, the paparazzi continued to shout, trying to grab Jackie's attention. Hoving recounted, "I thought Jackie was going to crawl under the table. She was shaking." After the craziness subsided, she made it clear that if she had to face the same frenzied crowds in Russia, she would not go. Hoving laughed. "The one good thing about Communism was that the state-controlled press would take one photo on arrival and one on departure—both times only after her permission." Relieved, she gave Hoving a smile.

During the long flight, Hoving and Jackie discussed the exhibit at length. She had clearly done her homework—she had reread *War and Peace* and grasped the details of the costumes.

Her first order of business was to convince the Soviet officials to loan clothing worn by Czar Nicholas and Czarina Alexandra. Under the Soviet regime this request would most certainly be rejected, as the last imperial family was put to death by the Bolsheviks. Releasing these items could be seen as extremely subversive. But Mrs. Onassis was not going to give up easily. Next, while in Russia she hoped to procure approval for the emigration of a member of the curatorial staff of the Hermitage. Hoving recalled that he paled when he heard this, while "Mrs. Onassis just smiled with supreme confidence."

While she was denied approval to use any of the last czar's clothing, with the standard phrase "Nielzya" meaning "Impossible," she insisted that they release a lap robe of green velvet belonging to Princess Elizabeth, daughter of Peter the Great and Catherine I, which she used on sleigh rides. Soviet officials claimed that it did not exist, that it had disappeared in the war. Jackie insisted it did exist. Her persistence paid off—a few days later in Leningrad, Mrs. Onassis was presented with not only the robe in question, but the sleigh upon which Elizabeth used to ride. Jackie Onassis had managed the biggest "coup" of the Russian–U.S. exchange.

The clothes and their caretakers arrived in New York in late October. Nina Yarmolovich, the conservator from the Kremlin, spoke only Russian, Tamara Kochenova, from the Hermitage, also spoke German, and Luiza Efimora, from the State Historical Museum in Moscow, also spoke French. Judy Straeten remembered: "They were scared green never having been out of Russia before and here it was way before glasnost. We had a translator who was of White Russian descent whose family had fled the Soviets. No one was happy about that. Everyone who comes to the Met has to be fingerprinted. When they realized they had to be fingerprinted, they almost got on the plane and went back."

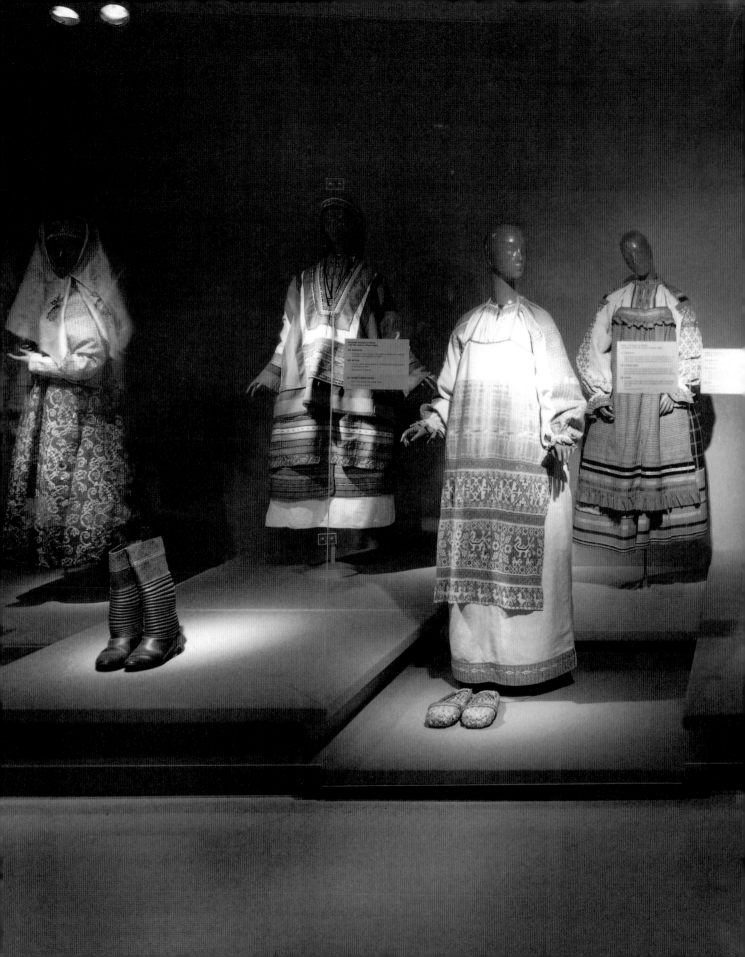

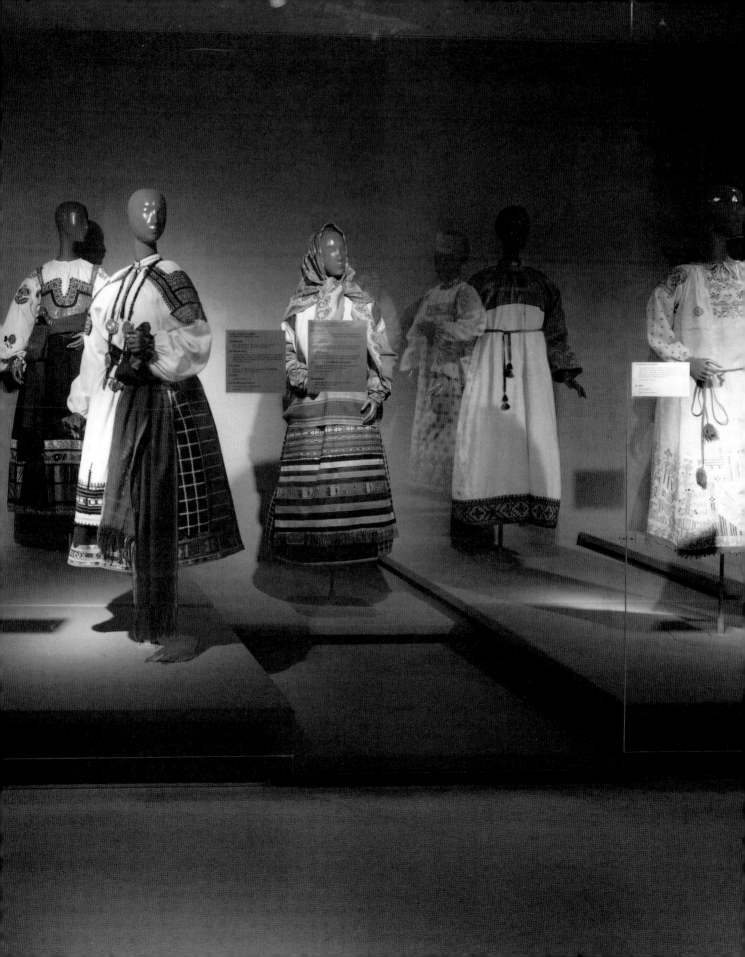

When they arrived, they stopped at the registrar's office and then went downstairs to meet Mrs. Vreeland. "Oh, I'm so glad you're here, finally," she said. "We've been looking all over to find a map of czarist Russia." On hearing this, the curators froze. And then she went into the colors. "We're going to have 'the colors of Russia.'"

There were other disagreements. The Russians assumed the colors would be white with gold and red walls. Oh no. There would be two greens—malachite and forest green as well as lapis lazuli and red. They were thinking about the way costumes were exhibited in galleries. She was thinking of the interiors of palaces.

The work on cataloguing the clothes for the Russian show was particularly difficult, as all the "condition lists" were in Russian. The curators had to go through every single thing as they unpacked and translate each list before anything could be touched.

Diana faced other administrative obstacles hurled at her from the Russian conservators. With her usual strong ideas, she had decided the mannequins would be painted red. The Russian curators were afraid this dye would stain the costumes. And Diana wanted to see blue or perhaps even green Dynel braids on the mannequins, whose heads were to be covered by stockings. With Russian experts present and a new protocol of consultation and analysis, she knew she was on a tighter rein, but she finally won out.

Since the clothes in the exhibit spanned two hundred years of Russian history, the curators thought it only logical to display them in an ordered, chronological fashion. Vreeland saw things differently. She craved magic and theater. Her tendency to change her mind at a moment's notice plus the dizzying pace at which the show was prepared left the Soviet women slightly breathless and confused. According to Judy Straeten, the Russian conservators were frustrated by Mrs. Vreeland's methods like everyone else. "They were museum people."

As always, reporters converged on the exhibit before the opening. Vreeland's personal tour included her favorite items of the show. This time she made sure her visitors from the media got a sneak peek at the jackboots of Peter the Great (1672–1725). They stood as imposing remnants of the excessive czar: thick-soled, square-toed and well worn. These three-foot thigh-highs were an impressive size 14. They came right up to her hip. As Diana Vreeland often proclaimed, "I lost my sense of proportion in Russia." The rest of Peter's clothes—the primary male presence in this exhibition—Vreeland scattered throughout the exhibit. This thoroughly mystified the Russian curators, who still clung steadfastly to a chronological ordering.

In Mrs. Vreeland's exhibition, Peter the Great's uniform, now black with age, stood regally in the midst of the aristocratic apparel. Even with the color faded, the costume continued to do what it had been created to do—impress. He had donned this uniform of green broadcloth, with large gold buttons down the front and wide red cuffs, for the decisive Battle of Poltava, where he defeated Charles XII of Sweden. A sash of gold and silver net dangled from the shoulder and was knotted at the hip.

As Vreeland told a writer from *The New Yorker*, with Peter "the point is results." She had heard a story about Peter being kept prisoner in his own palace by his own men. He said, "I want these men killed," and was told that it wasn't possible. So he sent for the men who were keeping him prisoner and he cut their heads off himself—one by one. For Diana, the point was, "you have to do it yourself."

Vreeland was particularly taken with Catherine the Great and the mark she made on Russian history. Born in Germany, Catherine became ruler of Russia soon after the assassination of her husband, Czar Peter III. She took to wearing military-

The red velvet sleigh with the green velvet gold-embroidered robe. Pages 238–39: The intricacy, colorfulness and craftsmanship of Russian peasant dresses would later make them fashionable even in court. Each region had its unique patterns, but red was a traditional color; in Russia the word for red and beautiful is the same. Their brightness lit up the gallery; the headdresses, or kokochniks, *were displayed elsewhere.*

style attire of silk cloth as the self-appointed Honorary Colonel of the army and marine regiments. "What color!" Vreeland exclaimed upon discovering one of her rare regimental outfits at the Hermitage. Her costumes—wide dresses mounted on a farthingale and French in shape—always matched those of the regiment, and the colors were changed three times a day, from pale blue and silver, to bright yellow and gold, to forest green and gold.

Near these regimental outfits in the exhibit stood Catherine's infamous silver moiré wedding gown. "What a waist!" Vreeland exclaimed. With a nineteen-inch waist and six-foot-wide skirt the dress was quite an astonishing sight, and proba-

bly a cumbersome fit for Catherine. "You know, people say they don't believe she was that thin, but I believe it absolutely," continued Vreeland. "You get what you wish for, you know? And at that moment women wished for waists. I never had a waist until the 1930s. Then all of a sudden you had to have one, so I got one."

The large waists of Catherine's regimental costumes, which measured thirty-six inches, contrasted with the slight waist of her wedding dress. When questioned about this, Vreeland suggested: "Life moved on."

During the months the staff and the volunteers worked on the show, Vreeland kept demanding that some Parma violets be found. She asked a young intern, Andrea, to go downtown and find Parma violets, and each time, she returned with false flowers, Vreeland wasn't satisfied. The workers kept asking, "Parma violets, what are Parma violets?" When the show opened, no one could find the Parma violets that were so necessary to Vreeland's image of the Russian past. Finally they were spotted in the famous sled that confronted visitors in the first

241

Jackie Onassis with Karl Katz and Philippe de Montebello at the opening of the "Vanity Fair" show (1977). As Bill Cunningham reported, a Vreeland opening "rivals anything on Broadway or Park Avenue," as "splendor seekers" from all over town fling themselves "into the most outrageous fashion statements," so that it all "adds up to two shows." Jackie chose a simple but stunning red Valentino gown, a very different look from the "McFadden Grecian column" she wore at the previous year's Russian party. Photograph by Darleen Rubin.

major display room. There the violets sat, a little bouquet lying on the tufted taffeta seat. It turned out that Vreeland wanted the violets to be included in the show because they illustrated a story she had heard from her friend Vava Adelberg. His father, a member of an aristocratic family and the governor general of St. Petersburg, related at lunchtime the occurrence of a family scandal. Vava's uncle had become so enamored of an Italian dancer performing in St. Petersburg that he had the entire snow-covered road from the train station to her hotel paved with bouquets of Parma violets. He had had them sent from Paris at a cost of about $40,000. As Harold Koda, who worked on the show with Vreeland, says, that was how Diana Vreeland saw history, "animated by personalities."

While it highlighted the personalities of royals like Peter and Catherine the Great, the exhibition also displayed clothes that Russians of varying classes would wear. The clothes of the "rich peasant" class, which included the *sarafin,* a jumper-like garment worn over a *roboka,* or shirt, did not appeal to Mrs. Vreeland—they tended to be less lavish, with fewer precious jewels and cloth. There was no way for her to make them glamorous or infuse these garments with that certain "je ne sais quoi," which was her strength as a curator.

Not terribly interested in the peasant clothes, Diana put them together in one gallery. There, these clothes, with their linen and wool elaborately layered and stitched with vibrant red embroidery thread, made a stunning show. They appealed to visiting designers, who found their bright colors and dazzling patterns much more interesting than the sheer white morning dresses made by Lamanova, the "Worth of Moscow," which were Western in design.

Vreeland wanted to get her friends involved in the Costume Institute show, particularly the Russian expatriates. Serge Obolensky was a descendant of Field Marshal Alexander Suvorov

(1729–1800), Catherine the Great's top general, who fought the Turks successfully and squared off against Napoleon in Italy. As her assistant Ferle Bramson remembers, Mrs. Vreeland, Vava Adelberg and Serge were invited to Jackie Onassis's apartment, where Ferle worked the tape recorder and took notes as the two talked and reminisced. Kenny Lane remembers attending a tea party Diana organized with the Russian curators, Obolensky, Adelberg and Ferle. Serge Obolensky spoke Russian to the Communist ladies from Moscow, and Diana and Ken and Ferle sat speaking French to the curator from the Hermitage. "It was a stroke of genius. There was some chatter about Smirnoff vodka. Serge said that is what they always drank in St. Petersburg."

Even before the exhibition opened, word got out that it would feature garments of great opulence, more luxurious than anything in the West. Knowing that Vreeland would go out of her way to re-create an imperialistic Russian extravaganza, many of the guests attending the preview party made a concerted effort to take their cues from both the aristocratic and peasant Russian spirit.

As the women filed into the galleries, awash in yards of taffeta, tiered and ruffled, the most amusing game of the night began, which was, as *W* magazine put it, "to count and classify the fantasy peasant looks" of Oscar de la Renta and Yves Saint Laurent. The night was an absolute triumph for these designers, since at least 60 percent of the crowd came in their genuine, made-to-order originals or high-priced copies. Nan Kempner was overheard telling a fellow YSL-clad guest, Lynn Wyatt, "Yves must have made a fortune on those puffed-sleeved dresses."

Guests found themselves working their way down a receiving line, greeting Jacqueline Onassis, the event's chairperson; Douglas Dillon; and Yuli Vorontsov, chargé d'affaires at the Soviet embassy in Washington, D.C., and his wife. They so blended in with the lavish displays that it became difficult to differentiate what was actually on display—eighteenth- and nineteenth-century costumes worn by the peoples of Imperial Russia or the newly regenerated Russian looks worn by New York society. *W* reported, "One possible winner in the Catherine the Great vein was Marina Schiano, in an over-the-top black Yves Saint-Laurent taffeta with a bird of paradise headdress. Doris Duke and Mrs. Pierre Schlumberger tried a bold peasant turban look while Mrs. William Fine looked as if she stepped out of the novel *War & Peace*," with the help of a center-parted hairdo and a Thea Porter dress of antique brocade and lace. But not everyone opted to go back to the past. Jackie Onassis, Mary McFadden and Diana Vreeland chose a simple and slim look.

Vreeland, never one to disappoint, had provided ambience enough for any grand setting. She had produced a glorious show and made sure her guests looked like members of the Russian court. In the Costume Institute rooms, now painted red, blue, or green, hung chandeliers and borrowed portraits. Furs were strewn about the floors of the exhibit to, as Eugenia Sheppard wrote, "give the idea of savagery." The scent of Chanel's Cuir de Russie hung in the air, and the music of Moussorgsky, Borodin, Rimsky-Korsakov, Tchaikovsky and Glazunov played. And finally, in her tradition of displaying spectacles, Vreeland made sure that the first hall held "the red-and-gold sleigh of Czarina Elizabeth I, a long way from icy mornings."

In the main hall, a band of balalaika players strummed into the wee hours of the morning while the young and those still young at heart danced. As the morning closed in, most were deciding to retire; but not showing any signs of fatigue, Diana Vreeland stood by the bookshop, with Jacqueline Onassis's book *In the Russian Style*—expressly released for the exhibition—in one hand chanting, "Buy a book. Buy a beautiful book."

The Russian curators left in January, but

Diana missed their going-away party at the Russian mission because she couldn't find it. In a letter to Ivan Kouznetsov, she apologized profusely "for not making the farewell cocktail party for Luiza, Tamara, and Nina at the mission. I was so very fond of all of them.

"I am very very sorry that I could not appear, but after ringing doorbells up and down 93rd Street and inquiring with the policeman at the Russian church on the corner, I had to give it up, as it was freezing cold and I had to go home and dress for dinner."

After the success of the Russian costumes, Vreeland felt more comfortable about working with truly historical costumes, and with her next show she proceeded without any foreign curators.

Diana now had six successful shows to her credit, including "American Women of Style," which had run for most of 1976, the year before "The Glory of Russian Costume." In "American Women" she had shifted the emphasis to those who showed off fashion—a variety of show-stopping women, ranging from Josephine Baker and Isadora Duncan to Elsie de Wolfe and Gertrude Vanderbilt Whitney. Their clothes reflected, as Richard Martin and Harold Koda later pointed out, "the style democracy [Vreeland] had promoted in *Harper's Bazaar* and *Vogue*." Each woman was someone who had merited an article during Vreeland's magazine days, and each was famous for her accomplishments, glamour, personality or social position. Using her high-fashion mannequins, along with paintings—a Léon Bakst painting of Baltimore art collector Alice Garrett, and Boldini's enormous portrait of Consuelo Vanderbilt and her son—Diana evoked these past stars.

The spirit of Mrs. Charles Dana Gibson graced the exhibit with her "Gibson Girl" look.

André Leon Talley styled Diana in her red living room for this photograph by Jonathan Becker.

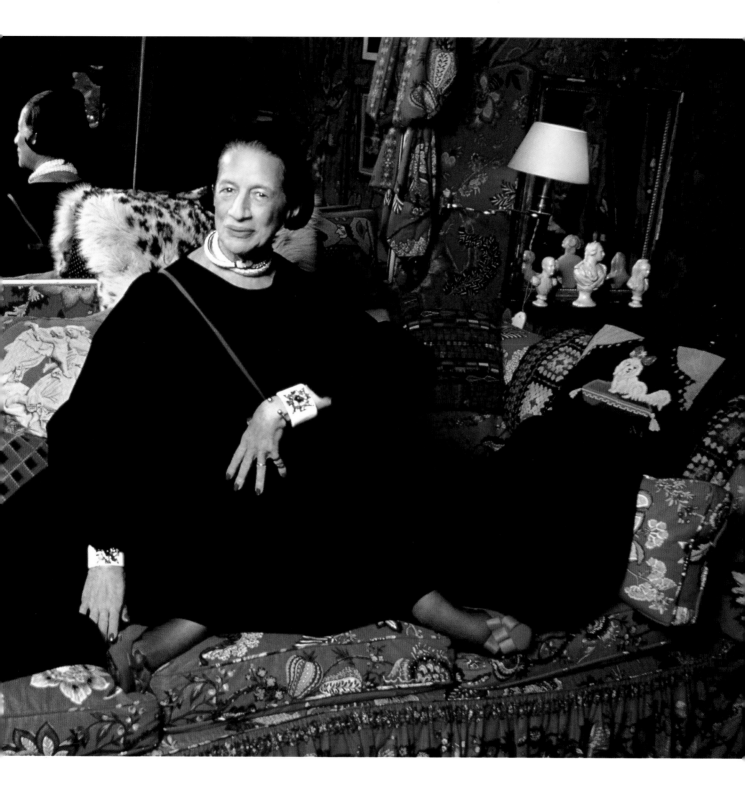

Irene Castle, who lit up the floor with her ball-room moves and her new jazz steps, was pictured in a large photograph dancing with her debonair partner. A figure representing Vreeland's old friend Millicent Rogers, whom she had featured often in *Harper's Bazaar*, wore the Schiaparelli costumes inspired by Rogers's wanderings through Paris, Austria and eventually Taos. André Leon Talley helped to get backing from *Ebony* magazine to help finance the borrowing of Josephine Baker's costumes, the grandiose Folies-Bergère costumes with their butterfly wings studded with brilliants and trimmed with white plumes, headdresses of ostrich feathers, and outfits in vibrant pink, coral, turquoise, purple and orange.

Vreeland's ten women were not all show; they were also models of strength. Almost all were involved in women's suffrage movements, and although Diana Vreeland resembled some more than others, she undoubtedly saw a bit of herself in each one—the performer, the trendsetter, the aristocrat, the carefree socialite, the art patron, and finally, the foremost pillar of style.

By the end of 1976, honors were bestowed on Diana repeatedly for her work in magazine and fashion history. At the roof garden of Lord & Taylor, Vreeland, "looking like an Oriental empress," was given the Dorothy Shaver Award for her imaginative and innovative leadership in the fashion field. The columns reported that Bill Blass was merely the start of a parade of toasters. "Pauline Trigère did hers with a French accent, Oscar de la Renta did his with a Spanish accent, and D. D. Ryan did hers with a Vreeland accent." Mollie Parnis, in her tribute to Vreeland, cited her as the inspiration both for her decision to restart her clothing designing following her husband's death and for the clothing line itself. "By the time I got done with them, I forgot I hadn't designed them myself." Nicholas Vreeland, Diana's grandson, related a story of going dancing with his grand-

mother. She had roped him in by convincing him that he would have fun, as she would attract all the handsome men and leave all the women for him. Instead, he recalled, he was left alone as all the men and women flocked to her.

Less than a month later, on October 19, 1976, Vreeland was given the Girls Town of Italy Fashion Achievement Award, and on November 3, she received the Legion of Honor at the French consulate. Because it came from France, the Legion of Honor meant the most to her. It didn't, however, come to her easily. In January 1974, Diana wrote, "My Dearest Frecky: as you know I am most anxious to have the 'Légion d'honneur.' I am told it is intelligent to ask for it and give reasons why I feel I deserve it." She then gave her reasons: "Anything and everything to enhance the allure and spirit of France I have worked on during these years. All my working interests have been slanted towards France and most especially French dress-making."

Frecky, stationed in Paris, went right to work as her campaign manager. After many, many letters written to build up the Vreeland file with the Grand Chancellor, Frecky's diligence succeeded. On November 3, 1976, his mother received the Legion of Honor from the French consul in New York City.

In 1977, after the Russian show had opened and was under way, she began working on a new exhibition called "Vanity Fair," over which she was given complete control. The exhibition would re-create the grandeur, the excess and the foibles of high society of generations past, which Diana would showcase in galleries transformed into great ballrooms, boudoirs, harems and imperial courts. As she explained it to Jackie Onassis, who worked on the catalogue for the event, the exhibition had to convey what it meant to be "something the world envies." Taking a magnifying glass to societies of yesteryear and combing through the museum's own collections (some thirty thousand

objects), Diana unearthed about five hundred items and came up with a brilliant portrait of luxury and a paean to the art of self-adornment.

Diana was inspired by a passage from John Bunyan's *Pilgrim's Progress*, and she created her displays strictly on the basis of beauty and extravagance. Tossing chronology to the wind, she jumped through history, adding, as she put it, "more life." The entrance hall of the show, called "the souk," or international bazaar, held a mélange of clothing: men's tailcoats, corsets and bundles of Chinese slippers. In another room a mannequin in a French court dress was shaded by a tasseled parasol held by children standing nearby in Chinese satin embroidered pants and jackets. One reviewer of the show observed that in "skipping blithely from place to place and merrily mixing periods, Mrs. Vreeland often gives her back hand to curatorial scholarship. A serious student of costume could come away from the show convinced, for example, that a woman of the French court, dressed in cloth of silver striped with blue silk (c. 1760–70), could have been followed by child pages in Chinese costumes of the late 19th or early 20th century."

A room of particular interest to visitors was devoted entirely to lingerie. Miles and miles of lace and ruffles were lavished on the embroidered Victorian petticoats, morning gowns, peignoirs, negligées and combing jackets. As Jackie and Diana looked on the racks of undergarments, Vreeland commented, "You know, the obsession of women isn't with themselves, it's to own something that's so exquisite. It's the greatest projection of pleasure. And what's wrong with pleasure? What are we here for but for pleasure?" The pleated dresses of Fortuny in the 1920s also caught Diana's eye. As she told Jackie Onassis before the show, in the red room would be "those marvelous pleated dresses from Venice. One will be on a mannequin and the rest will be coiled in a basket like rainbow snakes."

The great variety and richness of her discoveries delighted her. She wrote to Mona Bismarck: "I sorted out 35,000 items—shawls from India, 18th century parasols, Chinese Turkish European clothes from the 16th century and up, an entire room of 19th century lingerie, combing jackets, dressing gowns—petticoats, chemises, etc. . . . We have Queen Alexandra on a huge black horse. I have the Duke of Windsor's golf culottes (not plus fours!!!) and on and on. It's like a big Souk and the music is street from North Africa through Bach's Viennese Waltz for Eugenie, etc."

Phyllis Magidson went to work as a volunteer at the Costume Institute in the mid-seventies to learn about costume history at the time when there weren't any formal master's degree programs in the costume field. For the "Vanity Fair" exhibition, the staff was dressing mannequins in early nineteenth-century gowns. There were rumors that women would wear them without anything underneath, but they were never able to prove this, so they showed the dresses with all the underpinnings.

As they were putting Empire dresses on the tiny period mannequins, reflecting the corseting of the period and the fact that women were smaller then, Diana came by. She saw what they were doing, as Magidson remembers, and said, "'*No no no, dahlings*, I want to see *sheer*, I want to see the *bodies* underneath,' and she wanted to put them on these six-foot Schlaeppi mannequins, the high-fashion European mannequins." And Liz Lawrence said, "'But Mrs. Vreeland, the women were tiny and didn't wear them with nothing underneath, and we have to put them on mannequins that reflect the corseting and the shape of the women.' And she said, '*Dahling*, the shape of woman has not changed since Eve.'"

Diana had by now become so practiced in producing her theatrical exhibits that she could make magic using only the treasures of the Met's own collection, which she did in her own idiosyncratic way.

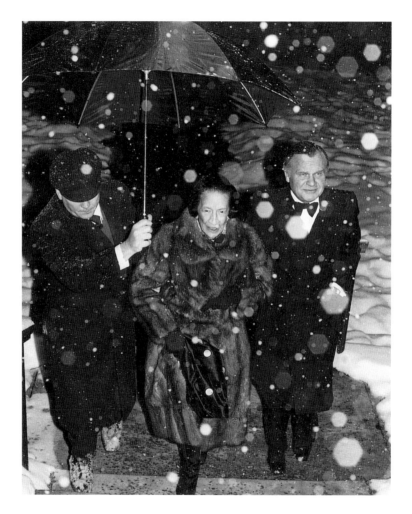

I've always been so flattered that anyone, whatever

his status, feels he can ask me to a party. —DV

FUN IN THE SEVENTIES

By day Diana was immersed in the past, working on her exhibits and collecting honors for her life's achievements, but at night she was living very much in the present. As always, she complemented her day work with an exciting nightlife and took holidays to visit friends in exotic places.

During the seventies she was seeing more and more of the exciting crowd that gathered around Andy Warhol. As she had been uplifted by the currents of individuality, experimentation and rebellion in the sixties, it was not surprising that she warmed to this group and their iconoclastic creativity. She was getting older, and she liked to be around the young; she needed their energy to feed her creativity. She enjoyed life and liked those who shared her passion for it. She went to all kinds of parties, dined with friends and went dancing whenever she got the chance. Although she had a string of male companions to escort her around town, she was particularly fond of Fred Hughes, a prominent member of Warhol's group who had gone with her to Japan and Russia.

When Fred Hughes first met Andy Warhol in 1967, at Philip Johnson's Glass House in New Canaan, Connecticut, he sensed they were two of a kind. "He saw the pot of gold at the end of the rainbow, just like I did," Hughes said later. Hughes, an aspiring art dealer, was the son of a Texas furniture company representative, and the young favorite of Jean and Dominique de Ménil, art collectors and heirs to the Schlumberger oil fortune. Andy was very impressed by Fred, the perfectly tailored man who looked like something out of another era. He recalled, "In those mod,

flower-power days, Fred was conspicuous—one of the only young people around who insisted on Savile Row suits. When he came by that first day, he was wearing a flared, double-vent dark blue suit, blue shirt, and light blue bow tie. . . . I told him we were having dinner in the Village and invited him to come along. Fred laughed and said that just coming down to the Factory on 47th Street was a big deal because it was the farthest downtown he'd ever been, so the Village struck him as really an expedition."

Fred began by sweeping floors at the Factory, Warhol's art and film studio hangout for the chic, avant-garde New York counterculture. It was in its first incarnation, the "silver Factory" period, its walls covered with aluminum foil and metallic spray paint. The trend-hungry from every walk of life congregated there; models and actors camped out on the floor next to poets, magazine editors and miscellaneous hangers-on pulled off the streets by Andy's cohorts. Fred soon became president of Warhol Enterprises, responsible for finding commissions, selling art and keeping Warhol's business running and profitable.

While Fred was a new friend, Diana had known Andy Warhol since he had arrived in New York from Pittsburgh and appeared at *Harper's Bazaar* with his sketches in the 1950s. Now he was the iconoclastic pop artist who was changing the way art was seen, and was famous for his Campbell's soup cans and Brillo boxes. Currently he was doing portraits of the rich and famous—of such people as Truman Capote, Diane von Furstenberg, Halston, Roy Lichtenstein, Liza Minnelli, Yves Saint Laurent, and

Gianni and Marella Agnelli—all friends of Diana's. The portraits "brought home the bacon," as Warhol was wont to say. He was also working on his screen series in the seventies, the Mao portraits (1971) and *Hand-Colored Flowers* (1975). His interest in film, which had peaked during the late sixties, was gradually diminishing. He capitalized on his already-won fame by selling himself more and more.

effortlessly and less self-consciously, a product of her innate performing personality. Warhol's trademark sunglasses and wig became the equivalent of Diana's lacquered hair and extreme makeup, features that made each instantly recognizable.

Both Diana and Andy Warhol were intensely private and hid their true feelings beneath their carefully composed exterior appearances. When Warhol's mother died, he didn't tell anyone; friends

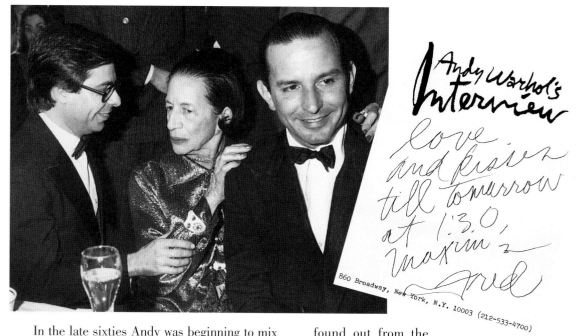

In the late sixties Andy was beginning to mix in the celebrity–movie star–artist–fashion world that Vreeland knew, and he and Diana were again thrown together. She was the sort of celebrity he was thrilled to know. In the seventies Andy organized lunches for Diana's friends at the new Factory near Union Square, and they were delighted to show up. By then Andy had risen to a higher social position, where they were on a more equal footing.

Vreeland and Warhol, the two icons, can be seen to represent different ways of cultivating celebrity. Each established a unique character, but Warhol worked hard to project a rather vacuous image. Diana's fame had come to her more

found out from the newspapers or other sources. Diana kept all of her problems at home, like a good "society" lady. Like Diana, Warhol made up details about his childhood. But the motivation was different. He was ashamed, while she just liked to present life as being more dramatic than reality. Warhol was not a good audience for her

Above: *Bob Colacello, Diana and Fred Hughes.*
Opposite: *Andy Warhol immortalized Diana at the time of her "Man and the Horse" exhibit in* Diana Vreeland Rampant *(after David's portrait of Napoléon Bonaparte).*
Page 248: *Diana with Bill Blass.*

Right: *Diana with Fred Hughes and "Jamie H."*
Below: *Diana, Lee Radziwill, Liza Minnelli and*
Martha Graham. Diana featured Lee in many issues
of Vogue. Opposite: Diana and Mary McFadden, an
intimate friend whom she had known since Mary's
Long Island coming-out party in 1956. Diana had
helped her in her career. "She has always been my
supporter, I must say that." When Mary moved to South
Africa, Diana made her editor of Vogue South Africa.
When she came back she became special projects editor
at Vogue. When Mary started her own business, Diana
was "one of [her] biggest backers," buying Mary's
clothes, urging friends to do likewise, and taking
pleasure in Mary's success. The photographs below,
page opposite, and on pages 254–255 (Taylor, Hutton,
Hawkins, Avedon, Mirabella) by Darleen Rubin.

Clockwise from top left: Diana with Elizabeth Taylor and John Warner; Cristina Ferrare, Lauren Hutton and Halston; Ken Lane and Diana; John Richardson and Jonathan Lieberson; Oscar de la Renta and Marina Schiano; Diana and Valentino; Erté and Diana; Diana, Richard Avedon and Mary McFadden; Diana with Grace Mirabella and Bill Cahan; and (*center*) Diana and Ashton Hawkins. Diana knew the legendary Erté from her *Bazaar* years, when he was designing the widely acclaimed covers. Erté had started as a designer for couturier Paul Poiret and lasted eight months in Hollywood creating beautiful and esoteric costumes for several silent films, including *Ben Hur*.

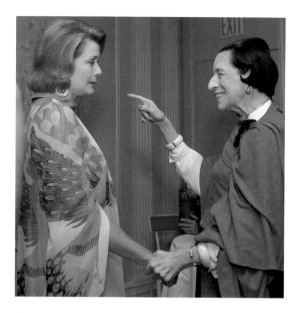

Diana's exhibits brought international society figures into the museum. Diana and Princess Grace of Monaco at the Metropolitan.

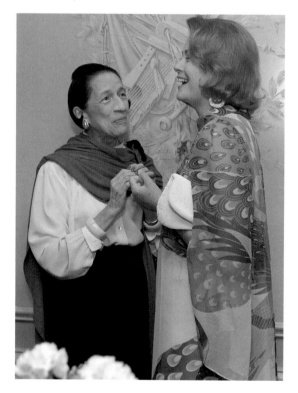

and did not hold the same fascination for Diana that she held for him. Fred, who seemed more naturally the socialite, suited her taste.

Fred and Diana had a passion for parties, and in the seventies, parties were the rage. In March 1977, for example, Andy saw Diana at Carrie Donovan's black-tie dinner at "21." She was Fred's date for the evening, and they went to the Iranian embassy afterward. In Los Angeles that spring, Diana and Fred went to party after party. On March 25, Diana Vreeland hired a limo, taking Fred and Andy to George Cukor's. Afterward, Fred and Andy went back to the hotel to get ready for Sue Mengers's dinner party in Bel Air. As the evening wore on, Warhol noticed that Diana was getting drunker and drunker, and Fred was, too. She became jealous, Andy thought, because Fred was with Jacqueline Bisset, not realizing that Jacqueline's French boyfriend was there, too. When Vreeland told Fred it was time to leave, he refused, and Diana got "really upset" before Andy took her home.

While Fred had his flings with young women and Diana became jealous, Andy, too, felt some jealousy and was intensely aware of their intimacy, as he complained that when Fred was drunk, he "talk[ed] like Mrs. Vreeland." In April 1977, Andy commented that "she must be mad at Fred or something, and that's why she's putting me down, because I can't believe it, we had such a good time together that night last week, she was so much fun." In 1986, long after Diana and Andy had stopped seeing each other regularly, there is a revealing entry in his diary: "I told Fred that the kitchen was dirty and he looked at me and said, 'Well, I'm not going to do the dishes.' Diana Vreeland has been a really bad influence on him. I should've broken that up."

On Friday, April 15, 1977, at a lunch for her, Diana ranted that all magazines suffered from giving the country what it wants—except for Andy Warhol's *Interview*. She was a fan of

Interview, and when she and Andy and Fred met, she would give them magazine advice. "She had tons of ideas," Fred said. The intent of *Interview* magazine, unlike that of *Harper's Bazaar* or *Vogue*, was for stars to talk candidly to other stars about their films and lives (its original title was *inter/VIEW*, suggesting a more detailed access to celebrities than other magazines offered). Its readers were pop-culture consumers, men and women eager to get a little closer to Hollywood insiders. The three would have dinner and talk about covers, and Diana gave nonstop suggestions, including her favorite magazine dictum: "No, no, you don't give people what they want; you make them want what they never dreamed they wanted."

When they weren't at the Factory, at restaurants, or at Diana's, her new friends often went to Studio 54, the hangout one veteran reporter called "the embodiment of the most decadent period of any city in modern history." During its reign every night, the scene was frantic, everyone with a Manhattan connection pushing to get inside somehow. As Steven Gaines describes it, "Once inside the club, like Alice down the rabbit hole, nothing seemed real. It was a cross between an amusement park and a nightclub, Mardi Gras on laughing gas." A former opera house and onetime TV studio, it easily held three thousand people. And what a mix of people; there were the strange, the beautiful and the ordinary. "There were business men in pin-striped suits, and women in gowns, and diplomats, and foreign royalty, and men in leather, and drag queens with beards and debutantes with West Pointers in uniform." Even the bartenders were startling: "Stripped to the waist, [they] danced and twirled as they served drinks to music so loud it seemed to carbonate the air." Diana turned up there occasionally, doing some dancing and, even more important, absorbing energy from the young.

Warhol chronicled some of the odd highlights

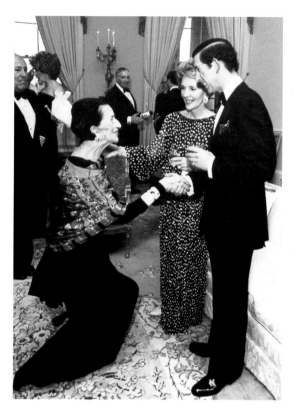

Diana with Nancy Reagan and curtsying to Prince Charles, 1981. "If you live in London, you don't just make this little bob, you go all *the way* down *and then all the way* up."

at Studio 54—like the time Yves Saint Laurent gave Halston "a really big kiss—That was fashion news." Or when Andy told a stranger on the dance floor: "You have to be careful, you're dancing with a drag queen." Or his guest, "Jamie," the marquis of Blandford, going with Andy down to the basement and reporting back that everybody down there was "in different corners, having coke."

Although Diana could dance as well as her friends, she was a generation older than most and it was an effort to act their age. At a dinner at Diana's apartment for Cecil Beaton not long after Cecil had had a stroke, Andy sensed her fear of Beaton's physical deterioration. Cecil could not

walk or talk very well, as he was paralyzed on one side. Andy felt that Diana, afraid something like that would happen to her, didn't like to look at him. "She overreacted in the other direction, she was running and jumping and dancing and humming and pushing forward with her tight body and her beautiful clothes."

Although Diana enjoyed the Studio 54 culture, she didn't become part of it. For example, she preferred vodka and Scotch to drugs. According to John Richardson, "Diana drank quite a bit . . . [and] she always drank the same thing. . . . Vodka without any ice and a piece of lemon peel, or orange peel. She used to achieve quite a few of those and she used to get hiccups occasionally and she'd do this thing about reaching for the moon—she had this ritual, touching the moon, or praying to the moon. It would stop the hiccups."

For Diana, marijuana was pronounced "mara-ju-wanna." One night while having dinner at his house on Thirty-eighth

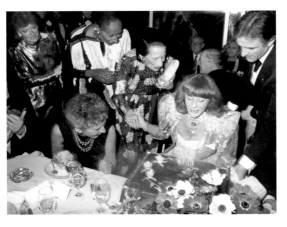

Diana amid guests at Régine's birthday party, 1982.

Street with her and Robin Hambro, Kenny Lane said to her, "You're always talking about mara-ju-wanna. I think it's about time you smoked one." She didn't know that Ken had taken apart a regular cigarette and put the tobacco back in. He gave it to her and she lit up. "Oh my God! Oh my God!" she exclaimed, and then she became trancelike. "Mmmmmm. Mmmmmm. Oh my God. Ohhh. Ohhh. Ohhh. I feel so strange, so wonderful." And, as Lane remembered, "we're all looking at each other. She finished the performance and I said, 'Darling, I'm afraid it's not marijuana. It's a joint made with regular tobacco put back in.' 'Oh no! How could you have done this to me?'"

Although Diana often saw Fred and Andy and the Factory group in the mid- and late seventies, her nonstop social life included older friends as well. Her close friends Oscar and Françoise de la Renta entertained beautifully. As Boaz Mazor remembers, there were two places you wanted to go in the evenings in the seventies: the parties of "the Paleys and the de la Rentas, and Diana was always there, naturally." Françoise, who had exquisite taste in everything—houses, tables and linens—was an intimate friend of Diana's.

Now she spent her winter holidays—Christmas and New Year's—with Oscar and Françoise in Santo Domingo. In the 1970s there was very little to do at the resort in Casa de Campo, but Diana, who never appeared before noon, decided that one of the most exciting places to go in town was the pharmacy. She was looking for vitamins from Europe, which she felt were far better than their American counterparts. When she went to the pharmacy, she would be dressed in a caftan, and got a lot of attention. As Oscar remembered, at five o'clock in the afternoon, "there would be a crowd that had gathered outside the pharmacy to wait for Diana's arrivals and departures. She realized that she owed to her public this kind of dressing. Every day the outfits got more and more extravagant, and every day there were more and more people waiting for Diana's arrival and departure. Finally one day she told me, 'I really have to stop going to the pharmacy because I think now they expect me to come in a horse and carriage.'" That pharmacy today is called Pharmacy Diana.

During the de la Rentas' house parties, Diana, Boaz Mazor, and John Richardson stayed in an attached bungalow, where they shared a porch. At dinnertime the two would escort Diana from the bungalows to the main house. They would pick her up and carry her because "it was very dark, and Diana needed someone to help her because she couldn't see very well." One year she shared a bungalow with Geraldine Stutz, and as they took bubble baths in preparation for dinner, they shared stories through the partition. Geraldine, aware that Diana's eyesight was poor, remembers taking her and guiding her down the steps to dinner. Diana counted the steps out loud: "One, two, three, four, five, six, seven, ground."

A regular dinner guest in Santo Domingo was Irving Lazar, always called Irving because he hated his nickname, "Swifty." To Geraldine, Diana and Irving seemed like Abbott and Costello, because she was tall and sat very straight and he was little. Diana's stories were always punctuated with a slap on Lazar's shoulder. One night she was telling a story, and she had already hit Irving once. "While she was busy addressing the table, he took a plate and shoved it into his jacket, so she goes wacko and everyone howled. She didn't hurt herself, but nobody howled louder than she. She didn't mind being teased."

In the winter of 1976, Diana took a break from museum work to visit Kitty Miller in Palm Beach. Lou Gartner remembers sitting with Diana at a large party. When dinner was over, at about 10:30, guests started to get up. Diana said, "Where are they all going?" And Lou replied, "They're all going home." And she said, "What the hell is this, Scarsdale?" Not feeling ready to turn in, she said, "I want to go dancing." He took her to a place in West Palm Beach on Dixie called Marrakech, with an enormous indoor space for dancing, and bars and tables all over. They found a table, sat down and got a drink. Then, Lou recalls, "I was talking to her and this shadow came across the table. And I looked up and there was the biggest black man I have ever seen in my life and he said, 'Do you want to dance?' And Vreeland looked up and smiled at him, and he said, 'Not you, him.' And I said, 'I don't dance, but she's wild, she's great.'" Diana got up and "I've never seen anything like the two of them on the dance floor. I mean, you talk about dirty dancing, it was unreal." They were on the dance floor for about twenty minutes, and then the stranger brought her back and thanked her, and she sat down. She told Lou, "'He's the most marvelous man. He's just out of prison. He needs help and support.' I said, 'We're going home.' That was typical."

In September 1979, when she received an award at the opening of the Costume Institute in Philadelphia, Kenny Lane went with her. They stayed with Walter Stait, "a very nice young man," who was quite taken with the idea of having Diana Vreeland as his guest. As she liked to dance, Ken found out about a fantastic discotheque in Philadelphia called Emerald City. He mentioned it to Diana, "because Diana did Studio 54, of course," and she was enthusiastic. When he called Walter Stait, he asked him when the museum event would be over because they wanted to go "to this place called Emerald City." Stait said, "Emerald City! How'd you hear about Emerald City? Well, I mean, Mrs. Vreeland . . ." Ken could see him turning pale, eyes rolling in his head, but he assured him that Diana would adore it.

During their drive down in the car, he coached Diana: "'Diana, I want you to say to Walter Stait just before we go to the museum, just before, that you've heard of this wonderful club called Emerald City and that it might be amusing to go.' So every once in a while she'd say, 'The Club Emerald. Emerald City! That's it. Got it!' Then she'd say just out of the blue, 'Emerald City! Don't say Oz, say Emerald City.'" At Walter Stait's, she got dressed for dinner and came down the stairs looking absolutely extraordinary. And

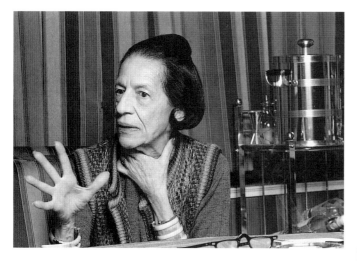

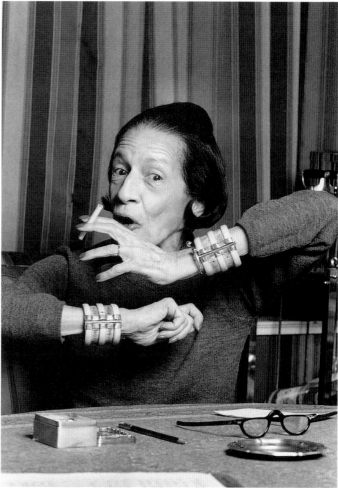

Jonathan Lieberson described Diana's fingers stretching and kneading the air as she spoke during his interview with her. Diana photographed by Priscilla Rattazzi in her dining room with the striped banquettes.

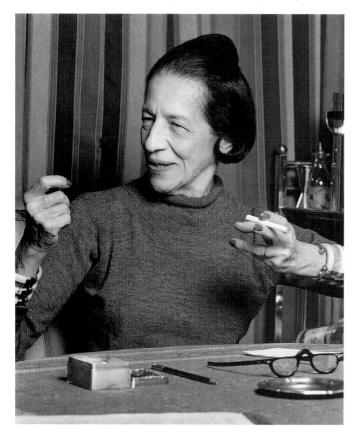

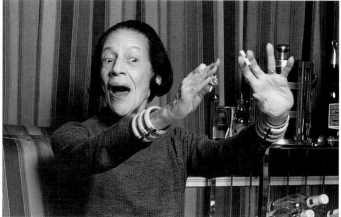

just as they were going down the steps, she said, "Oh, I say, Walter, I think it would be great fun, perhaps if later we went to a club I've heard of called um, um"—and she looked at Ken and said, "Esmereldas!"

Through her association with the pop art world she got the chance to see an old acquaintance, Greta Garbo. The art dealer Sam Green, one of the first to give Warhol a show in the mid-sixties, frequently accompanied Garbo, as "she couldn't go to a lot of places alone because she was often plagued by her fame." Garbo lived in the East River House on Fifty-second Street, and Green took her on afternoon strolls in the neighborhood.

In the late seventies Green arranged a seemingly impromptu afternoon tea at Diana's place. He and Diana made sure that at precisely 4:50, she was home from the Met and ready to greet Green and Garbo when they "rang up . . . and [Green] would suggest casually that Mrs. Vreeland might be home and would invite us up for tea." Diana greeted them, dressed in red for Garbo's appearance.

After they had tea, Green observed a stunning role reversal—"Garbo was always quiet as a mouse and inconspicuous as possible." But now she acted completely out of character, taking over Diana's personality. "She said, 'Oh, how wonderful this room is, red. Oh, the color! How did you ever do it?' And then she said, 'Reed had the most extraordinary taste. His clothes were wonderful.' There was Diana sitting in the corner watching this performance with her hands in her lap, not showing amazement at all. Garbo went into Reed's room and brought out this beautiful cashmere coat and put it on and strode up and down the living room, saying, 'Men—men have the best clothes. Why can't we women have wonderful clothes?,' striding back and forth, swishing this wonderful coat around." Green sat there amazed, watching each one play the other. Garbo lit up and took on Vreeland's personality. "She

couldn't do this with anybody else because she had established that she was going to be this mousy type." For some reason, she could perform for Mrs. Vreeland. Green and Garbo stayed unusually late—"Garbo had never stayed that long after dark . . . it was the first time it ever happened"—and they had tea and vodka.

Since she was so close to the Factory group, it was only natural that they do a cover story in *Interview* on Diana. Jonathan Lieberson wrote a rambling piece interspersed with anecdotes from Vreeland's and Lieberson's past exploits, and touching on most of her favorite topics. Vreeland's uniqueness is revealed through the frenzied rhetorical style whereby she outdoes even the most discerning of interlocutors. Rather than responding directly to Lieberson's questions, Vreeland steers the conversation where she feels like taking it, and simply allows the attendant reporter to tag along. (The gigot she orders during the interview, for instance, prompts Vreeland to wax eloquent about the many gigolos she has met in the past.) Lieberson describes the way she spoke, using her immoderate and theatrical gestures, intermittently dragging on a Camel and proffering such epigrams as "Communism is okay if you've got a car and driver." These epigrams, he decides, should be called "crypticisms": "Peanut butter is the greatest invention since Christianity," and "The Civil War was nothing compared to the smell of a San Diego orange." Having her usual fun with words, she admits to being an "idea-rist" as she has "spasms of ideas." She offers up opinions on money, women's liberation (girls have had the pill for ten years: "How free can you get?"), and details of her youthful reading. Even sex, love and promiscuity are touched on: "Sex loosens up." But "love is the power in a woman's life." The article radiates the good humor of its subject and the fun she had with her younger friends in the 1970s.

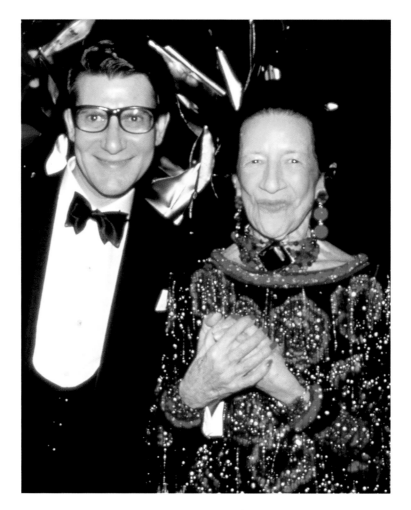

*There's an excellent profile in Interview
in which Jeanne Moreau says: "I shall die very
young." "How young?" they ask her. "I don't know,
maybe seventy, maybe eighty, maybe ninety.
But I shall be very young." —DV*

The Last Act

By the end of the 1970s, Diana was in her mid-seventies and still highly productive. After "Vanity Fair" (1977–1978), she produced four more Costume Institute exhibitions: "Diaghilev" (1978–1979), "The Fashions of the Hapsburg Era: Austria-Hungary" (1979–1980), "The Manchu Dragon" (1980–1981), "La Belle Epoque" (1981–1982), and "The Eighteenth-Century Woman" for the 1982–1983 season. Her affectionate grand finale, which opened in December 1983, was "Yves Saint Laurent: 25 Years of Design." After 1984, she came to the museum less and less. Although she was still the "special consultant" by title, she depended on her staff to take over her many responsibilities.

Even though she was slowing down and her eyesight was deteriorating, she still managed to travel to necessary places (including Paris and Austria) to produce her exciting and highly praised exhibitions. She also continued her lively social life into the mid-1980s. Then, as the eighties wore on, her health forced her to retire from center stage into the privacy of her red Park Avenue apartment, where she received only family and very close friends. One of the reasons Diana continued to be so productive in these last years was her genius for marshaling people around to help execute her vision. Another was her strong will to survive.

In the spring of 1979, Vreeland went to Vienna and Budapest for the research on "The Fashions of the Hapsburg Era: Austria-Hungary" exhibition. She wrote Susan Train, "I am back since a few weeks from a trip to Vienna and Budapest,

trying to straighten out clothes from behind the Iron Curtain. Russia was a cinch compared with that poor oppressed country, Hungary!"

One of her many helpers, Bob Lavine, a costume designer for stage and screen who had worked on the Hollywood show, had gone to Vienna before her. His treasure hunt for possible exhibit items was as exciting as any exotic Vreeland photo shoot in past magazine days. He reported: "I have found some marvelous things here." The kind and enthusiastic museum directors promised him robes of the Hapsburg court, satin and velvet gowns with eight-foot trains covered in gold, silver and jeweled embroidery, court uniforms and livery plus fans, gloves, exquisite shoes and a gold toilet service—"I think they would send the cathedral if we asked." Other possible items were two magnificent "robes de style" handpainted with "Jugensteil" roses and morning glories by Gustav Klimt, and the museums would be willing to loan the Klimt paintings, which had never been out of Austria.

Lavine finished by exclaiming, "God knows what else they have around! Hidden somewhere is the crown of the Holy Roman Empire (Charlemagne's) and the court jewels! In a rock vault in the Alps I am told." When he looked at the royal orders, "a wide band of apricot moiré left me faint." An added excitement was that Elizabeth Taylor was at the same hotel. "Such excitement! I was asked for drinks."

While they were preparing the show, Bob Lavine came to see Vreeland at her apartment one evening. He reported to Cecil Beaton that they dined together after he arrived with some Bérard

drawings for her at her "garden in hell." He found a boldly scrawled note pinned to her portrait in the entrance hall. It read: "Bob Dear, I am without a servant. As I am painting my face (which could take *forever*), wander in and get drunk. I have managed to find some *almonds*, which you will find in a pretty little silver dish. Do *eat them*. And do *sniff* the *immense* lily in the *Chinese* pot. It's *pure anesthesia*!"

She appeared half an hour later, "hair lacquered, cheekbones rouged, her brittle wrists encircled by savage ivory bracelets. Many kisses. 'Ooohs' and 'aaahs' over the Bérards." He had brought her essence from Floris, and an ivory-handled lace parasol he found in London for the museum collection. After a hefty vodka, she confessed to him that she didn't write letters anymore, even though she "used to turn 'em out like *Cartier's* do vermeil *nut dishes*!" Then she asked him to button the cuffs of her black crepe blouse ("My *fingers* have gotten lazy"), and they went off to dine.

At the restaurant Vreeland ordered another vodka. Her complaints about the food produced an uproar with the waiters. "The avocado is MUSH! Do they have plain boiled chicken? The *way Queen Victoria used* to like it . . . " She reported to him on her recent trip to Rome, which was like a big wonderful old railroad station: "all those *sweet* Corinthian columns

Austrian cream satin wedding dress for the Hapsburg show. Opposite: *A Hapsburg headpiece.* Overleaf: *Uniforms of Austrian officers.*

everywhere." She hated the trip back. "I was bitten by a *mosquito*—have you ever heard of a mosquito crossing the Atlantic in a jet?" She told him she wasn't considering writing a book ("My God, I can't even manage to *read* one anymore . . ."). After announcing that the ice was "frost" and having another vodka, she was ready to go.

Back at the apartment she asked if Bob would "now *unbutton* her blouse cuffs." Her good night was a farewell like that of a French actress in a Guitry play: "'Take another sniff of that *lily*, kid. It'll be a *long* time before you have another such chance. . . .' Would I wait until she was safely in her bedroom? She would call to me. PAUSE: (OFF-STAGE) 'I made it! Bless you, dear—call me in the morning . . . I'm always awake by eight . . . my God, these bracelets are *heavy* . . . but then, elephants are *immense* . . . and so *divine*. . . .' As the elevator arrives, CURTAIN."

"The Fashions of the Hapsburg Era: Austria-Hungary" opened to the public on December 11, 1979. It presented the mix of Western and oriental fashion influences on Austria and Hungary. The exhibit was elegant and opulent, and included military regalia of the time as well as extremely feminine women's attire.

Knowing that by now she had become an icon and wanting to preserve Vreeland's way of creating magazine spreads, Jackie Onassis urged her

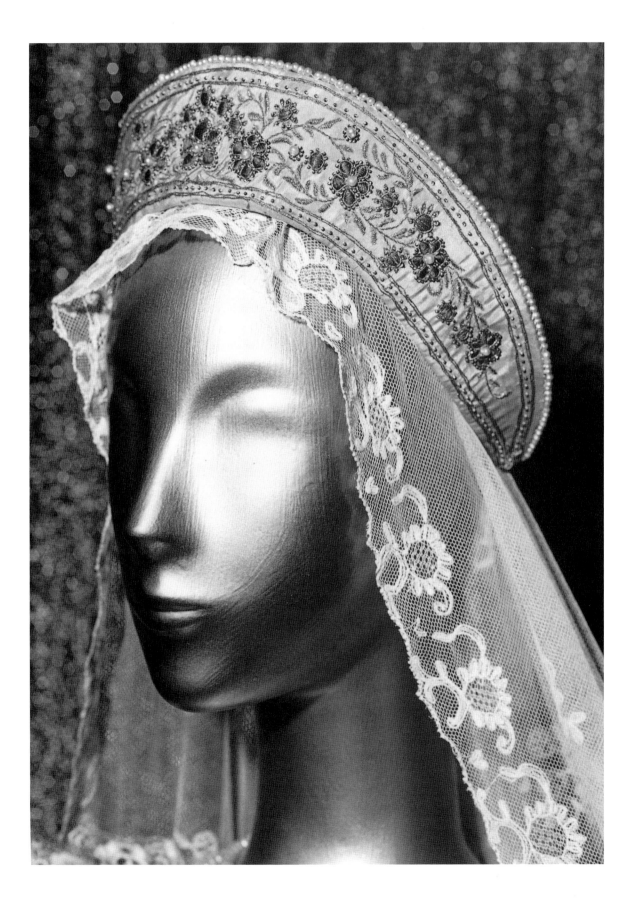

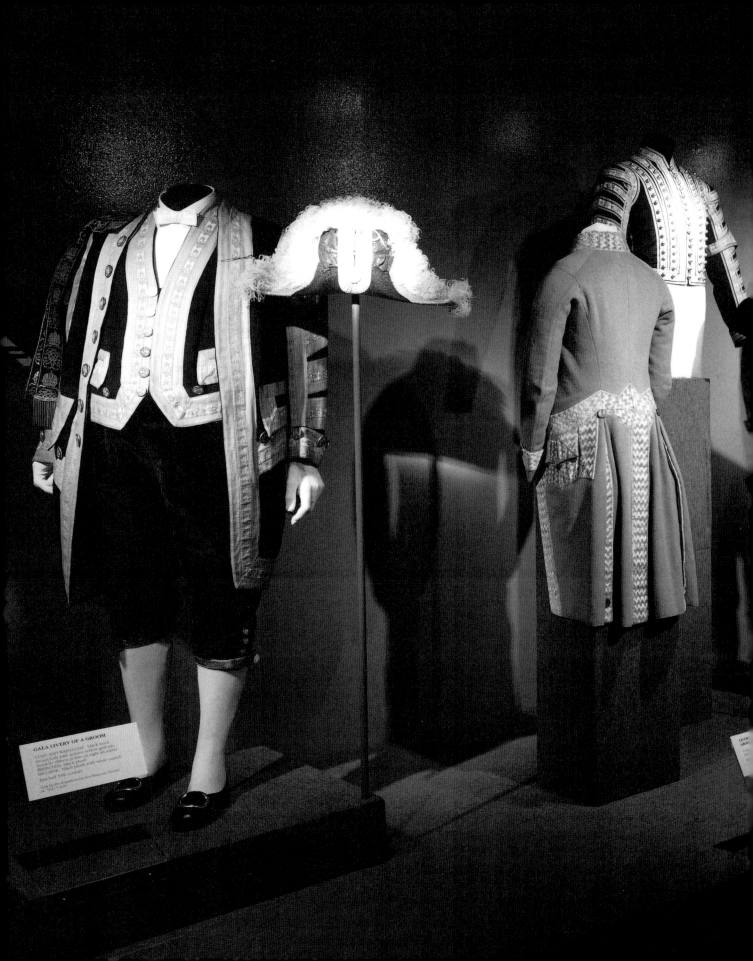

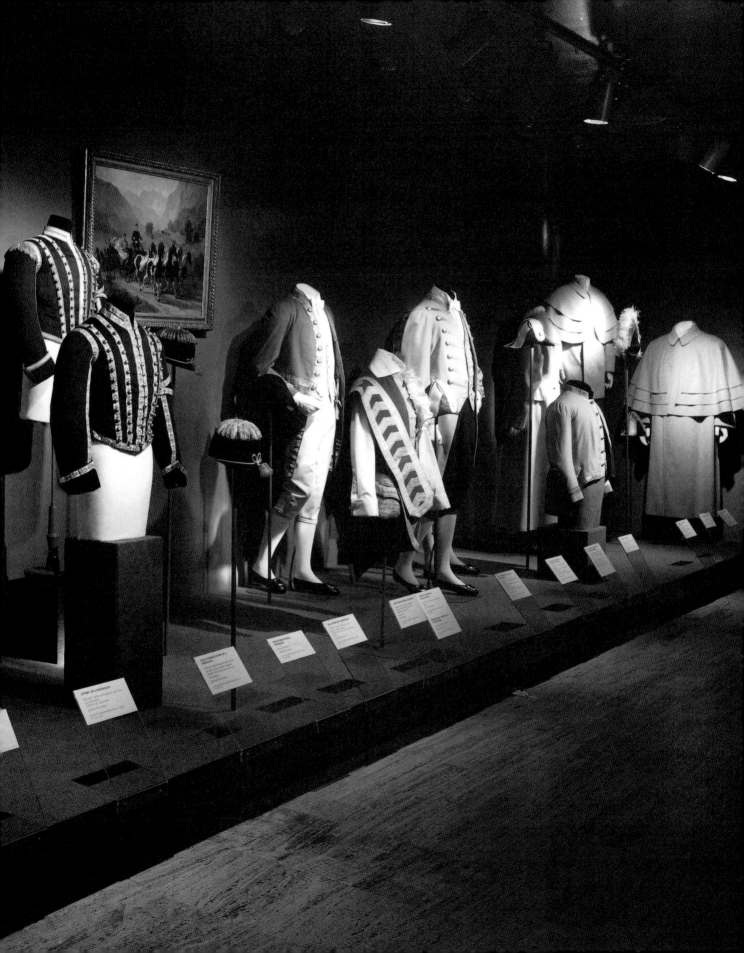

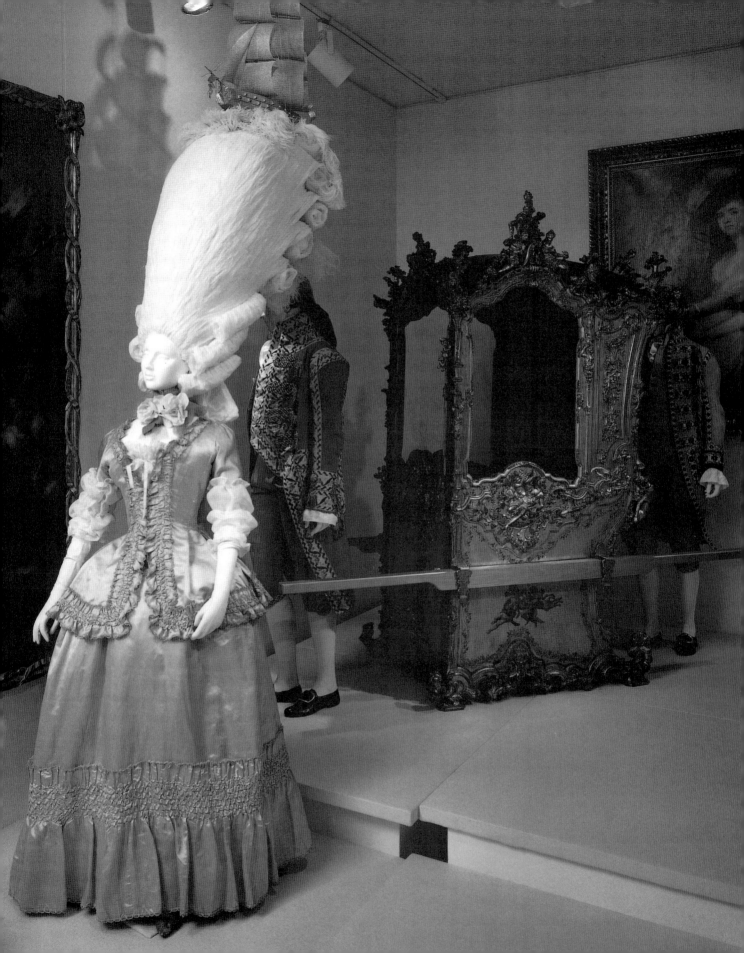

friend to collaborate in creating *Allure* (1980), a big, handsome photography book. Although an occasional man—such as Mick Jagger or Niki de Gunzburg—is featured, for the most part it is a celebration of beautiful women, photographed in the most romantic and admiring way. It is also a celebration of Vreeland's eye. Her words are heard, too, and now and then an anecdote is included—a story from Diana's past or a quip from her philosophy.

Allure blazed the faces of Maria Callas, beautiful models and socialites, dancers, artists, writers and performers over its enormous pages. It included photographs of many of Diana's favorite people—Daisy Fellowes, Mick Jagger, Marilyn Monroe and Isak Dinesen were all there, photographed by de Meyer, Steichen, Man Ray, Beaton, Horst and, of course, Avedon. There was a spread of the coronation of George V and photos of an eye-lift operation.

Allure captured her unusual way of laying out photographs. As she said in her commentary: "I have the kind of eye that will travel over a magazine page, find a tiny, insignificant-looking detail no bigger than your fingernail—and get totally mesmerized. My immediate instinct is to want to blow it up—making it big!" The book was impressive and imposing in size—measuring 15 x 11 inches—and was bound in red, naturally, with a glossy cream-colored dust jacket and the title in large old Roman script running along the top, while "Diana Vreeland" stood in large black letters at the bottom. Her beautiful book—full of energy and movement—gave her readers "something else."

On Sunday afternoons Jackie Onassis and

Harold Koda redid this fantastic headdress for the "Eighteenth-Century Woman" exhibit several times until it suited Diana, who looked at the finished version with glee and pronounced, "Mmmm, now she's ready for the guillotine!"

Ray Roberts, both editors at Doubleday, met to work with Diana and the writer Christopher Hemphill on the layout, occasionally at Vreeland's red-lacquered office at the Met, but more often at the Doubleday offices. Everything was readied beforehand, the table moved out so a large area of gray, carpeted floor was available for spreading out the prints. Diana would always bring a bottle—either of vodka or Scotch—and Ray found glasses so everyone could have a drink. Vreeland placed the favorite photos all over the floor and moved them here and there to get the right mix of text and images. Jackie coaxed the stories out of Diana to go with the text. Many subjects, both words and images (like the description of George V's funeral), had their origins in past magazine spreads, and Vreeland would rethink the relationship of word to image as they would meet again and redo it.

When Jackie sent Ray a copy of the finished product, she wrote, "Here it is—with a drop of your Sunday afternoon blood on every page—I wish we could do it again." The book was well reviewed and sold well for $40 a copy. (Now, twenty years later, it sells for $700.)

While helping Diana to create "The Eighteenth-Century Woman," which opened in December 1981, Katell Le Bourhis, a young Frenchwoman, began to be an important colleague. Trained as a costume curator, she would become a close friend and go on to become associate curator at the Costume Institute. Katell first met Diana in Paris through friends they had in common but did not get to know her until later, in New York. The evening they started to be friends—"To click, you know—it was love at first sight"—was when Katell was invited to one of Vreeland's "bigger" parties, in the library at the Knickerbocker Club, where Vreeland reserved three tables of ten. As Katell walked up the stairs, she reflected that she'd been used to society all her life, but despite this she was very

impressed and somewhat nervous "going to the big DV dinner party." She said to herself, "'Oh, my God, I've made the worst mistake of my life. She's going to hate me because I'm all dressed in red, and she's going to think I'm a little girl who's trying to please her and to make her take an interest in me.' And I have a lot of pride. I'm Gaelic and she was Gaelic, too. We always had our Gaelic pride in common."

And then Kattel was surprised, as she was seated at Diana's table. Many of Vreeland's close friends were there, including Hubert de Givenchy, Françoise and Oscar de la Renta, Lally Weymouth and Ashton Hawkins.

When Vreeland did finally acknowledge her dress, she said, "Hum, hum, my daaarling Katell . . . what a lovely orange frock!" Katell explained that to "the rest of the guests, I was red from head to toe. But to Diana Vreeland (as I have learned working with her for many years), if red was not opera red—crimson—it was orange!"

Katell and Diana saw each other continually in the last years of Diana's life. As Diana's health failed, Katell helped her disguise her poor eyesight and her increasing absences from the museum. Diana worried incessantly about her bright young French friend, imploring her not to be a woman alone, and saying that she herself felt a strong loneliness. While Katell describes Vreeland's public persona as a "perfectly built, organized, structured façade that was hard like an egg, like a perfect shell," she was one of the very few who knew Diana's other side. Vreeland allowed Katell to know the person she was "inside the shell"—a vulnerable and fragile woman who struggled with solitude and the decline of her body.

When they were not at the museum, they often had fun. One afternoon, Vreeland surprised everyone, including Katell, by announcing that she wanted to go shopping. "She never went shopping in her life. So we did Madison Avenue at a walking speed in the stretch navy blue London Town car." They drove up Madison Avenue, looking at each window, until they arrived at the Saint Laurent boutique. Inside the boutique, disappointed that it was not like a salon, she said to Katell, "Now, honey, the boutique has not arrived." There was no ashtray by the chair, or a glass of anything to drink. Katell produced the amenities, and in five minutes the surroundings were organized, with a chair, a stool for the girl to sit by her, the ashtray in the right place, and a notepad, just like in a salon. And then she wanted Katell and Elaine Hunt, her secretary, who was very tall, to try on the clothes and pass in front of her. "So we had the blond type and we had the brunette." And Diana remembered it often. She would say, "Wasn't it fun that day we went to Yves Saint Laurent?" Katell suggested they could do it again, but she would say, "Oh no, these things have to come like that, on the spur of the moment."

In the fall of 1982, Diana began to work with George Plimpton on her memoir. She herself came up with the title, *DV*—the initials that she scrawled in green ink at the bottom of each page of magazine copy in her days as editor at *Harper's Bazaar* and *Vogue*, and later on the bottom of pages of exhibition details at the Costume Institute. When Robert Gottlieb, an editor at Knopf, heard of the title, he was delighted. *DV* also stood for *Deo volente*, or "God willing," which happen to be the initials that, as Plimpton told her, popes signed on the bottom of their papers.

As they talked in the late afternoons and evenings in her apartment, she reflected on the important events of her life, which George recorded. He noted that whenever she talked about someone she gave the most accurate

As Diana got older, she regaled her audiences with stories and her life-tested philosophy, always accentuating the importance of beauty.

descriptions of what that person was wearing. And she said, "I have a completely visual memory . . . which of course means that I've remembered everything else, too." She confessed that she couldn't see very well. Now the wonderful eyes that had spent a lifetime looking and observing so vividly were failing her, and soon she was going to the hospital for a small eye operation. "I just don't see at all, George." During their conversations the blinds in the apartment were kept down, as the light bothered her.

In the course of their conversations, she reviewed her life from her childhood days with her family in New York, through different stages of her career, to the happy memories of Reed, her sons and her many friends. Her remembrances produced vivid and often hilarious anecdotes,

delivered in her forceful style, a steady flow of musings on personalities, amusing happenings, scents, colors, hairstyles and clothes. She often placed herself much closer to historical events like Lindbergh's flight over the Atlantic, "the Night of the Long Knives" and the theft of the Mona Lisa than she really had been. But her spirit and her attitudes and personality shine through the details, as do the main events of her life. She also articulated a lifetime's worth of philosophy as well as her many likes and dislikes. She commented on everything, from her love of flowers—"the most important thing outside of certain people I love"—to the desirability of blue jeans (then not as ubiquitous as now) and the great importance of looking your best.

When the book came out, the reviewers didn't

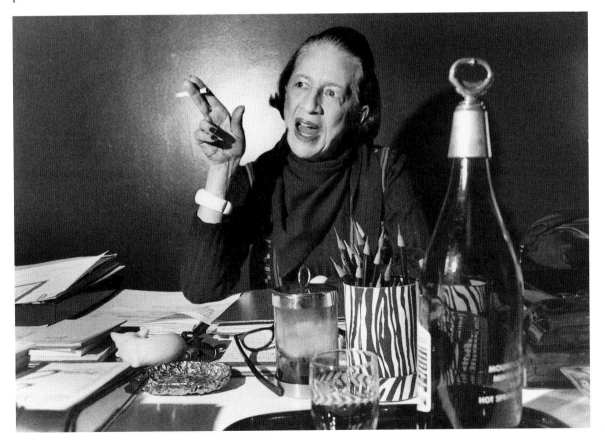

Diana and Yves Saint Laurent at the Yves Saint Laurent Archives in Paris (top) and in the galleries at the Met (above and right). The Yves Saint Laurent show was unique because it honored a living couturier, one whom Diana had always admired. The brilliant designer from North Africa was first hired by Dior when he was only eighteen. Once he opened his own house in Paris, every collection he created was seen as dazzling. He was known as the "great adapter," equally inspired by artists, writers and political movements. He put women into pants and used images from the street to inspire his designs. Despite Diana's great respect for her friend, it was ultimately her show. Now almost eighty, Diana spent weeks in Paris examining sketches and dresses with Yves and Pierre Bergé. Bergé remembered how she said, "'Pierre, it's my exhibition, not yours. I mean, if you or Yves don't like something, you tell me. If you're right, I'm going to change it. If not, I will decide myself. It's my exhibition.' I said, 'Okay!' And she was right."

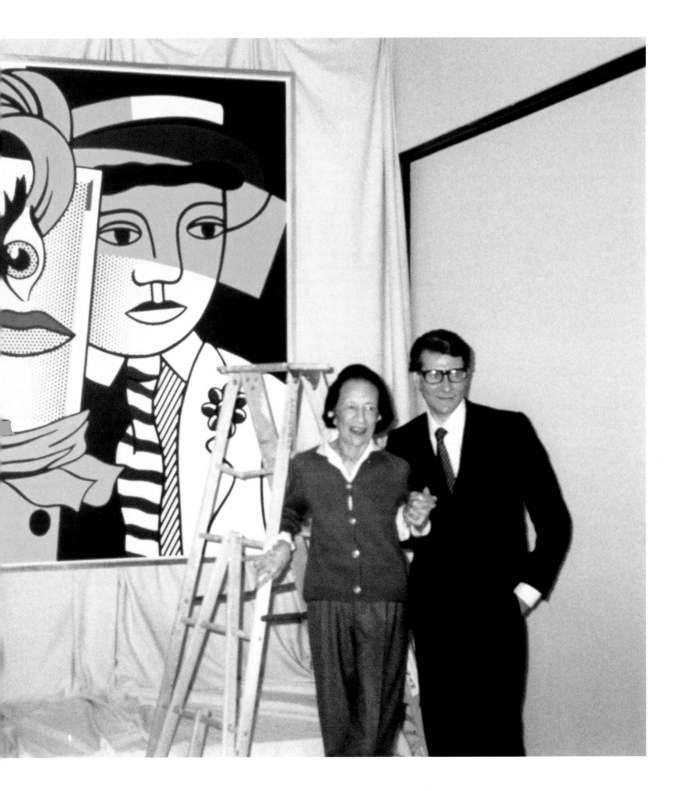

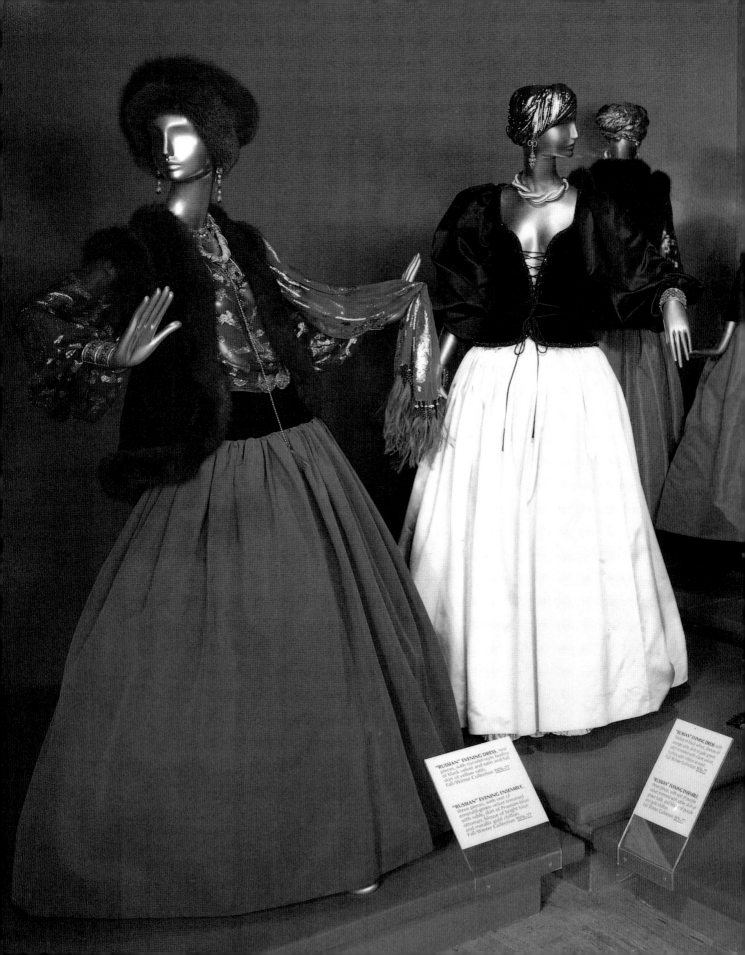

"RUSSIAN" EVENING DRESS, two
pieces, with corselet-style bodice
of black velvet and satin and full
skirt of yellow satin.
Fall/Winter Collection 1976-77

"RUSSIAN" EVENING ENSEMBLE,
three pieces, with vest of
emerald-green velvet trimmed
with sable, skirt of Prussian-blue
ottoman, blouse of purple-blue
and metallic gold chiffon.
Fall/Winter Collection 1976-77

"RUSSIAN" EVENING DRESS with
bodice of black velvet, sleeve of
orange satin, skirt of pale green
cotton embroidered in red.
Fall/Winter Collection 1976-77

"RUSSIAN" EVENING ENSEMBLE,
velvet vest, with vest of purple
velvet trimmed with sable and
green tulle, gold lamé, and
red tulle skirt of purple.
Fall/Winter Collection 1976-77

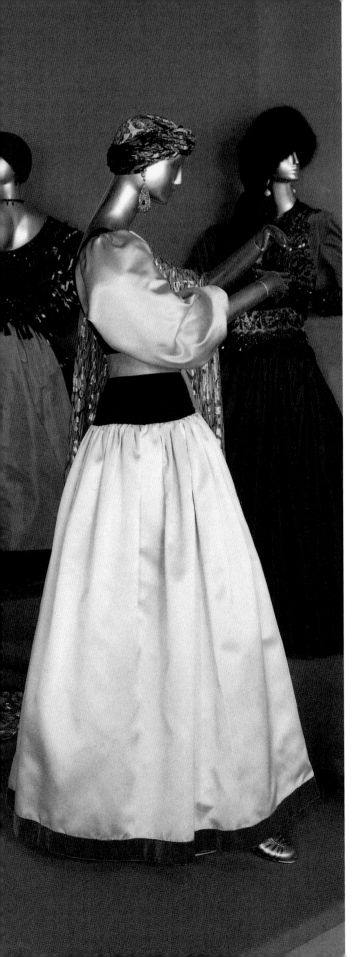

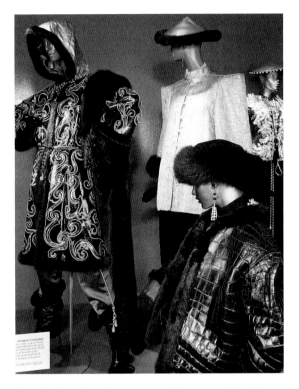

The fact that Saint Laurent was alive presented problems for the exhibition designers. It meant that the show had to please him—when he came to New York, he objected to a fountain in the galleries, which was changed—and it had to withstand criticism for being an advertisement for the couture house. For the most part, however, it went off very well, because Saint Laurent realized what a privilege it was to be so honored and that everyone respected his genius. The exhibition displayed his great achievement. In true Vreeland style the clothes were not exhibited chronologically. The first room, which "vibrated with the same red beauty and intensity as the clothes." housed his most famous creations. Another room showed his Matisse and Mondrian designs displayed flat on the walls. A third room showed just black clothes in all kinds of fabrics and designs. There was a green room with garden lattices, the "Chestnut Bois." which showed his "day" clothes; and another room presenting dazzling embroidered and decorated jackets and, in the center, a circle of mannequins wearing clothes inspired by his African themes. There were 243 garments in all. Left and above: The Russian dresses from his fall/winter collection, 1976–77.

quite know what to say: Cathleen McGuigan of *Newsweek* put it well when she said, "Don't think of *DV* . . . as a book; it's more like a lunch. A bit of soufflé, a glass of champagne, some green grapes—light, bubbly and slightly tart—all served up by an egocentric but inventive hostess." But many were intrigued by her boldness in writing an autobiography unique in its stream-of-consciousness prose. "Her style is sweeping. She is the queen of the bold stroke, the goddess of grand gesture," wrote the *Daily News*. The *New Yorker* called it a "hint of autobiography [that] shimmers like moiré."

The most unsettling part of her biography for reviewers must have been its end. In the last conversational paragraphs, she calls her own bluff. "There's so much I still haven't told you. Have I ever told you about my obsession with horses? About the horses that used to come around the corner of Park Avenue and Seventy-ninth Street? I have? About the little toy stall I used to have in my room and about how I used to water my little horses all night long? I have? Did I tell you about Josephine Baker and sitting next to her cheetah at the Mirabar? I did? Did I tell you about the zebras lining the driveway at San Simeon? You believed that, didn't you? Did I tell you that Lindbergh flew over Brewster? It could have been someone else, but who cares—*Fake it!* Did I tell you about the elephants at the coronation? Of course I did. What about hitting Swifty Lazar in the nose? Well I never did *that*, you know. Why, it would break my arm! It would never heal." What in her life was true? Diana Vreeland finally answers the question in her roundabout way by saying, Who knows, and does it really matter?

In the months that she was working on her book, she was preparing the Yves Saint Laurent show, an exhibition that differed from all the others. She wanted to honor a living legend, a contemporary designer who would be the only one to get a museum retrospective in his own lifetime.

She convinced Philippe de Montebello to go along with it. At the time no one realized that Diana might be opening the door to the criticism that the museum would be used for promotion, for commercialization.

To prepare, Diana went to Paris to see the Saint Laurent archives with her assistant Stephen Jamail. She examined the clothes from the different periods of Saint Laurent's career, which confirmed her notion that, in the words of Pierre Bergé, M. Saint Laurent was "a genius in the art of fashions."

At the Met she worked in the usual indirect way. She told Katell, "You know, darling, Saint Laurent dresses the maids of France." Katell said, "WHAT? Saint Laurent dresses the maids of France?" Not understanding, Katell asked her to elaborate on the idea. Then, two weeks later, Diana said to Katell, "But you're not in France? You're supposed to find the maids of France for Saint Laurent." Katell still wondered what she meant by the "maids of France." Finally, Diana gave a hint: "She's at the Louvre," and Katell guessed, "Joan of Arc! But what's Joan of Arc got to do with Saint Laurent, then?" Diana said, "You finally got it." As Katell remembered: "In the end she wanted me to borrow this Joan of Arc painting, this enormous painting, where she's making an armour, you know, and you know why? You're going to love this one. Because Saint Laurent put women in trousers.

"Diana could not say, 'I think the woman who dresses as a modern woman in trousers embodies the idea of the free woman like Joan of Arc did.' It's a stretch, but it's an idea, and it's true that Joan of Arc in her trial was accused of being a sorcerer and a heretic because she wore men's attire. But Diana wasn't able to say that. She was able to say 'Go and find me the maid of France.' She was so visual that she could not tell you all her points because the verbal point has disappeared. Only the image remains."

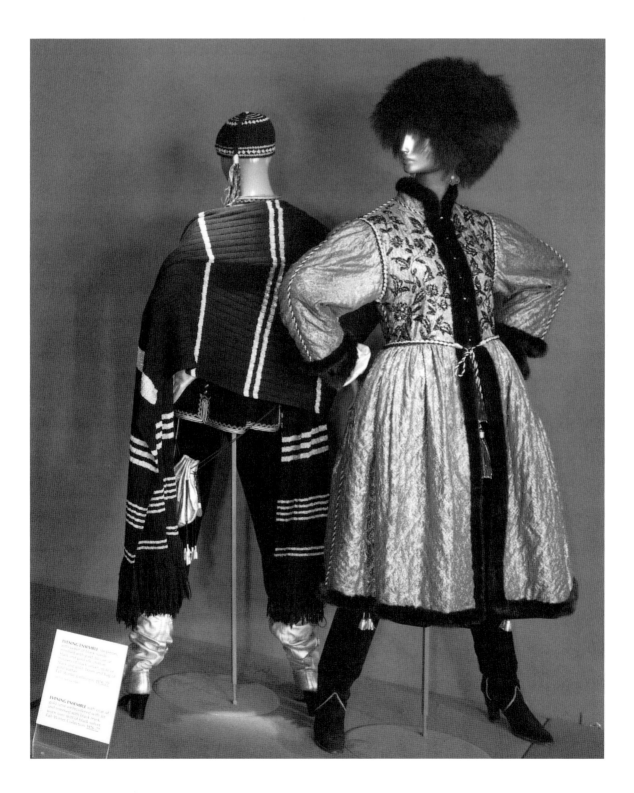

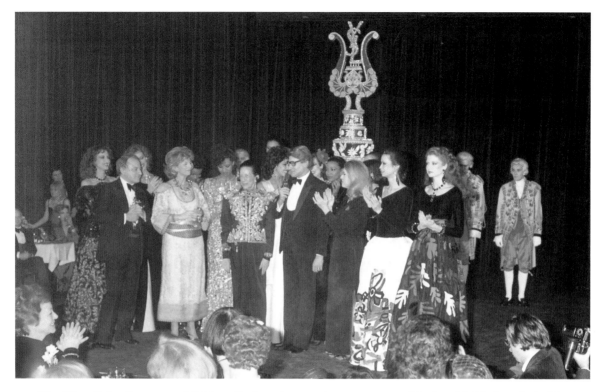

The Yves Saint Laurent exhibition displayed the designer's achievement—243 garments in all—in Vreeland's usual nonchronological fashion. The first room housed his most famous creations; another showed his Matisse and Mondrian designs; a third, just black clothes; and in the "Chestnut Bois," his day clothes could be seen. His embroidered and decorated jackets were assembled in the last room, with mannequins wearing clothes inspired by his African themes.

Diana's *DV* came out in the summer of 1984, and the book party was held at Mortimer's. As Katell remembers, "It was terribly hot that day, with unbearable New York weather: stormy, windy, humid, and hot." (Katell said, "It's voodoo weather!" and Diana replied, "You're right, darling.") Katell was helping Diana prepare to go to the party at Mortimer's. Robert Gottlieb, her editor, who projected a dis-

tinct, very casual look, with his long hair, his tennis shoes and no tie, was going with them. Diana was late as usual, and he waited for about two hours in her living room, drinking the vodka the maid gave him, standing by the air conditioner, and absorbing the unbelievable smell of Diana's favorite Madonna lilies.

As usual, getting ready for an event was a major event itself. Diana was back in her bedroom, putting on her layers of rouge. She changed her clothes three times. She would have ready three different outfits on her bed with all their accessories. Suddenly she would announce, "Okay, I'm changing," and one outfit would disappear.

Diana wore a gold-embroidered pagoda ensemble by Yves Saint Laurent to his twentieth-anniversary celebration in Paris, January 1982. In 1984, she donated it to the Costume Institute.

Gottlieb had brought an old Bentley to create the atmosphere for Diana, but it had no air-conditioning. There was a very elegant driver, but it was like an oven in the car. When they arrived at Mortimer's, suddenly it started to pour. Mortimer's has only one front door, and Diana saw that there were a lot of people entering. She did not like the fact that she had to enter with her guests, and she refused to enter early, as people were still coming in. Katell asked, "What are we going to do? It's pouring rain. We are not going to go to the corner coffee shop, you know, to wait." So they sat in the hot Bentley, touring around the block to be sure that they would be late enough. Finally Gottlieb had a great idea. He suggested that they enter by the kitchen. "She was so right, because if she had entered the tiny and crowded restaurant with everybody, she would have been like one among the others. Then it was HER party. She made a big entrance by the kitchen door."

As the 1980s progressed, Diana would come in to work later and later in the day. Margaret Van Buskirk, her secretary at home, would call Elaine, Diana's secretary at the office, and Elaine would announce, "Madame is coming!" To her workers at the museum, it was as if the emperor were arriving. Everybody started to put on lipstick. But half an hour later, she would not have arrived. Her workers were alerted and ready with the correct folders and files. They always felt the pressure and the incredible professionalism she demanded. They had to be ready for anything and be able to produce any bit of information at a moment's notice. To prepare for Vreeland's arrival, special arrangements at the museum's doors on the street level at Eighty-second Street had to be made. A wheelchair was readied, and the security system was disconnected, and when the automatic security was turned off, an armed guard was necessary. An hour after the original telephone call, Diana still would not have arrived. Everybody wanted to leave, but the guard had to remain, and the young women were getting angry.

When she arrived, at about seven in the evening, only three or four of the old guard would be waiting. The maid had called every five minutes from home, saying that Diana was putting on her coat, and then had taken it off. She was lighting a cigarette, she was extinguishing it. By the time she arrived, they were all extremely irritated. As she got out of her London Town car, her Vuitton bag would come first. Then they could see the toes of her little slippers, then the gray flannel slacks. And then Madame! And the animosity would dissolve with her remarks: "Hellooooo. What are you doing? Darling, it's so sweet of you. Oh, you look great today. Katell, turn around. Show me your dress."

With so many memories behind her now, Vreeland would launch into an unanticipated anecdote and mesmerize her audience. When the "Dance" exhibition was being prepared in 1986, she came into the museum one day and saw that someone had pinned over her desk the Avedon photograph in which a nude Nureyev is leaping into the air, stretching out his arms behind him. It was part of the beautiful *Vogue* spread for the 1967 Christmas issue, in which shots of the handsome, muscular dancer were coupled with details from paintings from the ceiling of the Sistine Chapel. Readers were told that "Nureyev, here in an agony of action, could have been the source and inspiration for many of Michelangelo's sublime realizations of the human form." When she saw this photo, she said to Andrew Solomon, a young intern, "Oh, I see you have my photograph." And then she told the story of taking the famous photograph of Nureyev.

A passionate ballet fan and a great admirer of Nureyev, she was determined to do a photograph that would be "the *apotheosis* of the

dance." On the chosen day Diana, with several of her assistants, and Richard Avedon, with his assistants and some stylists from *Vogue*, were all waiting in "Dicky's studio, which was like a *cathedral.*" The "Russian boy" arrived fresh off the plane and wanted to warm up a bit. Even though there was no music, he just began to dance in among those assembled—"He danced this way and that way. My dear, it was pretty strange, but *rather* beautiful." They agreed that even in the big studio it had to be "a genuine private moment," so they sent away the assistants and only Diana, Avedon and "the Russian" were left. "Then he sort of went behind a screen to get ready for the photograph. He took off his clothes and he came in . . . and, *my dear*, you know how it *is* with men in the morning?" And then she made an extraordinary gesture—"Well, it was like *that* and we had to wait a half an hour for it to go down and it was very strange but *rather* beautiful." As Solomon remembered, "She quoted herself quite a lot at that stage. But there was a sense of high theater about her."

As she got older she talked of the past more, often launching into greatly embellished life stories. She relaxed a bit about keeping a strenuous schedule, but when she did appear at an event, she tried valiantly to hide her infirmities. She went very occasionally into work, and others took over the responsibilities for the exhibits. After the publication of her memoir, her excursions into the limelight became fewer and fewer. For the party to open the exhibition "Costumes of Royal India," in the beginning of December 1985, she got dressed to go and then decided not to.

She was spending more and more time in the apartment—in the red wonderland filled with mementos of her life. She wandered around the rooms wearing a stylish white terry-cloth robe. Her personal maid, Yvonne, who had worked with her since before Reed's death, taking care of her clothes and caring about the way she presented herself, had retired in the early eighties and was replaced. A cook and a cleaning lady were on hand part-time, but the person who ran the apartment was the capable Dolores Celi, a woman from Ecuador who paid the bills and managed the household.

Although she had a good salary from the Met and a good pension from Condé Nast, Diana's expenses exceeded her income. In 1987, she decided to sell some of her costume jewelry, and called Kenny Lane to ask what her "junk" jewelry might bring at auction. He replied, "More than it's worth. Thirty or forty thousand dollars." Astonished, she replied, "That much? My God!"

Kenny Lane called Robert Woolley, the head of decorative arts at Sotheby's, to arrange the auction. Friends and worshipers of Diana's alike packed themselves into the room at Sotheby's for the event. The sale of the "junk" brought in $167,000, well over Lane's estimate. As he recalled, "When I told D.V. over the phone what the results were, she said, 'Is that all?' And I said, 'Well, I'm glad I'm sitting down.'"

Diana's trademark was a profusion of accessories. As Katell said, "She never wore a single bracelet on one wrist, but always a pair, or pairs, as cuffs. She never hung a necklace over her head, but draped it from the back to the front and then tied it with a knot at the side." Now she decided that others should enjoy her baubles.

Her eyesight had deteriorated due to macular degeneration, which was diagnosed at the Jules Stein Eye Institute in Los Angeles. Her prognosis was poor. There was not much the doctors could do, so Dolores made little changes in the apartment to help her, such as changing the blinds in the bedroom because she couldn't stand the light.

Dolores also took her to the Lighthouse for the Blind to help her learn to deal with her oncoming blindness, but she refused to use any

new things to improve her daily living. "She never talked about it, never." They hired readers and signed her up in the Books on Tape club, and she loved to listen to them.

When the exhibition called "Dance" was being planned, she consulted the museum workers by telephone, and sent Dolores to see a flamenco dancer. "She was involved from the house," Dolores recalls. "I had to call the Duchess of Ferria in Seville to send this flamenco dress from this famous flamenco dancer, Carmen Amaya." On Broadway there was a show, *Flamenco Puro*, and Diana sent Dolores to see it. Dolores told Diana the next day exactly how she felt, what it was like, and then Dolores taped the flamenco music for her. By this stage in her life, Vreeland could not bring herself to venture out. Dolores became her eyes.

As she backed off from center stage, her world became smaller. Her family, some good friends and her household help took the place of her devoted staff at the Costume Institute. Most of her family was far away, but kept in touch from long distance through letters and phone calls. Tim, whose marriage to Jean had broken up, had married the designer Nancy Stolkin in 1982. His children with Jean, Phoebe and Daisy, were now in their early twenties.

Phoebe and Daisy maintained a fond long-distance relationship with Diana. The girls admired their Nonina. Though neither ended up working in the fashion industry for very long, each flirted with the idea. As an undergraduate at UCLA, Phoebe worked part-time as a salesgirl for a local boutique. Daisy especially looked to her Nonina for career aid and advice. When Daisy pursued a modeling career, Diana had naturally helped her get involved with the right people, such as Eileen Ford. She appeared in magazines and in print advertisements, and spent time abroad in Sydney working for Australian *Vogue* before returning to the States to pursue more opportunities in Los Angeles.

Nicky, who had been Diana's important helper in New York since 1973, was leaving. He was studying with Khyongla Rato Rinpoche, a Tibetan incarnate lama who had founded the Tibet Center in New York. "The simplicity, the humility of this man" inspired Nicky to continue his studies in Buddhism in the late seventies. When he decided that he might become a Buddhist monk, he knew he was giving up many things that his grandmother valued. He was devoted to her, so his departure was difficult for both of them.

He first shaved his head in the late seventies, because it had a spiritual significance for him and he wanted to remove something that had so much to do with his image of himself. When he called her to tell her that he had done it, she was very upset and asked him, "How could you have done this to me?" He said, "I didn't do this to you, I did it for me," and he told her the reasons. She said, "But it must be so ugly." A month later, on the plane back to New York, he was trying to think how he was going to deal with what he feared was going to be a constant barrage of criticism. He decided to give her a day, and tell her, "During one day, you can say as much as you want about it, but after that I don't want to hear it." He was proud of his little gimmick.

"I arrived. I went into her bathroom, which was an intimate place where she talked to close family. There were chairs and little tables, and her music system. I came in, and she looked at me and she said, 'It's not so bad.' And she never mentioned it. She took the wind right out of my sails. Years later I told her how impressed I had been by her response. And she said, 'I tried.'"

After Nicky joined a Tibetan monastery in southern India, he wrote his grandmother in 1988 describing his very different life: "In a world where greed, pride, ambition are considered qualities to be admired and cultivated it's quite special that there exists this little island of people

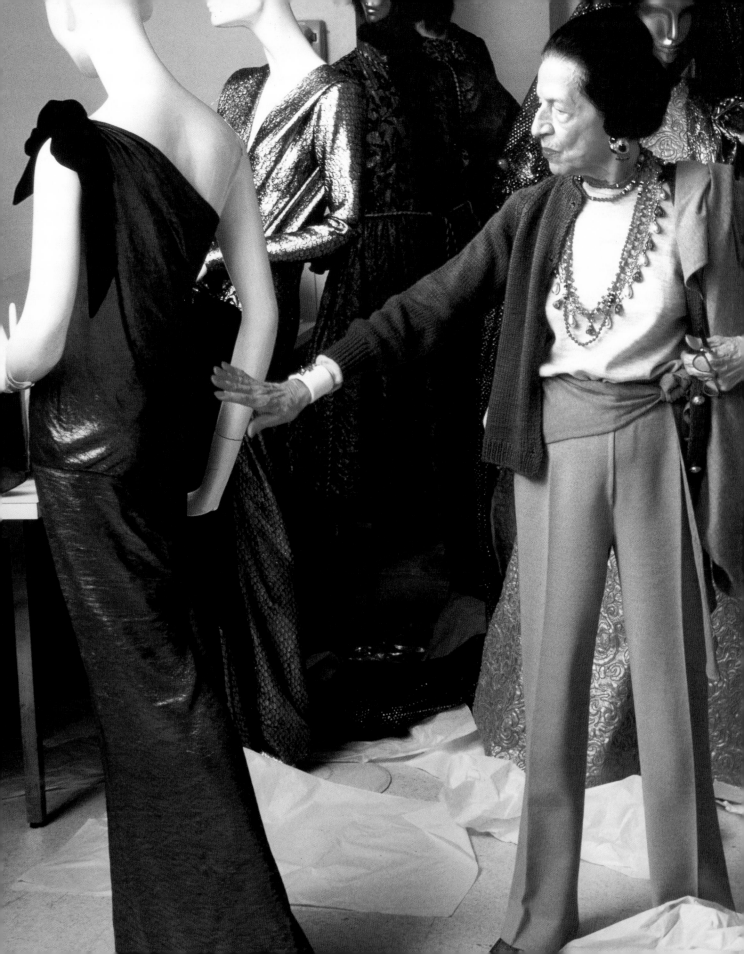

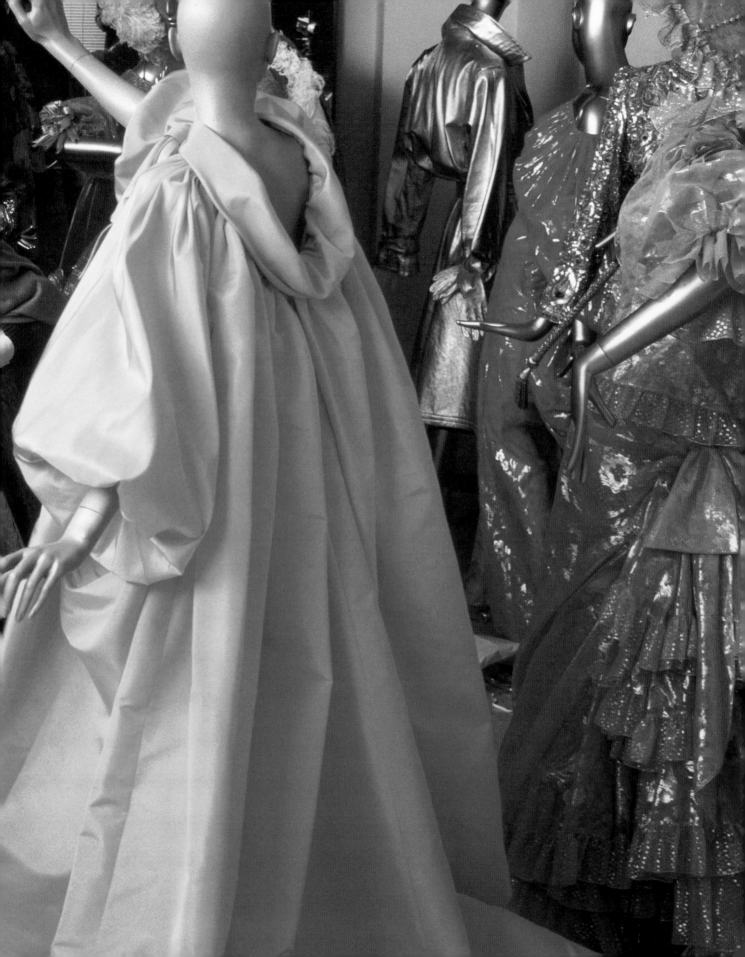

who haven't totally lost their perspective and values." Many of the young monks who had recently come from Tibet "don't know that the Earth is round or that whole continents such as South America, Africa, or Australia even exist. However, as simple as they may be—and actually it seems to be a quality of their simplicity—they have very wholesome values. One can see a certain purity in their attitudes—they haven't been tainted by sophistication."

Nicky's departure from New York left Diana somewhat empty, but she approved of his quest. As her other grandson, Alexander, said later: "She missed Nicky, but she was also very proud of him." His new mission "dealt with great purity, great sincerity. It was a great work ethic, and was all the things she stood for."

Now she became close to Alexander, who came to New York in 1986 after having spent years in Australia, where he was head of the Inner Peace Movement, an organization that helped people realize "a deeper sense of happiness and fulfillment." From childhood he had always felt his grandmother's positive and warm feelings about him and the life his family led, but since he lived in Europe, he only saw her on short visits. Now she helped him make the transition into the fashion world, as he was working for Ralph Lauren. He would come by the apartment and they would talk for hours, about whatever was on either one's mind. She liked to talk about seeing Reed again. "She believed in past lives and she believed in reincarnation and she believed in a spiritual attitude towards life," he said. She also gave him very good advice—to concentrate only on his family life and his work.

In the last years, Mary McFadden came to the apartment to visit her. She sensed that although Diana was almost blind, her imagination was as vibrant as ever. "She would say, 'Oh, doesn't Mary look wonderful tonight?' But of course, she never knew what I had on, but she would say that

because she would imagine the clothes that I might have had on." She had asked Mary to dine with her alone because she was fascinated by Mary's conversion to Islam. "She wanted to know about the Islamic world. She was very interested in mysticism, and I would try and explain it to her."

Alexander's family became her family. She loved his little boy, Reed, and called their apartment to check on the boy's schedule. "Was he in school? Was he in the park?" The little boy liked to come over and hold her hand.

As her emphysema worsened, she secluded herself in her room and would not let anyone see her. When she stopped dyeing her hair, Alexander asked her, " 'Why don't you get Mary Farr and her people to come up and dye your hair?' And she said no." When she stopped dyeing her hair, she didn't want to see anybody, and even people who came to read to her, read to her in the hallway. Whenever she invited people to dinner, she wouldn't come out of her room. Instead, she'd call them on the telephone in the dining room, where the meal was served, and conversation would proceed over the wire. The last two years of her life, very few people went to the apartment at all. The show was closing down.

As she became bedridden, her greatest pleasure was talking with family and friends on the telephone, always strong of voice, animated, interested in what was going on. She would have a talking date arranged beforehand, and then the nurse would dial the number and prop the receiver near her ear, because she could not sit up. For the rest of her waking hours, she would listen and learn, hearing music and books, plays, magazines and newspapers played on tapes or read aloud to her. Very good friends, like Kenny Lane, Oscar de la Renta, André Leon Talley and Jacqueline Onassis, would come and read to her. Frecky came from Europe and Timmy made visits from the West Coast. Tim sat by her bed. "We read everything: Balzac, Henry James, Truman

Capote, Alain Fournier, Isak Dinesen, even *Les Liaisons Dangereuses*. Reading aloud had always been a tradition in our family. She and my father had read to each other from the time they were married. . . . Reading was a form of communication between us, and at the end it brought us very close." They all tried to get her to eat—Dolores made soups from Ecuadoran recipes.

One morning Dolores came in and was told by one of the nurses, "Mrs. Vreeland isn't breathing well." That afternoon the nurse came to Dolores's office and said, "Come and hear how Mrs. Vreeland sounds." She was in pain and was complaining about it: a terrible pain in the back of her neck. During her bedridden years Diana had never once complained about any pain. Several times Dolores had called for an ambulance, only to have Diana revive—once, famously, she shot straight up on the stretcher and ordered herself returned. As Dolores remembered, "Now she was hallucinating, talking to her mother. From what she was saying now, she was young again, dancing at a party, enjoying herself. So I stayed there, and all of a sudden she said, 'Who's there?' So I said, 'It's Dolores, Mrs. Vreeland, how are you feeling?' She said, 'Oh, Dolores.' And it's the first time she said to me, 'Thank you for all you have done for me.'" Suddenly she cried out; in her strong voice, speaking to the bandleader, "Don't stop the music or I'll tell my father!" These were her last words. She sank into a coma and did not revive again after the ambulance trip to New York Hospital, where she died on August 2, 1989.

In the nurses' register, where a record of her daily condition was kept at the apartment, the last entry read "Mrs. Onassis called."

285

On a rainy day in the autumn of 1989, a memorial service for Diana Vreeland was held at the Metropolitan Museum. If it were not for the somber mood, one might think the crowd of friends and colleagues had congregated for one of her fabulous Costume Institute openings. Everywhere there were recognizable faces. Jacqueline Onassis came alone wearing a black suit and sunglasses. Lauren Bacall, also alone, soon joined company with Grace Mirabella. Oscar de la Renta, Richard Avedon, C. Z. Guest, S. I. Newhouse and Bill Blass all came and delivered eulogies.

A crowd of about 450 shuffled into the Medieval Sculpture Hall, where, probably to Mrs. Vreeland's delight, theatricality was not forgotten. Background music featured traditional Scottish laments, the Rolling Stones' "You Can't Always Get What You Want," Josephine Baker's "J'ai Deux Amours" and Maria Callas singing an aria from *Tosca*, all combining to set the mood for this finale. Friends and colleagues told rich Vreeland anecdotes. People were overheard saying, "It was just what she would have wanted."

After her death the memory of Diana Vreeland continued to inspire the fashion world. Jean Druesedow, who had worked at the Met as the associate curator in charge in the last years of Vreeland's reign, claims her work has influenced

institutions around the world to show costumes in a dramatic way and that all subsequent costume exhibitions reflect her influence. Costume historian Caroline Milbank feels that "years later, Vreeland's exhibitions really hold up," and are remembered not just for being glamorous, but also for showing "a very educated eye."

In 1993, the Costume Institute honored her memory with a show—"Diana Vreeland, Immoderate Style." It summed up her influence in the magazine world, in the fashion world and in the world of costume history. Richard Martin saw her as the great person to reckon with in the history of the Costume Institute of the Metropolitan Museum. "She was constantly thinking about fashion in a very fresh and new way." In addition, "her own style changed, and her openness to style changed all the time." Even though she was a woman in her sixties when she was at *Vogue,* "she went further than any other American fashion magazine editor in terms of expressing nudity and a sense of the body. . . . She loved all kinds of beauty, Asian beauty, African beauty. Today we call that being politically correct, being sort of global, but Mrs. Vreeland loved that back in the 1960's and made that a part of the fashion magazine."

Martin was also impressed by her juxtaposition of the old and the new, as in her December

1969 spread when she took photographs of Woodstock, New York, and accompanied each one with a complementary photograph from art history. She showed how "a group scene looks like *Saturday Afternoon on the Grande Jatte*," and another group scene "looks like Manet's *Déjeuner sur l'herbe*." In the year of Woodstock, "when in fact countless Americans were despairing of what was happening to American youth culture" or "what was happening in their society," Mrs. Vreeland "takes a contemporary event, and she puts it into a profound context. To all of those people who thought that the 1960's were bewildering, she says to them, 'It is no different than the 1860's, and what you saw as radical behavior for a painter like Manet in the 1860's is really a reasoning tool to look at something that we observe in our own time.' And this was all but unique, to be able to have this sense of the composure of a world between history and the present. I think it's remarkable."

In 1995, *Full Gallop*, a lively one-woman show brilliantly acted and written by Mary Louise Wilson and Mark Hampton, played in New York to rave reviews and brought Diana Vreeland back to life. It was set in a replica of her red living room during an evening in the summer after she was fired from *Vogue* and was trying to figure out what to do next. As one reviewer put it: "Seven years after her death, New York theatre audiences are discovering" that "there is no such thing as enough Vreeland." He went on to say that "what makes Vreeland—and *Full Gallop*—so intoxicating is that she refuses to surrender even when life turns ugly. In fact, the play is Vreeland's nonstop gallop to the battlefront, armed with glorious, eccentric observations from her rise to the top."

Even though Vreeland's style might not appeal to everyone—as she said, "If you want the girl next door, go next door"—it has appealed to many. *Full Gallop* played off-Broadway in New York in 1996 and 1997. It has since been produced all over the world, from Italy to Scandinavia and many cities and towns of the United States, including San Diego and Palm Beach. It continues to spark interest in this comic prophet as her memoir continues to be read and her brilliant picture book, *Allure*, is coming back into print.

After seeing *Full Gallop*, Carrie Donovan said, "Mrs. D would be so fascinated by this. It's a third career for her. Her first career was in magazines, the second in the Costume Institute and now here is this posthumous career." She was amused that young people who wouldn't have known about Diana's career loved the show.

While she was alive, Diana Vreeland was a fascinating figure in the fashion world. And when she died she became a legend.

Chapter 1: New York Childhood

1: Interview with Carrie Donovan and article in the *New York Times*, March 28, 1962.

1: Grandson's story about being born in Vladivostok: Interview with Nicholas Vreeland.

1: Diana's claim that she was born in the Atlas Mountains: Lieberson, *Interview*, December 1980.

2: Her birth date is established as July 29, as recorded in the 16th Arrondissement Bulletin de Naissance, issued August 2, 1903. However, when her birth was recorded with the British consulate general on October 30, 1903, the date was stated to be September 29. A copy of each record is in her file of personal papers. Diana always gave September 29 as her birth date.

2: Emily Key Hoffman and Frederick Young Dalziel were married the twenty-sixth of September, 1901: Church records at St. Peter's Church, Eaton Square.

3: The Dalziels' family motto was "I dare": Interview with Frederick Vreeland, July 1997.

3: Diana's description of her father as a penniless Englishman I found in George Plimpton's *DV* tapes (tape 2, side A). The tapes were made during Plimpton's interviews with Vreeland for her memoir, *DV*, edited by George Plimpton and Christopher Hemphill in the early eighties. A cousin, Henry Cobb, told me about the Ellis family.

5: Diana on her sister's beauty: *DV*, 10–11.

6: Diana on her relationship with her mother: *DV*, 11.

6–7: Information on Robert Chanler: *The Astor Orphans: A Pride of Lions* by Lately Thomas, and article in *Century* magazine: Diana Vreeland Archives.

6–8: Diana on her eccentric godfathers: George Plimpton's *DV* tapes (tape 2, side A).

7: The Gould-Decies wedding was described in great detail in collected articles in the Diana Dalziel Childhood Album. The bride, Vivien Gould, was the older sister of Diana's friend Gloria, eighteen years old—a debutante for only three weeks—and she came down the aisle on the arm of her father, George Jay Gould, son of the notoriously rich Jay Gould. The climax of the constant newspaper reportage came on the wedding day, when traffic was detoured for blocks, and a large crowd of reporters and cameramen pressed in four-deep at the church entrance on Park Avenue. Mrs. Gould had arrived well before the ceremony to deliver her two young daughters and Diana, and one can imagine their excitement getting out of the automobile amidst the shouting and shoving of reporters, cameramen and police. The reception guests—"confined to about a thousand people," the *Times* reported—were notables, from Enrico Caruso to Mr. and Mrs. John D. Rockefeller.

7–8: The descriptions of "The Children's Revolution" are from the Diana Dalziel Childhood Album.

8–9: The descriptions of European stays are from the Diana Dalziel Scrapbook of European Trips: 1911–1913.

9: The summer vacation in Idaho is detailed in the Emily Hoffman Dalziel Album and was also described to me by Henry Cobb, June 1997.

9: Clippings describing Emily Hoffman Dalziel as a game hunter are in the Emily Hoffman Dalziel Album.

9: Diana tells about her mother's flirtations and the flamboyant green dress she wore to Brearley in *DV*, 29 and 21. Interestingly, this image foretells Diana's own stylish appearance and use of excessive makeup, which would later embarrass her own sons when she visited them at school. Because of her hostile feelings toward Emily, it is likely that Diana dressed up her mother in her imagination to be more bizarre than she actually was. The evidence in the photo albums and articles gives a picture of a woman who is dressed in an appropriate manner. Emily appears to be intelligent and pleasing, not the bizarre creature Diana described in *DV*. The anecdote is typical of one kind of story in the memoir—it is a bit distorted.

9–15: Diana Dalziel Personal Diary, 1918.

14: On dancing school: Interview with Georgie P. Dwight.

15: Adrian Allen was told by her aunts that Diana was made fun of at school.

15: Diana on "unconscious dressing": Interview with Andrew Solomon.

16–18: I found information on the family's finances from the wills of Mary Weir and Emily Hoffman Dalziel. Whatever affection Emily may have felt for Diana was obscured by a lawyer's labored prose: "I make no provision or gift to my daughter DIANA, for the reason that under the will of my mother, Mary M. Weir, the gifts and devises [Villa Diana] given to my daughter DIANA so much exceed those given under said will to my daughter ALEXANDRA that it is my desire, in so far as I may be able, to equalize the fortunes of my two daughters."

18: Anna Key Thompson's sister and niece contested the will based on Anna's eccentricity and "undue influence by distant relatives." The *Times* headlines in 1923 read RICH TEACHER'S WILL CALLED INSANE ACT and, soon afterward, THOMPSON WILL UPHELD.

19: Clippings about Emily Hoffman Dalziel as a game hunter are in the Emily Hoffman Dalziel Album.

19–20: The descriptions of Diana as a debutante are from clippings collected in the Diana Dalziel Childhood Album. That year, Diana was active in a number of society charities. She waited on tables in the Colonial House restaurant at the Squadron A Armory during the Horse Show to Aid Charity. "One of the most attractive of the season's debutantes," she also took part in "Tag Day" arranged by the Mayor's Committee of Women, chaired by Mrs. William Randolph Hearst. Diana's smiling face also looked out from under a large hat in photos that were captioned with the information that she was sailing and later returning from Europe, where she had gone shooting in Scotland.

19: Diana describes the invitation from Condé Nast in *DV*, 48, and *DV* tapes.

19: Reed's upbringing and schooling were described in the Diana Dalziel Childhood Album and interviews with Frederick Vreeland.

19–20: Information on Reed's father, Herbert Harold Vreeland, I found in his *New York Times* obituary and *Who's Who*.

20: Diana's feelings about her looks and Reed are detailed in *DV*, 30.

Chapter 2: Mrs. Reed Vreeland of Hanover Terrace

23: Information about Diana's wedding and her mother's adultery scandal was found in a *New York Times* article dated February 27, 1924, and the gossip column clippings in the Diana Vreeland Archives.

24: Alexandra Dalziel described her mother's infidelities.

24: Emily Dalziel died September 12, 1927. Her certification of death in Nantucket, Massachusetts, listed the cause of death as hypertension, cardiac failure and pulmonary embolus. The *Times* reported: "Mrs. Dalziel had been ill for some time. Death was the result of an attack of

pneumonia." Her granddaughter remembers cancer being blamed, coupled with anxiety over the divorce case. In 1964, Diana told her doctor it was "tropical fever."

28: Aspects of Reed Vreeland's personality are taken from interviews with Frederick Vreeland, Mary Warburg and others, as well as from *DV*.

28: Diana describes how she was often shy around Reed: *DV*, 33.

28–31: By the time the Vreelands came to London, the Great War had changed people's way of seeing the world. This cataclysm had taken the lives of a generation of young men, men just older than Diana. The England of the late twenties that the Vreelands actually knew was the England of Evelyn Waugh, whose social satire in his *Decline and Fall* (1928) and *A Handful of Dust* (1934) captured the disillusioned and cynical frivolity of this generation. Diana, as always, picked out the positive aspects of English culture, and liked to think of the prosperous and strong England of Edward VII (1900–1911). Comments on Diana's life during this period are from *DV* and interviews with her sons, Frederick Vreeland and Thomas Reed Vreeland Jr.

29–31: Descriptions of the house in England are found in *DV*, 6–8, in newspaper articles from the Diana Vreeland Archives, and in a description for selling the house in the mid-thirties.

31: As appearances were always important for Diana, she was sure to take care in dressing her own children, as described in *DV*.

31–32: Details of Diana's social life in London were told to me by Emi-Lu Astor and Mary Warburg.

34: The description of Syrie Maugham's shop is from *The Sweet and Twenties* by Beverley Nichols.

34: Diana describes Elsie de Wolfe in her introduction to *Elsie de Wolfe: A Life in the High Style* by Jane S. Smith.

34–35: Although Diana said in *DV* that Edwina d'Erlanger ran the lingerie business with her, her daughter Tess d'Erlanger and sister Mary Warburg have denied this. Information about the lingerie shop comes from *DV*, 69, papers, including an account book, in the Diana Vreeland Archives, as well as an interview with Mary Warburg. One wonders why the Vreelands needed money when a substantial inheritance came to Diana in the 1920s. We can speculate that her capital was shrinking because, one, she was a lavish spender, and two, if her inheritance was invested in securities, as it most likely was, it declined in value during the Depression.

34–35: Information about the Duke of Windsor is from *Edward VIII* by Frances Donaldson.

35: As Wallis was not "on her own" (or separated from her husband) until 1935, a time when the Vreelands had left London, the truth of this story mentioned in *DV*, 69, is questionable. (Timetable: In 1928, Wallis married Ernest Simpson and went to London; 1930, Wallis met prince; 1933, prince gave party for Mrs. Simpson's birthday; 1934, prince visited her often.) As with all stories in *DV*, however, some parts of it may be true, such as Wallis's coming to the lingerie shop to buy something pretty.

35: Details about the Vreelands' dining with the Windsors at Senlis come from George Plimpton's *DV* tapes.

36–37: Facts about the Baron and Baroness d'Erlanger's party at Sidi sou Said are from *DV*, 44, and *Vogue*, August 15, 1931.

37: Designers like Chanel made clothes more practical and affordable during the Depression, according to *Fashions of a Decade: The 1930s* by Maria Costantino.

37: The change in attitude of fashion during the Depression is captured in Johnny McMullin's article "The Big Parade in Paris As Seen by Him": *Vogue*, October 1, 1932.

40: Details about high fashion in the thirties were taken from *In My Fashion* by Bettina Ballard.

40–41: Descriptions of Coco Chanel's and Elsa Schiaparelli's styles are excerpted from an Acoustiguide for Diana Vreeland's Costume Institute exhibit "The Tens, the Twenties, the Thirties": The Costume Institute, The Metropolitan Museum of Art.

41: Information on Christian Bérard is from Boris Kochno's book, *Christian Bérard*.

41: Information on Jean-Louis de Faucigny-Lucinge comes from his book entitled *Legendary Parties*.

41: Reed's friends, such as Mary Warburg, remembered that Reed was seriously ill, and thought it was TB. It is mentioned in letters of the period, but the exact illness remains a mystery, and it is not referred to in his later health records.

41: Diana recounts her time in Ouchy in *DV*, 83–84.

CHAPTER 3: "WHY DON'T YOU?"

43: Bettina Ballard's account of Diana's one-of-a-kind personality comes from Ballard's book, *In My Fashion*, 295.

47: Although prosperity did not mark their current lives, the Vreelands enjoyed being part of New York's "smart set"—a set that was very involved with fashion magazines. Their goings-on—weekends in the country, skiing and hunting vacations, parties and lifestyle—were covered in the magazines. The women were pictured in the latest fashions, and some even worked for the magazines.

47: Cecil Beaton speaks of Diana's social allure in *Cecil Beaton's New York*.

47–54: The information on the history of *Vogue* and *Harper's Bazaar* magazines comes from issues of *Vogue* and *Bazaar*, 1929–1940, including the "Why Don't You?" column by Diana Vreeland 1936–1938 and 1942. On April 15, 1939, Carmel Snow wrote to Diana telling her that Dick Berlin had increased her salary to $125 per week.

47–48: Diana retells the story of being discovered by Carmel Snow and of her instant attraction to the world of magazines in her autobiography, *DV*, 88–89.

50–51: Spoof of "Why Don't You?" column from *Harper's Bazaar*, June 1937. It was a reprint of a spoof written for the *Boston Herald*.

51–52: S. J. Perelman's reactions to the "Why Don't You?" column were printed in *The New Yorker* (1938) and can be found in "Frou Frou or the Future of Vertigo," *The Most of S. J. Perelman*, 53–55. Carmel Snow later chastised Perelman for his comments: *DV*, 92–93.

54: Reed Vreeland describes his son Thomas Reed Vreeland Jr., or Tim, in a letter to Endicott Peabody, the headmaster of the Groton School, 1935.

54: The "Rest Awhile" compound would be the center of Vreeland family life. Reed, his sister and his three brothers, all married with children, would spend time there for as long as Herbert Harold was alive to be the focus of their family affections. Diana's claim that Lindbergh flew over Brewster (*DV*, 59) is typical of her practice of inching closer to an exciting

and well-known event in her imagination than she was in reality. The statement shows her enthusiasm about Lindbergh's pioneering flight on May 20–21, 1927, but Lindbergh actually took off from Long Island and flew over the sound and Connecticut and headed north to Nova Scotia and Newfoundland, flying some distance east of Brewster, New York.

54–55: Interviews with Everett W. Vreeland, Emi-Lu Astor, Tim Vreeland and Frederick Vreeland helped me picture family life at Brewster.

CHAPTER 4: THE WAR

57: Frederick Vreeland recounts their trip to Bermuda in his letters to his mother, 1939.

57: Memories of Diana in Paris are from an interview in Bettina Ballard's book, *In My Fashion.*

57: Diana Vreeland describes her narrow escape from France as war broke out in *DV,* 96–97.

58: In a letter to the headmaster of Groton, Reed Vreeland explains the boys' need for a scholarship, 1941.

58–59: The state of the fashion industry in Paris at the start of the war is summarized in comments made by Carmel Snow and others in issues of *Harper's Bazaar* and *Vogue.*

59–61: Information on the status of the Parisian fashion industry during the war is described in Lucien Lelong's "Report to the Chambre Syndicat de la Couture Parisienne, July 1940–August 1944."

61–62: Experiences during the war are described in letters of Diana's various friends, including Johnny Schlumberger, Johnny Lucinge and Cecil Beaton, as well as Alexandra Kinloch, Diana's sister, and other Kinloch family members. Beaton's letters, as well as those of Johnny Schlumberger and Johnny Lucinge, were written to Mona Bismarck and are quoted courtesy of the Filson Historical Society, Louisville, Kentucky. The family letters are in the Diana Vreeland Archives.

65: Diana speaks about the change in the "Why Don't You?" column: *DV.*

65: The description of Diana is from *Harper's Bazaar,* May 1941.

65–66: Diana's tips for country living come from her "Why Don't You?" column: *Harper's Bazaar,* 1942.

67–70: Frederick and Tim Vreeland spoke to me about life at home and their time at Groton. Their letters to their parents also provided details.

68: Emi-Lu Astor described growing up at the Vreelands' in an interview. Also, she wrote her aunt in June 1947 alluding to her visits to Brewster.

68–69: Guests were frequent at Brewster, according to the Vreelands' guestbook: Diana Vreeland Archives.

69: Many people told me of rumors about Reed's infidelity.

70: Description of war juxtaposed with students' activities from the form of the 1945 Groton yearbook by Gurnee Gallien.

70: Tim Vreeland remembers his mother crying as he went off to war: Interview with Tim Vreeland.

70: I learned of the Théâtre de la Mode from the book of the same name by Edmonde Charles-Roux and from conversations with Susan Train.

71: Diana was relieved to discover that couture had survived the war, which she discusses in the "Vanity Fair" catalogue: The Costume Institute, The Metropolitan Museum of Art.

71: Diana's excursions during her return to Paris after the war are recounted in *DV,* 114–5.

CHAPTER 5: *HARPER'S BAZAAR*

79: The information on *Harper's Bazaar*'s history comes from Richard Martin's *125 Great Moments of Harper's Bazaar.* I learned of Vreeland's *Harper's Bazaar* work from interviews with Adrian Allen, Ann Vose, Richard Deems, Dottie Schott-Henry, Lillian Bassman, Eileen Ford, Melvin Sokolsky, Carmen dell'Orefice, Dorian Leigh and Suzy Parker. I also interviewed some of her close friends, like Jacqueline de Ribes, C. Z. Guest and Marella Agnelli, whom she included in the magazine.

79: The information on Christian Dior couture is from a *Harper's Bazaar* article, "The New Look," 1947.

79: In a letter to Marion Skelton dated February 18, 1947, Diana discusses the Dior "New Look" sketches.

81: Calvin Tomkins discusses Carmel Snow's concept for *Harper's Bazaar* in his article "The World of Carmel Snow" for *The New Yorker,* November 7, 1994.

81: To Richard Avedon, Carmel Snow was one of the first stars, ibid.

81: In an interview, Richard Deems spoke to me about Diana's role in layout meetings.

82: Diana discussed Brodovitch's vision for the magazine in her tribute to Brodovitch: Catalogue for the Philadelphia College of Art exhibit, February 1972.

82–85: Richard Avedon's memories of Diana come from his tribute at her memorial service.

91: In a letter to Cecil Beaton dated June 18 and written during the late 1940s, Diana describes life in Brewster after the war and their customary visit to Southampton: St. John's College Library, Cambridge University, Cambridge, England. Further information on her personal life is taken from interviews with Ann Vose, Melissa Bancroft, Cathy di Montezemolo, C. Z. Guest, Nicholas Vreeland, Thomas Reed Vreeland Jr. and Alexander Vreeland.

91–92: When I interviewed Ann Vose, she told me about Diana's striking bathing attire in Southampton.

92: The description of Kitty Miller's New Year's Eve party comes from Billy Baldwin's *Billy Baldwin: An Autobiography* with Michael Gardine, and friends of the Millers and the Vreelands whom I interviewed.

92: In a letter to Diana, Johnny Schlumberger speaks of the Vreelands' red apartment: Diana Vreeland Archives.

92–96: Descriptions detailing the decorating transformation of their apartment at Sixty-second Street and Park Avenue are from *Billy Baldwin: An Autobiography,* 245; an interview with Thomas Reed Vreeland Jr.; and an article written by him entitled "Diana Vreeland 550 Park Avenue, New York" for *Nest,* winter 1999/2000.

96: In an October 6, 1991, letter to Frederick Vreeland, Sen Paruaque tells how Reed selected the menus for the evening dinner and recounts the guests who came to Diana's dinner parties.

97: I spoke to Tim Vreeland about his experience abroad, and also read letters he wrote his mother during this period.

97–98: Information on Emi-Lu Astor's courtship with Hugh Astor and her impressions of her aunt Diana are from her letters to Diana in 1949.

99: Alexander Vreeland remembers his grandmother putting on makeup: Interview with Alexander Vreeland.

99: Betty wrote Diana in 1957 after seeing Marie-Louise Bousquet in Paris.

99: The composer Ned Rorem speaks of Marie-Louise Bousquet in his book *Setting the Tone: Essay and Diaries.* I also learned of Marie-Louise Bousquet and her gatherings from Hubert de Givenchy, la Baronne Eli de Rothschild and François Valéry.

99: Betty Vreeland often wrote Diana about her shopping trips, giving her a blow-by-blow account of her excursions in Paris. This letter from Betty to Diana is dated March 25, 1958.

99: When Timothy Vreeland became engaged to Jean Partridge, Frecky sent his parents a telegram in July 1958.

100: When Carmel Snow left *Harper's Bazaar,* she warned the Hearst executives not to hire Diana as editor-in-chief, according to Adrian Allen and an article written by Calvin Tomkins, "The World of Carmel Snow," published in *The New Yorker,* November 7, 1994: 157–58. Vreeland's reaction to Nancy White's appointment as editor-in-chief also came from the Tomkins article, 158.

100–101: Diana discusses her situation at *Harper's Bazaar* in letters to Cecil Beaton: June 27, 1958, and September 1958: St. John's College Library, Cambridge University, Cambridge, England.

CHAPTER 6: JACKIE AND DIANA

113–22: The Jacqueline Kennedy letters quoted in this chapter are either from the Diana Vreeland Archives or from Hamish Bowles, *Jacqueline Kennedy: The White House Years.*

113: Jacqueline Bouvier was Frederick and Betty's first dinner guest: Interview with Frederick Vreeland.

113: Frecky Vreeland told me of Avedon asking Diana how to photograph Jacqueline Bouvier.

113–14: A letter from Jacqueline Kennedy to Diana Vreeland written during the summer of 1960 sums up Jackie's love for French designs and the clothes she felt she needed to wear as a public figure.

114: Hamish Bowles, curator of "Jacqueline Kennedy: The White House Years," helped me understand the development of Jackie Kennedy's style. The second quotation is from his book, *Jacqueline Kennedy: The White House Years,* 17.

117: In a letter to Diana Vreeland, dated September 1960, Jacqueline Kennedy declares Diana her fashion mentor.

118: Diana's observations of Washington during the inauguration are from *DV,* 171.

118: The description of Jacqueline Kennedy's inaugural ball dress comes from *Women's Wear Daily,* January 20, 1961.

119: Diana on the advice she gave to Jacqueline Kennedy is from *DV,* 170–71.

119–20: In a letter dated February 2, 1961, Jacqueline Kennedy speaks of the First Family's photo shoot for *Harper's Bazaar.*

120: Joseph Kennedy offers to pay for Jacqueline Kennedy's clothes: Oleg Cassini's *A Thousand Days of Magic: Dressing Jacqueline Kennedy for the White House,* 49. Vreeland, in cahoots with Bergdorf Goodman, helped Jackie find what she needed. Oleg Cassini, a Hollywood designer, had been the owner of a ready-to-wear dress firm in New York since 1950. Cassini enjoyed the cachet of working in alliance with Mrs. Vreeland and Mrs. Kennedy—as well as the fact that his name became, overnight, internationally famous.

120: Cassini saw a chance to make a statement in dressing Jacqueline Kennedy, ibid., 18.

121: Information on Hubert de Givenchy dressing Jackie and the persistent rumor that he was ultimately behind her look: *WWD,* June 2, 1961, and June 5, 1961.

121: On Jackie's wardrobe during the Paris visit: Interview with Hubert de Givenchy.

122: Jacqueline Kennedy thanks Diana Vreeland for an enjoyable evening in a letter dated March 1961.

122: Diana Vreeland thanks Jacqueline Kennedy for her good time at the formal White House dinner in a letter dated February 1963.

122: Frederick Vreeland told me in an interview how he had spoken to the president about his Berlin speech. There has been some intellectual debate as to the exact meaning of President Kennedy's statement. Some believe his statement contained an inadvertant pun concerning a jelly doughnut. His audience, however, understood his meaning and loved his statement. Jacqueline Kennedy soon after wrote Diana to tell her what wonderful ideas Frecky had: Jacqueline Kennedy letter to Diana Vreeland, June 20, 1963.

CHAPTER 7: GETTING STARTED AT *VOGUE*

125: Carrie Donovan on Diana Vreeland's departure from *Harper's Bazaar: New York Times,* March 28, 1962. I spoke to her and S. I. Newhouse about Diana's hiring at *Vogue.*

125: On Jessica Daves's reign at *Vogue:* Daves's obituary and interview with Susan Train.

125–26: In *Allure,* Diana explains her reasons for running the Marilyn Monroe spread in *Vogue* during the summer of 1962.

127: Details on Diana Vreeland's offer from *Vogue* are outlined in a memo in her personal papers in the Diana Vreeland Archives.

127: In an October 9, 1962, letter to Diana, Cecil Beaton gave her his enthusiastic welcome to *Vogue.* Copyright© The Literary Executors of the Cecil Beaton Estate, c/o Hugo Vickers, executor, Wyeford, Ramsdell, Hampshire, England.

128: Diana's memories of the large office at Condé Nast come from *DV,* 146.

128–35: Information about Grace Mirabella was taken from her memoir, *In and Out of Vogue,* and my interview with her. I learned of the work atmosphere at *Vogue* while Diana was editor-in-chief from interviews with Grace Mirabella, Cathy di Montezemolo, Gloria Schiff, Carrie Donovan, Susan Train, Polly Mellen, Denise Doyle, Nuala Boylan, Lesley Blanch, Nicky Haslam and Felicity Clark.

135–36: In a 1964 letter to Cecil Beaton, Diana explains her newfound desire to emphasize personality over society: St. John's College Library, Cambridge University, Cambridge, England.

136–41: Fashion articles from *Vogue* are identified in the text. The "pink" issue was was that of April 15, 1963.

136–37: Memos and notes on Hope Cooke's Sikkim wedding story are in the Diana Vreeland Archives. The wedding in Sikkim article ran in *Vogue,* June 1963.

137–38: For reactions and statements on the assassination of President Kennedy, I drew from my interview with Nicky Haslam, and a letter from Diana to her friend Lan Franco Rasponi, dated December 12, 1963.

138: Diana told George Plimpton she didn't save her magazines: George Plimpton, *DV* tapes.

138–39: In a letter dated January 7, 1964, to Cecil Beaton and a letter and telegram to Susan Train, Diana gives explicit instructions to her photographer and editor regarding the shoot.

139: Cecil Beaton's reaction to Plisetskaya is from *Cecil Beaton: The Authorized Biography* by Hugo Vickers, 404.

139: The quotations about Mrs. Johnson are from "Mrs. Lyndon Baines Johnson: The First Lady," People Are Talking About, *Vogue*, May 1964.

139: Susan Train told me what happened at the shoot with Plisetskaya.

139–40: Correspondence between Betty Vreeland and Diana during the summer of 1964, as well as a memo from Mary Henry found in the Diana Vreeland Archives, provided information on the preparations for the Moroccan royal family shoot. Descriptions of the Moroccan landscape are from a letter written to Diana from Frederick Vreeland in December 1966.

141: Diana described her visit with her grandchildren in a letter to Mona Bismarck, December 12, 1964: Diana Vreeland Archives.

141: One of Vreeland's earliest *Vogue* pages showed beautiful women in scarves.

CHAPTER 8: SWINGING INTO THE SIXTIES

142: Diana's quote on her tenure at *Vogue* is from *DV*, 47.

143: Diana's remarks on the sixties are recorded in her article for *Rolling Stone*, "The Sixties," 1977.

146: The story of Polly Devlin's start in the magazine business is told by Devlin herself in an article, "Wrists, Mists, and Poets," published in the summer of 1995.

147–50: In correspondence with Jim Thompson, Diana expressed her desire to photograph the queen of Thailand. (Thompson went to Thailand just after the war, revived the Thai silk trade and became an important patron of Thai art. His house and art collection were photographed twice for *Vogue*. He mysteriously disappeared in 1967.) Diana's letter is dated February 1964, and Thompson's letter is dated March 10, 1964: Diana Vreeland Archives. Frustrated that she wasn't getting any response from the State Department, Diana wrote Mr. Krairiksh, master of the royal household, on July 30, 1964: Diana Vreeland Archives. Details about the photo shoot come from correspondence between Henry Clarke and Diana, dated August 17, 1964, and September 8, 1964; the *Vogue* article on Thailand, which ran February 1965; and a memo on Thai national costumes—all from the Diana Vreeland Archives. Information about fashion shoots headed by Diana during the sixties comes from interviews with Susan Train, Lesley Blanch, Vera von Lehndorff, Polly Mellen, Penelope Tree, Lauren Hutton and Despina Messinesi.

152: Speaking with Susan Train and reading her diary notes published in *Vogue* gave me information about the fashion shoot in Turkey.

153: Andy Austin Cohen interviewed Penelope Tree in January of 1996.

153–55: Information about the Tahiti shoot is from Norman Parkinson's *Fifty Years of Style and Fashion*, 112–14.

156: Veruschka's biography is taken from Michael Gross's *Model*, 184.

158: "The Great Fur Caravan," *Vogue*, October 15, 1966.

158–59: Details about Reed's health are taken from his own health

records. Other clues to Reed's failing health and how Diana ultimately dealt with his death are from interviews with Sarah Slavin, Thomas R. Vreeland Jr. and Susan Train.

159: Diana describes Reed's illness and her memories of him to George Plimpton: George Plimpton's *DV* tapes.

CHAPTER 9: THE HIGH *VOGUE* YEARS

161: Descriptions of Truman Capote's Black and White Ball are taken from Charlotte Curtis's book, *The Rich and Other Atrocities*; Amy Fine Collins's *Vanity Fair* article of July 1996, and Gloria Steinem's article "The Party," in *Vogue*, January 1967.

161–62: Penelope Tree's memories of Capote's party and of Diana are from the January 1996 interview conducted by Andy Austin Cohen.

162: Patrick Lichfield also remembered Penelope Tree at the party and described her to me.

162: In a memo Diana explains why Penelope Tree intrigues her: Diana Vreeland Archives.

162: In *Alex: The Life of Alexander Liberman*, co-authors Dodie Kazanjian and Calvin Tomkins comment on Richard Avedon's photographic style.

162–73: Through interviews with models Lauren Hutton and Marisa Berenson, editor Gloria Schiff, photographers Patrick Lichfield and Lord Snowdon, and Diana's colleagues Susan Train, Kenneth Jay Lane and Pilar Crespi, I learned of Diana's life during these years at *Vogue*.

166: Although Diana and Elsa Schiaparelli were friends for a long time, Elsa never spoke to Diana Vreeland after she launched Berenson's modeling career. Marisa said there was jealousy on Elsa's part.

166: Diana talks about Twiggy in *DV*, 148.

166: "Twiggy-mania," as Twiggy's popularity was called, and her first reaction to meeting Diana are described in Twiggy's autobiography, *In Black and White*, 68–72.

172: Horst explains how he captured the jet-setting crowd's "lifestyles" for *Vogue* spreads in his book, *Horst: Sixty Years of Photography*.

172: President Kennedy had a great passion for gardens, and Horst's photographs were meant to show off the Kennedys' formal gardens. In the Rose Garden, chrysanthemums bloomed, bordered on each side by a row of neatly trimmed crab apple trees, with magnolias framing the square in each corner.

173: In June 1969, Diana wrote to Penelope Tree about her desire to scale back the grandeur of the photo shoots.

CHAPTER 10: THE LAST COLLECTIONS IN PARIS

175: For descriptions of Diana's reputation in the Paris fashion world, I relied on tributes from her two close friends Yves Saint Laurent and Pierre Bergé.

175–81: For an insider's view of her life at *Vogue* during this period, I drew on interviews with Denise Doyle, Grace Mirabella, Felicity Clark, Susan Train and Lord Snowdon.

176: Pauline de Rothschild described Diana's clothes in a letter to Diana, September 2, 1967: Diana Vreeland Archives.

176: In his autobiography, Billy Baldwin writes of Pauline de Rothschild's enthusiasm for clothes.

177: In a letter to Diana, Pauline de Rothschild sums up their friendship: Diana Vreeland Archives, n.d.

177: The Duchess of Windsor describes the frustrations of her life in Europe in a 1967 letter to Diana: Diana Vreeland Archives.

177: Diana Vreeland's description of the duchess comes from *DV*, 68; and George Plimpton's *DV* tapes.

177: Preparation details for the de Redé ball shoot come from Diana's memos, a letter to Susan Train in the Diana Vreeland Archives, and *Vogue*, February 15, 1970.

178: In her July memo on the Paris summer collections of 1970, Diana recounts the momentous occasion of attending the collections: Diana Vreeland Archives.

178–80: The letters and *Vogue* memos, which are referred to in the text, are from the Diana Vreeland Archives.

180–81: In a thank-you letter to Patrice Calmettes dated August 1971, Diana reminisces about Paris. Patrice Calmettes kindly showed me his letters from her.

181: Lord Snowdon spoke to me about the mix-up with the photographs in the Nijinsky piece, and the letters and memos are in the Vreeland papers. C. Z. Guest in an interview told me she caught the mistake.

181–85: Diana's colleagues, including Grace Mirabella, Tony Snowdon, Carrie Donovan, S. I. Newhouse and Polly Mellen, spoke about Diana's firing from *Vogue*.

183: When Grace Mirabella was appointed editor of *Vogue*, Margaret Case wrote Cecil Beaton, April 1971: Letter at St. John's College Library, Cambridge University, Cambridge, England.

184: Babs Simpson and Alex Liberman explain Diana's downfall in *Alex: The Life of Alexander Liberman* by Kazanjian and Tomkins.

184: *Vogue*'s business losses in 1971 and Betsy Blackwell's comments were recorded in articles at the time of her firing.

CHAPTER 11: THE ENTR'ACTE

187: The public announcement of Diana's retirement: a memo to *Vogue* staff in Diana Vreeland Archives.

187: Diana held her head high as she wired Grace Mirabella after hearing the formal announcement of her termination: Diana Vreeland Archives.

187: Pauline de Rothschild consoles Diana in a May 16, 1971, letter: Diana Vreeland Archives.

187–88: Diana's travels are recorded in her 1971 datebook.

187–90: For Diana's reactions after she was fired from *Vogue*, I drew from interviews with Bill Blass, Kenneth Jay Lane, Jeanne Vanderbilt, Rosamond Bernier, Katharine Graham, Aline Romanones, Susan Train, John Richardson, Carrie Donovan and Nicky Vreeland, and numerous letters that are in the Diana Vreeland Archives.

188: Margaret Case's death was reported in *Women's Wear Daily* on August 26, 1971. Her final letter to Cecil Beaton was dated just four days prior to her death: St. John's College Library, Cambridge University, Cambridge, England.

188: Diana spoke to George Plimpton about Margaret Case's firing and death: George Plimpton's *DV* tapes.

188: Grace Mirabella wanted to give *Vogue* back to real women: *In and Out of Vogue* by Grace Mirabella, 145.

190: Information regarding Diana's health comes from papers in the Diana Vreeland Archives and interviews with Kenneth Jay Lane and Carrie Donovan.

190: Diana always hid any unpleasant situation and therefore wrote to Felicity Clark in April 1972 describing the lovely view from the hospital room and how spoiled she was. In a letter to Mainbocher (August 1972) she spoke of reconstructing her life.

190: Diana wrote Mary Warburg, July 21, 1972, about the possibility of a job at the Metropolitan Museum of Art.

190: Details about the "war chest" assembled for Diana come from an interview with Ashton Hawkins and a memo dated December 1972 in the Diana Vreeland Archives.

190: Mona's five husbands included Harrison Williams in 1926, Edward von Bismarck in 1955 and Umberto de Martini in 1971. From this point on, however, we will continue to call her Mona Bismarck.

190–200: Information about the Metropolitan Museum of Art and the decision to hire Diana Vreeland as a consultant to the Costume Institute is from interviews with C. Z. Guest, Ashton Hawkins and Thomas Hoving.

196: Details about the creation of the Costume Institute were found in museum publications. See note for pages 209–10.

202: In a letter to Diana, Cecil Beaton described the Duke of Windsor's funeral, June 1972: St. John's College Library, Cambridge University, Cambridge, England.

202: In a letter to Ashton Hawkins, Diana listed the Duke of Windsor's clothes she wanted for the exhibit: Diana Vreeland Archives.

202: Diana spoke of Balenciaga and his clothes to George Plimpton: George Plimpton's *DV* tapes and *Vogue*, May 1973, 151.

203: Comments from Madame Feliza, who worked with Balenciaga, came from notes in Diana's papers in the Diana Vreeland Archives and from an interview with Nicky Vreeland.

204: In a letter to her colleagues at the Costume Institute, Diana ingeniously handled the mannequin situation: Diana Vreeland Archives.

205: Descriptions of work on Diana's first exhibit are from interviews with Gardner Bellanger, Douglas Dillon, Ellen Alpert, Susan Train and Bill Blass.

205–6: Details regarding the arrangements for the Balenciaga show are listed in Diana's personal notes: Diana Vreeland Archives.

206: Reactions from friends and the press to the first exhibit are detailed in various magazines articles, including *Vogue*, May 1973, 150–51; Sciaky, *Women's Wear Daily*, March 23, 1973; Fraser, *The New Yorker*, June 21, 1973; Morris, *New York Times*, March 23, 1973.

207: In April 1973, Diana wrote to Mona Bismarck de Martini about the success of her first show. And in a previous letter to Mona, dated October 9, 1972, Diana apologized for being a bore: Diana Vreeland Archives.

207: Information about her whereabouts that summer comes from Diana's datebook in the Diana Vreeland Archives, interviews with her friends and a letter written to Cecil Beaton: St. John's College Library, Cambridge University, Cambridge, England.

207: In the book *The Life and Death of Andy Warhol*, Victor Bockris tells how Andy Warhol lived at director Roman Polanski's house while working on his movies in Rome, 273–74.

207: I spoke to Nicky Vreeland, her grandson, about Diana's rebirth at this stage in her life: Interviews with Nicholas Vreeland and Sam Green about the Venice get-together.

CHAPTER 12: THE COSTUME INSTITUTE

209–10: The background history of the Costume Institute and its exhibitions I obtained from Leo Lerman's book, *The Museum: One Hundred Years and the Metropolitan Museum of Art;* Stella Blum's article, "The Costume Institute: The Past Decade," in the "Vanity Fair" catalogue; Thomas Hoving's memoir, *Making the Mummies Dance;* and interviews with Thomas Hoving, Eleanor Lambert, Stuart Silver and Judy Straeten.

210: Information about Diana's contribution to the Costume Institute is from interviews with Thomas Hoving, Stuart Silver, Phyllis Magidson, Sam Green, Jean Druesedow, Ferle Bramson, Judy Straeten, Andrew Solomon, Tonne Goodman, Kenny Lane, André Leon Talley, Katell Le Bourhis and fashion journalist Bernadine Morris.

210: Andrew Solomon described Diana's attitudes about dressing mannequins.

211: According to Harold Koda, the armor was used as a centerpiece next to mannequins wearing lingerie to evoke the idea of romance: women dreaming of their knights in shining armor.

215: Before an exhibit opened, the press received preview tours. It was on such tours that reporters like Bernadine Morris would get their sound bites: Bernadine Morris interview.

216: The description of the opening party for "The Tens, the Twenties, the Thirties" is an excerpt from Philippa Toomey's article in *The* (London) *Times,* January 2, 1974.

216: Diana's thoughts on the designers of the twenties and thirties are found in Cobey Black's article for the *Honolulu Advertiser,* March 20, 1975.

216: The layouts of the exhibits are described in the exhibition catalogues: The Costume Institute, The Metropolitan Museum of Art.

216–18: Diana's summary of Vionnet comes from Blair Sabol's article in *Arts* magazine, March 1974. Vionnet's comments on her style are from her *New York Times* obituary, March 5, 1975.

219–20: Information about the Callot Soeurs' designs, Poiret and Chanel is from the Costume Institute's Acoustiguide for "The Tens, the Twenties, the Thirties: Inventive Paris Clothes 1909–1939" and from an interview with Rosamond Bernier.

220: To Anne Hollander, Diana's exhibits were show business, as she states in her *New York* magazine article, January 6, 1974.

220: The Richard Martin and Harold Koda quote is from their catalogue for "Diana Vreeland: Immoderate Style": The Costume Institute, The Metropolitan Museum of Art.

220–22: Tim Vreeland described to me his mother's trip to Los Angeles.

221–22: Diana's disappointment in not finding the Hollywood costumes is documented in two articles: Luther, *Los Angeles Times,* July 28, 1974, and Trow, "Haute, Haute Couture," *The New Yorker,* May 26, 1975.

222: Diana's finding Mary Pickford's curls was described in Trow's article for *The New Yorker,* May 26, 1975.

222: Eugenia Sheppard of the *New York Post* stated in her article that designers helped re-create the Hollywood dresses: November 18, 1974.

222: In the Acoustiguide for the exhibit "Romantic and Glamorous Hollywood Design," Diana described the costumes: The Costume Institute, The Metropolitan Museum of Art.

222: Eleanor Lambert described Diana's method in putting together the show: "Historic Movie Costumes Are Being Assembled," *St. Paul Pioneer Press,* September 10, 1974.

223: In the show's catalogue, Diana described the role movies have in our lives and the workmanship that went into creating the costumes: *Romantic and Glamorous Hollywood Design Program,* 1974, The Costume Institute, The Metropolitan Museum of Art.

224–27: The story of Marilyn Monroe's paillettes is from George Trow's article in *The New Yorker,* 86.

226: The critics' responses to "Romantic and Glamorous Hollywood Design" were articulated in newspaper reviews.

226: The opening of "Romantic and Glamorous Hollywood Design" is described by Carol Troy in the *Village Voice,* December 2, 1974.

CHAPTER 13: EXPEDITIONS TO THE EAST

229–30: Jun Kanai told me of Issey Miyake's reaction to Diana's exhibition. Memories of Diana's trip to Japan are from *DV,* 26–27, 37.

229: Diana described "The Tens, the Twenties, the Thirties" show in Japan to George Plimpton: George Plimpton's *DV* tapes.

229: On geishas, see *Geisha* by Liza Dalby.

229–30: In her memoir Diana remembers the dinners and parties in Japan: *DV,* 36–37.

230: Nicky Vreeland and his girlfriend, Priscilla Rattazzi, accompanied her to Japan. Nicky and Priscilla described the trip in interviews.

230–35: Information gathered from Thomas Hoving's book *Making the Mummies Dance* supplied the background on the series of exchanges between the Metropolitan Museum and Soviet museums, while an interview with Hoving and his book supplied the details of the Russian trip with Diana. I also spoke to Fred Hughes about the trip.

232: In interviews, Kenneth Jay Lane, André Leon Talley and others described Diana and Fred Hughes's friendship during the seventies.

234–35: The description of the first meeting at Kremlin: Hoving, *Making the Mummies Dance,* 355–56.

234: "Rich peasants" was Diana's term.

235: In June 1976, *Vogue* published an article written by Diana describing her firsthand view of Russia.

235–36: According to a January 15, 1976, interdepartmental memo, Diana and her staff began to prepare for the Russian exhibit: Material in the Metropolitan Museum Archives.

236: Diana described her view of Russia and its people on the Acoustiguide for "The Glory of Russian Costume."

236–43: I spoke to Marielle Worth, Judy Straeten and Harold Koda about the preparations for the show.

236–37: I learned about Thomas Hoving and Jacqueline Onassis's trip to Russia by speaking with Hoving and from his book *Making the Mummies Dance.* On their departure from Paris, television crews, newspaper reporters and paparazzi hounded them. Jackie toughed it out while French and Italian reporters continually asked Hoving who he was. By the time they reached the Soviet Union, the tabloids had marked him as Jackie's new secret lover.

236–37: On July 9, before Jackie's departure, Diana wrote her with a bit of advice: The Costume Institute, The Metropolitan Museum of Art.

240–41: In *The New Yorker* article of December 20, 1976, Diana was

quoted describing Peter the Great. The Russian costumes are also described in the exhibition's catalogue, *The Glory of Russian Costume*, and in Jacqueline Onassis's book *In the Russian Style*.

241–42: Harold Koda told me the story about the Parma violets.

243: The press covered not only the exhibit but the clothes the guests wore on preview night: Stanfill, *W* magazine, December 24–31, 1976; Larkin, *Daily News*, December 7, 1976; *The New Yorker*, December 20, 1976; Morris, *New York Times*, December 7, 1976.

243: Description of the exhibit is from Eugenia Sheppard's article.

243–44: Diana wrote to Ivan Kouznetsov to apologize for missing the curators' going-away party: Papers on "The Glory of Russian Costume," The Costume Institute, The Metropolitan Museum of Art. This letter reminds us that her eyesight was now failing and that frequently, even after a day of hard work, she dined out.

244–46: Information on the "American Women of Style" exhibition: Richard Martin and Harold Koda's catalogue for "Diana Vreeland: Immoderate Style," the catalogue from "The American Women of Style" and an interview with André Leon Talley.

246: In 1976, Diana received multiple awards, including the Dorothy Shaver Award, the Girls Town of Italy Fashion Achievement Award and the French Legion of Honor: *New York Times*, September 30, 1976: 46; *Daily News*, March 23, 1976: 12; letter from Diana to Frederick Vreeland, January 15, 1974; letter from Frederick Vreeland to Diana, May 18, 1974: All letters are in the Diana Vreeland Archives.

246: For information about "Vanity Fair" and Diana's quotes about the show, see the exhibition catalogue.

247: Diana was often chastised by critics for not following the norm: Feldkamp, *Evening Bulletin*, December 5, 1977; and Feldkamp, *Christian Science Monitor*, March 15, 1978: 18.

247: In a letter to Mona Bismarck, Diana shares her "Vanity Fair" discoveries: Diana Vreeland Archives.

247: Phyllis Magidson described to me working with Diana Vreeland.

CHAPTER 14: FUN IN THE SEVENTIES

249: Fred Hughes's background and information about his first meeting with Andy Warhol comes from his *New York Times* obituary, January 16, 2001.

249–58: For much of the information on Andy Warhol and Fred Hughes I relied on the book *Popism* by Andy Warhol and Pat Hackett, where Andy describes Fred Hughes on page 216.

250–58: Diana, Fred and Andy's outings are mentioned in the *Warhol Diaries*, 35–36.

256: Andy spoke of Fred's relationship with Diana and her effect on their relationship in the *Warhol Diaries*.

257: Diana's advice for *Interview* is from Diane Rafferty's article in *Network Woman*, November 1987: 60.

257: Steven Gaines, pop columnist for the New York *Daily News*, describes Studio 54 in his book *Simply Halston: The Untold Story*.

257: Odd highlights of Studio 54 were chronicled by Warhol in the *Warhol Diaries*, 131, 247 and 308.

257–58: Warhol spoke about Diana's reaction to Cecil Beaton's stroke in the *Warhol Diaries*, 113.

258–61: John Richardson spoke to me about Diana's drinking habits. For

more information about Diana's social calendar in the seventies, I spoke with many of her friends and peers, including Kenneth Jay Lane, Boaz Mazor, Oscar de la Renta, Geraldine Stutz, Lou Gartner, Bill Blass and Sam Green, and consulted her datebooks.

261: On the enigmatic Diana Vreeland and her startling looks: Lieberson, "Empress of Fashion: Diana Vreeland," *Interview* magazine, December 1980: 25.

CHAPTER 15: THE LAST ACT

263: On June 8, 1979, Diana wrote a letter to Susan Train telling of her visit to Hungary: Letter courtesy of Susan Train.

263: Details about Bob Lavine's clothing hunt in Vienna comes from his lists in the Diana Vreeland Archives.

263–64: Bob Lavine describes his dinner with Diana while working on the Hapsburg show in a letter to Cecil Beaton, September 23, 1977, and in an insert from his diary: St. John's College Library, Cambridge University, Cambridge, England.

263: For the "Hapsburg Era: Austria-Hungary" exhibit, I relied on my memories of the show and interviews with Judy Straeten and Phyllis Magidson, and on Stella Blum's introduction in the catalogue *Fashions of the Hapsburg Era: Austria-Hungary*.

269: Diana describes her eye for detail in her book *Allure*.

269: The creative process behind *Allure*: Interview with Ray Roberts.

269: Jacqueline Onassis sent Ray Roberts a copy of *Allure* and a thank-you note: Courtesy of Ray Roberts.

269–80: Katell Le Bourhis talked to me about her relationship with Diana and how it grew over the years. I also read Katell Le Bourhis's introduction in Italian to *D.V. La divina*, 8. She contributed a wealth of information about Diana's work at this later stage in her life.

270–71: Excerpts from Diana's conversation with George Plimpton are taken from George Plimpton's *DV* tapes.

276: Reviews of *DV* are from McGuigan, *Newsweek*; Arond, the *Daily News* and *The New Yorker*.

276: Diana calls her own bluff at the end of *DV*, 195–96.

276: I discussed the preparations for the Yves Saint Laurent show with Pierre Bergé and Katell Le Bourhis.

276: For criticism of Vreeland's methods, see *Selling Culture* by Debora Silverman.

279–80: The Nureyev story is from an interview with Andrew Solomon.

280: Diana getting dressed for "Costumes of Royal India" and then deciding not to go: Interview with Katell Le Bourhis.

280: Diana sells jewelry in 1987: Interview with Kenneth Jay Lane, and Lane and Miller's *Kenneth Jay Lane: Faking It*, 120.

280–85: I spoke with Dolores Celi, Nicky, Frecky, Alexander and Tim Vreeland and Mary McFadden about Diana's health and her final retreat from social life during her last years.

280: At the end, seven friends agreed to contribute $10,000 each to Diana's support.

285: In an interview Dolores Celi gave me her account of Diana's death.

285: The last entry for Diana is from the register kept by Diana's nurses at 550 Park Avenue, New York City.

287: Comments on *Full Gallop*: Marc Peyser, *Newsweek*, October 1996.

BOOKS

Alsop, Susan Mary. *To Marietta from Paris: 1945–1960.* New York: Doubleday and Company, Inc., 1975.

Baker, Patricia. *Fashions of a Decade: The 1940s.* New York: Facts on File, Inc., 1992.

———. *Fashions of a Decade: The 1950s.* New York: Facts on File, Inc., 1991.

Baldwin, Billy. *Billy Baldwin: An Autobiography,* with Michael Gardine. Little, Brown and Company: Boston, Toronto, 1985.

Ballard, Bettina. *In My Fashion.* New York: David McKay, 1960.

Bassman, Lillian. *Lillian Bassman.* Boston: Bulfinch Press, 1997.

Beaton, Cecil. *Cecil Beaton's New York.* New York: Lippincott, 1938.

———. *The Glass of Fashion.* London: Cassell, 1989.

———. *Photobiography.* New York: Doubleday, 1951.

Birchfield, James D. *Kentucky Countess: Mona Bismarck in Art and Fashion.* Lexington: University of Kentucky Art Museum, 1997.

Bockris, Victor. *The Life and Death of Andy Warhol.* New York: Bantam, 1989.

Bourdon, David. *Warhol.* New York: Harry N. Abrams, Inc., 1989.

Bowles, Hamish. *Jacqueline Kennedy: The White House Years.* New York: The Metropolitan Museum of Art and Bulfinch Press, 2001.

Bradford, Sarah. *America's Queen: The Life of Jacqueline Kennedy Onassis.* New York: Viking, 2000.

———. *Splendours and Miseries: A Life of Sacheverell Sitwell.* New York: Farrar, Straus and Giroux, 1993.

Breward, Christopher. *The Culture of Fashion: A New History of Fashionable Dress.* New York: Manchester University Press, 1995.

Cassini, Oleg. *A Thousand Days of Magic: Dressing Jacqueline Kennedy for the White House.* New York: Rizzoli, 1995.

Charles-Roux, Edmonde, et al. *Théâtre de la Mode.* Edited by Susan Train and Eugène Clarence Braun-Munk. New York: Rizzoli, in cooperation with the Metropolitan Museum of Art, 1991.

Clarke, Gerald. *Capote: A Biography.* New York: Simon and Schuster, 1988.

Colacello, Robert. *Holy Terror: Andy Warhol Close Up.* New York: HarperCollins, 1990.

Connickie, Yvonne. *Fashions of a Decade: The 1960s.* New York: Facts on File, Inc., 1991.

Costantino, Maria. *Fashions of a Decade: The 1930s.* New York: Facts on File, Inc., 1992.

Curtis, Charlotte. *The Rich and Other Atrocities.* New York: Harper and Row, 1976.

Dalby, Liza. *Geisha.* Berkeley: University of California Press, 1983.

De Marly, Diana. *Christian Dior.* London: B. T. Batsford, 1990.

Donaldson, Frances. *Edward VIII.* New York: Lippincott, 1975.

Ellis Miller, Lesley. *Cristóbal Balenciaga.* London: B. T. Batsford, 1993.

Faucigny-Lucinge, Jean-Louis de. *Legendary Parties.* New York: Rizzoli, 1987.

Flanner, Janet. *An American in Paris: Profile of an Interlude between Two Wars.* New York: Simon and Schuster, 1940.

Francis, Mark, and Margery King. *The Warhol Look: Glamour, Style, Fashion.* Boston: Little, Brown and Company, 1997.

Fraser, Kennedy. *The Fashionable Mind: Reflections on Fashion 1970–1981.* New York: Alfred A. Knopf, 1981.

———. *Ornament and Silence.* New York: Alfred A. Knopf, 1996.

Gaines, Steven. *Simply Halston: The Untold Story.* New York: G. P. Putnam's Sons, 1991.

Gross, Michael. *Model: The Ugly Business of Beautiful Women.* New York: William Morrow and Company, Inc., 1995.

Herald, Jacqueline. *Fashions of a Decade: The 1970s.* New York: Facts on File, Inc., 1992.

Heymann, C. David. *A Woman Named Jackie.* New York: Carol Communications, 1989.

Horst, Horst P. *Horst: Sixty Years of Photography.* Text by Martin Kazmaier and edited by Richard J. Horst and Lothar Schirmir. New York: Universe, 1991.

Hoving, Thomas. *Making the Mummies Dance: Inside the Metropolitan Museum of Art.* New York: Simon and Schuster, 1993.

Howard, Jean. *Jean Howard's Hollywood: A Photo Memoir.* Photographs by Jean Howard. Text by James Walters. New York: Harry N. Abrams, Inc., 1989.

Kazanjian, Dodie, and Calvin Tomkins. *Alex: The Life of Alexander Liberman.* New York: Alfred A. Knopf, 1993.

Kochno, Boris. *Christian Bérard.* London: Thames and Hudson, 1988.

Lane, Kenneth Jay, and Harrice Simons Miller. *Kenneth Jay Lane: Faking It.* New York: Harry N. Abrams, Inc., 1996.

Lawson, Twiggy, with Penelope Dening. *Twiggy in Black and White: An Autobiography.* London: Simon and Schuster, 1997.

Lerman, Leo. *The Museum: One Hundred Years and the Metropolitan Museum of Art.* New York: Viking, 1969.

Martin, Richard. *125 Great Moments of Harper's Bazaar.* New York: Hearst, William Morrow, 1993.

McConathy, Dale, and Diana Vreeland. *Hollywood Costume: Glamour! Glitter! Romance!* New York: Harry N. Abrams, Inc., 1976.

Milbank, Caroline Rennolds. *Couture: The Great Designers.* New York: Stewart, Tabori and Chang, 2000.

———. *New York Fashion: The Evolution of American Style.* New York: Harry N. Abrams, Inc., 1989.

Mirabella, Grace. *In and Out of Vogue.* New York: Doubleday, 1995.

Nichols, Beverley. *The Sweet and Twenties.* London: Weidenfeld and Nicolson, 1958.

Onassis, Jacqueline, ed. *In the Russian Style.* New York: Viking, 1976.

Parkinson, Norman. *Fifty Years of Style and Fashion.* New York: Vendome Press, 1983.

Perelman, S. J. "Frou-Frou, or the Future of Vertigo." In *The Most of S. J. Perelman.* New York: Simon and Schuster, 1958.

Penn, Irving, and Diana Vreeland. *Inventive Paris Clothes: 1909–1939.* New York: Viking, 1977.

Plimpton, George. *Truman Capote: In Which Various Friends, Enemies, Acquaintances, and Detractors Recall His Turbulent Career.* New York: Doubleday, 1997.

Rorem, Ned. *Setting the Tone: Essay and Diaries.* New York: Coward-McCann, Inc., 1983.

Ross, Josephine. *Society in Vogue: The International Set Between the Wars.* New York: Vendome Press, 1992.

Seebohm, Caroline. *The Man Who Was Vogue: The Life and Times of Condé Nast.* New York: Viking Press, 1982.

Shrimpton, Jean, with Unity Hall. *Jean Shrimpton: An Autobiography*. London: Ebury, 1990.

———. *The Truth about Modelling*. London: W. H. Allen, 1964.

Silverman, Debora. *Selling Culture: Bloomingdale's, Diana Vreeland, and the New Aristocracy of Taste in Reagan's America*. New York: Pantheon Books, 1986.

Smith, Jane S. *Elsie de Wolfe: A Life in the High Style*. Introduction by Diana Vreeland. New York: Atheneum, 1982.

Snow, Carmel White. *The World of Carmel Snow*. New York: McGraw Hill, 1962.

Sokolsky, Melvin. *Seeing Fashion*. Santa Fe: Arena Editions, 2000.

Steele, Valerie. *Paris Fashion: A Cultural History*. New York: Oxford, 1998.

———. *Women of Fashion*. New York: Rizzoli International, 1991.

Stein, Jean. *Edie: An American Biography*. New York: Alfred A. Knopf, 1982.

Tapert, Annette. *The Power of Style: The Women Who Defined the Art of Living Well*. New York: Crown, 1994.

Thomas, Lately. *The Astor Orphans: A Pride of Lions*. Washington Park Press, 1999.

Vickers, Hugo. *Cecil Beaton: The Authorized Biography*. London: Weidenfeld and Nicolson, 1985.

———. *Loving Garbo: The Story of Greta Garbo, Cecil Beaton, and Mercedes de Acosta*. New York: Random House, 1994.

Vreeland, Diana. *DV*. Edited by George Plimpton and Christopher Hemphill. New York: Alfred A. Knopf, 1984.

Vreeland, Diana, and Christopher Hemphill. *Allure*. Garden City, N.Y.: Doubleday and Company, Inc., 1980.

Warhol, Andy. *The Andy Warhol Diaries*. Edited by Pat Hackett. New York: Warner Books, 1989.

Warhol, Andy, and Pat Hackett. *Popism: The Warhol Sixties*. New York: Harcourt Brace Jovanovich, 1980.

ARTICLES

Arond, Miriam. "How an 'Ugly Little Monster' Became Queen of Fashion." *Daily News*, June 15, 1984.

Black, Cobey. "Elegance as a State of Mind." *Honolulu Advertiser*, March 25, 1975.

Blum, Stella. "The Costume Institute: The Past Decade." In *Vanity Fair: Centuries of Fashion from the Costume Institute of the Metropolitan Museum of Art*. New York: Metropolitan Museum of Art, 1977.

Buckler, H. Warren. "Mona Strader Bismarck: Countess from Louisville." *Louisville Courier-Journal*, May 5, 1996.

———. "Vanity Fair." *Soho Weekly News*, December 22, 1977.

Collins, Amy Fine. "The Cult of Diana." *Vanity Fair*, November 1993.

———. "A Night to Remember." *Vanity Fair*, July 1996.

Cunningham, Bill. "The World of Balenciaga Is a Great Triumph for Diana Vreeland." *Chicago Tribune*, April 9, 1973.

Chatfield-Taylor, Joan. "A Spectacular 'Vanity Fair.'" *San Francisco Chronicle*, December 21, 1977.

Devlin, Polly. "Wrists, Mists, and Poets." *The World of Hibernia*, summer 1995.

Donovan, Carrie. "Diana Vreeland, Dynamic Fashion Figure, Joins *Vogue*." *New York Times*, March 28, 1962.

Druesedow, Jean L. "In Style: Celebrating Fifty Years of the Costume Institute." *The Metropolitan Museum of Art Bulletin*, fall 1987.

Feldkamp, Phyllis. "All Is Vanity." *Christian Science Monitor*, March 15, 1978.

———. "Bizarre Bazaar Mirrors Human Vanity." *Evening Bulletin*, December 15, 1977.

Fraser, Kennedy. "On and Off the Avenue: Feminine Fashions." *The New Yorker*, June 16, 1973.

Hollander, Anne. "The Costumer Is Always Right." *New York*, January 6, 1974.

Lambert, Eleanor. "Historic Movie Costumes Are Being Assembled." *St. Paul Pioneer Press*, September 20, 1974.

Larkin, Kathy. "Balenciaga's Fashions Live in Retrospective." *Daily News*, March 23, 1973.

———. "Some Russian Dressing." *Daily News*, December 7, 1976.

Lelong, Lucien. "Report to the Chambre Syndicat de la Couture Parisienne, July 1940–August 1944."

Lieberson, Jonathan. "Empress of Fashion: Diana Vreeland." *Interview*, December 1980.

Lipson, Eden. "From Russia, with Opulence." *New York Times Magazine*, January 16, 1977.

Luther, Marylou. "She Works with Hollywood Ghosts of Fashion's Past." *Los Angeles Times*, July 28, 1974.

McGuigan, Cathleen. "Just Desserts." *Newsweek*, June 25, 1984.

Morris, Bernadine. "The Era of Balenciaga: It Seems So Long Ago." *New York Times*, March 23, 1973.

———. "Metropolitan Toasts a Dazzling Russia of Old." *New York Times*, December 7, 1976.

Peyser, Marc. "The Lady Is Still a Champ." *Newsweek*, October 1996.

Rafferty, Diane. "Vreeland." *New York Woman*, November 1987, 60.

Review of *DV*, by Diana Vreeland. "Briefly Noted." *The New Yorker*, July 23, 1984, 107–8.

Sabol, Blair. "The Tens, the Twenties, the Thirties." *Arts*, March 1974.

Sciaky, Françoise. "Eye View: Balenciaga's World." *Women's Wear Daily*, March 23, 1973.

Sheppard, Eugenia. "Inside Fashion: Those Were the Days." *New York Post*, November 18, 1974.

Stanfill, Francesca. "At the Metropolitan Museum: 'The Glory of Russian Costume.'" *W*, November 18, 1976.

———. "BP Mad for Evening." *W*, December 24–31, 1976.

Steinem, Gloria. "The Party." *Vogue*, January 1967.

"The Talk of the Town." *The New Yorker*, December 20, 1976.

Tomkins, Calvin. "The World of Carmel Snow." *The New Yorker*, November 7, 1994.

Toomey, Philippa. "Fashion History Relived with Mrs. Vreeland." *Times* (London), January 2, 1974.

Trow, George. "Haute, Haute Couture." *The New Yorker*, May 26, 1975.

Troy, Carol. "Hollywood at the Met: Fantasy for the Recession." *Village Voice*, December 2, 1974.

"Vionnet, Couturier, Dies at 98." *New York Times*, March 5, 1975.

Vogel, Carol. Obituary of Fred Hughes. *New York Times*, January 16, 2001.

Vreeland, Diana. "The Sixties." *Rolling Stone* 245, 1977.

———. Tribute to Alexey Brodovitch. In Brodovitch, Alexey. *Alexey Brodovitch and*

His Influence. Philadelphia: Philadelphia College of Art, 1972.

———. "USSR: The Shock of Luxury." *Vogue,* June 1976.

Vreeland, Thomas Reed. "Diana Vreeland, 550 Park Avenue, New York." *Nest,* winter 1999/2000.

COSTUME INSTITUTE CATALOGUES

The World of Balenciaga. New York: Metropolitan Museum of Art, 1973.

The Tens, the Twenties, the Thirties: Inventive Clothes 1909–1939 Checklist. New York: Metropolitan Museum of Art, 1973.

The Tens, the Twenties, the Thirties: Inventive Clothes 1909–1939 Catalogue. New York: Metropolitan Museum of Art, 1973.

Inventive Clothes 1909–1939. Kyoto: Kyoto Chamber of Commerce and Industry, 1975.

Romantic and Glamorous Hollywood Design Exhibit Catalogue. New York: Metropolitan Museum of Art, 1974.

The American Women of Style: An Exhibition Organized by Diana Vreeland. New York: Metropolitan Museum of Art, 1975.

Vanity Fair: Centuries of Fashion from the Costume Institute of the Metropolitan Museum of Art. New York: Metropolitan Museum of Art, 1977.

Diaghilev: Costumes and Designs of the Ballets Russes Checklist. New York: Metropolitan Museum of Art, 1978.

Diaghilev: Costumes and Designs of the Ballets Russes Catalogue. New York: Metropolitan Museum of Art, 1978.

The Fashions of the Hapsburg Era: Austria-Hungary Checklist. New York: Metropolitan Museum of Art, 1979.

The Imperial Style: The Fashions of the Hapsburg Era: Austria-Hungary. New York: Metropolitan Museum of Art, 1980.

Olivier Bernier. *The Eighteenth Century Woman.* New York: Metropolitan Museum of Art, 1981.

La Belle Epoque Exhibition Checklist. New York: Metropolitan Museum of Art, 1983.

Yves Saint Laurent Exhibition Checklist. New York: Metropolitan Museum of Art, 1983.

Yves Saint Laurent. New York: Metropolitan Museum of Art and Clarkson Potter, Inc., 1983.

Richard Martin and Harold Koda. *Diana Vreeland: Immoderate Style.* New York: Metropolitan Museum of Art, 1993.

COSTUME INSTITUTE ACOUSTIGUIDES

The Tens, the Twenties, the Thirties: Inventive Clothes 1909–1939. Audiocassette. Metropolitan Museum of Art.

Romantic and Glamorous Hollywood Design. Audiocassette. Metropolitan Museum of Art.

The Glory of Russian Costume. Audiocassette. Metropolitan Museum of Art.

UNPUBLISHED LETTERS AND MEMOIRS
The Diana Vreeland Archives

Photo Albums and Scrapbooks

Diana Dalziel Childhood Album; Emily Hoffman Dalziel 1905–1906 Album; Diana Dalziel Scrapbook of European Trips: 1911–1913; Alexandra Dalziel Childhood Album; Diana Vreeland photo album of late 1920s.

Reed and Diana Vreeland Personal Books

Diana Dalziel Personal Diary, 1918; the Vreelands' Brewster Guestbook; Vreeland Garden Book for Brewster; Reed Vreeland Recipe Books; Diana Vreeland Datebooks.

Letters from *Harper's Bazaar* Years

Letters to Marion Skelton, Louise Dahl-Wolfe and others.

Letters to Diana Vreeland

Letters from Leslie Benson, Edwina d'Erlanger, Frederick Vreeland, T. R. Vreeland Jr., Pauline de Rothschild, the Duchess of Windsor, Elizabeth Breslauer Vreeland and Nicholas Vreeland, Alexander Vreeland, Daisy Vreeland and Phoebe Vreeland, Alexandra Kinloch, the Kinloch family, Emi-Lu Astor, Jacqueline Kennedy and others.

Diana Vreeland *Vogue* Papers, Letters, and Copies of Letters

Correspondence with Henry Clarke, Susan Train, Lan Franco Rasponi, James Thompson, Mr. Krairiksh, Penelope Tree, Grace Mirabella, Felicity Clark, Charles Engelhard and others.

Diana Vreeland Copies of Letters in Early Seventies

Letters to Mainbocher, Ashton Hawkins, Mona Bismarck, Mr. Kouznetsov and others from Diana Vreeland.

Miscellaneous papers—clippings, household records, financial records, etc.

Letter from Sen Paruaque to Frederick Vreeland and other documents.

Correspondence of Diana Vreeland, Reed Vreeland and Friends

Letters from Reed and Diana Vreeland to Groton School. Diana Vreeland letters to Jacqueline Kennedy, courtesy of the John F. Kennedy Presidential Library. Letters to Patrice Calmettes, courtesy of Patrice Calmettes. Letters from Diana Vreeland to Susan Train, courtesy of Susan Train. Diana Vreeland letters to Louise Dahl-Wolfe, courtesy of the Center for Creative Photography. Letters from Cecil Beaton copyright © The Literary Executors of the Cecil Beaton Estate. Letters from Johnny Schlumberger, Prince Jean-Louis de Faucigny-Lucinge, Diana Vreeland, Reed Vreeland and others to Mona Bismarck, courtesy of the Filson Historical Society, Louisville, Kentucky.

Thank-you note from Jacqueline Kennedy to Ray Roberts, courtesy of Ray Roberts.

Letters from Diana Vreeland to Cecil Beaton; letter from Bob Lavine to Cecil Beaton; letters from Margaret Case to Cecil Beaton: St. John's College Library, Cambridge University, Cambridge, England.

The Metropolitan Museum of Art

Records of the exhibition "The Glory of Russian Costume." Scrapbooks of exhibition reviews 1973–1984.

***DV* Tapes**

Conversations between Diana Vreeland and George Plimpton.

Wills

The wills of William Alexander Dalziel, Mary Weir, Emily Hoffman Dalziel and Herbert Harold Vreeland.

ACKNOWLEDGMENTS

The members of Diana Vreeland's family, Frederick Vreeland, Thomas Reed Vreeland Jr., Nicholas Vreeland, Alexander Vreeland and Emi-Lu Astor, helped me in every aspect of my work. They talked with me for hours, they encouraged others to do the same, and they helped me to understand Diana and her world by generously sharing their memories and their own responses, which reminded me often of hers.

Diana Vreeland's friends and colleagues were very generous with their time and memories. I am grateful to the following for speaking with me:

Donna Marella Agnelli, Suni Agnelli, Virginia Ryan, the Countess of Airlie, Adrian Allen, Ellen Alpert, David Bailey, Letitia Baldrige, Lillian Bassman, Marisa Berenson, Pierre Bergé, Rosamond Bernier, Lesley Blanch, Bill Blass, Hamish Bowles, Nuala Boylan, Ferle Bramson, Dolores Celi, Felicity Clark, Colin Dalziel, Richard Deems, Hubert de Givenchy, Oscar de la Renta, Carmen dell'Orefice, Cathy di Montezemolo, la Vicomtesse Jacqueline de Ribes, la Baronne Eli de Rothschild, Polly Devlin, the late Carrie Donovan, Denise Doyle, Lou Gartner, Tonne Goodman, the late Katharine Graham, C. Z. Guest, Nicky Haslam, Thomas Hoving, Francis Kellogg, Nan Kempner, Eleanor Lambert, Kenneth Jay Lane, Katell Le Bourhis, Dorian Leigh, Patrick, the Earl of Lichfield, China Machado, Phyllis Magidson, Boaz Mazor, Mary McFadden, Polly Mellen, Despina Messenesi, Grace Mirabella, Bernadine Morris, S. I. Newhouse, Suzy Parker, Mary Jane Pool, Priscilla Rattazzi, John Richardson, Countess Aline Romanones, D. D. Ryan, Gloria Schiff, Dottie Schott-Henry, Stuart Silver, Sarah Slavin, Lord Snowdon, Andrew Solomon, Judy Straeten, Geraldine Stutz, André Leon Talley, Susan Train, Penelope Tree, Jeanne Vanderbilt, Vera Von Lehnsdorf, François Valéry, Ann Vose, Mary Warburg, Henry Wolf, Marielle Worth, and the others who graciously shared their memories and expertise.

I would like to thank those at libraries and archives who helped me, including Joan Rapp at the Filson Historical Society, Louisville, Kentucky; the staff at St. John's College Library, Cambridge University, Cambridge, England; Deirdre Donohue and Stéphane Houy-Towner at the Costume Institute at the Metropolitan Museum; Charlie Scheips and Michael Stier at Condé Nast; and Diane Nillsen and Leslie Calmes at the Center for Creative Photography at the University of Arizona. I am also grateful to the Metropolitan Museum, the Filson Historical Society, St. John's College Library, *Harper's Bazaar* and *Vogue* for giving me permission to quote from printed material.

Experts in the fashion world generously shared their knowledge and memories with me: Phyllis Magidson, Jean Druesedow, Judy Straeten, Harold Koda and Caroline Milbank. Susan Train helped in many ways and shared her expertise and years of fashion history.

I want to thank those who read my manuscript and offered advice: Corliss Smith, Pat Irving Frederick, Viola Winner, Carol Hill, Candida Dixon, Cindy Dwight and Mary Yost Crowley.

My assistants were invaluable: Annabelle Chan, Minna Procter, Adrienne Watewitz, Sally Hurst, Dana Burnell, Soo-Min Oh, Carey Kasten, Caroline Giordano, Leigh Goldstein, Stefania Heim and particularly April Marks, whose elegant and intelligent contribution was enormous.

And of course I want to thank my agent, William Reiss, and my thoughtful and skillful editor, Meaghan Dowling, as well as Julia Serebrinsky and our excellent designer, Elizabeth Avedon.

I am very grateful to the photographers who so generously contributed their photographs: Jonathan Becker, the Payson family, Richard Avedon, Frederick Eberstadt, Lady Airlie, Madame Gilberte Brassaï, Stuart Silver, Sam Green, Francesco Scavullo, Priscilla Rattazzi, Patrick Demarchelier, and Emi-Lu Astor.

I could not have written the book without the encouragement of friends and family, including my daughter, Daphne Trotter, whose enthusiasm and curiosity were inspiring, my son Sarge Gardiner, who with his superb visual sense gave me excellent advice; and my son Willard Gardiner, who with his wife, Beth, graciously acted as my host during work stays in London. My sister-in-law, Shelley Emery, spent hours transcribing interviews and helped me enormously. My sister, Andy Austin Cohen, interviewed for me. Other friends were wonderfully encouraging, including Ann Thorne, Linn Sage and Mary Blanchard.

The work of the late Shaun Gunson, who catalogued the Vreeland Archive, was invaluable, as was his encouragement. I was lucky to be able to hear from my mother-in-law, Georgie P. Dwight, her impressions of Diana and her sister when they were children living on the Upper East Side of New York in the first and second decades of the last century.

Most important was the constant enthusiasm of my husband, George H. P. Dwight.

PHOTOGRAPH AND ILLUSTRATION CREDITS

OPENING PHOTOGRAPH, FRONTISPIECE, AND PHOTOGRAPH OPPOSITE THE TABLE OF CONTENTS: © Jonathan Becker/All rights reserved.

CHAPTER 1: NEW YORK CHILDHOOD
All photographs in this chapter are from the Diana Vreeland Archives.

CHAPTER 2: MRS. REED VREELAND OF HANOVER TERRACE
22: Drawing by Augustus John, Diana Vreeland Archives
22, 24, 26–27, 35: Diana Vreeland Archives
25: Cecil Beaton Archives, Sotheby's, London
28: (*top*) Courtesy of Payson Family Photo Collection and Diana Vreeland Archives; (*above*) © National Portrait Gallery, London
30: Photograph by Vennemann, Diana Vreeland Archives
31: John McMullin/© *Vogue*, Condé Nast Publications Inc.
32: © Bettmann/CORBIS
33: Cecil Beaton Archives, Sotheby's, London.
36: Watercolor by Bébé Bérard, courtesy of Yves Saint Laurent Couture Archives, Paris
37: "Mrs Reed Vreeland went to Mainbocher," R. B. Willaumez/© *Vogue*, Condé Nast Publications Inc.
8–39: (*left*) Photograph by Cecil Beaton, Cecil Beaton Archives, Sotheby's, London; (*remaining photographs*) Photograph by Louise Dahl-Wolfe, © 1989 Center for Creative Photography, Arizona Board of Regents

CHAPTER 3: "WHY DON'T YOU?"
42: Photograph by Martin Munkacsi, © Joan Munkacsi/Diana Vreeland Archives
44: Photograph by Jerome Zerbe, Diana Vreeland Archives
45, 48: Photograph by Hoyningen-Huene, Diana Vreeland Archives
46: Photograph by Cecil Beaton, Cecil Beaton Archives, Sotheby's, London
50, 51: Diana Vreeland Archives
52–53: (*far left*) John McMullin/© *Vogue*, Condé Nast Publications Inc.; (*DV and Reed playing pool*) Photograph by Pragoff Cantor, Diana Vreeland Archives; (*left center and below*) Photograph by Louise Dahl-Wolfe, © 1989 Center for Creative Photography, Arizona Board of Regents; (*remaining photographs*) Diana Vreeland Archives
55: Photograph by George Platt Lynes, Courtesy Estate of George Platt Lynes

CHAPTER 4: THE WAR
56: Photograph by George Platt Lynes, Courtesy Estate of George Platt Lynes
58, 65: Diana Vreeland Archives
59: (*top*) Photograph by Fritz Henlé, Diana Vreeland Archives; (*above*) Photograph by Louise Dahl-Wolfe, © 1989 Center for Creative Photography, Arizona Board of Regents
60: (*clockwise from top left*) Reprinted with the permission of the Hearst Corporation; Photograph by Louise Dahl-Wolfe, © 1989 Center for Creative Photography, Arizona Board of Regents; Reprinted with the permission of the Hearst Corporation; Photograph by Louise Dahl-Wolfe, © 1989 Center for Creative Photography, Arizona Board of Regents
62: (*above*) Photograph by Cecil Beaton, Cecil Beaton Archives, Sotheby's, London; (*below*) Photographer unknown, Diana Vreeland Archives
63: Photograph by Cecil Beaton, Cecil Beaton Archives, Sotheby's, London
64, 66, 67, 71, 73–77: Photograph by Louise Dahl-Wolfe, © 1989 Center for Creative Photography, Arizona Board of Regents

CHAPTER 5: *HARPER'S BAZAAR*
78: © Richard Avedon, 1946
80, 81: Photograph by Louise Dahl-Wolfe, Courtesy of the Museum at the Fashion Institute of Technology, New York
82, 83, 84: Photograph by Louise Dahl-Wolfe, © 1989 Center for Creative Photography, Arizona Board of Regents
88: (*left top*) Diana Vreeland Archives; (*remaining photographs*) Photograph by Pragoff Cantor, Diana Vreeland Archives
90, 91: Diana Vreeland Archives
93, 94–95: Photograph by Slim Aarons, © Getty Images
98: Courtesy of Lady Airlie, Diana Vreeland Archives

100: Courtesy of Emi-Lu Astor; Diana Vreeland
 Archives
101: Diana Vreeland Archives
102, 103: © Estate Brassaï
104: © Horst Estate/ Diana Vreeland Archives
106–7: Oberto Gili/© *House & Garden,* Condé
 Nast Publications Inc.
108–9, 110–11: © Lizzie Himmel

CHAPTER 6: JACKIE AND DIANA
112, 115: © Bettmann/CORBIS
114: Photograph by Cecil Beaton, Cecil Beaton
 Archives, Sotheby's, London
116, 118, 119, 121, 123: Courtesy of the John
 F. Kennedy Library
117: © Jacques Lowe
120: Courtesy of the John F. Kennedy Library/
 Photographer: Robert Knudsen

CHAPTER 7: GETTING STARTED AT *VOGUE*
124: Diana Vreeland Archives
126: (*top*) *Women's Wear Daily,* Diana Vreeland
 Archives; (*left*) Diana Vreeland Archives
127, 129, 130, 132, 133, 137, 140:
 Photographer: Rowland Scherman
131: Diana Vreeland Archives
134: Magnum Photos, Photographer: Marc Riboud

CHAPTER 8: SWINGING INTO THE SIXTIES
142, 154, 155, 157: Franco Rubartelli/© *Vogue,*
 Condé Nast Publications Inc.
145, 148, 149, 151: Henry Clarke/© *Vogue,*
 Condé Nast Publications Inc.

CHAPTER 9: THE HIGH *VOGUE* YEARS
160: Drawing by Cecil Beaton, Courtesy of
 Hugo Vickers
162, 169: © Bettmann/CORBIS
163: Courtesy *Vogue,* Condé Nast Publications
 Inc.
164: Arnaud de Rosnay/© *Vogue,* Condé Nast
 Publications Inc.
165: Henry Clarke/© *Vogue,* Condé Nast
 Publications Inc.
166: Diana Vreeland Archives
167: © 1967 Gösta Peterson
170, 171: Patrick Lichfield/© *Vogue,* Condé
 Nast Publications Inc.
172, 173: Horst/© *Vogue,* Condé Nast
 Publications Inc.

**CHAPTER 10: THE LAST COLLECTIONS IN
 PARIS**
174: Courtesy Frederick Eberstadt/Diana
 Vreeland Archives

176, 178: Bert Stern/© *Vogue,* Condé Nast
 Publications Inc.
177: David Bailey/© *Vogue,* Condé Nast
 Publications Inc.
179: Patrick Lichfield/© *Vogue,* Condé Nast
 Publications Inc.
180: Diana Vreeland Archives
182: Photograph by Frederick Eberstadt/Diana
 Vreeland Archives
183: (*top, bottom*) Photograph by Frederick
 Eberstadt/Diana Vreeland Archives;
 (*middle*) Diana Vreeland Archives

CHAPTER 11: THE ENTR'ACTE
186, 198: Courtesy of Joe Eula
190: Photograph by Louise Dahl-Wolfe, © 1989
 Center for Creative Photography, Arizona
 Board of Regents
191: Karen Radkai/© *Vogue,* Condé Nast
 Publications Inc.
192, 193: Courtesy of Stuart Silver
194: The Metropolitan Museum of Art, Gift of
 Baroness Philippe de Rothschild, 1973.
 (1973.21.3) Photograph © 1994 The
 Metropolitan Museum of Art.
195: The Metropolitan Museum of Art, Gift of
 Baroness Philippe de Rothschild, 1973.
 (1973.21.8) Photograph © 1984 The
 Metropolitan Museum of Art.
197: The Metropolitan Museum of Art
200: © Bettmann/CORBIS
201: Photograph © by Ellen Graham
203, 204: Diana Vreeland Archives
205: Courtesy of Sam Green

CHAPTER 12: THE COSTUME INSTITUTE
208: Photograph © by Ellen Graham.
211: (*top*) Courtesy of Stuart Silver; (*above*)
 Photograph by Peter Simins, 1973, *Women's
 Wear Daily*
212, 214, 225: The Metropolitan Museum of Art
213: © 1977 by Irving Penn
215: Cecil Beaton Archives, Sotheby's,
 London
217: Photograph © by Ellen Graham
218: Courtesy of Stuart Silver
221: © Francesco Scavullo
226: © Patrick Demarchelier/All rights reserved

CHAPTER 13: EXPEDITIONS TO THE EAST
228, 231, 232, 233: Diana Vreeland Archives
234, 235: Photograph by Fred Hughes, Diana
 Vreeland Archives
238–39, 241: The Metropolitan Museum of Art
242: Photograph © 1999 Darleen Rubin.

245: © Jonathan Becker/All rights reserved.
 Styled by André Leon Talley

CHAPTER 14: FUN IN THE SEVENTIES
248: *Women's Wear Daily*
250: (*left*) *Women's Wear Daily;* (*inset*) Diana
 Vreeland Archives
251: The Andy Warhol Foundation, Inc./Art
 Resource, NY
252: (*right*) Diana Vreeland Archives; (*below*)
 Photograph © 1999 Darleen Rubin
253: Photograph © 1999 Darleen Rubin
254–55: (clockwise from top left) Diana and
 Elizabeth Taylor and husband John Warner
 at Tavern on the Green on opening night of
 The Act, 10/29/77, Photograph © 1999
 Darleen Rubin; Halston, Lauren Hutton,
 Cristina Ferrare, Lauren Hutton and
 Halston at the Belle Epoque party at C.I.,
 12/6/82, Photograph © 1999 Darleen
 Rubin; Ken Lane and Diana at the YSL
 opening party, 9/20/78, Courtesy of *Women's
 Wear Daily,* photograph by Nick Machalaba;
 John Richardson and Jonathan Lieberson at
 the YSL opening party, Courtesy of *Women's
 Wear Daily,* photograph by Nick Machalaba;
 Oscar de la Renta and Marina Schiano at
 the Designer Awards, 1/15/82, Courtesy of
 Women's Wear Daily, Photographer Lane;
 Diana and Valentino at Valentino party,
 9/11/77, Courtesy of *Women's Wear Daily,*
 Photographer Carlin; Erté and Diana,
 1975, Diana Vreeland Archives; Diana,
 Dick Avedon and Mary McFadden, RISD
 Awards, 1/18/79, Photograph © 1999
 Darleen Rubin; Grace Mirabella and Bill
 Cahan, RISD Awards, 4/2/81, Photograph
 © 1999 Darleen Rubin; (*center*) Diana and
 Ashton Hawkins, RISD Presidents Awards,
 3/27/80, Photograph © 1999 Darleen
 Rubin
256, 257, 258: Diana Vreeland Archives
260: © Priscilla Rattazzi/All rights reserved

CHAPTER 15: THE LAST ACT
262: Photograph by Roxanne Lowit
264, 265, 285: Diana Vreeland Archives
266–67, 268, 274, 275, 277: The Metropolitan
 Museum of Art
271: *Women's Wear Daily,* Photographer Simins
272: (*top*) Yves Saint Laurent Couture Archives,
 Paris; (*above*) Photograph by Roxanne Lowit
273, 278: Yves Saint Laurent Couture Archives,
 Paris
282–83: Ken Probst, © Bettmann/CORBIS